A Different Light

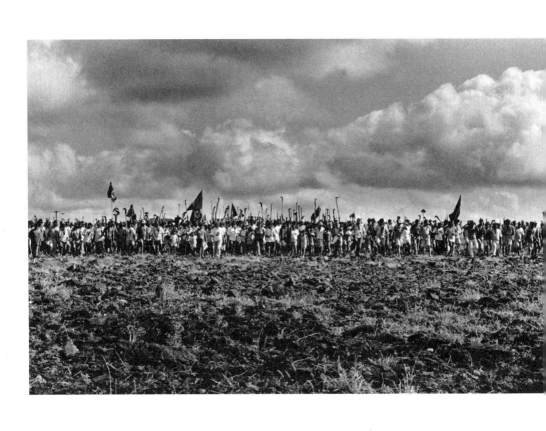

PARVATI NAIR

A Different Light

THE PHOTOGRAPHY *of* SEBASTIÃO SALGADO

Duke University Press *Durham and London* *2011*

PRINTED IN THE UNITED STATES OF

AMERICA ON ACID-FREE PAPER ∞

DESIGNED BY C. H. WESTMORELAND

TYPESET IN CHARIS WITH MAGMA

COMPACT DISPLAY BY TSENG

INFORMATION SYSTEMS, INC.

LIBRARY OF CONGRESS CATALOGING-

IN-PUBLICATION DATA APPEAR ON THE

LAST PRINTED PAGE OF THIS BOOK.

FOR JAMIE

CONTENTS

ACKNOWLEDGMENTS

In conversation with me, Sebastião Salgado referred several times to the notion of community. The practice of photography weaves together people and places, he said, linking his and Lélia's lives and projects to those of so many others. The same can be said of writing. Unexpectedly, this book project has consolidated a community of friends and proven the solidarity of strangers.

My first words of gratitude go to Sebastião and Lélia Salgado for their generous support. In the midst of working on *Genesis* and other projects, Sebastião spoke with me at length on more than one occasion; Lélia too gave of her time, even reading and commenting on some of this book. My thanks also go to Neil Burgess for help on numerous occasions and for facilitating the process of obtaining rights for reproducing the images in this book. I am grateful to Else Vieira, who put me in touch with Amazonas Images, and passed along several useful references. My thanks as well to all my colleagues at the School of Languages, Linguistics and Film at Queen Mary, University of London, and, in particular, in the department of Iberian and Latin American Studies. Research leave granted by my institution in 2006 and 2007, which was funded in part by an award from the Arts and Humanities Research Council, supported the writing of this project. The British Academy awarded me a research grant that enabled travel to Brazil and other places, as well as the payment of permission fees for the stills included here.

I sincerely thank Ken Wissoker, Mandy Earley, Jade Brooks, Molly Balikov, and Rebecca Fowler at Duke University Press for the interest, care, and attention given to this project. I am also hugely grateful to the anonymous readers who commented extensively and in close detail on the draft. My thanks go as well to Leslie Gardner. Amanda Hopkinson and Barbican Education generously allowed me to cite Hopkinson's interview with Salgado at the Barbican Centre in London in 2003. Ellen

Tolmie of UNICEF in New York shared her knowledge of Salgado's life and work with me. Andrea Noble, who has done much to forge important inroads into the study of Latin American photography, also supported my project. Julio Ramos generously shared his work and ideas. Jim Johnson's article on Salgado and his dynamic web blog on photography, theory, and politics have been extremely thought provoking. Jo Labanyi always inspires with her example. Bernard McGuirk has furthered and supported my interest in Salgado's work in important ways. James Dunkerley offered encouragement and support. Ismail Xavier of the University of São Paolo was unstinting in his help in obtaining research materials. Carlos Eduardo Gaio of Justiça Global gave me his time and valuable information on land disputes in Brazil. Gerardo Fontes and numerous other members of the São Paolo and Rio de Janeiro offices of the Movimento Sem Terra offered help and paved the way for a most memorable trip to the settlement at Terra Prometida. For their hospitality, I thank Amaro, Rosana, Alberto, and Amadeu. I also thank Aline and other members of the staff, as well as the students of Instituto Terra in Aimorés, Minas Gerais, who helped make our stay fruitful. I must acknowledge two Brazilian photographers who were so helpful during my stay in Brazil. For her spontaneous generosity and warm hospitality in São Paolo, I shall not forget Maureen Bisilliat, whose own photographic work is so remarkable. I also thank Claudia Andújar for the generous gift of her book of photographs.

For help with references, reading and commenting on drafts, useful suggestions, interest, inspiration, encouragement, friendship, conversations on and around photography, or maybe just laughter and light relief along the way, I thank: Juan Tomás Ávila Laurel; Valeria Baker; Layil Barr; Kanishka Chowdhury; Noèlia Díaz-Vicedo; Ángela Dorado; Louie Fasciolo; Omar García-Obregón; Ayesha Garrett; Dominika Gasiorowski; Berta Gaya; Tony Gorman; Julian Daniel Gutierrez-Albilla; Kamal Kannan; Anne Kershen; Pushpinder Khaneka; Joya and Lionel Knight; my parents-in-law, Richard and Elaine McGlinn; Alejandro Melero; John Perivolaris; Carlos Reyes-Manzó; Reza Tavakol; Morena Tiberi; Pedro Trespademe; Tom Whittaker; and Robert Young.

To my parents, Madhavan and Krishna Nair, I am and always will be indebted beyond measure. I first encountered and was struck by Salgado's photography when Mark McGlinn gifted me with a copy of *Terra* in 1997, and, throughout the many routes that led to this book, he has been the very best of travelling companions.

For the light that he brings my way, this book is for James Vikram Nair Heagerty.

Photo-Trajectory

THE PHOTOGRAPHY OF SEBASTIÃO SALGADO invariably evokes response. There are those who leave his exhibitions with tears in their eyes and those who feel somehow ennobled, yet humbled, by the images they have seen, as if the pathos and the splendour of these visions of human struggle, and above all human survival, had touched their brow with an extraordinary brush of light. There are also those who voice in no uncertain terms their objection to the representation of social disempowerment through images that can only be classified as exceptional works of aesthetic appeal. Then there are others, the photo enthusiasts and the aspiring photojournalists, who scrutinise his photography in order to deconstruct, and thereby apprehend, his unquestionably masterly technique. For many more, most particularly members of his avid following in the cosmopolitan metropolises of the West, his images frame otherwise unseen realities, both in terms of the particular and the general, and transport viewers across not merely the distance between far-flung continents and geographies but across differences of class, context, and power. In so doing, they render a global vision that implicates viewers, however momentarily, in a web of humanity framed in the act of social survival.

The diversity of viewers' reactions confirms the point, central to the analytic project embarked on in this book, that there can be no conclusive or correct reading of a photograph. Whatever their differences, most viewers will concur that Sebastião Salgado is a photographer of majestic proportions, one whose lifetime's work has, in recent years,

come to claim its rightful place as a key visual archive of the contemporary era, of the world that we, his historical peers, inhabit.

Tracing the Light

Salgado is no doubt one of the greatest photographers of our times. For over thirty years, he has chronicled various forms of displacement that have occurred in the latter part of the twentieth century and that persist into the twenty-first. His lens pans the entire world, particularly those parts that at once form the global majority and are the least favoured in economic and political terms. A sizeable number of those familiar with Salgado's work, though by no means all, enjoy a relative measure of security and prosperity in their own lives. A sizeable number of his subjects do not. His work is hugely relevant, if only because many of his photographs are the sole representations in circles of privilege of subjects who would otherwise be reduced to anonymous statistics. The scope of his work is so geopolitically wide that it offers a truly exemplary and comparative perspective of displacement across the globe. Salgado's photographs are also deeply memorable for their beauty. At work is a signature style that calls upon a sustained and recognizable aesthetic, expressed through the depths and heights of a pristine light. In this way, his images negotiate the awkward boundary between the social engagement of serious documentary photography and the seduction of the image in art.

There is much that is obviously admirable in Salgado's work and much that is open to contention. He is a Brazilian photographer, from the global south, but well established as a leading name in the West. He is an economist by training, fully aware of global inequalities and displacements; a resident of Paris; and a leading name in the upper echelons of the photography world. His work is wide and deep, but it also incites questioning and raises numerous questions in its own right. His following among practitioners and connoisseurs of photography is ample; by the same token, criticism has come his way from various quarters.

Despite the indisputable magnitude of Salgado's work, no sustained study of it has been carried out. Salgado's images are well known and circulate very widely, both in the elite circles of art photography and as part of a plethora of socially committed causes. He has spoken publicly on numerous occasions, interviews with him abound, and several crit-

ics, writers, and academics have dwelt on his work. Yet, given the depth and range of his photography, it is indeed curious that no full-length study of his work should exist. This book seeks to fill this gap. Its aim is to explore the gamut of Salgado's lifework in order to better understand the triggers behind its import, in practice and in theory.

To write on Salgado's work requires one to think about photography in wider terms. In turn, this leads to questions on and around vision. It is not solely to reflect on what Salgado's work offers viewers but also to ask from what perspectives and premises they view photographs and how they make sense of them. It is also to explore the ways in which images affect viewers and alter what they know of the world. In so doing, a series of debates on aesthetics, history, ethics, and politics, as also on photography and humanism, comes to the fore. These are of relevance beyond that of Salgado's work, as they are all issues that must be confronted whenever one thinks or writes about photography in general, and photodocumentary in particular. Salgado's photography offers a rich case study for exploring this complex, diverse, and interconnected theoretical arena brought to life by photodocumentary.

This book will therefore combine a biographical focus on Salgado's life and work—taking into account questions of background, photographic traditions, and the photographer's own objectives—with an interdisciplinary theoretical approach to analysing the way in which photodocumentary has an impact on our collective historical, ethical, and political consciousness. My aim is both to explore Salgado's work in some close detail and also to seek to understand photography better. I believe that few photographers can offer material as rich as Salgado's for the study of the genre itself—and, by extension, for understanding why that material matters so much.

Behind the Lens SEBASTIÃO AND LÉLIA

> I don't know if photography is a passion. Passion is something you can have one day and then the next day it disappears, replaced by another passion, another wish. It could be that it is a way of life.
> SEBASTIÃO SALGADO, quoted in Ken Light, *Witness in Our Time*

The details of Salgado's life assist in situating, and hence interpreting, his work. While an approximation to the facts of his life cannot explain his momentous output, certain biographical details are of particular

relevance to his photographs.[1] Sebastião Ribeiro Salgado, the sixth of eight children and the only son of his middle-class family, was born on February 8, 1944, on a large cattle farm owned by his parents. His early years were spent in close contact with rural Brazil. He was raised in the small town of Aimorés, in the state of Minas Gerais, not far from Espíritu Santo, in what was once the Atlantic rainforest and is now prime cattle-growing land. Later, he moved to a nearby city for his schooling. For his higher studies, he went first to Vitória, and then to São Paolo, where he trained as an economist. In 1967 he married Lélia Deluiz Wanick, whom he met while studying in Vitória, and they now have two sons and one grandson. Salgado began his career as an economist in Brazil in 1968, working for the secretary of finance of the state of São Paolo, and then moved to Paris, where he embarked on and finished the coursework for a doctorate in economics. The move from his homeland to Paris was triggered by his involvement in the student struggle against Brazil's military dictatorship; Salgado's Brazilian passport had been revoked by the dictatorship that he had opposed as a student and was only regained after a process of litigation. For a period of ten years, Salgado and his wife were unable to return home from Europe. Thus, the Salgados experienced, if only temporarily, the position of exile, severed from their place of origin while still in their twenties and thirties. Later, they moved from Paris to London, where he worked as an economist for the International Coffee Organization, and then back to Paris again. Although their exile ended when the political situation in Brazil changed, the Salgado family made the decision to continue living in Paris, largely to ensure better care for their second child, born with Down syndrome.

Salgado's turn to photography took place in the early 1970s, happening through chance: his wife, who was studying architecture, purchased a camera that he began to use.[2] The camera led him to take pictures of those close to him, initially of Lélia, and from there, he extended his range of subjects and discovered his affinity with the medium. In the process, he was confronted with a major career decision: whether to give up the security of a job as an economist in favour of the uncertainties of life as a photographer.

The question was resolved by 1973. By then, Salgado had made photography, and photojournalism in particular, his main occupation and was working for Sygma, a Paris-based news agency, covering Portugal and lusophone Africa. A year later, he moved as a freelancer to the Gamma agency, where his coverage spanned Europe, Africa, and

Latin America. In 1979, Salgado joined the prestigious photojournalism agency Magnum, founded in 1947 by four of the most enduring names in photo reportage: Robert Capa, Henri Cartier-Bresson, George Rodger, and David "Chim" Seymour.[3] His nomination to this agency came from Raymond Depardon, himself a photographer who had moved from Gamma to Magnum. Salgado thus came to claim a place among the elite photojournalists of the twentieth century, almost all of whom have been associated with Magnum.

Nevertheless, neither his entry into Magnum nor his exit some fifteen years later were without turmoil. Russell Miller, in his account of the history of the photo agency, provides largely anecdotal insights into Salgado's time at Magnum.[4] Miller's book outlines Magnum's own controversial course as a leading agency that started off as a cooperative founded by four men who had no business experience and nothing in common but a shared passion for photography. The ensuing financial uncertainties that plagued this agency were alleviated somewhat in the early 1980s by an unexpected break that came via Salgado. Sent in March 1981 to cover Ronald Reagan's speech to industrial leaders in Washington, D.C., Salgado was present, and the only photographer to document the whole incident, when Reagan was shot in the chest by John Hinckley Jr. as the president walked toward his waiting car. Miller reports that Salgado arrived in Washington in his usual casual clothes, more suited to the outback than to a presidential retinue, and that he had to borrow a suit from a Magnum colleague, which proved too big for him. Ill at ease in his borrowed gear, Salgado left the building where the president was speaking a few minutes prior to the president's own exit. He thus happened to be outside as the president walked by and was shot. According to Miller, Salgado states that he followed the president and so found himself walking toward the gunfire. As a result, the key images, much disseminated in the press and which linger in the collective memory of that shooting, were taken by Salgado.[5]

In a matter of seconds, Salgado indisputably had made a name for himself as a photojournalist and had also made substantial sums of money for Magnum. Despite this, Miller states that Salgado was refused full membership in Magnum when he submitted his first application. Miller quotes Salgado as saying, "I suffered a lot from this. . . . I don't think my pictures were the problem; I think some people in Magnum wanted to teach me a lesson."[6] Indeed, according to Miller, discord with some colleagues, combined with a certain dissatisfaction

with the workings of the agency, continued to be a problem, which ultimately led to Salgado's resignation in 1994. Despite this, it is clear that throughout the 1980s Salgado occupied a leading position at Magnum. It is also clear that his time at Magnum confirmed his status as a, if not *the*, leading photojournalist of his generation.

Salgado and his wife established their own agency, Amazonas Images, with its office in Paris in 1994. Salgado often states that to attribute his work solely to himself is to touch no more than the tip of an iceberg. For behind the scenes and by his side is his wife, Lélia Wanick Salgado, cofounder and director of Amazonas Images and the artistic director of all his work. If the Salgado name has become iconic, then much of this fame surely is owed to Lélia's vision and acumen. Indeed, and as Salgado himself often acknowledges, theirs was a joint project from the start. Salgado's decision to give up a secure job as an economist and take up the challenge of making a living through photography was made together with his wife, as it affected the family as a whole. Furthermore, there is little doubt that Lélia's interest in architecture and design played a seminal role in awakening Salgado's own imagination to the possibilities of representing what he has termed the "three-dimensional" within the confines of "two-dimensional" space. She works closely with him, supported by a small but long-standing team that steer his images from dark room to finished product. Lélia conceptualizes and organizes the layout of his books and acts as curator of his photography; the presentation of his images is inextricably tied to her vision of how his work should be projected and made public. The inseparability of their lives and work becomes all the more evident when one considers that their photographic projects have been complemented since 1999 by the work of the Instituto Terra, a nonprofit organization cofounded by them and directed by her to replenish the depleted Atlantic rainforest. Indeed, to those who have met the Salgados, it quickly becomes clear that Lélia directs and manages several matters relating to the public dissemination of his work and so must be seen as a key decision maker whose contribution to the success of their projects is crucial. In this sense, she is one of two main architects of the Salgado name.

In conversation with Lélia, it becomes clear that her appreciation of the impact and potential of photography is firmly linked to the beliefs and values that the Salgados share. A profound compatibility is what makes their personal and professional closeness possible. Salgado's photographs bring together his interest in and awareness of economic

issues with the potential of visual representation that he first discovered with and through his wife. Beyond this, there is also Lélia's vision, her ability to spot a good photograph and to construct photographic narratives and essays, her foresight and sense of aesthetic, all of which become inseparable from his own sensibility. Additionally, there are the ethical and political concerns that they share, expressed through his work as a photographer and through hers as a trained musician, a designer of his books, and the director of where and how his work is seen.

Together, they have designed and produced numerous highly acclaimed volumes of Salgado's photography and collaborated in the mounting of several large-scale photographic exhibitions, in some of the world's most prestigious venues. They have also committed pieces of his work to projects and organizations that they wish to support, most importantly the cause of the Movimento Sem Terra in Brazil and other humanitarian organizations. Furthermore, as laid out in the final chapter of this book, Lélia's commitment to environmental work, evident in her project at the Instituto Terra, is closely bound to Salgado's current photographic project, *Genesis*. In this sense, his success is hers as well, and the recognition that has come his way is to no small degree through her efforts. With this in mind, it should be understood that any study of Salgado's work implicitly focuses on Lélia's work as well. Given her presence behind the scenes, all mentions in this book of "Salgado's work" will carry reference to her work as well, inextricable as it is from his.

To date, Salgado has won every major award in photography, among them the W. Eugene Smith Grant in Humanistic Photography and, on two occasions, the nomination for photographer of the year by the International Center of Photography in New York. He has also been awarded honorary doctorates from several universities. Among the most notable of the awards he has received are the Grand Prix National de la Photographie from the Ministry of Culture in France and the Principe de Asturias Award for Arts from Spain. He is also an honorary member of the American Academy of Arts and Sciences. In 2001, he was appointed a UNICEF goodwill ambassador and, in 2004, he was made Comendador da Ordem de Rio Branco in Brazil. His work has received attention and the warmest of praise from critics of photography, such as John Berger; it has also inspired writers, such as Eduardo Galeano and José Saramago, among others, to comment on and elucidate his subject matter in the form of essays that accompany Salgado's photographs.

Through Brazilian Eyes

Salgado is a global photographer and also a Brazilian one. Indeed, he states that to be born Brazilian is, in a sense, to be born into a global community, for Brazil is a diverse and heterogeneous nation.[7] This is a point worth bearing in mind. If his gaze is that of an economist-turned-photographer who works at a global level, then it is also surely a gaze forged in the Latin American context, most specifically that of Brazil. While Salgado occupies a leading role in the league of world-class photographers, there is much that speaks of Latin America, and Brazil in particular, in his work.

Salgado's early life in Brazil, his awareness of Brazil's position of debt within the hierarchical system of global capitalism, and the visual impact of Brazil's expansive horizons, even the quality of light over the vast stretches of land in Brazil, all contribute to his approach as a photographer. While intellectually he has an understanding of Brazil's placement in a global hierarchy of power, on a sensory front, his perceptions of the world around him reveal the indelible mark of his first landscapes. It is impossible not to be struck by the breathtaking span of Salgado's lens. This sense of vastness can be found not merely from photo-essay to photo-essay, but also within images, so that both man and beast, depicted as individuals, groups, and communities, are framed within the wide expanses of nature and land. Indeed, in many of his photographs, in particular those of Africa and Latin America, the sky features as a limitless expanse, against which the drama of existence is cast. Before such a sprawling canvas, and in counter-direction to the gaze of the viewer, the diverse subjects of his images appear to move in the photograph against a horizon of time.

The magnitude of Salgado's images is in keeping with that of his native Brazil. A giant of a nation, it is the largest country in Latin America and the fifth largest in the world. Its complex geography stretches from the Atlantic coast, through the central plateau, to the Amazon and Paranagua basins. Viewed from the Atlantic coast, the Great Escarpment of Brazil, with its uplands that drop suddenly to the sea, appears as an imposing wall. The country presents the most amazing contrasts of climate and landscape, as well as extreme examples of the sociocultural features of developing nations, particularly in the spread of the megalopolis São Paolo. It is at once the tenth most industrialized country in the world and entrapped in a seemingly insurmountable debt to the

International Monetary Fund and the World Bank. This is also a country with a heterogeneous history imprinted with the stamp of colonization and slavery, and it has the resulting hybrid cultural identity.

The drama of Salgado's photo-essays bears a direct link to the drama of Brazil's social contradictions. In analysing Salgado, his photography must be considered the lynchpin connecting the artist's specific rooting in Brazil together with his acute awareness of global economics and Brazil's position within this scenario. This is not to say that Salgado is not a global photographer with a planetary vision. The daring sweep of his camera transgresses individual, national, and continental boundaries, encompassing a global community. Indeed, the sheer planetary dimensions of his efforts challenge and supersede attempts to locate or, indeed, confine Salgado as a "Latin American" or "Brazilian" photographer.

Nevertheless, in part, Salgado has attributed this breadth of vision to a particular spatial imagination that derives from his own childhood in Brazil.[8] The farm he grew up on, he states, was of dimensions unthinkable in Europe. The memory of the spatial expanses of Brazil combine, in Salgado's work, with an awareness of global economic chains to produce a vision that is distinct even as it is broad. He explains, "You photograph with all of you. I come from an underdeveloped country where the social problems are very strong. And so it's inevitable that my photos reflect that. . . . I think there is a Latin American way of seeing the world. And it's something you can't teach, because it's just part of you."[9]

Some would say that this is a debatable, even objectionable, statement. Can there be a single Latin American (or any other single, culture-specific) way of seeing? Eduardo Galeano has stated quite specifically that there is not; rather, there are Latin American *ways*, he stresses, of seeing the world.[10] We must assume, therefore, that Salgado's is one such way—a vision forged by his own subjective and intellectual experience of being Brazilian, as well as one shaped by the experience of being, at least for a while, a Latin American exile in Europe whose photography is in dialogue with that of other leading photographers, both Latin American and otherwise. Most would agree, though, that Salgado's visual aesthetic reveals the historical and cultural accents of Latin America, and Brazil in particular.

Equally present in his work are established traditions that make up the genre of photodocumentary. It would not be surprising if Salgado,

when venturing into photodocumentary, had not looked for direction from the masters of this genre who had gone before him. Indeed, such is the migratory nature of the photographic medium that it is impossible, even incorrect, to demarcate it geoculturally. Like the very modernity from which it was born, photography is about movement—the movement of vision over and beyond the here and now. Even so, like that of any other visual genre, the trajectory and development of photodocumentary is punctuated by iconic names and arresting moments. Salgado has both of these, and so is part of an ongoing tradition that extends back to the origins of the medium.

The Photographer at Work

Inseparable from Salgado's vision is the question of praxis—his own life experiences, commitments, approach to work, and photographic practices. The methodology he employs for constructing his detailed photoessays involves long stays among the subjects of his images. If these bodies of work have taken an average of six years each to complete, then this is because he spends long periods of time, often months, living amid the people whose lives he seeks to visually represent. In this prolonged engagement with the subjects of his images, Salgado can be contrasted with another of the greats of social documentary, Henri Cartier-Bresson, who, it is said, moved lightly and swiftly through his subjects. Salgado dwells on his subjects, his lens seeking to see into their realities, his stated aim being to draw to the fore what might at first glance go unseen.[11] The resonance and epic gravity that are the hallmarks of his images are partly owed to this in-depth visuality. Not being one to rely on zoom lenses, Salgado prefers to partake physically of the space his subjects inhabit. Thus, part of his engagement with the broader issues that channel his line of vision is his physical proximity, his own immediacy, to the contexts and people that he seeks to represent.

As Salgado himself has stated, an entire volume of his photographs, each shot at 1/300 of a second, represents in all just one second of human experience.[12] Yet, it is this very brevity of the photographs that preserves what is ephemeral and passing, staging experience through the stark drama of black and white. In their shifts and reversals of light and dark, the photographs offer a metaphorical representation of the subjects moving between life and death. The gravitas of that which is depicted is thus highlighted, as is the impression left on the viewer of

the photograph as a fragment of time, a fragment that somehow evokes that other fragment that implicates us all: the brevity of an individual life in the relentlessly pliable face of time.

Not surprisingly, then, this approximation to the subject that Salgado seeks is reflected in his choice of camera and lens as well. Like the great photographers of Magnum, most notably Robert Capa and Henri Cartier-Bresson, all of whom were committed to the ideological project of photodocumentary, Salgado has used a Leica camera for all but his current project, *Genesis*. Unlike many of them, however, he eschews range finders, and tends to rely instead on reflex cameras. He explains, "I work with Leica cameras. I prefer Leica cameras, because they are simple, solid, they are not too electronic, sometimes they are not electronic at all, and they allow me, at times, to stay for two or three months in extreme climatic conditions, and they last. Really, they are a totally reliable working tool. They have a fabulous optical quality. I have lenses that have been with me since I began photography; I bought lenses that are still in working order, they are perfect."[13]

Salgado tends to work with Kodak TRI-X film with the camera set at an American Standards Association film speed (ASA) of 200, 400, or 800. He also works with T-MAX film, which allows him an ASA of 3200 or 6400, in order to have high levels of sensitivity or to work in poor lighting conditions. His choice of lens has varied between 28 mm and 60 mm, his preference being for close-range photography that allows him to be near his subject. Salgado states that he avoids the use of a flash. Rarely does he use a zoom lens, and when he does, his images are never very good. While Salgado's photographs are taken without resort to artifice, he states that they are, in fact, carefully worked on in the "laboratory" or darkrooms at his agency in France.[14] Thus, the final image is as much the product of painstaking attention, even to the extent of spotting by hand with a brush, as it is of an image framed and shot in the right way at the right time. Salgado has twice won the Leica Oskar Barnack award and is a master of the precise manual control of shutter speed, aperture, and focal plane that this camera requires.

The question of acceptance is central to his efforts; from the subjects' acceptance comes the right to represent them. Photography without such acceptance would be tantamount to intrusion. It would be a transgressive act of taking, not offering, which is made possible by acceptance. What is more, representation backed by acceptance carries the force of an apparent authenticity, arising from the subject's willingness

to be so represented. If the photographer aligns himself to the subject, then the relation between viewer and subject becomes less obviously fettered or constructed. Bearing in mind that photographs, like other "texts," are indeed constructs, acceptance of the photographer and his purpose by the subject smoothes the passage of the image from what the subject offers to what the viewer is presented with.

The Leica has proven to be the must-have tool of the serious photographer. The fact that Leicas are carefully handcrafted not only renders them unique as cameras but also imbues them with the power to reinforce the semblance of authenticity that accompanies the photograph as symbol of lived reality.[15] Indeed, the Leica opened up a wealth of possibilities for photojournalism following its invention in 1913 by Oskar Barnack, an employee of the Leitz family. The Leica was notable because it offered revolutionary new possibilities to photography. Its reduced size and use of small, 35 mm movie film made it easy to use and allowed numerous frames to be exposed in quick succession. This made it possible to frame the same scene several times, thus releasing the photographer from the pressures of having to get the image right on the first try. In 1925, the camera was presented to the public at the Leipzig Spring Fair and became an instant success.

The fact that the camera was held at eye level, as opposed to against the chest, meant that it could seem like an extension of the eye itself, inseparable from the photographer. The Spanish Civil War became the first major testing ground for the photojournalistic potential of the Leica. It soon became iconic of the work of Robert Capa, as well as other major photojournalists. The Hermanos Mayo, or Mayo Brothers, former Spanish Republicans who had gone into exile in Mexico, first began using the Leica in Spain, in the course of the civil war. They transported their Leicas with them to Mexico, thereby introducing this camera to Mexican photographic contexts.[16] Over the decades, the usage of Leicas has become, and continues to be, a trademark of photodocumentary across generations. Eugene Smith used them, as did Cartier-Bresson and his peers. In later years, Tony Ray-Jones used one to document in his inimitable way the English at leisure. More recently, up-and-coming photographers of note—such as the New Yorker Esther Levine, a documentarian of urban spaces who published her first major work on Berlin not so long ago—also rely on Leicas.[17] Indeed, it could be argued that the Leica is the signature tool of continuity between the major photographers of the twentieth century and the twenty-first, forging through

its name a relation between photographers engaged in documentary but with very different styles and preoccupations. Salgado must be viewed as having his place in this long-established and continuing line of photodocumentarians.

With regard to *Genesis*, Salgado's current project on the environment, many of the chief subjects are animals. An interview published in Australia's *Sydney Morning Herald* quotes Salgado on the topic: "'It's the first time that I decided to photograph other animals, beyond man,' he says, adding that he quickly discovered how not to scare the wild creatures away, be they giant Galapagos turtles or jungle beasts. 'If you come walking on foot they go away, but if you come on your knees, at their height, they accept you.'"[18] Clearly, this would not be the case with a giraffe. The photography of animals, as opposed to man, has required certain alterations to Salgado's photographic practices. Thus, for this latest project he now uses a Pentax 645 camera with a format of 4.5 × 6 cm. It has proven better suited than the Leica to the subjects at hand. To meet the demands of the project, he also has had to avail himself of other forms of technology—ships, for example—to get his shots. Nevertheless, he continues to spend considerable time among his subjects, or as close to them as possible. In order to photograph his nonhuman subjects, he first immerses himself as deeply as possible in their habitat, seeking to learn their ways and see the world through their eyes. He goes to great lengths to know and understand the places, creatures, and people that are the subjects of *Genesis*, in the same way as he has done for previous long-term projects.

While Salgado has worked in colour for magazines, his own photographic projects have been shot in black and white. Although this aspect of his work will be explored in more depth later in this book, it should be noted that a key feature of his photographs is a skilfully constructed tonality. His images are worked on beyond the darkroom in order to reach the status of not merely document but artwork. In the video *Looking Back at You*, we see his team of assistants in Paris enhancing an image with a paintbrush.[19] In so doing, a parallel emerges between the uniqueness of the painted image and the photographed one, a parallel that contravenes Walter Benjamin's famous assertion that the photograph, as a modern form of reproduction reliant on technology as opposed to the human hand, lacks the uniqueness of aura that is associated with the painting. While Salgado's photographs do, of course, rely on technology for their reproduction of the subject and

its subsequent multiplication, they nevertheless rise above the plethora of images that inundate this global era of ours, and leave their distinct mark on viewers' minds. It is, no doubt, his carefully constructed aesthetic of black and white, with its absence of colour but carefully enhanced tonality, that has given rise to views of Salgado's photojournalism as high art.

This entree into the art world also allows Salgado's photographs to maintain the aura of exclusivity: in turn, such exclusivity and privilege leads to a tension between socially engaged photography and the world of high art—and, by extension, the market for art. Ranging across tones from the purest of white to the deepest of black, his images often present memorable contrasts of light and shade. The glint of an eye, a wisp of hair catching a sliver of sun, a streak in a cloud-filled sky: these elements and others turn his images into canvases of light and dark. Across the pages of his books, white descends into the opposing pole of black across tones of grey so that the play of light, with its shadows and silhouettes, carrying with it visual metaphors of the silences and the thoughts of those portrayed, is framed in passing.

Best known for his major photographic projects on socioeconomic issues, focusing on global processes rather than headline-hitting events, Salgado nevertheless also engages in news items and advertising. The revenue from such work helps to fund the large-scale projects which typify his oeuvre. He has, however, also covered specific moments of tension that have hit the headlines, most notably the aforementioned attempted assassination of Ronald Reagan, as well as the taking of hostages in Entebbe and wars in Angola and the Spanish Sahara. His advertising work includes assignments in Spain and Italy, as well as with the Volvo car company and, more recently, with the Illy coffee company. Earnings from such work, together with those secured from publishing his photographs in magazines, such as *Stern*, *Paris Match*, *El País*, *La Vanguardia*, *Visão*, *New York Times Magazine*, *Rolling Stone*, and the *Guardian Weekend* review, provide income and also contribute toward the costs of the numerous travels he undertakes in the course of any single photo-essay project. Few, however, know Salgado for his advertising work. As is usual with such commissions, the photographer's name lurks behind the image, which is constructed specifically to promote the product in question. When it comes to how viewers relate to Salgado, the emphasis is clearly on his photodocumentary work. Over and above any commercial uses he makes of his photography, Salgado's

name thus remains largely synonymous with concerned photojournalism of a kind that dwells on the historical and geopolitical course of industrialization and globalization.

Over the years, Salgado has taken numerous commissions, necessary to sustain the costs of his documentary work. But the success of his photo-essays *Migrations: Humanity in Transition* and *The Children* has meant that he now receives support from sources such as UNICEF, allowing him to be more discerning in his choice of commercial work. These commissioned projects bear many of the same visual traits as his more personally engaged work. At once art, document, and advertisement, such images confound categories of photography and invite multiple readings as well as diverse and often contradictory responses. The commercial work that Salgado has done confirms that it is impossible to extricate his aim of social engagement from the commercial contexts in which he works, and also from the multifaceted and paradoxical medium of photography itself. No doubt many aspects of photography serve to underline the fact that late capitalism is heavily reliant on the image for its self-perpetuation. Likewise, it is hard, if not impossible, to extricate the image from the cultural and economic contexts that allow it to circulate. The fluid mobility and translatability of images mirror those of capital, while also both melting into and subverting the pervasive mechanisms of the latter. Thus, images that are typically hard to label, such as those of Salgado's Illy coffee advertisement/photo-essay, *In Principio*, become both document and advertisement (a subject explored in chapter 2), creating awareness of environmental and other issues while also marketing a brand name.

In many ways, though, it is important to note that the ambivalent readings that are projected by such images also emanate from Salgado's work overall. He has become in his own lifetime a celebrity photographer, no doubt the most famous photodocumentarian of our times. Salgado's images proclaim his name even as they reveal his subjects and enthuse the viewer. In 2006, a Salgado print in New York's Aperture Gallery cost in the region of $2,000.00. In London's Photographer's Gallery, the same print—one of three Indian miners taken in Bihar—cost £2,500.00.[20] Some websites sell his "originals" (the notion of an original in photography is in itself a curious one) for as much as $5,000.00.[21] A "Salgado" is thus a valuable artwork that is also at once document and commodity.

As artwork, and hence fetish, Salgado's images are also didactic and

revelatory. The photographs take viewers to parts of the world many might have preferred not to know about, and yet they also reveal them as spaces of beauty and of light. What is more, they do so through a very deliberate and careful espousal of the aesthetic, an approach that has crossed the sensibilities of many who consider it exploitative to depict what they view as misery in terms of beauty. For such viewers, to make such images is bad enough; to do so and then, in the process, gain fame and wealth for oneself is, in the eyes of some, unforgivable. Such works embody the crossing of boundaries between ethical interests and economic ones, whereby the photograph turns into a restless field of ideological contradictions.

Modernity and Postmodernity

The ambivalent and multifaceted nature of Salgado's work is not surprising when one considers the cultural and economic contexts in which it circulates. Indeed photography itself came to the fore not solely for its representational potential but also because it proved the success of technology in the modern era. Upon its invention in the first half of the nineteenth century, the photograph awed the world and established itself as the flagship achievement of modern man. There has always been a link, therefore, between the medium and its historical context, one whereby the photograph gives testament to and extends the modern project. Unexpectedly, photography has also offered the frame within which the disunities of modernity can be viewed.

The rise of Salgado's career as a photographer in the late 1970s coincided with a growing theoretical focus on the failures of modernity. There was by this time widespread theoretical concern that modernity—rather than offering a rational and coherent route to utopia, as once thought—had proven itself to be, in Marshall Berman's words, the experience of "maelstrom."[22] Postmodernity, as this moment of reflexive realization came to be called, signals the awareness in critical theory of the loss of the utopian dream. Accompanying it is the loss of belief in a linear logic of history. Instead, postmodernity, as a set of interrelated theoretical concepts, marks the ruptures and fragmentations of modernity, of a kind that is both temporal and spatial.

While the term *postmodern* has gained ground in critical theory since the late 1970s, it is important to note that *modernity* and *postmodernity* do not refer to different historical periods. *Postmodernity* denotes the

critical awareness of the flaws of modernity and the error of privileging rationality. Through its inclusion of the non-modern, its emphasis on the constructed nature of modernity, and its splitting of supposed unities, such as the notion of a single historical master narrative, the postmodern foregrounds the cracks in the discursive and ideological structures of modernity. Fredric Jameson states, "No 'theory' of modernity makes sense today unless it comes to terms with the hypothesis of a postmodern break with the modern."[23] It is important to note that Salgado's work arose at more or less the time when this breach was first noted by theorists. The realization of such a break led theorists and critics to increasingly scrutinize cultural texts, especially those that were visual. Photography came to be more than either documentary or art; it opened up spaces of reflexivity.

Postmodern theory emphasizes the displacements and mobilities triggered by modernity and its many socioeconomic processes. Numerous economic, social, scientific, and political factors contribute to this sense of upheaval and rootlessness. The very motors of the modern project put in place in previous centuries—scientific discoveries, technological progress, an overriding focus on rationality, the creation of new social milieus and the destruction of old ones—have lead to its undoing. Yet they continue to be the goals that we pursue. While the practice of living may be increasingly subjected to the scatterings caused by modernity's ruptures, the discourses and rationale of modernity largely continue to prevail. By extension, the theoretical concerns of postmodernity do too. Salgado's many photo-essays reflect these ruptures of our times. Consequently, they also offer a frame within which to consider the conceptual and practical dichotomies of modernity.

One reason why the myth of modernity persists is that it is closely tied to the logic of capital. Indeed capitalism is the economic and ideological ally of the modern project. The ideology of capitalism has its roots in the European expansion of earlier centuries, when colonial endeavours enriched imperial heartlands. In the course of modernity, it has propagated itself on the back of industrialization and globalization. These mass processes have greatly complicated the condition of postmodernity. One of their chief consequences is the ubiquity of the displacement of peoples toward the flow of capital. Today, even as the uncertainty of capital is rife, the ideology of capitalism is as firmly in place as ever. The market becomes ever more the measure of things. It is not so surprising then if cultural media and artefacts, such as photographs,

should be appropriated to a great extent by this overriding force of capital.

If, at one time, postmodern uprootings were seen to affect only the social, the communal, and the individual, in the twenty-first century, there is a growing awareness that they also affect the environment and the balance of nature. Thus, postmodernity needs to be understood as the historical, psychosocial, and environmental manifestation of modernity as it falters. It is evident in the mass migrations undertaken by people, in the breakup of communities, in the rupture of mankind's relation to land and nature, in the melting of glaciers, in the desertification of the earth. All of these elements form the ground swell propelling Salgado's work. Modernity, once thought to be a rational and linear route to progress, is hopelessly fraught with its own complications. Postmodernity must be understood as the syncopated beats of modernity and its many undoings. Salgado's images repeatedly and in diverse ways bring this condition to the fore.

It has often been pointed out that the danger in postmodern theorizations is the effacement of history and the subsequent levelling of lived experience that results from temporal and spatial scattering. Perhaps what is most striking in the postmodern is the overlap of tradition with modernity, whereby temporality acquires a dissonance. The rupture of the historical logic of modernity does not mean, though, that historical differences across the globe are erased in postmodernity. The contradictions of the postmodern are most evident among the historically less empowered. And so, as Gerard Delanty rightly points out, postmodernity is most keenly experienced in the peripheries of the West.[24] The postcolonial can also be viewed as the postmodern in very obvious ways.

The margins and crevices of the industrialized and developed world are where postmodernity is most manifest. Brazil and India, at once industrialized and persistently feudal or traditional, with histories complicated by colonization and unfinished development, offer prime examples of such postmodern dissonance. Africa, Asia, and Latin America, all peripheral to the West and once subject to its empires, offer the uneasy geopolitics of postmodernity at its most acute. And it is on these locations that Salgado most often trains his lens.

Photography is surely one of the cultural developments that best display the contradictions of modernity and postmodernity. From the start, photography has been a paradoxical medium. Though archetypal

of modernity, the impulse to recreate reality dates back to premodern times. Writings on the pinhole camera can be found from the fifth century BC, and there are numerous instances of experiments with the camera obscura in premodern times. The invention of chemical photography in the first half of the nineteenth century was a landmark event in the history of modernity, bringing with it a new dawn of realism that had a crucial impact on literature, on art, and, of course, on photography itself. Early photography was valued above all for its documentary potential. As such, photography was seen as a useful tool in furthering the modern project. It was employed as a means of advancing science and the knowledge of nature, as an ally of colonial projects in early anthropological ventures, and as a means of securing "authentic" proof of lived realities. It has since also become indispensable in the implementation of law, and is an implicit part of any process of citizenship and legalized belonging.

Photography signalled technological progress and its discovery is without doubt a milestone on the modern route. Yet, like other cultural artefacts, it was soon appropriated, not solely by institutions and the academy, but also by the market. The materiality of images lends itself to value that is monetary as well as symbolic. Images can become icons, can resemble totems, can hold a grain of magic. At the same time, they can be bought and sold; their material value can rise or fall. Developed along the lines of modernity, indeed one of the most important milestones of modernization, but also possessing a degree of visual alchemy, photography is an eminently postmodern medium, one that shifts restlessly across the gamut of arenas.

For these reasons, Salgado's photographs are, of course, entirely postmodern in their fluidity and in the plurality of fields they cross. They throw open the conflicts of modernity and postmodernity; they slot at once into multiple frames. The inseparability of economic, aesthetic, ethical, political, and market forces in Salgado's work make it entirely symptomatic of the breakdown of modern demarcations and hence emblematic of postmodernity. However, I shall also argue that the aesthetic that he espouses is a deliberate attempt to offer a historical frame outside of the predominantly Western logic of modernity and postmodernity, both reliant on discourses and theories of rationality. Salgado's images turn both to the nonrational and the sentient or affective, and to the rational and conceptual, as well as to the spiritual, in order to turn the frame of the image into a space where another mode of

history can be imagined. The most significant contribution of his work is its offer of a way out of and beyond the repetitive double bind of debates on and narratives of modernity and postmodernity. The interjections of photography are such that they instantly force a reckoning with the syncopation of our complex historical moment, a temporality that encompasses the nonrational.

Salgado's work is multidimensional, as are our responses to it. I do not aim to slot Salgado's work into any one category. His images can be approached from diverse perspectives, and I do believe that his critics who berate his aesthetic style do so because they fail to understand the heterogeneity of his work and its borderline locations. Salgado's work radiates in many directions: those of high art and social engagement, of the market and ethics, of aesthetics and politics, of the mind and the heart, of the eyes and the soul. This book aims to explore all these different, but inextricably related, issues.

Traditions of Photodocumentary

Photodocumentary—and it should be recalled that documentary was, indeed, photography's first function—has played a key role over the decades in furthering the project of modernity, even if in so doing it has also revealed the incompleteness of the project. Salgado's work has its place in this genre, while it also extends its remit. His photography slots into the history of photodocumentary and also makes an important contribution to this genre.

By the mid-nineteenth century, photodocumentary had already established itself as a means of framing individuals and social groups. As Françoise Heilbrun reminds us, the very aspiration of photography to reproduce reality lent it, from its inception, a close association with the idea of social documentary.[25] By the late 1840s, ordinary people and social realities had already become the focus of photographers. From the start, photography was not solely a means of documenting the silent and as yet little-represented majority of society—workers, craftsmen, peasants, washer women, fishermen, the poor, and the homeless, as well as non-Western peoples, living beyond the margins of Europe—but also a way of conferring dignity on these subjects. Thus, photography became a useful tool in the nineteenth-century preoccupation with social reform. Heilbrun gives the example of the painter David Octavius Hill and the photographer Robert Adamson, who, inspired by the writ-

ings of Sir Walter Scott on the nobility of peasants, went together to northern Scotland and produced a collection of photographs titled the *Fishermen and Women of the Firth of Forth* in 1843.[26] The French photographer Charles Nègre was the first to embark on street photography in the 1850s; at the same time, the Crimean War became the first war to be photographed. The potential of the lens to act as historical witness also was of critical importance when Désiré Charnay set off in 1863 on an exploration to Madagascar as a historian-photographer. By this time, of course, photography had reached the shores of Latin America, as elsewhere around the world, and its documentary function extended in several parts, including Brazil, to recording the diversities and mixes of race. Portraiture, once the artistic prerogative of the wealthy, became commonplace and a mode of documentation through photography.

In all of these early instances of photography, we see the importance of staging the image: photographers inevitably selected aspects of reality, which they then dramatized for better effect. Thus, from the start, questions of veracity have haunted photojournalism. Although photography was first developed in France, a country that fomented cutting-edge photographic endeavour well into the twentieth century, many of the greatest innovations and experiments in the field took shape in the United States. From the early twentieth century onward, photography flourished in North America as a method of holding a mirror to society. In this role, it triggered, at least in part, the realism sought through literature in the nineteenth century and proved its superiority to painting for reproducing the world. Yet, if photographs were to be eye-catching, they also had to render reality theatrical.

In the early twentieth century, photodocumentary, particularly the photo-essay, formed a cornerstone of magazines such as *Life*. But by the time Salgado turned to photography, the popularity of the photo-essay was already waning, due, no doubt, to the spread of television. At the same time, this genre, as a tool for visual narration that documented social realities while also inspiring and moving the viewer, had long become familiar to viewers in many parts of the world. Thus it was that photography also has strong links to humanism, ensuing from the ability of photographic neorealism to arouse warmth, compassion, and an imagined sense of lyricism or poetry that allows for the viewer to commune with his fellow man, regardless of divisions of race, culture, language, nation, or social class. Of course, even when photographic technology was in its infancy, a certain power imbalance existed be-

tween the photographer and viewer, on the one hand, and the subject, on the other, who was being captured and framed by the medium. Yet the importance of relaying such images in order to promote understanding was also present from the start.

Photography makes possible a kind of universalism, one that some might mark as dangerous in overriding distinctions, and others as inspiring for rising above such distinctions. Implicit in such humanism are empathy, compassion, optimism, and a sense of seeking out dignity in difference. In short, humanistic viewing is imbued with idealism. In this way, looking at images of others ceases to be in any way vicarious, self-empowering, or negative and becomes instead an act of generosity, a route to understanding. Salgado continues here a line formed by photographers of earlier generations, such as Paul Strand, Robert Capa, Bill Brandt, Henri Cartier-Bresson, and Josef Koudelka, to name but a few.

According to Jean-Claude Gautrand, the climactic moment in humanistic photography was the staging of the ambitious *The Family of Man* exhibition, organized in 1955 by Edward Steichen and aiming to "mirror the essential oneness of mankind throughout the world."[27] There is no doubt that today's viewer of *The Family of Man* may well question this idealism, while also being moved by it. So many of the events that have followed the time when the collection was put together— the heightening of the Cold War, the spread of television, the fall of the Berlin Wall, the onset of the digital age, the turn of the millennium, the global war on terror, and so on—have put the idealism of the postwar period into question. Nevertheless, *The Family of Man* collection continues to inflect how we approach the work of a global photographer, such as Salgado. As Gautrand goes on to state, Salgado has "made it his mission to become a photographic witness to humanity's state in the world."[28] This was written over ten years ago. Since that time, Salgado has also made it his mission to witness the state of the planet in the face of mankind.

This is no doubt the aim of his current project, *Genesis*, a radical departure from his previously homocentric focus. In *Genesis*, Salgado's lens points at premodern spaces and communities that struggle to survive on the fringes of the modern world. Nature and the environment come into sharp focus here. Thus it is possible to say that his work extends the notion of universality by decentering mankind as much as it may also focus on it. In this sense, it also questions the premises of humanism, whereby the human is exalted over the nonhuman. The rele-

vance of *Genesis*, as we shall see, is that it ultimately forces us to rethink humanism in light of ecological balance and imbalance as represented through photography.

This endeavour is an important and innovative move on Salgado's part. In the past, environmental photographers, such as Ernst Haas, were seen as belonging to a separate category from photographers who portrayed people. They were also photographers who dared to go where few ventured, taking their place alongside explorers, men who sought to tame the wildest corners of the planet in mankind's name. What is more, the camera became the technological tool whereby such capturing of the "primitive" became possible. This outdated stereotype does not apply to Salgado or his work. In the span of his career, Salgado has insisted instead on the inextricability of people from place. Through this move, Salgado replaces the homocentric idealism of old with a new vision, one that is urgently required if environmental degradation, ecological imbalances, and human suffering are to be curtailed in the years to come. This is also a vision that is supported by his perspective, not solely as photographer, but also as economist with a clear understanding of issues around development.

On Victims, Voyeurs, and Viewers

Since its inception in the nineteenth century, photography, particularly the genre of photodocumentary, has been subject to numerous debates about its motives, achievements, and modus operandi. These challenges evolve from the fact that photographs, as technological reproductions, offer "copies" of reality, yet they are often selected and framed in such a way as to distance the representation from its subject. Furthermore, much discomfiture ensues from the fact that photographs, especially those that are deliberately enhanced, often serve at once as documents and works of art, which invests them with a market value that may well exceed even the annual income of many of the subjects of the images. There is also the simple fact that anyone who looks into an image does so with a certain voyeuristic instinct. Images offer windows into other lives and places.

These issues become all the more intense in the context of documentary photography when one considers that this is a genre that frames "others"; marked differences in class and power often separate the viewer from the subject. Some argue that disempowered subjects re-

main within the frame of the image, victims of voyeurs that include both the photographer and the viewer, while others seek a kind of epiphany through the act of viewing. Indeed, both are possible at once, so that an epiphany may be reached while the subject of the images remains victimized. For many, aestheticized documentary photographs such as those that Salgado produces retain elements of the spiritual—lit, as it were, by a certain magic and fire. In this sense, his images call on discourses and references that already circulate in our midst through religion and art. Many consider the act of seeing to be a release of their vision, the first step in a move of solidarity with the otherness encountered in and through the image.

These debates have yet to be resolved, and they are complicated by the ambiguity that surrounds photographs: the same image can be used in varied contexts and can be open to diverse interpretations. Different viewers will read an image in accordance with their own point of view. The resulting predicament is embodied in the history of documentary photography. This genre, especially that which dwells on the displacement of people through economic upheavals, took off with the invention of photography and flourished in the twentieth century, reaching its heyday in the years prior to the advent of television through dissemination in magazines such as *Life*. Mostly welcomed as an empathetic window onto other social realities, it was also valued for its ideological potential. Accompanying such acclaim, however, has been the rise of numerous critiques, with attention drawn to the ineffectiveness of such images for impacting usefully or directly on the lives of its subjects. The blurring of boundaries between documentary and art only heightens such concerns, as this conflation immediately renders these images into "products" shaped from social misfortunes, which then accrue market value. Furthermore, "ownership" of the images thus becomes the prerogative of the photographer.

On his successful entry into the photographic way of life, Salgado, like so many other photodocumentarians who both preceded him and are his contemporaries, inevitably found himself in the midst of such dissent. The dramatic tonality of his images, that hallmark style that turns his images into a kind of documentary-artwork that is often unforgettable, combined with his sustained focus on global economics, on the social consequences of industrialization, and on the environmental and demographic upheavals of modernization, often place him at the epicenter of such debates. More to the point, Salgado has earned admi-

ration that is deep and wide, as well as criticism that is fierce and relentless. Regardless of individual perspectives, most will agree that Salgado's abiding concern has been and continues to be with the margins of modernity. He remains an economist-photographer and a superbly talented artisan of light.

Aesthetic Agency

Salgado's photography is notable not solely because of the contexts from which it emerges, but also because of its pronounced aesthetic. Indeed, the question of aesthetics comes to the fore when we study his work. Aesthetics, generally understood as the philosophy of art, culture, and nature—and hence the theoretical study of emotional and sentient practices, perception, values, and judgements—is always at the forefront of the study of images and representations in general. The concept of the aesthetic has altered its points of reference since it first came into use in the eighteenth century.[29] Initially, it was closely associated with the idea of beauty and the perception of the latter through the senses. The term has since broadened to include the study and the questioning of what constitutes the aesthetic and how this manifests itself. Despite the tendency to equate the aesthetic with beauty (both have applications to art, which is itself often thought of as the pursuit of beauty), it is important to remember that there is a difference between the aesthetic in any image and the question of beauty. The aesthetic may or may not be beautiful.[30] But it is part and parcel of representation, always there in one form or another. The aesthetic is a mode of communication. However, in the case of Salgado's work, aesthetic considerations must take into account a very deliberate, overt, and sustained cult of the visually compelling. A key facet of Salgado's work is the forging of beauty through light. In writing of Salgado's aesthetic, I shall therefore be addressing the construction of translucence and beauty in his images, where all three become virtually inseparable.

Writing about beauty in photography, especially in terms of the photography of landscapes (of great relevance to Salgado's work), Robert Adams states that it offers us "three verities—geography, autobiography, and metaphor."[31] When brought together in the image, they work, he claims, to keep intact what he calls "an affection for life."[32] To a large extent, Adams bases his view on the fact that landscape photography is akin to art. It provokes an affective response and an imaginative one.

Through an affective route, it leads to a sense of revitalization or regeneration. This notion of regeneration is centrifugal to Salgado's photography, as it is to his philosophy of life.

As Elizabeth Grosz states, art is born of the senses and is experienced bodily. It returns us to nature. Perception and affection are enhanced through art, not so much to reflect or express what is known, but to project new futures that are possible in the present.[33] For Grosz, art offers a route back to nature and to chaos, from which we normally shield ourselves by taking sanctuary in the known, the habitual, the discursive, and the predictable. The bodily, in her view, enables us to transform the world around us. Through this return to the natural, we are able to sense the announcement of the future. "Art," she tells us, "is the opening up of the universe to becoming-other."[34]

If we think of aesthetics as the study of the affective, the sentient, and the emotional—in other words, that which functions as art—then modernist discourses inevitably relegate these fields to outside of the realm of rationality. Perhaps for this reason, questions of aesthetics have seldom focused on photography. No doubt this is because photography continues to be categorized as witness and document and therefore as a material token that confirms the rational. Scant philosophical attention has been paid to the imaginative potential of photography or to its suggestive force. Our understanding of photography as a hybrid and borderline medium that oscillates between document and art is still fledgling. The philosophy of photography is a field that hovers at the point of taking off. Nevertheless, photography has played a central role in forging the ways in which we have come to reflect on modernity. By framing the contradictions of modernity, the photograph has proven itself to be a prime instigator of postmodern reflexivity.

Politics, like photography, is seen in modernist light to be an adjunct of rationality. Art tends to stand without. Where, then, does photo art find itself? Patrick Maynard points to misgivings when it comes to acknowledging the politics or agency of aestheticized photography.[35] From a structuralist perspective, aestheticized photography is disturbingly hybrid, hard to articulate in terms of modernist discourses. Yet, interestingly, photography may have more to do than one would imagine with the repositioning of aesthetics, and by extension politics, that is increasingly taking place. Precisely because photographs do not confine themselves within supposed divisions and because of the unstoppably postmodern fluidity of contemporary culture to which

photographs contribute greatly, art and the aesthetic are no longer marginalized from the realm of politics. On the contrary, and as this study of photography will show, the aesthetic acquires agency in postmodernity. Indeed, it not only acquires agency, but it also becomes indispensable in terms of the impact of the image.

Considerations of the aesthetic are of major relevance when analysing what supposedly lies outside of rationality—and thus in exploring the limits and limitations of reason. My premise here is that the aesthetic plays a key role in considering what lies outside of or beyond the purely rational. Discussions of images of nature, such as landscape painting, inevitably rely on aesthetic theory. The aesthetic points to the sentient or affective; it also foregrounds the natural in contexts where the latter is usually pitted against the social or cultural. Aestheticized photography, as document and artwork, acts as an agent that repositions politics on the edges of rationality. The aesthetic in the image allows for the binary opposites of reason and sentience to meet on border zones of the photograph. This is also the point where the natural overlaps with the cultural. Rationality, the theoretical premise on which photography was invented, combines in the photograph with the aesthetic, the fertile idiom of metaphor, through which the photograph may speak.

In the context of photography such as Salgado's, where, as we shall see, nature, landscapes, and life forms play a major part, the aesthetic politicizes representation. It does so by mobilizing history, ethics, and politics in all of Salgado's photographs. It imbues an image with agency, allowing it to speak and, even more importantly, to suggest. The aesthetic is not the language of rational representation—if representation could ever just be rational. It is a proposal. It is also an invitation to engage, which is all the more important when one considers that Salgado's aestheticized photographs focus on the displaced and the dispossessed, who remain mostly obscured in the play of mainstream politics.

From the Edges of the Frame

If photography was decidedly Eurocentric in its origins, it did not remain so for long. Certainly, Salgado's work cannot be located solely within a Eurocentric frame. Salgado's images draw from and build on numerous and vastly diverse trends in photography, both Western and non-Western. They also resonate across the globe.

Though undoubtedly North American and European in its origins, the photo-essay soon became firmly planted in other parts of the world, such as Brazil, where photography, like other cultural forms, sought to emulate patterns and modes established in the more dominant and technologically advanced parts of the world. Often the first connections that come to mind when viewing Salgado's work are with much cited American names and images: early reform photographers, such as Jacob Riis and Lewis Hine; *The Family of Man* collection; or the images of the Farm Security Administration and the various photographers associated with this movement, such as Walker Evans and Dorothea Lange.

It is equally important to locate Salgado's work in a context of the postcolonial, with all the latter's complex and hybrid interactions with the West. Within this frame, the images serve to foment the redefinition of historically disempowered peoples and places in the wake of decolonization, and so help to redress inequalities and injustices. Without his images being overtly political or militant, Salgado has his place in a league of important postcolonial photographers who have sought to represent and reformulate the indigenous and the local, who seek or have sought to forge new ways of seeing those historically determined as Europe's others. As this book explores, Salgado's photography includes in its frame those who have been historically sidelined or ignored. His work offers a sense of polity to the hitherto excluded.

In the foreword to *India, México: Vientos paralelos*, a collection of images of India and Mexico taken by Salgado, the Mexican photographer Graciela Itúrbide, and the Indian photographer Raghu Rai, the French screenwriter Jean-Claude Carrière poses the problematic that

> Europe states that it discovered the rest of the world. Prior to this "discovery," did this part of the world exist? . . . Following the discovery and the explorations, the trade and the conquests, Europe carried on discovering this other world, a worthy object of its curiosity, in its own way. It counted it, it studied it, of course it photographed it; it sent officials, ethnographers, missionaries, traders. It convinced it that Beethoven, Shakespeare, and Picasso were very superior to any "indigenous" production and that they should be admired unreservedly by the whole world. It imposed its laws, as well as its tastes and ways, its masterpieces. For centuries, any approach to the rest of the world had to go via Europe, for its criteria and judgement.[36]

Carrière also warns that the images in Salgado's collection largely "pass Europe by." Mexico and India, formerly colonized by Spain and England

respectively, also have access to specific types of gaze that are not European. The secrets and perceptions of such gazes are, he states, beyond the understanding of the solely European. Of course, there is in Carrière's statement a hint of exoticism in that he tends to align Mexico with India on the sole basis of their having been dominated by European powers. No doubt, perceptions and forms of gaze vary widely between the two cultures and peoples.

I choose to highlight the above point made by Carrière, because I believe it to be of major relevance to my own arguments: namely, that the images of *India, México: Vientos paralelos* allow us to visually trace the overlaps of the Western and the non-Western (for no colonized people or place is solely non-Western, and all bear the mark of hybridity in some cultural form or other), as well as the rational and the nonrational, the logical and the sentient, the stated and the hinted at. That photography should allow us to extend beyond the realms of the logical or scientific and enter the zone of this hybrid otherness is important too. Such is the versatility of this medium, its inherent translatability, that it defies the hegemonic origins of its own technological and eminently modern nature to penetrate into these arenas of alterity.

A paradox lies in the fact that while photography is able to put forward a universalistic message, it also presents, through its framing of otherness, the notion of relativism and an appreciation of difference. By extension, photography acts as a useful tool in forging new vision. In any case, it becomes clear that the practice of photography is inevitably linked to specific, if often divergent, ideologies. In postcolonial contexts, there is ample evidence of how photography has been used and continues to be used as a mode of self-redefinition. This process often involves adopting and adapting European or North American perspectives, approaches, and techniques to local needs. A postcolonial politics of photography manifests itself in diverse ways across the postcolonial world: Sunil Janah's images of the Partition of India and Pakistan in 1947 and of the assassination of Mohandas Gandhi offer good examples of how photography became a key part of the process of decolonization. His images, as part of his work for the Communist Party of India, focus largely on workers and peasant movements.[37] The visual narrative they offer is of national change as lived by those who have to struggle hardest. The images, when viewed alongside the idyllically harmonious and aestheticized work of, for example, Raghu Rai, or the insights into India's burgeoning urban middle class of the more contemporary Dayanita Singh, also show the ways in which divergent ide-

ologies produce very different images of the same national contexts.[38] This inevitable marriage between politics and photography is evident in many examples of postcolonial photography. In South Africa, for example, photographers such as David Goldblatt and Peter Magubane have used socially engaged photography to provide a visual critique of apartheid and injustice.[39] In all of these cases, photodocumentary does more than merely reflect or represent social realities. It also helps to give presence to silenced histories and, on this basis, to forge a revised vision for the future.

Photography in Latin America

Photography has had a rich, diverse history in Latin America. As a Brazilian photographer of international renown, Salgado puts Brazilian, and more generally Latin American, photography in the spotlight. Certain Latin American photographs are essential to the global canon of iconic images. Although many may not be aware of it, one of the most iconic portraits of our time, an image that continues to resonate across the globe, is Latin American: the Cuban photographer Alberto Korda's portrait *El guerrillero heróico*—his image of Che Guevara that has spread across the world as an international symbol of revolution while also being appropriated by the market in true capitalist mode— was taken in Havana in 1960.[40]

While the influence of European approaches to the medium were marked in early photographic ventures in Latin America, very soon, photography, like other visual modes, was put to the service of constructing regional and national identities. Photographs often reflected the contradictions of modernity in Latin America by revealing the heterogeneity of the region and its mix of the indigenous and the colonial. Modernization in the course of the twentieth century was uneven and brought its complications, and these too can be viewed in the images produced. This socioeconomic focus of photography opened onto another important aspect of the medium: how the politics of photography could be suited to the complex, diverse, and hybrid natures of Latin American societies. Photodocumentary became widespread and offered an important route to self-definition in the decades following decolonization. Later on, by the mid-twentieth century, it also helped pave the way for forging an identity that stood up to the hegemony of the United States in the region. Needless to say, the unevenness of mod-

ernization across Latin America meant that photographic techniques from the nineteenth century persisted well into the twentieth in some parts, while others adapted the latest European techniques to local needs and contexts.

Latin American photography was for a long time primarily documentary, a genre that flourished in Mexico, Brazil, Peru, and Cuba. For example, in Cuba, photographers accompanied and recorded the revolution as it was being prepared and then carried out. Perhaps what is notable in Latin American photodocumentary is the overt ideological impetus that propels it.[41] This is not surprising, when one considers that the rise of photography coincided with decolonization in the region, when new discourses on nation, class, and race were urgently needed. Visual culture played a key role in forging a new vision.

Perhaps it should also be borne in mind that the somewhat arbitrary divisions between document and art that exist in the West do not necessarily apply to Latin American perspectives. Nor do those between art and the market—or for that matter, between document and ideology. Salgado is in keeping with other Latin American photographers by not restricting his work to any single category or dimension. In Mexico, for example, Diego Rivera and Frida Kahlo were "artists," but their work was imbued with ideological weight and had a direct bearing on Mexican society. It is also curious to note that images can have diverse readings depending on the cultural location of the viewer, a phenomenon that has often resulted in diverse, and often contradictory, readings of the same image. For example, Manuel Álvarez Bravo, perhaps one of the most important Latin American photographers, insisted that his images were more related to Mexican art and life than to any photographic movement or tradition. The artist has been widely recognized for his craft; his famous photograph of a sleeping nude, *La Buena Fama Durmiendo* (1938–39), was welcomed as significant by André Breton, leader of the surrealist movement. Yet, Álvarez Bravo's legacy, which spans much of the twentieth century, has been to visually construct a sense of Mexican identity, one that reflects the needs and concerns of a specific national collective. Evident here is the question of how culture and politics frame the gaze of the viewer. Álvarez Bravo came from a family of artists and was influenced by the leading Mexican artists Tina Modotti and Diego Rivera. His images displayed both simplicity of form and a deliberate aesthetic that have since rendered his work iconic.

In twentieth-century Mexico, the Hermanos Mayo created a photo-

graphic archive of several million images, which forms one of the largest collections of images in Latin America.[42] Their photographs, taken in Spain and Latin America, reveal a focus on political struggle and social transformation, as well as on the migration of workers in the face of modernization and a new sense of the nation. They clearly bring to their photographs their ideological perspective as Spanish Republicans in exile, forging through their work a curious parallel between the repression of the republic in post–civil war Spain (internal colonization within the country) and the urgency to put photography at the service of new nation building in Mexico in the wake of decolonization.

For Salgado's work, Martín Chambi may well be a Latin American photographer of specific relevance. Under acclaimed but hugely memorable, the Peruvian photographer is also to date the only indigenous Latin American photographer of note. Resonating through Chambi's images is a quiet dignity, a contemplative feel that brings out great depth in the subject. His work is indigenous and *indigenista* in its focus, and the photographer has worked closely with the indigenist movements of Peru. *Indigenismo*, usually understood in light of Ángel Rama's *La ciudad letrada* as a movement that found its expression largely through literature, took on a new light through photography.[43] This was a medium with a much wider reach than literature. Not only was it able to penetrate remote areas, but it also depended on collaboration with the subjects. This meant that they were able to have an input by determining the clothes they wore, the locations where they were photographed, the objects that surrounded them, and so forth. As Jorge Coronado points out, photography enabled broad segments of Andean society to participate in their own representation.[44] Chambi was the most important of a relatively small group of indigenous photographers engaged in the construction of visual representation of their people. To cite Chambi: "I feel I am a representative of my race; my people speak through my photographs."[45] In creating this dynamic, he probed the question of modernity in Peru, never quite encountering the non-modern but certainly entering deep into the historical and temporal complexities of colonized peoples. Many would say that indigenismo at best portrayed those sectors of society that had already been hybridized to some extent by their encounters with, and implications in, modernity. Photography, for sure, was able to move much further afield than the written word in this quest for the indigenous. It is interesting—and also ironic—to note that the eminently modern technology of the

camera was more effective than the written word in achieving these goals of the indigenistas. It is this accomplishment that makes Chambi a notable postcolonial photographer.

Of course, Chambi was also a mediator of the indigenous. He took their images in stylized ways and brought these to the attention of a national elite that was nonindigenous. By ensuring that his portraits penetrated the circles of the empowered, he worked in favour of a politics of representation. Yet, he also ensured that the images were aestheticized in such a way as to make them acceptable to the Peruvian bourgeoisie. Something of the same could be said of Salgado. Several times in the course of his photographic career, Salgado's lens has sought out indigenous peoples in his native Brazil and elsewhere. His images are framed by his aesthetic and also appear as cultural bridges for predominantly Western viewers.

Indigenismo is clearly a movement that is specifically Latin American. It takes different forms in diverse parts of the continent but can be understood as a quest for a Latin American identity that predates colonial incursions and the advent of modernity to the region. In a basic sense, it involves the effort to seek out what is premodern in the Americas. To do so through the medium of photography is to somehow transgress the constructed divisions of modernity and explore the alliance of mankind, landscape, and nature in specific geocultural contexts. It could be argued that Salgado transports and translates the aims of indigenismo (thereby embroiling his work in the controversial politics that surround this movement) to more global contexts, not so much as a search for the indigenous in any specific place, but more to probe and reassert the indigenous bonds of mankind to nature and to land, and thus to assert in the face of imminent environmental disarray what is indigenous to the planet as a whole.

Chambi utilized a still but persistent flow of tonality in his black-and-white images to bring home the tenacity of the indigenous in the face of violence and displacement. What matters in Chambi's images is not so much what is shown as what is suggested. His images bear many visual traits in common with Salgado's. Both photographers focus on everyday realities but also enhance them through attention to tonality, texture, and selection. Both bring out in their subjects a subtle grace, almost a kind of stillness, which turns the ordinary into the extraordinary. The Peruvian writer Mario Vargas Llosa has said that there is a magic pulse that courses through Chambi's images.[46] A similar magic

pulse reverberates through Salgado's photographs. It can be found in the temporality suggested by Chambi's and Salgado's work, one that runs against the grain of a linear, historicist chronology as imagined in the West. The temporality of Chambi's photographs is resilient, pondering, stalwart, and almost motionless, in contrast to the scattered frenzies of modernity. This is so of Salgado's images as well. By contemplating their work, a different historical sense comes to the fore, one that deviates in its tempo from Western notions of history and time, but one that is also inflected by the latter. In this we glimpse the uneven temporalities of life lived on the peripheries of the West.

Although photodocumentary has flourished in Latin America, with much of it bearing considerable artistic merit (as is the case with Chambi's or Álvarez-Bravo's work), histories of fine-art photography are relatively few and far between. The eminent Brazilian historian of photography Boris Kossoy stands out for his contributions, though his writing foregrounds the history of documentary photography. What is striking is the production of such art histories of Latin American photography emerging from outside of Latin America. For example, several studies have been published on the work of Tina Modotti, but many of these are by authors based outside of Latin America and working in anglophone contexts.[47] This situation raises two noteworthy points. First, while photographs emerge from specific geocultural contexts, they cannot be confined to them. Latin American photography circulates around the world, as do images from elsewhere. Second, the postmodern fluidity of the photograph and its propensity to cut across contexts invites critical analyses from numerous disciplines, many of which rely on discourses forged in North American and European academia. It also appears that the art history of photography as a genre of scholarship has more of a presence in the wealthier parts of the world and, as such, is largely the academic prerogative of the global north. Photography, however, is a medium through which the local is conjoined with the global precisely because there are many ways of seeing, and no single way or analytic approach is complete. Salgado's work is a clear case in point.

Brazilian Photography

Salgado is no doubt the most globally renowned of Brazilian photographers, but photography has been and continues to be a thriving

medium in Brazil. Indeed, as far back as 1833, a Frenchman living in Campinas invented "photographie," a process using silver nitrate that received little recognition until the 1970s, when Boris Kossoy brought his efforts to light successfully.[48] Following the invention of photography by Louis J. M. Daguerre in 1839, a friend of his, by the name of Abbot Louis Compte introduced it to Brazil in January 1840, by offering a demonstration of this novelty in one of the main squares in Rio de Janeiro.[49] The daguerreotype caught the imagination of Pedro de Alcantara, who as Emperor Pedro II of Brazil continued his keen interest in the medium and gave much support to its dissemination. Early photography offered an important means of documenting daily life, ethnic and racial groups, and the social classes in Brazil. The turn of the century saw a proliferation of postcards and picture magazines that documented changes in rural and urban life. According to Maria Luiza Melo Carvalho, "Portraiture played a crucial part in characterizing popular aspects of Brazilian ethnicity."[50] Ethnographic representation of this sort revealed not solely the traces of the indigenous and the colonial but, importantly, also those of slavery. Photographs taken in the nineteenth century also charted the expansion of São Paolo, thus providing visual records of modernization, urban growth, and their impact on daily life in Brazil.

As was the case elsewhere, in Brazil photography was first valued for its documentary role, and it took the country several decades to recognize the aesthetic potential of the medium or its worth in terms of art. Perhaps what is most unusual about the course of photography in Brazil is the fact that while it enjoyed an early proliferation and wide dissemination in the nineteenth century, it then went into "semi-hibernation" until the late 1960s.[51] It is relevant to note that the resurgence of photography coincided with the rise of resistance to the lengthy period of dictatorship endured in Brazil. And it is well known that, prior to turning to photography, Salgado had been involved as a student in this movement of youth protest.

Since the 1980s, and in the wake of the dictatorship, photography has experienced a boom in Brazil as a vehicle for political and ideological transformation. Numerous photographic agencies have been established, and there are diverse and very interesting images surfacing that cross boundaries between documentary, criticism, politics, visual experimentation, art, and commerce. While Salgado's career developed largely outside of Brazil, it is nevertheless interesting to note that many

of the themes he focuses on—indigenous rights, questions of land distribution, the dispossession of children, workers' rights, ecological movements, gold mining, and deforestation—are also concerns shared with a wide array of photographers working inside Brazil.

Preeminent among his fellow Brazilians is Miguel Rio Branco, a member of Magnum and a key image maker of Brazil. His work stands out for its rich use of colour, especially its russets, blood reds, and blues.[52] Rio Branco's images are often reminiscent of paintings, and their tone is more earthy, more bloody than any image of Salgado's. Yet their work is very compatible in thrust, for both focus on the dispossessed. Strong links with other Brazilian photographers can be found in Salgado's images of indigenous American peoples. Chief among these are the images of Claudia Andujar, whose work on the Yanomami of the Amazon region is well known. Andujar uses black and white to great dramatic effect, her images depicting the subjects emerging from obscurity, as if the camera were bringing to light what had remained in the dark. Indeed, this has been her mission: to use photography as a way of establishing recognition for the Yanomami.[53] In this endeavour, she shares a focus with another Brazilian photographer, Maureen Bisilliat, an Englishwoman who has long lived in Brazil. Bisilliat's work reveals the overlap of documentary and artwork, as she moves smoothly between her focus on minority groups in Brazil and her training as a painter.

While these photographers confine their work to the locations and people of Brazil, this is of course not the case with Salgado; he travels the world. However, in the course of his career, Salgado has repeatedly reiterated his links with Brazil, for example, through his focus on the tribes of the Amazon, the landless of Brazil, and on the Sertão in northeastern Brazil, as well as, more recently, through the marriage of photography and environmental concerns. Over and again, Salgado returns to his native land, but his preoccupations and concerns as a photographer remain transferable across contexts. Although Salgado is most definitely a Brazilian photographer, his work cannot be defined as solely Brazilian—not even his photographs that are specifically of Brazil.

Salgado's work is distinct precisely because its range and applicability is so wide. Yet, if there is a single message that can be discerned, it is this persistent reiteration of the periphery, the underbelly, the historically and economically displaced or disregarded other of modernity.

Salgado's photographs reveal historical disjuncture and inequality; they also speak of hope and grace and dignity for those to whom these have been denied. For this alone, he must be accorded his place as a master photographer of the displaced. However, unlike those photographers who may have shot their images in the service of a nationalism aligned to the thrust of modernity, Salgado uses the postcolonial position as a vantage point from which to question and critique the tenets of modernity as a global project. The subjects of his images inevitably bear the specificities of their national contexts but share a subalternity inflicted on them by the large-scale historical processes of modernity, colonization, industrialization, and globalization. They feature in localized and contextualized images that are symptomatic of larger global disruptions.

Among these subjects is a wide variation between the human and the nonhuman, so that different peoples, places, environments, and creatures all claim the focus of Salgado's lens as he pans the impact of modernity across the globe. Like, for example, the writer Arundhati Roy or the environmental activist Vandana Shiva, Salgado points out through his work the shortsightedness of the modern project, allied as it is to market interests and disregarding as it is of environmental harmony and sustainability, as well as its inevitable ruptures and countless failures. The need for response, in Salgado's case, is not geographically assigned, but links itself to global concerns and argues for a global community that extends from the social or the human to the planet as a whole. While the accents of Brazilian visual culture are discernible in his work, Salgado's photographs are from across the planet and they resonate likewise.

Alterity and the Global South

Photography, in its framing of the subject, always presents us with the vision of alterity. The subjects of Salgado's images are inevitably those who additionally have been made other by large-scale historical, economic, political, and environmental forces. Alterity and the global south are two concepts that course through the entire breadth of Salgado's work. If it is established that Salgado's work offers a critique of modernity and its complications, then implicit in this idea is the notion of divisions—those of social class, race, wealth, and power. All are divisions characteristic of modern demarcations that have also been

subjected to the postmodern deconstructions made possible by photography and other cultural media. These splits are palpably present throughout those parts of the world where modernity was introduced in earlier centuries by colonial powers and where the project of modernity continues to be most undermined by this very inheritance. At stake are important political, economic, and historical factors that turn the postmodern and the postcolonial, and the global south, into spaces of alterity. For the purposes of this book, then, the two concepts are intertwined.

By definition, the idea of a "global south" involves the notion of a border, and hence difference. Furthermore, postmodern fragmentation that is both spatial and temporal has led to the bleeding of difference, whereby borders and categories become porous and turn into loci of contagion. Borders and categories are mobilized, as are those who inhabit them. The global south is therefore not geographically rooted; rather, it includes, but is not limited to, the territories of decolonized nations. It is shifting and fluid, identifiable in the mass migrations and displacements undertaken by peoples and places. It is present in the migrant ghettoes of the metropolises of the global north, in Mexican sweatshops south of the U.S. border, in the arduous, northward trail across the Sahara of Africans attempting to enter Europe, in the sprawling, filth-infested slums of so many metropolises of the developing world, in the dispossession of those rendered homeless by civil strife, in the slash and burn of Brazil's majestic forests, and on and on.

In short, the global south is the human, social, and environmental fuel by which the ideology and practice of capital gain momentum. Globalization, a heightened manifestation of capitalism that is both advanced and advancing, displaces people across borders, out of their ties with land, into the currents of capital, and often away from citizenship. It disrupts the environment and destroys animal and plant life. Globalization as we know it could not propel itself without such disruptions. The global south sustains globalization but does not direct it. The global south cannot take root anywhere because it is on the move, displaced by the flows of capital and also hopelessly dependent on them. Its displaced subjects are the others thrown up by the postmodern condition, and they are also the subjects of Salgado's lens.

Over the past thirty years, and ever since he first noted the disparity of profit in the coffee trade between those who grow the bean at grass roots and those who trade it in international houses—where coffee may

be consumed but the bean is never touched, where the prices of coffee are set, and where the meagre earnings of the growers are determined—Salgado has focused on the disparity and displacement foisted by global trade practices on those who produce the raw materials of such trade. He has been and continues to be a pioneer in the photography of the global south.

In tandem with the course of his career, there has been a global awakening to the possibilities offered by photography to the displaced of the global south. While some—especially those who adopt Lacanian views of the gaze—may think that photography objectifies the subject, many others—particularly those who view the gaze of the subject to the viewer and back again as a dialogic act—see it as an important political act of representation and openness. This is so particularly of photography that is non-Western, and it is worth reiterating that even if Salgado has a base *in* the West, he is nevertheless not *from* the West. As Stuart Hall has said, non-Western photography is strongly preoccupied by the question of difference, but also "refuses to be rendered motionless by place, origin, race, color or ethnicity."[54]

While I use the term *global south* largely because it suggests the idea of difference and hence a border, itself central to ideas of alterity, it should also be noted that an important intervention in hegemonic perceptions of the global south has, in fact, come from photography. This intervention has been the proposal of the idea of "the majority world," which emphasizes the fact that over 80 percent of the world's population lives in the global south, by the photographer Shahidul Alam, the Bangladeshi founder of Drik, Asia's largest photographic agency.[55] Alam is also the founder of the transnational photographic agency the Majority World, which aims to offer a platform for non-Western photographers. The Majority World acts as a bridge between the West and its others via photography, so that the points of view emerging from non-Western societies might help redress existing imbalances between the self-directed visibility of the West and the hitherto mediated visibility (or lack thereof) of its others.[56] Its aim is to penetrate the hegemony of the global north with images taken by those who inhabit the global south. In this way, the points of view and the gazes of the latter are able to intervene in and enter into dialogue with the visual discourses that predominate in the former.

As always with photography, this political intent cannot be disentangled from a commercial one. The largest market for photographs

also lies in the West. Through its reliance on the market in order to survive and flourish, photodocumentary both contests and furthers existing global hegemonies. The sad fact is that still today, it is not possible to be a "world-class" photographer, of the likes of Salgado, Cartier-Bresson, and others, if one has not exhibited one's work in the elite exhibition spaces and galleries of London, New York, Paris, and other Western capitals. An agency such as the Majority World targets precisely such venues and arenas for indigenous photographers who would not be able to achieve this exposure by themselves. One wonders, therefore, whether with all his talent Salgado would have won his undeniable international renown if he had never left Brazil. Perhaps his ten years of exile, which forced him to remain in Europe and thereby thrust him into the heartlands of the marketplace for documentary and art photography, have served him and his viewers well.[57]

Thanks largely to Alam's efforts, Bangladesh, one of the poorest countries in the world, has a surprising number of very active photographers, whose work is gaining increasing exposure. It would not be farfetched to assert that Salgado, as a Brazilian photographer who has succeeded in the West, has set an important example for photographers such as these from across the global south. His work is pioneering both in its aesthetic and in its choice of subjects; moreover, his impact on photography at the local as well as at the global level is considerable. Take for example his photo-essay *Workers: An Archaeology of the Industrial Age*, in particular his images of the breaking of ships in Bangladesh taken in the 1980s, and compare it to the recent work on the same topic by the Bangladeshi photographer Saiful Huq Omi.[58] Huq Omi's photographs share not only an aesthetic and a common subject with Salgado's, but also a point of view.

Salgado is, of course, an auteur among photographers. Firmly established in the West, but focusing always on subjects who have been relegated to the other, he takes on a hugely complex role to mediate between vastly different, even contradictory but nevertheless related, contexts. His work can be approached from myriad ways and speaks from many angles and perspectives. These frameworks include those of the elite art market for photography, well established in late capitalism; social, ethical, and political causes; and the struggle to counter the divisiveness of hegemonic discourses through a visual discourse that is dialogic and focused on connections. His work may direct itself to the eyes of the empowered world, but, in my view, it is not at all for

the sake of objectification, as some have claimed. On the contrary, and as this book will show, it is to establish connections and redress invisibility. Yet, his work also projects the play of power relations between the global south and the global north, as well as the interconnectedness of these supposed opposites. And it does even more: it also throws open new horizons, suggesting in the language of light another possible equation, envisioned in the image. His photography opens up a space for dialogic encounter with what is known and unknown.

Race, Bodies, Landscapes, and Nature

Everywhere in Salgado's work, images of bodies, landscapes, and nature arise. In his presentation of so many non-Western subjects, race and racial difference too run as implicit themes in his photo-essays. These tropes weave continuity through Salgado's photography, reappearing as they do in every single one of his major projects. Yet, it is not to confirm dominant perceptions of these concepts that Salgado works, but to question them.

The simple act of viewing an image inevitably calls on numerous visual points of reference that recur in the imaginary and in the discourses and narratives that surround us as viewers. Our vision, therefore, is somewhat framed even prior to the act of viewing. Shaping our vision are concepts that are central to the epistemological premises of modernity, the historical frame within which our cognitive responses are formed. In this context, where progress and development are prioritized and imagined in terms of capital and technological advancement, all that is natural—human bodies, the landscapes against which we live our lives, and nature in its fullness and diversity—is tacitly harnessed to the forces of production. Landscapes, the shaping of nature to suit man's needs, indeed the taming and trimming of nature, offer yet another measure of our view of the human in relation to the nonhuman. Landscape has a long history in art, as well as in photography. In painting, landscapes took on a special relevance in the nineteenth century, as modernization was spreading across the globe. Salgado's landscapes bear the traces of these artistic traditions but also veer from them through a reiteration of the vulnerability of these and other "scapes"—the constructed spaces of the modern imaginary—in the face of natural and environmental degradation.

Additionally, in light of the divisions wrought by modernity and

the elitist hierarchies put in place by European colonial expansions of earlier centuries, the question of race inevitably surfaces, always linked to that of the alterity imposed by a Western-oriented gaze on colonized and non-European persons. The idea of race helps us to organize, categorize, and distinguish people—almost inevitably in terms of a hierarchy. Also determining our point of view is the separation of nature from culture, whereby landscapes, animal, and plant life are taken to be lesser than man. It is generally assumed that they are separate but useful in serving the needs of mankind in a chain that goes on to link mankind to production and, ultimately, capital and technological prowess.

These divisions have a well-established role in the construction of the history of knowledge. The exploitation of natural resources, the pre-eminence accorded to certain races and ethnicities at the expense of others, the reiterated trope of the racialized human body at work, the upholding of civilization before that which is deemed barbaric, and the mass violence of dispossession that presents itself in the face of late capitalism have all become embedded aspects of the world as we know it today. For some centuries now, *race* has acted as an umbrella term for encapsulating this sense of contemporary difference; the concept of race divides human beings and organizes mankind into hierarchies. But this is no more than the culmination of a long-standing worldview whereby mankind sets itself apart from other creatures and nature. As such, it is an extension of the desire to divide all of the elements of the world into hierarchies. Thus, knowledge and history as we articulate them have been constructed on major planetary divisions between humans and nonhumans.

In considering the acquired and inherited frames through which we view Salgado's images, the concept of race looms large. Race most obviously denotes divisions and differences among humankind. In a broader sense, it also divides the human from the animal and, as such, points to difference and disparity. At its gentlest, race demarcates difference; at its most violent, it legitimizes genocide. As David Theo Goldberg and John Solomos assert, the notion of race is predicated on processes and practices that generate alterity.[59] Given the historical legacies of Europe in colonial times, it has a particular application to those of the global south, to those considered ethnically, culturally, historically, and politically to be Europe's others. So it is that the term often comes alive in the context of nonwhite peoples and, in particular, of those with links

to Africa. In keeping with modernist dualisms, the discourse of race departs from the antagonisms of white versus black, to the triumph of the former, while the geopolitical connotations of race extend to culture, place, and nature.

There is a long history behind the many usages put to the term *race* and its attendant connotations. In his *Philosophy of History*, Hegel wrote at some length of Africa, using it as a point of reference for framing, through its supposed marginality, the realm of historical development—a realm that did not include Africa.[60] For Hegel, the notion of civilization was predicated on the European, and the African remained unhistorical, uncivilized, and relegated to nature. Hegel identifies Africa as the margin that denotes the contours of the civilized world, namely Europe, the centre of historical—and hence cognitive—development: "It is," he states of Africa, "no historical part of the world."[61] Despite the abolition of slavery, the decolonization of African countries, and the end of apartheid, among other milestones in the effort to free Africans from an imposed condition of inferiority, Africa remains one of the poorest and least recognized continents in the world. Economic hardships, political instabilities, guerrilla warfare, the rampant spread of HIV/AIDS, and civil wars afflict many countries on the continent. They are afflicted as well by the perception of Africa as other and less important, which persists in most other parts of the world.

Africa has been a repeated focus of Salgado's lens. From his photo-essay on famine in the Sahel onward, Africa has appeared over and again in his work and Salgado continues to return to Africa ever since he first experimented with photography there. Indeed, he has collated his images of Africa from diverse photo-essays in the volume *Africa*.[62] His images frame the outward gaze of Africa's inhabitants, both human and nonhuman, as well as the struggle and survival of a disenfranchised continent. Of relevance here is Paul Gilroy's statement that he wishes to "endorse the suggestion that critical analysis of racisms needs self-consciously and deliberately to be updated. Few new ways of thinking about 'race' and its relation to economics, politics and power have emerged since the era of national liberation struggles to guide the continuing pursuit of a world free of racial hierarchies."[63] The analysis of nature, animal and plant life, and man's relation to these also urgently needs updating. As this book demonstrates, few "texts" force this self-conscious updating of knowledge in its multiple rational and non-rational dimensions as compellingly as photography does.

In *Africa*, as in other collections of Salgado's photography, the idea of race combines with bodies (human and animal), landscapes, and nature. In this photographic space, what comes to the fore is diversity and a place for the individual or the specific within the larger collective or community composed of human and nonhuman. Salgado's photography is about people, places, animals, and nature. It is about race, but not in terms of hierarchies; rather, it is about the race of the living, about questioning the premises on which we predicate our knowledge. His images are constructed so that they call on the understandings we carry with us of race, landscape, bodies, and nature. To some extent, they even appear to rely on these imaginings. However, through the appeal of the aesthetic, these images force a questioning of the cognitive premises on which we base these notions. Salgado's images pose a question to viewers as to whether the world as a whole would not be better off if we were to consciously jettison modernity's divisions in favour of a commitment to, and wonder in, a planetary race composed of interrelated and mutually implicated biodiversity.

Light Explorations

The first chapter of this book provides a detailed examination of Salgado's main photo-essays and photographic concerns. His development as a photographer is traced in an effort to understand the thematic and ideological links between his different long-term projects. This chapter also explores the finer detail of each of these photo-essays and situates them in wider sociopolitical, cultural, and photographic contexts. In subsequent chapters, I pursue four interconnected conceptual strands that arise from his work: those of aesthetics, history, ethics, and politics.

Chapter 2 enters into the unresolved debate of documentary versus aesthetic styles of photography in a bid to tease out some of the tensions and nuances in these inevitably related, but seemingly paradoxical, modes of representation. Salgado's photography bears the mark of a very distinct aesthetic. While the aesthetic and beauty are not the same, in his case the aesthetic style that he adopts is one that clearly calls on traditional notions of beauty. The result is an apparent conflict between, on the one hand, the distinctly unlovely contexts he photographs and, on the other, the striking images he produces. I argue that this situation is not coincidental; nor, indeed, is it a conflict as such. Contrary to superficial tensions between reality and representation,

the ideological thrust behind documentary work is enlivened by the aesthetic. This is so because the aesthetic draws the viewer to engagement. The presence of a marked aesthetic becomes all the more important in the visually saturated contexts of postmodernity, where images flit past us incessantly. Salgado draws on a more traditional aesthetic in order to make his images stand out from the general whirl. Indeed, Salgado's images are memorable in cultural contexts where memory itself is in crisis. An examination of his work reveals the importance of aestheticized photodocumentary in forging specific types of vision, whereby images from "elsewhere" and "of the past" intervene ideologically, thus framing not only what we, individually and collectively, see but also what we can envision. In particular, I address the deadlock that currently exists between criticisms on the aesthetic in documentary photography. This conflict is most commonly expressed in the context of Salgado's work through, on the one hand, vehement critiques of the photographer and a negation of his images' historical, ethical, and political possibilities, and, on the other, enthusiastic labelling of Salgado as an über-photographer-cum-artist, to be admired and relegated to a league of his own. By focusing on Salgado's work, indisputably a superb example of the conjoining of the documentary with the aesthetic, I hope to analyse the aesthetic and its many roles in terms of the documentary image. I consider the latter to be not a static representation but in fact a fluctuating, dynamic triad of the subject, the photographer, and the viewer.

In considering the image, three further critical arenas, namely those of history, ethics, and politics, emerge from reflection upon the question of the aesthetic. Chapter 3 explores the question of history in relation to Salgado's work, focusing especially on how silenced histories can emerge via the photograph. In the context of history, and especially in light of the postmodern breakdown of historical authority, photography opens windows onto new and different historical imaginations. In such imaginings, history is not rendered in a typically modern mode as a complete and authoritative master narrative, but as plural, incomplete, and open to revision. Furthermore, via aestheticized photography historical imagination awakens to the possibilities posed by the sentient, the magical, and the nonrational. My premise is that in order to understand this vital aspect of Salgado's work, one must take into account his inherited traditions of visual culture, and especially the baroque, in Brazil. The mark of the baroque in his aesthetic fulfils a sym-

bolic function by calling upon the silenced histories of the postcolonial as well as on the interrupted and splintered temporality of Brazil's hybrid and heterogeneous historical course.

This reimagining of history in terms of that which is always unfinished and open-ended has crucial ethical and political ramifications. In order to explore these, I return to the question of the aesthetic and the mode in which it arouses in the viewer not merely a rational response but also a sentient or affective one. Chapter 4 focuses on how photographs offer spaces for the construction of an ethics of vision. My claim is that Salgado's photography offers, if only in passing, the opportunity for viewers to make an ethical response to the image. Aestheticized photography, such as Salgado's, thus exceeds documentary and enters the zone of art. It engages the viewer at several levels and it is through this mixed, even contradictory, encounter that the viewer is forced to re-examine her or his epistemic certainties. This moment of self-questioning is also the moment of ethical possibility or re-envisioning. My argument is that if Salgado's photographs cast a different light, it is because they ignite a spark, brief and tenuous though it may be, of ethical possibility.

Chapter 5 seeks to translate the ethical in Salgado's work into the political by returning to an examination of the aesthetic. Salgado does not espouse an established politics of any sort, but the arena of politics is suggested in and through his work via the proposal of a planetary polity. I see the politics of his work not so much in terms of any clearly defined capitalist or anticapitalist stance, nor indeed in terms of any sort of activism as such, but rather as that which proposes the notion of belonging and responsibility, or polity. His photography falls into place alongside his training as an economist and his ongoing environmental projects to overcome the modern demarcations separating mankind from animal and plant life. His images, especially those of his current photographic project, seek to suggest connectivity and the inextricability of life forms from one another. What emerges is the notion of a planetary polity, and by extension, that of planetary responsibility. Ironically, therefore, photography, a medium that confirmed the project of modernity, works via the shifting combination of document and art to put forward ways of countering the divisions, the deconstructions, and the decimation wrought by modernity.

Throughout this book, I posit the aesthetic as a crucial form of visual pathway, one with an influence that pulsates between the physical, the

material, the psychological, the rational, the discursive, the narrated, the remembered, the imagined, and the spiritual. The aim of this book is to analyse Salgado's work, as well as to tease out the complex play of the aesthetic and to consider in its light the role of the viewer when face to face with the image. With and through Salgado's images, this book seeks to enter into dialogue with the many ambiguous, controversial, and unresolved arenas that surround photodocumentary—those of the aesthetic and beyond; those of the construction of new perspectives on knowledge and history, of ethics and response to alterity, and, in the final instance, of reviewing and re-envisioning the place of mankind on earth.

In all the forays made here, the inherent poignancy of the still photograph must be recalled. A frequency of uncertainty courses through the still photograph. We must pay heed to that poetics of the unknown, to that vibration of ambivalence in the still image that disturbs certainties. For I believe that it is this quality that bestows an ongoing interrogative on photographs, which is vital if photographs are to project and foment any degree of ethical or political stirring. My premise is that the image only comes to life through the act of viewing. Thus, to analyse Salgado's (or any artist's) work is also to take into account the complexities of vision as a process. What happens to images such as his after they have been seen? Do we carry them with us or put them away, or do they lead us somewhere? What dynamic exists between images, the emotions they arouse, and the ideologies, discourses, and practices with which we approach them and move on from them? If photographs ostensibly tell us about the past, then in what ways do they interject historically, ethically, and politically to orient us to the future?

1

The Moving Lens

Abiding Concerns and Photographic Projects

> In the end I discovered that the stories that
> gave me the most pleasure were the same stories I did before,
> not as a photographer, but as an economist, as a student.
> SEBASTIÃO SALGADO,
> in interview with the author, Gallery 32,
> London, September 10, 2007

INTERVIEWS AND CONVERSATIONS with Salgado tend to shift seamlessly from a focus on his photography to the global economic picture. Salgado will often talk in terms of statistics, facts, and figures, revealing a pragmatic mode of thinking that directs his practices as a photographer. Underpinning all his major projects is a concern with the changes and displacements to mankind, to land, and to communities that are brought about in the course of modernity. The focus of his work is most often on those who survive on the peripheries and underbelly of such major processes. In representing such displacement, Salgado's work brings to the fore major questions about modernity as lived in terms of industrialization and globalization.

In this chapter, I outline, analyse, and contextualize his major photographic projects to highlight their main features and uncover the links that connect them. In the process, both the diversity of his photographic

work and the singularity of his ideological impetus as a photographer will become clear. An understanding of the concerns, methodology, and impact of Salgado's work is necessary for a consideration of his photography in the light of the theoretical frameworks contained in the chapters that follow. Equally important is an understanding of the connections between each of the major photographic projects and larger social contexts, as well as of the abiding concerns that link the different projects together. My aim here is also to bring into view the wide canvas of Salgado's work, so that its relevance—theoretical, ethical, and political—as photography of and from the global south can come into focus.

Salgado's work is massive in volume, spanning principally Asia, Africa, and Latin America and highlighting key aspects of the social, economic, and political histories of the twentieth century and early twenty-first as experienced beyond the boundaries of the Western hegemony. To date, Salgado's work can be said to cover seven major themes: rural Latin America; the famine in the Sahel of the mid-1980s; workers and the modern displacement from natural means of production that has accompanied industrialization; landlessness in Brazil; global migrations triggered by economic and political forces; children affected by forced migrations, poverty, and other social problems; and the campaign against polio. Connecting these themes is the underlying concern with man's alienation from nature and the environment, a preoccupation that comes into distinct focus in his latest project, *Genesis*.

Salgado has undertaken these themes through a series of long-term photographic projects, typically involving extensive travel and several years in the making. The worldwide tours of Salgado's photographs take place periodically, and often, as with the *Exodus* exhibition in 2003, simultaneously in diverse global capitals.[1] In travelling exhibitions, his photographs have been shown in most of Europe's main cities, as well as in North America and Latin America. He has also exhibited in Asia. On a smaller scale, his work can be viewed at any time in the numerous volumes that have been published mainly with Phaidon, Aperture, and other major photography presses. Most of these photo-essays have appeared in dedicated volumes of photography, such as *Workers*, *Terra*, *Migrations*, *The Children*, and *The End of Polio*, while *An Uncertain Grace*, published by Aperture in 1990, brings together photographs from the different thematic projects that Salgado was concerned with in the 1970s and 1980s. His current project, *Genesis*, said to be the last major photo-essay of his career, was initially released in parts every

three months or so in the *Guardian* newspaper's Saturday review and continues to feature either in small-scale exhibitions or else in the press.

This chapter considers Salgado's major photographic projects in considerable detail and in the order in which he undertook them. It does not, however, dwell on his commissioned work done for commercial purposes, although this work shares many stylistic, aesthetic, political, and other aspects with the projects that he has embarked on personally. Of course, this is a somewhat arbitrary line that I am drawing: Salgado's images of Parma ham or of Malpensa airport in Milan, for example, share tonality and visual style with the rest of his work. Such endeavours also help to sustain financially what he calls his "personal projects." Moreover, in considering the work of an engaged photographer, such as Salgado, it is impossible to demarcate personal projects that reflect such engagement from commercial work that supports the former; it is also impossible to make such demarcations within the field of photography as a whole, for photography is at once commercial, documentary, and aesthetic. Yet, Salgado's commercial projects are too many and too dispersed to consider in close detail here. Suffice it to say that commercial work has provided Salgado with key financial means of pursuing those projects that he holds closer to heart and for which he is best known. Also, many of his commercial images share the tonality, the compositional structures, and the aesthetic of his personal projects. Indeed, all of Salgado's work is mutually implicated, in style as well as in content.

This is a reminder that photography as a medium straddles and connects economic, cultural, ethical, and political circuits. Furthermore, such is the fluidity and versatility of still photography that any single image can, of course, be slotted into diverse contexts. Salgado's work also appears often in collections, and as such is widely disseminated and often dispersed. Collections of Salgado's work, such as *An Uncertain Grace*, are well known and easy to locate, but I shall not analyse them specifically, although interesting readings can be made from the juxtaposition of images found therein. Nor shall I consider, save in passing, photographic volumes that juxtapose his work with that of other photographers with similar concerns. Overall, there is little doubt that only a small number of Salgado's photographs have been made public. The possibility of editing his numerous images from across his career into thematically linked collections is already under way: *L'homme et l'eau* is one such project, as is *Africa*. The possibilities for photographic

exhibitions, editions, and readings remain no doubt endless. This book can at best touch on a few of them. Instead, I shall focus on the major photographic projects for which he is best known.

Visualising Alterity

The trilingual appearance (in French, Spanish, and English) of *Other Americas* in 1986 marked the public culmination of the first of several long-term photographic projects. This collection of photographs, taken on travels around Latin America between 1977 and 1984, underlines the alienation of peasants from their natural environment. Many of the images in this photo-essay were taken in some of the most remote villages of Latin America. In them, Salgado records a disturbing decline in rural life. The alterity deliberately evoked in the title emphasizes the alienation of indigenous communities for whom a natural relation between man and land has become disrupted. It also stresses an America that dwells in a different temporal frame from the one so dominated and appropriated by the United States. Equally, through their contemplation of the silence and solitude of the indigenous Latin American peasant, the images reveal the abandonment experienced by those left behind in the heady rush toward modernization.

This early collection of images introduces and brings to the fore several key areas of focus sustained throughout Salgado's work. A reiterated attention to landscape, bodies, and nature forms recurrent motifs in Salgado's work, which both collude with and contest the ways in which these very concepts have been conceived of in the larger scheme of modernity. However, in this collection of images, there is also a deep silence, a voicelessness perceived in the subjects, as if they had been rendered mute in a historical void. The lack of detailed information in the volume about the particulars of those photographed also accentuates the silence that surrounds these images. The subjects appear suspended in time and space, abandoned by the course of history. The sole information available is the name of the country and the year in which each picture was taken. There is no text that provides contextualization. The images are thus bare, stripped to the bone and forlorn beyond description.

A wedding in northeastern Brazil exemplifies the stark poverty of the people. The bride, in her wedding dress, grips a lone flower with work-worn hands as she sits waiting in a rundown car (fig. 1). Her lips are tightly set, her tanned face already lined and weary, in stark con-

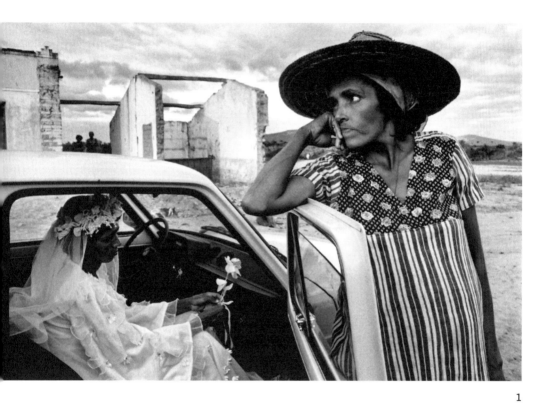

1

trast to the apparently absurd festivity of her white dress. The wedding party gather around a dining table in the open air where the plates are turned face down (fig. 2). Perhaps this is to protect them from flies, but the metaphor extends nevertheless to remind us of the poverty of the arid, Bahian *sertão*, one of the most economically disadvantaged places on earth.

Implicit in the images, though never directly presented, is the sharply uneven modernization of the Latin American continent, resulting in urban migratory patterns that have left the countryside bereft. In his critique of *Other Americas*, John Mraz makes the point that the singular focus in this collection on peasant alienation, without an attempt to contextualize the latter in terms of the larger effects of modernization, such as the overcrowding of urban areas, for example, strips this volume of historical relevance. The result, Mraz argues, is a representation that devolves into the historically enigmatic, the morbid, and the grotesque, as peasants are seen as part of an impoverished, abandoned, and moribund landscape. Mraz thus makes the accusation that "the book neglects both political and class struggle," a criticism made more acute by the juxtaposition of *Other Americas* with Salgado's subsequent projects on Latin America, most significantly *Terra*.[2] However, in this context, Mraz underlines the fact that *Terra* itself is composed of different parts; the early part of this volume consists of images from *Other Americas* while the latter part focuses specifically on the struggle of the landless. Thus, he concedes that this second Latin American volume succeeds in historicizing the very photographs stripped of historical significance in *Other Americas* and lends them a political force that they previously lacked by inserting them in a larger narrative of Latin American dispossession. Mraz's critique of *Other Americas* rests largely on his specifically Latin American geopolitical focus. While it is true that no clear Marxist narrative emerges from these images of rural Latin America, nevertheless, they do reveal a perspective of Latin American life—namely, the impoverishment and the displacement afflicting the indigenous—that does not always make itself readily accessible to Western viewers.

The photographic critic Fred Ritchin, in his essay "The Lyric Documentarian" (this title derives from that of a lecture given by Walker Evans in 1964), foregrounds instead the spirituality that emerges from these images. They are, he states, an attempt by Salgado to present his first-world viewers with a glimpse of the spiritual richness that defies

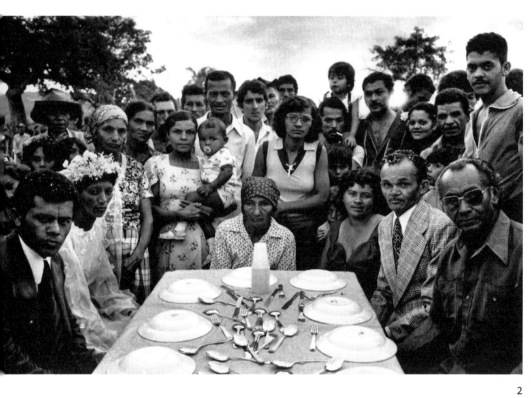

2

material poverty in Latin America. Ritchin also points to a certain spiritual unrest in Salgado himself, arising from his own dislocation from Latin America. If the subjects of these images are exiled from historical development, then the photographer too was exiled, from his homeland. Salgado speaks to this in his introduction to a Brazilian edition of *Other Americas*: "In 1977, when I began this project after some years of travel in Europe and Africa, my sole desire was to return to my beloved land, to my Latin America that is so dear and so profound, to my Brazil from which a somewhat forced exile had obliged me to stay away."[3]

The project on rural Latin America was tied, Ritchin argues, to a personal unrest in the photographer himself—namely, a need to reclaim the self, especially as Salgado had previously been forced into the position of exile, as a political dissenter. Furthermore, the images can be seen as a gesture by a Latin American, now resident in the West, toward reclaiming his roots in the face of personal dislocation. Indeed, Salgado often mentions the fact that much of *Other Americas* was shot in countries neighbouring his native Brazil, so that on occasion the land he stood on was indistinguishable from the one from which he was barred. The silence of this collection is in some ways, then, that imposed by exile.

Whatever the reasons, it is nevertheless clear that the twin themes of displacement and exile emerge in *Other Americas*. The exile experienced by the Latin American peasant is not one of being forced outside borders but rather that of being left stranded in the wake of a mass, rural exodus toward the urban promise of modernization. In the stolid and resolute silence of the peasants, in their stubborn rootedness to the land, the precariousness of their existences comes into view, revealing the traditional communities of Latin America to be, indeed, victimized and forced into dispersal by the capitalist dream of a better life. In light of Ritchin's lyrical reading of Salgado's photography, it is possible to connect the photographer's focus on a declining way of life with the nostalgia evoked by the Portuguese-derived word *saudades*, a term conventionally applied to poetry or music. This lyrical longing for things past or passing, a nostalgia for an irretrievable past, which Ritchin identifies as lyrical in Salgado's work, has previously been associated with Brazil. In his *Retrato do Brasil*, Paulo Prado states that the Brazilians are a melancholic people, prone to dwelling on a sense of nostalgia.[4] The temporal loss associated with saudades is indeed well represented by the medium of photography, as the photograph too proclaims the loss of a past time.

The images of *Other Americas* bring to mind works such as Claude Lévi-Strauss's *Tristes tropiques*, a masterpiece of structuralist anthropology that at once confirms the historical stasis imposed upon indigenous peoples in Brazil through the phasing out of their ways of life and the anthropologist's own, very modern, navigation through space and time in his pursuit of knowledge. Perhaps even more relevant in this context is Lévi-Strauss's other work, *Saudades do Brasil*, a photographic memoir of a people in passing. Taken between 1935 and 1939, these images attempt to shape an anthropology of an indigenous way of life in decline due to the spread of modernization in Brazil. In this context the photograph, a key documentary tool for structural anthropologists thanks to the apparent realism of the medium, underlines the temporal horizon closing in on traditional ways of life in the face of an encroaching modernity. So too can *Other Americas* be viewed as a lament for what is passing and a portrait of the isolation of man in his stubborn attachment to land and tradition; a hopeless, if admirable, resistance to the sweeping onslaught of more modern, and profit-centred, ways of life.[5]

Despite the lack of overt politics noted by Mraz, *Other Americas* is a very deliberate visual attempt to engage with the notion of otherness. In a postcolonial and, more specifically, Latin American context, the neglect of the other is experienced as self-estrangement by those who find themselves caught in long histories of marginalization. Such alienation derives principally from the domination and top-down sociopolitical discourses and structures imposed on indigenous peoples and communities by colonial and imperial forces. To understand the complexity of such social patterns of self-estrangement, whereby the colonized view themselves through the othering eyes of the dominant powers, we need only to turn to the work of the Martiniquan psychiatrist-turned-African-revolutionary Frantz Fanon. In his *Wretched of the Earth* and *Black Skins, White Masks*, Fanon explores the psychological dynamics of domination that lead to alienation from the self. His work takes up the issue of race in order to forge what remains one of the most forceful, explicitly political, and revolutionary studies on the mechanisms of power and identity from theorists working among and for the disadvantaged. In *Other Americas*, we glimpse the deep-seated alienation of indigenous peoples overtaken by colonization, modernization, and urbanization. In the silence of their gaze, we also see how such alienation might become internalized.

The Mexican writer Octavio Paz explores these issues in his *Labyrinth of Solitude* and *The Other Mexico: Critique of the Pyramid*. Of the indigenous peasant, he writes, "The Indian blends into the landscape until he is an indistinguishable part of the white wall against which he leans at twilight. . . . He disguises his human singularity to such an extent that he finally annihilates it and turns into a stone, a tree, a wall, silence and space."[6] Written a quarter of a century prior to Salgado's book of photographs, Paz's words could function as a description of the latter: the peasants of *Other Americas* are suspended in the landscape, rendered mute by the savage obliteration of their histories and circumstance. In the arresting force of the still photograph, such a call to recognise a continuing history of alienation acquires a visceral power perhaps more potent than that of words.

But not everyone espouses Paz's bleak view of the indigenous in the Americas. The silence emerging from *Other Americas* is in many ways disturbing, and while the indigenous may be displaced in the Americas, they are not silent. Despite the alienation imposed on them, they have survived across the centuries. When the Nobel Prize winner Rigoberta Menchú gave her testimony, it was notable precisely because it gave voice to the indigenous.[7] Despite the controversies that have since surrounded her work with regard to questions of authenticity, it did make its mark. And there are many other instances of agency on the part of the indigenous.[8] In Mexico, the Zapatista movement and the struggle for land in Chiapas point to the claims of the indigenous despite the onslaughts of history. With regard to *Other Americas*, the alterity imposed on the subjects both by the photographer's lens—Salgado himself separated from them by dint of his access to technology and to all that is modern—and by the title of the volume invite a questioning of his self-authorized right to represent. They also beg scrutiny with regard to perspective and motivation. The very engagement with otherness that Salgado seeks here is undermined by the historical stasis imposed on the subject as other. The stillness of these images, the desertion of the subjects, and the lack of context reduce the images to ghostly apparitions of a people in peril of extinction. What is seen here is not the extraordinary force of human survival that must inevitably underlie the lived experience of the subjects, but the silent and impassive surrender of an entire collective. Furthermore, the very poetic, indeed elegiac, force of these images is dependent on the silence that ensues from them.

Despite its shortcomings, *Other Americas* reminds us that the photo-

graph, always other to the viewer, provides an apt medium for reflection on alterity. Such reflection opens onto reflexivity, as the image of the other necessarily forces reflection on the self. The invitation to contemplate the other, to look, to see, and to recognise leads to a refiguring of the self in terms of this new vision. In their framing of otherness, photographs call on us to contemplate and dwell on difference. In so doing, they invite us as viewers to measure or delineate our selves. Regarded in the larger, more global light of Salgado's photographic course, *Other Americas* further reveals important aspects of Salgado's photography as a whole. The modern abandonment of traditional ways of life, the resulting displacement of peasants, the neglect and ransacking of the environment in the name of profit, and long histories of subjugation and violent exploitation all form the bedrock of Salgado's photography. Much of his work is about displacement and exile, as well as about the search by the dispossessed to find a place of their own. If *Other Americas* lacks the direct and clearly articulated political thrust of his later photographs, these rural images of Latin America both underline Salgado's concern with the devastation of lands and communities and form a foundation for understanding the larger, historical narrative that emerges from the gamut of his work to date.

The Winds of Hunger

Salgado's historical concern begins to be more explicitly articulated in his major project on Africa: *Sahel: L'homme en détresse* examines drought and famine in Africa, in the Sahel region. While Salgado was still an economist and travelling to Africa for work in 1973, he began to photograph the region and in particular the drought that regularly affects the many countries of the Sahel. Following this introduction to drought in Africa, Salgado returned in the 1980s in order to photodocument the appalling famine that had spread across the region. Many viewers of these images will recall the famine of 1984, a year when the drought in the Sahel grew to affect some 200 million people in twenty African countries.

If attention to this plight was created in the West largely through the media, then it is important to remember in the context of considering the potential of visual documentary that it was in fact a documentary report—produced by the BBC, presented by Michael Buerk, and filmed by the Kenyan cameraman Mohamed Amin in October 1984—

which launched unprecedented public response in the United Kingdom and elsewhere. In the United Kingdom, the viewing of the documentary unleashed an impressive move by ordinary citizens to donate aid money. The following month, the musician Bob Geldof assembled Band Aid, whose single "Do They Know It's Christmas?" earned an amazing $8 million worldwide, which went as aid to the starving. This success in turn led to the creation in the following year of Live Aid, an international music event that raised $100 million in aid. The BBC's television documentary had had the unprecedented effect of creating a moment in history of civic collaborative action that was rapid, focused, and determined. To quote Mary Price, "The broad response to the 1980s famine in Ethiopia was activated by photographs. Reports of the famine had appeared in the back pages of newspapers for at least two years, quietly ignored, before the stunning pictures of the gaunt, weary, barefoot men, women and children walking in the dry, sandy landscape towards an uncertain destination appeared on television and in newspapers."[9] The issue of whether such a wide response in the West actually did succeed in alleviating famine in the region—given the all too frequent obstacles of corruption and bureaucracy that hinder the passage of financial assistance from the rich of the world to the most needy—has been highly debated elsewhere.[10]

Salgado's images of the famine were the result of a collaboration with the French group Médecins Sans Frontières. This was also the first of his many collaborations with human rights causes. The partnership with Médecins Sans Frontières suggests an early alignment of Salgado's photographic objectives with the group's goals. This independent humanitarian aid agency has been committed since 1971 to providing medical aid wherever necessary, regardless of the recipients' race, religion, politics, or sex. A further objective of this agency is to raise awareness of situations and peoples in need of help. Médecins Sans Frontières currently works across eighty countries, often providing assistance in remote regions or zones affected by natural or manmade disasters.[11] Beyond rebuilding health, the agency functions as a witness in the cause of human rights. Through its numerous publications and, more recently, its website, Médecins Sans Frontières disseminates information about the crisis zones in which it operates, thereby taking on a key testimonial role for parts of the world, such as war zones in Africa, that often receive little attention from the Western media.

The notion of photographer as witness, so evident in *Sahel: L'homme*

en détresse as in all of Salgado's work, is also central to the ideology of ethics that supports photojournalism. Ken Light underlines the role of the photojournalist as witness in his book *Witness in Our Time: Working Lives of Documentary Photographers*. The witness, he states, is not a voyeur; the witness engages in a committed relation with the subjects of his or her vision and does so from a concern that stems from the self.[12] This notion of the photojournalist as witness bears a relevance to the ethical impetus behind Salgado's work, which cannot, in my view, be ignored. As he was working for Magnum when the volume came out, *Sahel: L'homme en détresse* added greatly to this photographic press agency's already illustrious history of committed photojournalism—a history that was built on the legacy left by two of its founders, Robert Capa and David "Chim" Seymour, both of whom tragically lost their lives in war situations.

Additionally, these images by Salgado of those stricken by famine in Africa bring into focus the disrupted relation of man and land. The collection of photographs pictures humanity adrift. Implicit too in these images of human disaster is another, more serious betrayal: that of man to man, as the viewer is confronted with suffering of a deeply shocking scale. Also evident is the struggle of man against nature, as the subjects of these images trail across an unforgiving and inhospitable landscape. Yet, in Salgado's depictions of this crisis in Africa, a distinct beauty shines through. This heightened aesthetic that is present in all of his work functions as a rhetoric of suffering. The visual language of the aesthetic is so strong in Salgado's work that, disturbingly, these photographs of stark realities present a presumed resilience and beauty of the human spirit that foreground the dignity of human life in the face of the most severe and shocking degradation.

Despite the lasting imprint left in the mind's eye by these images, the publication of *Sahel: L'homme en détresse* in 1986 did not receive the attention that the images have attracted in subsequent years. At the time, Salgado was not yet an eminent photographer, and the book did not circulate in the United States, its publication limited to France and Spain. Undeniably arresting as these images are, Salgado's relative lack of fame combined with the ethically discomfiting tragedy contained in the images to render it a commodity that was hard to market. Of course, these very photographs are now widely available, their accessibility rising in tandem with the photographer's fame.[13] Unsurprisingly, a new edition, this time in English, was published in October 2004 by

the University of California Press. *Sahel: The End of the Road* includes an essay by Fred Ritchin and a foreword by Orville Schell, an academic based at the University of California, renowned for his expertise on Tibet and China, and a board member of Human Rights Watch. Of Salgado's images, Schell states: "While art should speak for itself, Salgado's photography is first and foremost a documentary way of bearing witness to something else. His work is both an anguished *cri de coeur* and, although he professes not to be religious, something of a votive offering presented in the hopes of getting the attention of a world that sometimes seems to have fallen asleep."[14] Clearly, this new edition in English targets the wealthiest viewers in the world, namely an Anglo-American public, who would regard these images of some two decades ago in light of both Salgado's later and better-known photo-essays, such as *Terra* or *Migrations*, and numerous global events, such as the genocide of Rwanda, conflict in Darfur, and renewed famine in the Horn of Africa. It should be noted as well that, in terms of addressing these problems, these images make no direct intervention.

Despite their beauty, the images are hard to contemplate. Anguished, skeletal human forms, huddled in tattered shawls that offer them scant protection from glare, sunlight, or dust, are scattered across the cracked, interminable desertscape. At times, it is hard to tell the dead from the living. If this was truly a famine of biblical proportions, then the story of humanity in desolation that arises from these haunting images seems biblical as well. Young children, reduced to mere skin and bone, lie exhausted in refugee camps. They look no different from the other emaciated and childish frames seen on adjacent pages, awaiting burial. Yet, these are the survivors. An infant suckles at his mother's shrivelled breasts (fig. 3). There is little that provides hope here, amid the frayed shawls that swathe him and the scrawny, impoverished arms in which they are held. Even so, his tiny fists, shrivelled and already old beyond his days, are clenched in a determined grip, his eyes intensely shut as he draws out every last drop of milk. The earth here is harsh and barren; dry, like the skin of the subjects.

The insertion of textual narrative as a contextualization of the images is an important development in the early editions of *Sahel: L'homme en détresse*, as opposed to the relative lack of textual information in *Other Americas*. At the most basic level, and in line with Mraz's critique of *Other Americas*, the inclusion of text provides a historical perspective for the viewer, who is then able to read the images in light of

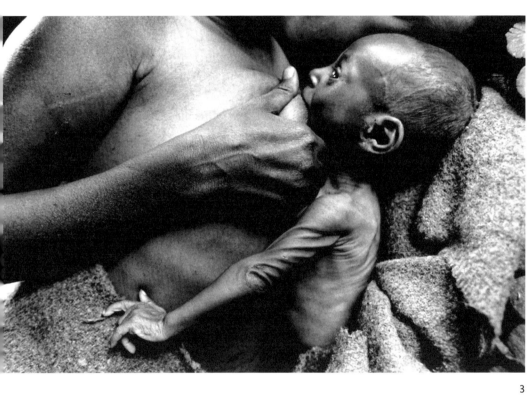

his or her own, more general knowledge of the context. By the same token, the viewing of these images within the framework of the textual narrative allows for new insights and perspectives to emerge from the photograph, thus enlarging the historical understandings that viewers possess. Mary Price argues that the language of description, be this in the form of a title, a caption, or a passage of text, deeply influences the way in which a photograph is viewed. The greater the textual details, she argues, the more directed the gaze.[15] Equally, it is possible to assert that the language of description can impose specific meanings on photographs and thereby limit their interpretative potential. This may be so, because captions and labels clearly ground the image in specific contexts. They help to foreground the sociocultural concerns that arise from the image, but in so doing, they curtail its imaginative potential.

If, as Roland Barthes has stated, "photography is an *uncertain* act,"[16] then language imposes on it an order and coherence; it constructs a context or frame for a unique event now reproduced, dislodged from time and space, and multiplied by the medium. The extent of contextual detail that Salgado has provided in the published collections of his work has increased steadily since *Sahel: L'homme en détresse*. From simple details relating to location and circumstance, he has moved on in his later volumes to providing brief histories of the people and places he photographs. As a result, the historical contextualization of his work has become very clearly defined, as has the ideological impetus to chart the complex and often obscure routes of global economics that drives him as a photodocumentarian. Over the years, Lélia Wanick Salgado has experimented with diverse forms of labelling images. The insertion of a slim booklet of captions into, for instance, *Migrations* allows the viewer to make the choice of referring to them or not while browsing through the photographs. Ultimately, the tension between aesthetic imagination and historical consciousness—a polemic that is always present in photodocumentary—is best witnessed in this unresolved struggle about where and how to caption an image.

Dignity and Dispossession

An Uncertain Grace, the first of Salgado's published collections that attest to the global reach of his ideological project, moves from Ethiopia to Latin America to Asia. This volume, which brings together diverse photographs taken between 1974 and 1989, establishes the central

focus of Salgado's lens: the disadvantaged, the dispossessed, the un-recognised on all the major continents. It also successfully combines the visual image with the printed word. Images belonging to Salgado's different photo-essays from the time he shifted to photography in 1974 to the end of the 1980s, such as those on the Sahel, on the end of manual labour, and on Latin America, are laid out in four main sections to construct a powerful narrative of human dignity and resilience in the midst of poverty. In its global span, the volume confirms the sociopolitical engagement that directs Salgado's vision.

The book itself is the result of collaboration with the Uruguayan writer Eduardo Galeano and the New York–based critic Fred Ritchin, who is also the director of Pixel Press. Galeano's participation in this project is particularly significant. His trilogy *Memory of Fire* rewrote the history of Latin America to much critical acclaim. In *Open Veins of Latin America*, which forms part of this trilogy, Galeano explores many themes that are extremely relevant to Salgado's work. In particular, he explores the ways in which the natural resources of Latin America, such as gold, silver, and sugarcane, have contributed to the wealth of Europe since colonial times. This ransacking of Latin America, what Galeano calls "five centuries of the pillage of a continent," has led to the decimation of indigenous peoples and ways of life.[17] It also opened up the vast slave trade to America, as ever more hands were brought in to bleed the earth of its resources. For example, the greed for sugar and yet more sugar, to be sold by the Portuguese in Lisbon to the Dutch, who would then refine it and sell it across Europe, led to the depletion of soil in Brazil's northeast, turning the region into what is still one of the poorest on the globe (fig. 4). Similarly, the flow of gold and silver from American soil into Europe—from Potosí, Huanchaca, and Minas Gerais to the markets of London via Spain and Portugal—led to the growth of industry, the burgeoning of banks and financial houses across Europe, and, in tandem with the steady impoverishment of Latin America, the rise of the European bourgeoisie.

An explicit and historically founded correlation thus emerges between the present wealth of the former imperial powers and the on-going poverty of the "third world." Salgado's photographs illustrate this point extremely well. In his focus on sugarcane plantations, cocoa growers, and miners through images that form an integral part of *An Uncertain Grace*, as of *Workers*, Salgado reveals the economic and political imbalances of colonial times as persisting in the face of twentieth-

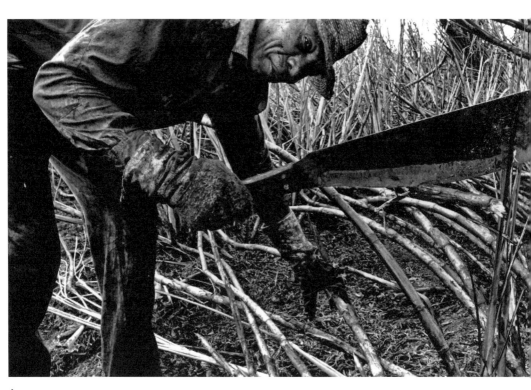

4

century decolonization. In his essay "Salgado, Seventeen Times," Galeano contemplates Salgado's images and chosen role as a photographer in seventeen brief prose meditations. Of the photographer and his work, he states: "This is stripped-down art. A naked language that speaks for the naked of the earth. Nothing superfluous in these images, miraculously free of rhetoric, demagogy, belligerence. . . . The profoundest sadness of the universe is expressed without offering consolation, with no sugar coating. In Portuguese, *salgado* means 'salty.'"[18]

To state that Salgado's work is without rhetoric is highly debatable. There is no doubt a noticeable, trademark rhetoric in all his work, namely a deliberate aesthetic that espouses beauty. Therefore, Galeano's statement is clearly open to contention. Yet it is interesting that he draws on the alignment between Salgado's surname and the idea of the "salt of the earth." Salt, abundant and free for the poor—as Mahatma Gandhi so forcefully proved in his march to the sea in 1930 in defiance of the imposition of a salt tax on Indians by British imperial powers—is the very antithesis of sugar, whose sweetness belies the salt-laden sweat of the unrecognised manual labourer on whose toil such sweetness is dependent.

While Galeano's own work in *Open Veins of Latin America* is largely historical, returning to earlier periods of colonization, it nevertheless raises important questions about global economics, poverty, and "development" in the present day. Galeano goes on in his trilogy to explore the legacy left by such a history of exploitation, despite decolonization. Many of these issues that Galeano deals with in *Memory of Fire* are directly relevant to how we view the subject matter of Salgado's work. Galeano's focus on the human cost of long centuries of economic and social subjugation raises questions around contemporary structures of power. Furthermore, the compulsion to write derives, like Salgado's compulsion to photograph, from an enduring preoccupation with historical, social, and economic issues. In words which could describe Salgado's own craft, Galeano states, "One writes to try and answer the questions that buzz in one's head, obstinate flies that disturb one's sleep, and what one writes can take on collective sense when it coincides in some way with the social necessity for a reply."[19] In similar vein, Salgado's imperative to photograph should be linked to his own exploration of a far-flung story of global economics and dispossession.

The Unseen Man

Following his years in the Sahel, Salgado's next major project, which spanned from 1986 to 1992, culminated in the publication of *Workers: An Archaeology of the Industrial Age.* By focusing on the end of large-scale manual labour, Salgado marks the growth of mass mechanization in the twentieth century, and with it the relegation of human labour to bygone, and less valued, modes of production. This collection of photographs pays tribute to the manual labourer, who struggles in diverse parts of the globe with natural resources such as sugarcane or the coffee bean in order to produce consumables. Through their depiction of muscle and sweat, of the fellowship of workers, and, most of all, of the rough encounter of the human hand with the raw materials of this earth, these images aim both to affirm the indomitable spirit of human labour and to mark the irrevocable phasing out by technology of traditional methods of production. Equally, they highlight the miracle of mankind that survives in the face of extreme adversity.

Industrialization, a process fuelled by the desire to foment the growth of capital and which acts as a stepping stone to globalization, disrupts man's relation to land, scattering history, community, and tradition in the name of rapid economic evolution. The result is an altered relation between man and his environment, as the individual becomes alienated from land, locality, and community. To quote Salgado, from his introduction to the volume: "These photographs tell the story of an era. The images offer a visual archaeology of a time that history knows as the Industrial Revolution, a time when men and women at work with their hands provided the central axis of the world."[20]

The carefully edited sequence of images in *Workers* constructs a deliberate narrative outlining man's shift away from nature and toward the globalized products of mechanization that symbolize modernity. The volume consists of six parts, moving from the painstaking engagement of the human hand with nature that yields sugar, tea, tobacco, and cocoa to, in the final part, the construction of dams and tunnels. In this shift toward industrialization, mechanization and technology increasingly dwarf the humanity of the worker, who nevertheless is instrumental in triggering the connections made possible by such modern modes of production. Salgado explains, "I worked in forty-two different places of work in many different sectors of the production process, like agriculture, light industry, heavy industry, and miners. Each year I

spent at least eight months in the places of work, living with the people, some for months, some for weeks. I have a very good idea about what the world of production is today. I understand how modern the world is today, how the means of production are linked."[21] Thus, the viewer moves from images of shipyards in Poland and France to those of ship-breaking in Bangladesh, where the steel is broken down for reuse. In the course of its travels, the steel will have passed through numerous, unseen, and unnamed hands, hands that have moulded and shaped the metal in order to determine its uses.

Interestingly, this connectivity that Salgado points to carries with it echoes of similar statements made by another Brazilian, a social anthropologist who wrote extensively on sugarcane and its production, Gilberto Freyre. In his work, Freyre repeatedly stresses that sugar was at once quintessential of Brazil—a country, he states, of cane and forest—and also an element that forged links across continents and palates.[22] If sugar was part and parcel of the colonial enterprise, then Salgado reminds viewers that the earth's resources, especially metals, such as gold or iron ore, also provide the basis of the products that form the hall-marks of industrialized societies: motorcycles, planes, cars, and ships. What is more, it is the human hand that has painstakingly clawed these metals from the earth, most often in dangerous and degrading conditions of work. And it is the worker who supports, through his invisibility and through sheer mettle, the production processes of the modern, industrialized world.

Workers is Salgado's first major photo-essay that spans the continents. In its depictions of a global workforce, it sets man against two interconnected backdrops: nature and industry. The material products of labour, extracted from nature and manufactured by industry, pass through the hands of the labourer, who is implicated in this impersonal process. The early images focus on the production of key consumer goods, such as sugarcane and tobacco. The workers in Cuba, Brazil, and Africa are racially and economically different from the consumers, who, one must presume, are none other than us, the viewers of these images. The silhouette of the sugarcane worker hacking the cane goes back many centuries, to the times of colonial enterprise and slavery, and it is an image iconic of Brazil's colonial harnessing to Portugal. Salgado's photographs invite an envisioning of this history, especially the obscured history of slaves trafficked from Africa to work on plantations. Despite abolition and the end of apartheid, one glimpses the ways in which modern-day

capitalism enacts in contemporary contexts the violence and the extractions set in place in earlier times. While Brazil has its own specific history, the realities of labour exploitation, prevalent at the bottom rungs of capitalist enterprise, are manifest in—and exemplary of—the global south.

From a visual perspective, Salgado's global images framing the under-recognised worker extend a long photographic tradition in Brazil. Central to such images from previous centuries are the representation of race, deprived social classes, and displaced peoples, as well as the exploitative relationship between man and land. As George Ermakoff points out, slavery and its abolition are central aspects of the history of Brazil. The nineteenth century was a key period for the nation owing to the new independence of Brazil from Portuguese colonization. The contribution of slave labour to the economy of Brazil had been significant, but in the course of this century, slavery was abolished. This was also a period of modernization, as the nation-state came into being. The history of photography in Brazil reveals the central role played by images of slaves in forging a visual archive of the emerging nation.[23]

Through these images, we can retrace the traffic of slaves, the harshness of their daily lives, the movement for abolition, and the ways in which foreign photographers honed in on slaves as a means of constructing an exoticized vision of Brazil. It is interesting to note that Europeans, and the French in particular, played an important role in introducing photography to Brazil. They also did much to frame the ways in which Brazil was visually perceived elsewhere, through a visual language of race and ethnicity. Boris Kossoy and Maria Luiza Tucci Carneiro have analysed the role of photographs of slaves taken by Europeans during the nineteenth century in constructing visual alterity in Brazil. According to them, typologies and categories of race were established by these images. The construction of an iconography of slavery was closely linked to the development of an ideology of race. From the hegemonic European perspective, slaves both were the labour force of Brazil, and so occupied the lowest rungs of the social ladder, and also confirmed the otherness of Brazil to Europe. The visibility of racial difference also turned Brazil into the exotic. Photography became very clearly a means of constructing this alterity. Images from this period document the lives of slaves in a variety of contexts—in the field, in urban settings, and as the subjects of portraiture. Physiological traits and the body of the slave worker from Africa formed the preoccupation

of these photographers.[24] The contours of the nation were imagined photographically in terms of the bodily and racial contours of the subjects. In their reiterated construction of alterity, the photographs confirm the ethnocentricity of the European photographers. The images, though, also reveal and suggest the lives of the slaves, thereby framing their otherwise unknown histories and offering glimpses into their realities and their struggles. What additionally emerges from these images is the relation of the slaves to the empowered classes, whereby we see the intricate interrelation between social and racial groups that were supposedly distinct. It is curious to note that these photographs from the nineteenth century typify slaves, but also offer an aesthetic and ethical space within which we, as viewers, can come to engage with their histories. The result is that these images have a contradictory effect, at once framing alterity and also enabling the viewer to engage with the subject who is other. The black and white palette (the sole medium possible at the time) makes a specific impact on the viewer, as does the gaze of the subject back to the viewer. These are all significant tropes in Salgado's work as well.

It is impossible to represent slavery without also representing the relation of man to man and man to land—both of extraction—and also of man to production. This iconography, of specific relevance to Brazilian visual history, must be taken into account when considering Salgado's work. His images call on, extend, and update this visual mapping of empire. They take it across the globe, revealing the alterity imposed on peoples and places by the ideology of capital and by modern, industrialized, and technologically dominated practices of capital expansion. These are repeated preoccupations that emerge in Salgado's work, but *Workers* is no doubt the first of his major photo-essays to dwell on them. In its course, *Workers* spans the continents of America, Africa, Asia, and Europe, making it an impressively global photo-essay. A transnational and transcontinental connectivity emerges from these images, wrought through steel and raw materials, linking the often-unseen worker with the all too conspicuous consumer (typically one who views these images in the comfort of a middle-class environment) in the complex chains of capitalist enterprise. *Workers* can indeed be viewed as a visual ode to the unrecognised labourer.

Best known among the images included in this volume are Salgado's arresting perspectives of Brazilian mineworkers. In 1986, Salgado photographed miners working in the Serra Pelada gold mines of Brazil.

The photographs, now well known to many and viewed as emblematic of Salgado's specific focus on underprivileged subjects, span several pages in the book, confronting the viewer with a landscape of struggle that is both majestic and terrifying. The steep, rugged mountain, so much mightier than man, both absorbs and seemingly rejects the nameless mass of humanity that stakes its lives on its flank. Innumerable men, rendered alike by a shared abject poverty, become almost indistinguishable from the mud that covers their bodies: human reduced to mere usage, without value, without name or distinction, engulfed by this larger thirst for a gold that is buried in dank slime. Who, the question arises by extension, seeing the glint of polished gold in a jeweller's shop window in the metropolises of the West, buying perhaps a wedding ring or a special gift for a loved one, would think back to that disturbing juncture of place and time when the precious metal was sourced? In Salgado's photographs, the workers employed in the mining of gold eke their way upward along the mountainside and into the earth, like ants crawling on a hillside. The mountain, whose summit we never see, itself becomes metaphoric of the larger scheme of capitalist exploitation within which these men are caught and against which they struggle. The ripped shirts, the caked faces, and the treacherous, wet mud against which the men must climb underline the harshness of human labour exploitation, if not degradation, which supports mining and other industries of the capitalist age.

Emerging forcefully from the images in *Workers* is the heroism of the labourer. In this sense, many of the images, in particular those of the miners of the Serra Pelada, can be said to have a Marxist slant in proffering an eulogy of the manual worker. In this, they recall Salgado's links with Marxist groups when still a student in Brazil. Certainly, *Workers* aims to redress an imbalance, bringing the unseen and often unrecognised worker to light. For Salgado, photography became a life project following his numerous trips undertaken as an economist to African coffee plantations. It is thus noteworthy that in this project, his camera journeys in the opposite direction of the coffee bean: his gaze rests not on the free markets of the West, but on the backbreaking work of impoverished and ill-paid peasants, not on the profitable coffee houses of consumer society, but on the parched earth of the world's forgotten regions. Yet, his images also beautify struggle, turning the disempowered into the silent heroes and heroines of an eminently interconnected planet. What emerges is a disturbing, if undeniable, global connectivity,

reliant on capitalist enterprise and thriving on the economic disjuncture of nations and peoples.

To return to Octavio Paz, the Mexican intellectual who wrote so succinctly against the objectification of human individuality, his remarks on the worker are of particular relevance: "Capitalism deprives him of his human nature by reducing him to an element in the work process, i.e., to an object. And like any object in the business world, he can be bought and sold. . . . Actually he is not a worker at all, because he does not create individual works or is so occupied with one aspect of production that he is not conscious of those he does create. He is a labourer, which is an abstract noun designating a mere function rather than a specific job."[25] It is this abstraction that *Workers* seeks to remove. The photographs frame and so establish the myriad daily miracles of production and distribution that workers around the globe make possible. What *Workers* foregrounds is not any late modern irrelevance of the labour force, but in fact, the overshadowing of workers by technology, whereby, the machine dwarfs the man though its superior efficiency and speed in transforming raw material.

Through a focus on workers as they are overshadowed by machines—which increasingly trigger, control, and direct the mechanisms of production so that the former remain ever more unseen in the multiplying, global web of economic and technological innovations—the images frame the obscured humanity of this age of late capitalism. Implicit here is a contrast between the deprivations of workers and the wealth that their toil makes possible. Thus, Salgado exposes the treacherous underbelly of Western affluence, which is reliant on the unrecognised labour of those on its peripheries. As Eduardo Galeano states of Latin America and her dispossession, "In these lands, we are not experiencing the primitive infancy of capitalism, but its vicious senility. Underdevelopment isn't a stage of development, but its consequence. Latin America's underdevelopment arises from external development, and continues to feed it. A system made impotent by its function of international servitude, and moribund since birth, has feet of clay. . . . The system has its paradigm in the immutable society of ants. For that reason it accords ill with the history of humankind, because that is always changing."[26] Those who accept the aesthetic in Salgado's images will be able to relate them to this point of view on colonization in Latin America. Few images depict a society of "human" ants as well as the series taken in the Serra Pelada.

Certainly, much of Salgado's work is about uncovering connections. *Looking Back at You*, a video documentary of Salgado's work produced by the BBC, which includes extensive interviews with him and his wife, elaborates on many of the images in *Workers*. Here, Salgado connects the steel factories that he glimpsed in the Brazil of his childhood to the numerous steel objects that abound in our every day: penknives, forks, ships. He links the objects of production to their sources, in the blazing furnaces where factory workers toil by day and night. He highlights the chain of production, and contemplates the passage of the product through countless, nameless, and unacknowledged hands till it reaches those of the consumer. He expresses the wonder he felt as a child in discovering this vast and almost magical global connectivity of natural and human resources forged by the hand of the worker and transformed via technology. In watching this video, an implicit juxtaposition arises between the images of the impoverished worker who harvests the cocoa bean but seldom tastes its delights and his Western viewer, for whom chocolate is in plentiful supply.

This global vision, which is the hallmark of Salgado's work, is crucially informed by his training as an economist. Globalization, a complex process of human subjugation to the game of profit, whereby capitalism extends its grip over the uneven economic geographies of the planet, functions as the horizon against which Salgado's subjects are located. As such, it is important to consider his subjects not in isolation but as the diverse and interrelated faces of a jagged history of late capitalism.

By the same token, Salgado achieves this global perspective by specifically directing his lens at human and natural resources. His lens serves to distinguish the uniqueness and individuality of mankind and nature in a bid to resist the totalizing sweep of industrialization and globalization. Man's relation with nature in the era of late modernity, complicated by the violence of capitalism with all the ensuing economic, political, and cultural implications, forms the driving force behind his work. In *Workers*, the products that facilitate the easy lifestyles of the West are seen in the light of a disrupted relation between workers and the land. Indeed, when considering the gamut of Salgado's photography, what emerges is an overarching narrative of man's displacement from land by the forces of globalization. As Ellen Tolmie, photography editor for UNICEF, has suggested, man's relation to land is a central, indeed fundamental, concern of Salgado.[27] It forms the basis of the global

panorama he pursues through his work and presents his subjects as driven by a forced mobility that exceeds their control.

A Place on Earth

This same disrupted relation to land underlies *Terra*, an important collection of photographs published in 1997 and exhibited worldwide. *Terra*'s stated aim is to pay homage to the struggle of the landless, but it can also be seen as part of a continuum with the rest of Salgado's photo-essays. The narrative of dispossession affecting indigenous peasants in *Other Americas* slips seamlessly into that of the poorly acknowledged toil of the labourer in *Workers*, and on to that of the Movimento Sem Terra's struggle to secure land for the landless in Brazil in *Terra*, which subsequently leads to that of migration to cities that later appears as part of *Migrations*. Thus, the key concerns that have arisen in Salgado's photographic collections to date, those of man's alienation from community and land and of the shift from manual labour to industrialization, as well as of the effects of capitalism on its disenfranchised subjects, acquire a distinct, political overtone in this volume through the deliberate inclusion of images of the fight for the most basic of human rights: the simple but vital right to land. *Terra* is undoubtedly the most explicitly political of Salgado's photo-essays. It also confirms his own identification as a Brazilian with the cause of the Movimento Sem Terra (MST), or Landless Workers' Movement, making it the most directly personal of his photo-essays, as his presence alongside the landless was as much to participate in and visually reinforce their struggle as to testify to it. As the photographs of the aftermath of massacre in Eldorado dos Carajás testify, Salgado was present with landless activists at this key moment in the history of the MST. The book *Terra* was conceived of and designed by Lélia Wanick Salgado, and the captions at the end offer substantial contextual information on the images. The carefully chosen photographs all centre on Brazil. As a result, *Terra* is at once the most Brazilian of Salgado's photo-essays and the most universal, since it deals, as the title suggests, with the central issue of man's relation to land.

Above all, *Terra* confirms Salgado's solidarity with the cause of the MST, a hugely supported rural movement by landless workers to claim land in a vast country where 3 percent of the population own over two-thirds of arable land.[28] As the MST celebrated its twentieth anniversary

in 2004, the photographs of *Terra* helped to remind the world of an ongoing opposition staged by workers to lingering feudal practices of land ownership and to capitalist profiteering.[29] In 2006, I interviewed Geraldo Fontes, a Mexican resident of Brazil who looks after international relations at the MST head office in São Paolo (itself a building that was apparently bought by Salgado for the MST). He described to me how Salgado's *Terra* project had afforded visibility to the MST in an unprecedented way at both national and international levels.[30] Given Salgado's established international stature as a photodocumentarian, this collection of images had acted as a bridge between landless people and the global geopolitical north. Friends of the MST had organized themselves and there were now groups dispersed in various northern locations, such as New York, Berkeley, and Norway. These groups work to create awareness of the MST's aims and projects and to collect funds. This international endeavour had, Fontes stated, only become possible as a result of the widespread dissemination of the *Terra* photographs. Furthermore, revenue from *Terra*, in terms of book sales and exhibitions, has been allocated by the Salgados to fund the Escola Nacional Florestan Fernandes, the MST training centre where leadership in the movement is trained, thus making it the ideological and political heart of the MST.

Released just three years after President Fernando Enrique Cardoso came to power in Brazil in 1994, bringing with him a new economic model of globalization and neoliberal capitalist development, *Terra* bears witness to a unique resistance from the poorest of the poor who became the direct victims of a crisis in agriculture. The massive privatizations of the Cardoso era of key industries, such as mining, telecommunications, and energy, together with the liberalization of capital flows severely undermined local producers and industrial workers. As James Petras and Henry Veltmeyer point out, Brazil became, quite simply, a land for sale.[31] The most effective opposition to such policies and practices came, surprisingly, from the MST. For over a decade prior to Cardoso's taking of office, the MST had been successfully involved in land occupation.[32] In tandem with the rising neoliberal reforms that were commonplace in Brazil and elsewhere in Latin America in the early 1990s, the MST sought resistance through implementing its motto of "Occupy, Resist, and Produce." A turning point occurred in 1996, while Cardoso was in office, when the movement accelerated its offensive with a record number of land occupations and a large-scale demon-

stration in Brasília, the "March against Neoliberalism," in which some 100,000 people took part. This same year, the Cardoso regime committed its notorious massacre of peasants as they attempted to occupy land in Eldorado dos Carajás in Pará. Nor was this massacre the last: during Cardoso's time in office, the regime assassinated some two hundred peasants. In the past decade, some one thousand peasants have lost their lives in this struggle for land.[33] Despite these losses, what sustains the MST in its struggle against landlessness is a fervent, quasi-religious, indeed almost mystical, belief in the project.

Salgado's photographs, in *Terra* and elsewhere, have often been linked to religious iconography. There are biblical overtones in many of his images, but Salgado himself seldom, if ever, refers to religion as such. Nevertheless, and as is apparent in the MST, the importance of faith among the dispossessed in Latin America is substantial. At the heart of the MST is a fervour for reform that is political, but this is a distinctly Latin American breed of politics that is inseparable, in many ways, from religious belief. Without a doubt, the MST receives much support from those involved in liberation theology, a branch of Catholicism that aims specifically to serve the spiritual and political needs of the dispossessed. Liberation theology, a grassroots movement to bring the church closer to the concerns of the lay person, came to the fore in Latin America and later took root in other parts of the world, especially the third world, where Catholicism prevailed alongside poverty and a heightened social awareness. Liberation theology questions the hierarchical, and colonial, structures of the Catholic Church with regard to their relation to indigenous peoples and to those who have historically been subjugated by imperial powers. It is a theology that has a particular relevance to many in the global south; while it is most prevalent in Latin America, it also has had an impact in India and in Africa. Gustavo Gutiérrez, author of a seminal text on liberation theology, states that its aim is to bring together the spiritual and the rational, so that religious practice becomes a mode of reflecting on questions of praxis in a wider sense.[34] While this is, in theory, true of Christianity in general, it nevertheless acquires new, political significance in the light of colonial histories that denied its subjects the right to collective and individual reflection and questioning. This is an interesting combination, especially in the context of photography. As a medium, the still photograph combines the document with the aesthetic, so that the rational and the sentient, or affective, entwine. While sentience and spirituality are not

the same, they both call on the nonrational. It would appear, therefore, that photography, especially of the kind that Salgado creates, is an apt medium for reflecting the premises of the liberation theologists. In photography, the interplay of rationality with sentience leads, as we shall see, to re-visioning knowledge, history, and politics.

Of obvious relevance to his alliance with the MST is Salgado's involvement with politics when he was a student in Brazil, an involvement that led to his subsequent decade of exile in London and Paris. Clearly, his Marxist leanings brought him close to the liberation theologists, who work to bring the church in line with the poor. Furthermore, both the MST and liberation theologists, who shared a common vision of a new Brazil, free of dictatorship and oppression, were inspired by their cause in a way not so removed from religious inspiration. Not surprisingly, the visionary statements of the MST are known as *la mística*, a mystic vision.

The MST state that the following are its aims: to construct a society where work has supremacy over capital; to pursue policies whereby land is for all, at the service of society; to guarantee work for all and a just distribution of land and its riches; to seek equality and social justice that is economic, political, social, and cultural; to foment and disseminate humanistic and socialist values; to fight against social discrimination; and to seek equal opportunities for women. The movement brings together church organizations (such as the Commissão Pastoral da Terra), human rights groups, trade unions, legal experts, parliamentary parties, and local officials. Numerous artists and intellectuals, such as Salgado himself, have espoused the cause. The MST's primary action consists of peasants organizing an invasion and occupation of land by large numbers of families in a synchronized and strategic way. To date, tens of thousands of peasants have been involved in hundreds of land seizures. The fight, however, is hardly over. In a BBC Radio 4 programme on August 13, 2003, the reporter Linda Pressly stated, "At an outdoor mass in the western corner of the state of São Paulo, offerings are made to the priest. There are baskets of fruit, bowls of beans and old, well-used farming implements. And there are flip-flops. Five pairs symbolise the long road people must walk before they get their own land. The MST has been fighting for agrarian reform for nearly two decades. The roots of the inequalities in Brazil's land tenure system go back five centuries to Portuguese rule."[35]

Despite his supposed socialist leanings and despite promises of sup-

port prior to his election, it is clear that Brazil's recent president, Luiz Inácio Lula da Silva, was resistant to the cause of the MST. The reason, no doubt, is that to support its mission would entail putting Brazil's valuable export dollars at risk. For it is clear that the MST's aim is not to merely occupy land: rather, such occupation carries with it a set of objectives that would "democratize" Brazilian society by, in fact, democratizing access to capital. The settlements established by the MST in the lands that its members have occupied function as collectives. Over sixty food cooperatives have been created, as well as small-scale agricultural industries. Furthermore, the MST stresses the importance of good health and seeks to instill positive health awareness and practices among its members. By the same token, they are involved in literacy programmes in a bid to bring education and access to knowledge to their members and their children. In Terra Prometida, a small settlement outside Rio that I visited, nine adults were taking literacy classes alongside the classes held for children. The commitment to improve the condition of women has led to the establishment of reliable childcare facilities in settlements, thus releasing women from the home and enabling them to work in the field.

In contrast to the capitalist model of making money in order to make yet more money, the MST aims for a well-being and self-sufficiency that is envisioned in communal and holistic terms. In the radical proposition of its call for a society of equality, the MST challenges the profit-based status quo of Brazil's political economy and the nation's dependence on the World Bank, the International Monetary Fund, and other global capital networks. Clearly, and in total contradiction to his early election promise of solidarity with those subsisting below the bread line, Lula da Silva was unwilling to risk the wrath of a powerful few to back a radical transformation in the production and power structures of his country. Such a move would topple the existing oligarchy in a sprawling nation where 60 percent of the farmland lies idle and 25 million peasants live in terms of economic and social impermanence on casual day labour.[36] The truth is that the dynamic presence of the MST in Brazil not only puts to the test the professed socialism of Brazil's current government but also confirms that, at a time of mostly unchallenged global capitalism, a revolution based around social class is incipient in Brazil. Nevertheless, the MST must work within what is possible and settle for small victories and long struggles.

During my visit to the MST settlement of Terra Prometida in summer

2006, I was told by Alberto and Amadeu, two members of this settlement, that despite disillusionment with the Lula government, they would in fact be voting for Lula in the forthcoming elections, but only for want of a better alternative.[37] In considering the plight of those suffering under the overriding global dominance of capitalism since the fall of the Berlin Wall in 1989, my mind turns to Karl Marx's famous call for an overturning of the bourgeoisie by the forces of the proletariat, issued in *The Communist Manifesto* (1848). Unfortunately, such a revolution is being undertaken only by the most disadvantaged, with incidences of violence occurring when their lives fall under threat from state-commissioned and other aggressors. It is not at all uncommon for landholders to employ armed guards, often local mafia, to "protect" their idle lands from occupation by displaced peasants. Thus, in the day to day, the violence of large-scale economic inequalities translates into a violence affecting the most vulnerable. What ensues is an ongoing struggle for the most basic freedoms. The Brazilian poet and literary critic Haroldo de Campos states:

> Nowadays, independently of colour and of racial origin, a great mass of Brazilians, reduced to misery, are struggling for a true AGRARIAN REFORM against owners of great, uncultivated *latifundia*, a minority of very rich people that despises the fate of that miserable stratum of the Brazilian population. This struggle, in my opinion, corresponds to a struggle for freedom and a conquest of citizenship and ought to be supported by politically aware Brazilian intellectuals, as was the case with the campaign for abolitionism and against slavery of our Romantic era supported by such as Luís Gama (poet, journalist, and ex-slave) or Castro Alves (poet and author of the celebrated anti-slavery poem "African Voices" of 1868).[38]

The question of citizenship—or social recognition that is at once economic, legal, political, and cultural—that Campos raises here, is central to the MST's social project.

In a country of vast landholdings controlled by a powerful but small minority, democratic notions of citizenship and social justice are not easily put into practice. The MST proposes revolution and renewal—at the most fundamental level, by heralding a new man and woman, refigured in terms of the collective or popular. As such, it is a grassroots movement that opposes the long-standing feudal tradition of *latifundios*, or large landholdings. The movement currently presents the most

radical opposition to Brazil's neoliberal project. Its presence raises the question, perplexing to those convinced that the peasantry is a vanishing class, of how a peasant organization could challenge the appeal and supposed benefits of free-market capitalism (fig. 5).

Many of those who visited the scores of *Terra* exhibitions held worldwide were learning for the first time of this ongoing revolution, at a time in our history of late capitalism when the potential for revolution is seemingly dead. An exception to the general lack of media attention to the plight of the landless was the extended coverage that the *New York Times* gave to *Terra*, with the inclusion of a website.[39] As indicated in the Forum section of this website, a key debate that arose around *Terra* concerned questions of objectivity and engagement in photojournalism. Without a certain neutrality in the photographer's point of view, could photojournalism be accurately labeled as such? Views differed: some believed that committed journalism, be it visual or textual, clouded the message; others believed that the journalist always has a point of view, which inevitably frames her or his perspective; still others sought out the work of journalists with specific political agendas, in a bid to access information that would otherwise not be accessible. As Graham Clarke states in his book *The Photograph*, documentary photography is invested with the expectations of objectivity.[40] Yet, the force of its impact often depends greatly on the photographer's ability to inject ethical or political relevance. Given that photojournalism is essentially about a story, the photographer will inevitably construct a visual account of a subject in terms of his or her point of view. Moreover, documentary photography seeks to bring to the viewer histories that would otherwise not be available; hence, the importance of the photograph as *document*—that is, as that which lends veracity to a lived event.

With regard to *Terra*, as to all of Salgado's work, it may be worth bearing in mind that each journalist tells a story that is ultimately his or her own, and told to a specific public. In Salgado's case, the story of *Terra*, one which he takes care to stress is by no means specific to Brazil alone, since peasant movements toward social justice are currently taking place across the globe (although the MST does provide an impressive example of such organizations), has a global relevance that exceeds the particular. The story of Brazil's peasants is not so different from that of peasants in other parts of the world, particularly in the global south, peasants whose lands have historically been appropriated by a deadly

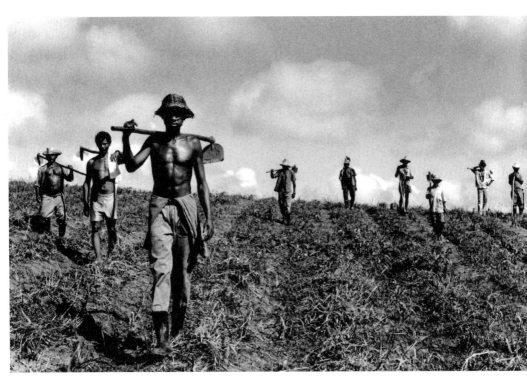

5

combination of entrenched feudal practices and encroaching colonial powers. Furthermore, in an era of increasing numbers of refugees, migrants, and displaced peoples, *land*, like *home*, has become a poignant and powerful term, tainted by the despair of loss and spurred by the simple dream of a place on earth.

Terra, through its inclusion of photographs from Salgado's photo-essays on America and workers, carefully constructs a narrative that historically represents the situation of Latin American peasants. The photographs have been organized into five main parts. The first part, which establishes the connections between the people and the land, leads into an exploration, in the second part, of the peasants' struggle against the enormity of nature and of their extensive engagement with the riches of the land: sugarcane, cocoa, gold, cotton, and the farming of cattle. Across the pages, Brazil expands before our eyes in its infinite stretches, the vastness and diversity of the land proclaiming riches that few can enjoy. Salgado captures fleeting moments in the lives of peasants—an expression, a gesture, a moment of rest. In so doing, his lens carries viewers to the day-to-day realities of these impoverished people, as we see into their homes and look into their lined faces. We wonder at a family of eleven, the parents still in their thirties, no doubt, the children focused and ordered before the camera. We see the simplicity of the worn utensils with which they cook their food, the sparseness of their possessions. We see two little boys, toddlers still and naked, but already companions holding hands against all odds, and we feel shaken by the shocking contrast between their young faces full of light and the cracked, broken skin of their bare feet. We contemplate in consternation a small group of children, who play intently with the sole toys at their disposal, the bones of dead animals, and we see, in their imaginative act of renewal, death transformed into the wondrous play of life.

This third part of *Terra* thus explores the resilience of the poor, for whom death, including infant mortality, is part of life. A key factor of Latin American society is represented in the fourth part: migration to the cities driven by inhospitable socioeconomic conditions in the rural areas, better known among the experts as the push-and-pull factor, which determines demographic patterns in Latin America. These images reveal the harsh conditions of migrancy that peasants endure, as well as the struggle to survive in overcrowded and ill-prepared cities, such as São Paulo. As in cities throughout the developing world, slum

dwellers live in insalubrious and overcrowded conditions, unsupported by urban policymakers, who deal ineffectively with the social and sanitary problems of such migration.[41] As Salgado informs us in the caption to one of his photographs, "With over sixteen million inhabitants, Greater São Paulo, one of the largest urban centers in the world, continues to exercise an untrammeled attraction for the growing waves of emigrants from the interior of the country."[42] This caption further offers important contextual information for interpreting the sequence of images: the latifundios, we are told, only represent 12 percent of Brazil's gross domestic product, thus contributing very little to national income. Given the vastness of Brazil's rural lands, this poor level of productivity further supports the case of the MST, especially if this fact is considered alongside the twelve million or so landless workers who drift across these stretches in search of land to call their own.

The visual narrative of *Terra*'s first three sections thus effectively sets the scene for the most important section of the volume, the photographs of the MST in action. The captions to this section are preceded by a brief account of the hardship of living conditions for peasants. The photographs that follow offer a clear perspective of the MST at work. Peasants are shown being prepared for occupation by the national leadership of the MST, organizing their initiatives, and teaching their children in a makeshift school in encampments set up on vast latifundios, some as vast as the Giacometi plantation of 205,090 acres.[43] The most poignant of these images are those that represent the massacre of Eldorado dos Carajás, where Salgado photographed the funeral of the nineteen massacred peasants. The photographs are weighted with emotion, as we see the grieving mother of a seventeen-year-old boy who lost his life when he was handcuffed and shot in the head, as well as a large throng of mourners keeping a wake over the dead. The occupation of the Giacometi plantation, like many other occupations, occurs in the half-light of dawn. It is the presence en masse of the landless that makes such occupations possible, their strength clearly lying in their solidarity and in the commonality of their needs. A young couple sits together in the chaos of the occupation, he smoking a cigarette, she breastfeeding their child. Their faces show exhaustion and apprehension. The occupation, they know, is only the first step in the lengthy legal process to rights and recognition. There is a long and uncertain road between the occupation of land and the granting of the right to remain there. Nevertheless, both in these images and in my memories of my visit to Terra

Prometida, occupied but still the subject of legal proceedings, there emerges a sense of hope, of purpose. The images of the settlements of Conquista na Fronteira and of Santa Maria reveal scenes of pastoral well-being. The occupants have formed cooperatives and engage in the production of agricultural produce. The homes are neat, pleasant, and, it would seem, content. These peasants appear to have overcome the uncertainty of landlessness and the insecurity of the dusty road. The outlying rural locations of these settlements, together with the need to supply food by farming and keeping chickens and goats, means that the residents live in close contact with the land and with nature. Salgado's images do more than urge the redistrubution of land: they also suggest a *different* relation of man to land, one of nurture and not exploitation. This harmony with the environment is important in light of Salgado's current project, *Genesis*.

Terra in its published version bears a preface by the Nobel prize–winning Portuguese writer José Saramago, himself of peasant origins. In it, he emphasizes his support for the struggle of the landless. Saramago writes of the massacre of Eldorado dos Carajás, which Salgado has documented, "The protesters' arsenal consisted of three pistols, rocks and farm implements. . . . We are all too well aware that long before firearms were invented, rocks, scythes and harpoons were considered illegal in the hands of those who, obliged by necessity to demand bread to eat and land to till, found themselves facing the military police of their time, who were armed with swords, lances and halberds."[44] Saramago frames the account of this massacre within a narrative of the dispossessed, in which a God, all too reminiscent of the affluent and unthinking rulers of so many third-world nations, acknowledges the arrogance and errors of divine foresight that have left masses of humanity in dispossession. Most importantly, Saramago underlines a point that is doubtless central to Salgado's representations of the poor: it is not charity or pity that they need, but recognition and justice. The dispossession of the poor arises not because they are victims per se, but because civil society and the nation-state have failed them. The blame lies, therefore, with those in positions of power who have abused their authority to act in the name of law or justice.

I argue that *Terra*, and the rest of Salgado's work, must be viewed in these terms. These photographs do not call for charity, for charity is an all too easy method of calming a troubled conscience. To quote Saramago, "Charity, what a pretty name."[45] They aim, in fact, to construct a

framework for recognizing the disenfranchised, a necessary precursor to the redistribution of wealth and power across the uneven and jagged socioeconomic terrain of this globe. If *Terra* is a collection of photographs on land redistribution, then these images are also, very importantly, about recognition, for only the latter makes the former possible. This relation between recognition and redistribution is, in my view, central to understanding the impetus behind all of Salgado's work and will be explored more fully later in this book. The photograph must act as a tool for recognition and offer a frame for regard.

The songs of Chico Buarque that focus on landlessness and the exhibition of *Terra* also issue this call for recognition.[46] This hugely popular singer-songwriter from Brazil has repeatedly expressed in his songs and media interviews his belief that the escalating social inequalities of Brazil cannot continue without erupting into violence and bloodshed. *Terra* in all its aspects also opens up many questions on the representation of otherness. The images, such as one of a dawn raid led by a man with his sickle held high in the air, have become iconic of revolution. Yet, they circulate in an increasingly neoliberal world where revolution is largely confined to ideal and removed from practice. As such, it could be argued that these images, like Buarque's songs, aid the confinement and limitation of the revolutionary impulse, rather than fomenting it, by providing the veneer of revolution while also promoting the career of the artist. To what extent, for example, do Buarque's moving lyrics actually aid or improve the lot of the landless? To what extent do they idealize or glorify dispossession? Even more worryingly, to what extent are documentarians such as Salgado, whose work also has art value, enhancing their own profiles through their focus on the dispossessed? To what extent are they acting as self-appointed and high-profile ambassadors for this cause?

Geraldo Fontes of the MST was quick to dismiss my questions. "This is certainly not opportunism on Salgado's part," he stated, "Far from it. This is sensitivity on his part." Fontes went on to argue that there was a sincere coincidence between Salgado's interests and those of the MST: land, he stated, was a central concern in both cases. Furthermore, Salgado's focus on man's relation to land had been established from his very early work and indeed had extended beyond *Terra*, as is evident from his current project, *Genesis*. Most importantly, what Salgado had done, Fontes said, was to lift the veil of darkness that had relegated the landless of Brazil, and possibly elsewhere in the world, to invisibility

for so long. In so doing, he had exposed practices and realities that were not only specific to Brazil, but to much of Latin America and other parts of the world.[47]

In problematizing as they do issues such as recognition, justice, and redistribution, which are at their most crucial where land is concerned, intellectuals and artists like Salgado and Buarque also highlight the complex configuration of each of these issues in postcolonial contexts. Land, as essential to human survival and well-being as air, is commodified as property, to be apportioned and fenced off as a measure of power. Looked at in light of the precarious situation of the landless, the commodification of land is a prime example of capitalist alienation at its extreme. At once absurd and unspeakably cruel, to deprive people of land is to deny them a place by which to orient their lives. As such, land provides key means to control. The Latin American history of European domination leads to long-standing traditions of property ownership that favour those who have carried on the juridical and political legacies of colonialism, which were set up in the first place to aid and abet the project of European expansion. A clash ensues between such legalistic perceptions of land ownership and more traditional, peasant relations to land, which have been determined by ancestry, community, and, in many cases, notions of the sacred. Nowhere is this conflict more acute than in Latin America, where the feudal practices of European land ownership broke and reshaped preexisting indigenous relations to land. Following decolonization, many of those who benefited from these colonial practices of jurisdiction, and indeed many of those who currently control the economic and political directions of these postcolonial nations (many Latin American landlords hold political positions and control industry in more urban areas), continue to exert a fearsome grip on local peasants and agricultural practices. The persistence of such discourses and practices of authority impacts directly on the peasant, who within this national system becomes the most disadvantaged postcolonial subject.[48]

Not surprisingly, and as Salgado himself has stated in the interviews I had with him, over a million peasants take to the road every year in a bid to find stability and security. Landlessness, then, is a central feature of our times, one that has arisen in many postcolonial contexts across five continents, the troubling result of histories of colonial appropriation combined with the mounting global dominance of a profit-centred system of capitalist expansion. Its effects are most keenly felt

by peasant communities, thus forced into landlessness and turned into migrants.[49] Some would say that to photograph the landless, as Salgado has done, is an act of recognition toward the most unrecognised. The photograph frames, and so confirms, those least framed by the land to which they would belong. To photograph is also to capture in stillness, in the fraction of a second, those beings ousted, like the Adam and Eve of Saramago's introduction to *Terra*, into migrancy and relegated to the uncertain road, deprived of the stabilities of land, home, or community.[50]

Humanity Adrift

The mass migrations undertaken by the disenfranchised in the last years of the twentieth century form the focus of Salgado's next major photo-essay, *Migrations* (2000). This collection of images joins *Workers* as an impressive example of the breathtakingly vast global reach of Salgado's lens. In order to construct this extended collection of photographs, Salgado covered over forty countries in seven years in an effort to capture the global phenomenon of mass migration. *Migrations* develops the theme of global dislocation explored in *Workers* and in *Terra* by focusing on the effects of displacement as they affect economically vulnerable groups across Latin America, Europe, Asia, and Africa.

If the shift to the industrial age has increasingly rendered the manual worker impersonal and unrecognised, as seen in *Workers*, and if the drive toward neoliberal free trade impacts negatively on those most vulnerable to the devastation wrought by it, as seen in *Terra*, then, the ensuing result of such global practices has been the disruption and uprooting of local communities and livelihoods. Globalization, as the dominant socioeconomic phenomenon of the postindustrial world, brings economic benefits to many, but simultaneously displaces millions. *Migrations* extends the global narrative of the effects of capitalism that forms one of the fundamental links between Salgado's photo-essays. This focus on human displacement as a key consequence of large-scale profit-centred practices is a hallmark of Salgado's work, present from diverse perspectives in all his projects. Central to his skill as a photographer is the ability to span geopolitical and historical contexts, as this volume attests. What emerges from his line of vision is a humanity that has more in common than not, despite vast differences in language, culture, religion, and ethnicity. Equally, Salgado presents

viewers with a global reality that upstages local histories and cultures, through the destruction of peasant communities and local landscapes. Also present in vivid form is the violence of such uprooting. Yet, the suggestive potential of his photographs also evokes these very threatened histories, framing place and people in that flash of "danger," as Walter Benjamin so famously put it, before destruction sets in. The many flights and marches of people across the globe that are framed in this collection also speak of their dreams and desires for the future, as they wander, like those in *Terra*, in search of a better life.

However, while *Workers* and *Terra* explored single themes, those of labour and landlessness, *Migrations* grapples with the plurality of contemporary global migration in all its complexity. Indeed, if migration is a global phenomenon that is on the rise, then, by the same token, it is also one that is hugely diverse in its causes and effects. Migration is at once a sweeping consequence of the modern way of life, shaped by the drive of capitalism—that "maelstrom" of modernity that Marshall Berman wrote so succinctly about[51]—and one that results from diverse triggers, some historical, some economic, some political, often in interrelation with one another. Migration also affects people diversely according to geography, history, culture, and, most importantly, socioeconomic class. At one level, it is possible to argue that late modernity has imposed migrancy as a way of life on its inhabitants; at another, it is undeniable that the migratory experiences of the average middle-class tourist, whose papers are in order, are a far cry from those of the average illicit immigrant. Without doubt, it is crucial to bear in mind that, within the overall cultural climate of late capitalism, migrants, and the conditions they must endure, differ sharply according to their levels of access to capital.

In his introduction to *Migrations*, Salgado states, "When poverty becomes intolerable, people seek to move on."[52] This is undoubtedly so. In the same prologue, Salgado also states that he was probably drawn to this project because of the moves that he himself has made in the course of his life, from Minas Gerais to Vitória, and from there to São Paolo and then on to Europe. No doubt experiences of migration bear certain commonalities that override differences of class, but, nevertheless, there are, in fact, huge divergences at play when it comes to the actual strategies of survival employed to cope with such displacement. Salgado undoubtedly faced an uncertain future at certain points in his life. He and his wife were also, for a decade or so, exiles. As an econo-

mist completing a doctorate while in Europe, Salgado fits well with the image of the Creole intellectual exiled overseas. As with others of this ilk, the combination of the experience of exile with intellectual acumen no doubt affords Salgado a keen insight into the problems of Latin America in general, and of Brazil in particular. It also gives him a comparative perspective, one that extends well beyond his native continent to encompass much of the planet.

It is doubtful, however, that the Salgados' experience of displacement from their native Brazil overlaps significantly with that of the globally dispossessed subjects of the photographer's images, whose economic vulnerability is such that they often lack access to even the most basic amenities of life. The danger of such apparent levelling is that through such a comparison, Salgado risks undermining the thrust of his project. Yet, his is clearly a sentiment of empathy. In order to better represent his subjects, it is in some sense crucial that he step away from them, if only to better transmit the specificities of their historical burden. Indeed, it is possible to argue that a photographer by definition stands away from his subjects, separated as he inevitably is by the camera, which acts as both a lens through which to see and a technological apparatus that acts as a barrier. Having said that, it is undeniable that both in the breadth of its scope and in its attention to the uniqueness of human lives, *Migrations* is a photo-essay that is at once intensely moving and arrestingly revelatory. Of the challenges he faced when taking up this project, Salgado has stated, "Probably to do a book like this is a wrong form, to make a film is a wrong way, to do a show of posters is not correct. But I sincerely want to know what *is* correct."[53] This challenge, of how to represent alterity "correctly," is one that remains unresolved for documentarians concerned with portraying difficult social realities.

Numerous kinds of contemporary migrations are represented in this volume: the ongoing rural exodus of peasants, economic migration from the global south to the north, the flight of refugees from ethnic wars and civil strife, the displacement of the underclass from our global capitals and urban centres. As the backdrop to such diverse movements is the overarching phenomenon of globalization, which, when seen through Salgado's lens, appears as a planetary upheaval, a large-scale phenomenon of mass migration where several hundred million people are forced onto the road in search of new horizons of economic and political security. Globalization, or the postindustrial age, is seen to uproot people

and traditions, to disperse and to scatter. Captive as they are to the capitalist dream of a better life, the globalized people move endlessly in routes predetermined by the flow of capital yet remain trapped in the disjuncture of global inequalities. The impacts of such migrations on both cities and countryside are profound. Salgado's photographs underline the displacement and dispossession that accompany the spiralling ventures of capitalism. In so doing, they provide a counter-narrative to discourses of success and power. The subjects of his photography exist in a world that belongs, not to themselves, but to others. They reap the bitter consequences of the embellishment of "other" worlds, removed from their own and unattainable in their lifetimes. Yet they are also swept up in the wake of such global currents. Not surprisingly, the question of power is paramount in Salgado's photographs, and the representation of the uneven play of power is precisely rendered through images of disempowerment. Salgado's subjects are driven by historical forces that are well beyond their own control. Despite their incessant struggle, they find themselves located in the impoverished margins and the deprived crevices of global centres of power and wealth.[54]

In an interview conducted at the Lannan Foundation in 2000 by Amy Goodman, Salgado stated that he initially thought of naming this photo-essay "Transitions."[55] Indeed, if there is one overriding commonality between the very different people and contexts represented in this volume, it is that they are captured in moments of fragile but indefinite transition. People framed in the midst of a provisional existence, making do as they can under the circumstances, struggling to relocate themselves in the wake of dislocation, form the substance of this essay. Photography lends itself to freezing transition as it takes place. Photographs are, of course, but the snippet of a moment, transitional by nature because they capture a brief moment of passage. What is thus most disturbing is this presentation of such transition as a mass global phenomenon of our times, affecting the lives of millions. Furthermore, the contexts that frame the lives of Salgado's subjects provide little hope that, in fact, the road that these people are on will lead them to a better place. And so *Migrations* is a photo-essay of warning; it points above all to the fact that, at the turn of the millennium, displacement has disturbingly become a way of life for a very significant proportion of the world's population.

If we could disengage *Migrations* from the fact that it came out as a photo-essay in 2000, at the threshold of the new millennium (and

hence, of what we imagine to be a new historical chapter), we might also be able to view the images here as symbolic of mankind's movements in a larger sense and see in them a historical evocation of migration as a long-established phenomenon intrinsic to the making of the modern world. As Saskia Sassen points out, there is, in fact, a relative normality to seeking work or travelling across borders, and the history of our modern world, is, in fact, one of repeated border crossing.[56] Thus, if migration and displacement bring with them rupture and trauma, then these are features of the larger context of modernization, industrialization, and globalization that have characterized much of the nineteenth and twentieth centuries. To think of displacement as solely a present problem is to disregard the long histories we all share of this phenomenon, as well as to disregard the consequences and effects of past migrations that make up our current contexts.

Nothing, however, can diminish the call to engagement to intervene in the suffering that accompanies displacement. There are complex historical, political, and ideological reasons for such suffering, none of which can serve to validate it. Photographs are often referred to as traces of the past. The images of *Migrations* and of *Exodus* (the title of the exhibition of these photographs), however, are not of the past per se, but indeed are traces of otherness in our very midst. Other lives, other places, other contexts that have become scattered and remain devoid of recognition. The force of these images arises from their ability to generate regard, however much in passing, for others. Ultimately, such regard is one forced by the border crossing of viewer to subject across the margins of the image. As I argue in chapter 4, it is precisely the migratory potential of image viewing that releases the ethical moment of encounter between self and other.

As *Migrations* shows, there are numerous reasons for which people are forced to be on the move. The volume begins with a focus on the planetary north–south divide, one that is most visible on an economic map of the world. Salgado rightly highlights two areas in such a map where the inequalities between the global north and south are most keenly felt: the border between Mexico and the United States, and that which lies on the Strait of Gibraltar, where Africa meets Europe. At both these border zones, the proximity of a hegemonic power center of the global north renders the porous border too inviting to resist for those on the south. Border crossings are risky, all too often lethal, and fraught with uncertainty. Yet nothing deters the migrant will to cross

over, and, on a daily basis, many take daunting risks in order to get through the barriers that demarcate the border.

An arresting image of the strait shows an ink-black ocean punctuated by a small boat crammed with hopeful migrants (fig. 6). This is a *patera*, or raft—a flimsy vessel ill equipped to carry the human cargo it bears in its illicit crossing of the Strait of Gibraltar, from some point of departure on the northern coasts of Morocco to the shores of southern Spain, and hence the much coveted Europe. The image is part of a series taken in the region and slots into a narrative of surveillance by the authorities, surreptitious movements on the part of immigrants, and, above all, human vulnerability. Subsequent images of migrants escaping inland after reaching the shore in Spain show only the blurred movement of the migrants as they flee capture by the police. Illicit and without papers, they have no face to show the world and find themselves without distinct identity, save that of the illegal. As such, and as the images so strongly suggest, the question of representation is itself blurred. On its own, the photograph of the patera on high seas is no more than an image of men in a boat, their eyes startled by the searchlight that has fallen on them—no doubt from a Spanish patrol boat monitoring the waters. Caught in a single flash by both the camera and the authorities, they appear startled, frozen, literally stopped in their tracks. Yet a wider story unfolds when one turns the pages and sees the image in the fuller context of the many pitfalls and intricacies of border crossing between continents. The video *Exodus*, shown by Salgado at the Lannan Foundation, moves from still to still, allowing the narrative of migrancy to evolve through implicit links between the images, so that the contexts within which migration takes place can be made evident.

In another film of the same title, the documentarian Sorius Samura takes the viewer to the city of Tangier, where numerous hopeful immigrants spend months, if not years, waiting for traffickers to grant them a place on a boat to Europe. The dream of Europe as that place that harbours "a better life" fuels the wait, and many will sell their souls to make the crossing. Borders, as Hastings Donnan and Thomas M. Wilson remind us, are where the practice of power is most keenly felt.[57] Here, the jagged and uneasy border between global north and south is also one that is both deadly and permeable. As Salgado's images of the Mexico–United States and Africa–Europe borders show, for many, borders are spaces where life and limb are risked and—as his image of the cemetery at Tarifa shows—lost. What is more, there are no numbers for

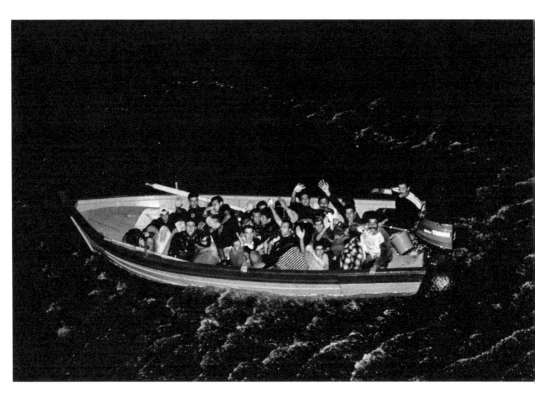

6

the dead. Without recognition or representation, they simply do not count. It is estimated that many thousands have died crossing the strait. Still others die from the struggle to survive in harsh and alien midsts. In his searingly honest indictment of state practices, the Spanish journalist Juan José Téllez writes of the inhumanity of the border, citing an occasion when the body of an illicit immigrant is washed up on the shores of Tarifa, half eaten by fish and unrecognizable: "Broken like a dream, with no time to spare, he was a human coral. . . . The remains of that man without name and without face, whose features had been devoured by fish and whose identity had been destroyed by the economic, social, and political abyss that divides the two shores of the Strait, left on the sand a long trail of questions and uncertainties."[58] The imposition of the border is seen here in all its violence. Likewise, the exercise of power evident in Téllez's story, in terms of uniformed officials and other markers of state and political hegemony, reveals the disempowerment that shadows the immigrant without papers who survives the crossing. Prey to chance and to the will of traffickers, illicit immigrants, devoid of state recognition, find themselves reduced to the ranks of the unauthorized and the unrecognized. As such, and for as long as their stay remains illicit, representation remains largely out of reach for them, save in the guise of nongovernmental organizations that struggle to build bridges between the licit and the illicit.

A major focus of *Migrations* is the global spread of refugees, people dispossessed of their roots and forced to flee their lands through turmoil, civil strife, and violence. The contexts may be varied, but the circumstances—despite differences of race, culture, history, religion, and language—are strikingly similar. Entire families and communities are seen on the move, from Russia to the United States, from Vietnam to Hong Kong, from Palestine to Lebanon, from Kurdish villages to camps and cities inside Turkey, from Rwanda and from Angola and Mozambique. Together with economic migration, refugees from war-torn places constitute a central focus of this photo-essay. Another key area of focus is on those who have had their homelands destroyed by the onslaught of capitalist enterprise, such as the indigenous population of the Amazon, whose way of life has been destroyed by incursions from outside. Similarly, internal migration is a focus of the volume. Through this phenomenon, globalization and urban expansion in developing countries has led to the growth of slum populations, as increasing numbers of people abandon rural areas to seek their fortunes

in the city. Indeed, it becomes hard at times to draw clear lines between these different groups of migrants, exiles, and refugees, for the consequences of their divergent histories and contexts often lead to the same insecure and unstable conditions of displacement. In an overarching socioeconomic context of capitalism and transnational networks, what emerges is the restless movement of peoples, pushed on by motives beyond their control. Turning the pages of *Migrations*, it is as if the viewer were watching a film where the camera pans in slow and deliberate motion across the globe, foregrounding one by one the displacements suffered by millions in every continent. Every image in this photo-essay is one of trauma, but of trauma not as an isolated event but as an ongoing process. As such, this trauma is a key feature of our times, one that coincides with the turn of the millennium and so marks our present historical juncture. Every story here is of rupture and loss, of death and the struggle to survive. Equally, though, the images speak of a fraternity of humankind, as people move and live in groups, forging community on the road through a shared sense of trauma and, despite it all, of hope. As Salgado describes, "For six years in forty countries, I worked among these fugitives, on the road, or in the refugee camps and city slums where they often end up. Many were going through the worst period of their lives. Yet, they allowed themselves to be photographed, I believe, because they wanted their plight to be known. When I could, I explained to them that this was my purpose. Many just stood before the camera and addressed it as they might a microphone."[59]

Perhaps what is most arresting about the images in *Migrations* is the fact that Salgado's lens hones in on the human, on the everyday struggle of the displaced to keep going on, on survival in the context of displacement. An African mother breastfeeds her baby by a dirt track, her older child playing patiently in the mud behind her. Another woman walks past carrying two infants in her arms, her worldly possessions balanced precariously on her head. In *Migrations*, we see in ways that we find hard to forget, but in ways that are often overlooked, people upon people, walking, waiting, hoping. We see people on the road, by buses, on trains, in boats; people without tickets or papers; people who carry their entire wealth on their person. We see people who risk their lives as they cross borders and oceans, people who move on even as they remember their land and their dead, people spurred by despair and by hope. We see people living in transitory conditions, in camps, in tents, in war zones; people holding on to one another because all else has been lost. Over

and again, in numerous interviews, Salgado has stated that his intention, above all, is to provoke a debate about the direction in which humans have taken and are taking the world, and which impinges directly on man's relation to nature and to land. As evident from the aforementioned quote, he also views his images as fields of representation, where the subjects "speak" through the image to the viewer. In this sense, Salgado's claim must be understood as one that argues for photography as empowerment or a channel of representation for those who are normally neither heard nor seen by those in the global centres of power.

In order to assess and so better understand Salgado's point, one needs to consider *Migrations* against the flux of the numerous other images and discourses that circulate in our midst on the topic of migration. In the video *Spectre of Hope*, Salgado states that much photojournalism, as it is presented today, does little to inform the public. What we see, he explains, are images of specific, isolated events that show us facts. Instead, the photo-essay presents us with a visual narrative, one that tells us the story behind the fact.[60] I believe this to be a crucial point with regard to the historical relevance of Salgado's work. Photo-essays, as visual narratives, combine history's narrative thread with the multiple perspectives brought to light by the medium of photography. Through the visceral response of the viewer to images via the sensibility of sight, abstract views on lives lived elsewhere can translate into emotional relation. I consider this aspect of Salgado's work in more detail later in this book. With regard to *Migrations*, however, what emerges from the book is a sense of crisis—one that the viewer, however momentarily, enters into via the emotive pull of the aestheticized image. The implicit contrast is with those passing images of asylum seekers, refugees, and immigrants that float before our eyes only to drift away again on an almost daily basis in newspapers, on television, and in the news. If Salgado has seen himself at points in his career as a photojournalist, then here, in *Migrations*, he is not reporting on but reframing the other. The effort is a humanistic one, aimed at overturning the discourses of otherness that all too often obscure the drama of the dispossessed.

The discourses surrounding displacement are often confounding. What is perhaps most troubling to note is that the rise in migration across the globe in the twentieth century coincides with the growth in awareness of and legislation on issues of human rights and human dignity. We live at once in times of an unprecedented charting of human rights and an unprecedented uprooting of people and communities,

whereby the implementation of even the most basic of human rights sometimes fails to take place. Paradoxically, globalization has brought with it the flowering of a global civil society, facilitated by both capitalist networks and technological developments—most significantly, the spread of electronic and other communication systems. Globalization facilitates humanitarian intervention and transnational legal accountability, as it does communication via the Internet and other methods.

There has been a surge as never before in a global consciousness of targets for well-being, in terms of a rational and legal acknowledgment of the basic needs for a decent life (as witnessed in the agendas and policies of welfare states), and in the mobilization of action against the violation of rights. Nevertheless, such global mechanisms are seldom evenly implemented or available. Major discrepancies occur from place to place and social class to social class. Inevitably, therefore, a large global underclass remains unrepresented and without redress. On a daily basis, we see before us major transgressions of basic rights, ones that work precisely toward upholding "civil" society, through assaults on the fundamentals of dignity and environmental balance. Thus, the growth of global networks occurs in tandem with the deepening of a global gulf between the global north and the global south, whereby there is a jagged and treacherous line that segregates the citizens of hegemonic spaces from those on the periphery. It is this scattered global underclass that is seen in *Migrations*: for example, those Rwandans who fled genocide and managed to stay alive but remain homeless and displaced, whose lives and access to land will not be restored by international tribunals investigating the genocide; or, those Croatians and other former Yugoslavs whose homelands were torn asunder by ethnic division; or, indeed, those migrants who, for reasons beyond their own understanding, embrace risk and invisibility in order to assume the challenge of the border as they attempt to cross over from the global south to the global north.

Salgado's presentation of such widespread displacement is, he insists, an invitation to enter into a debate on globalization. The stress falls on questions of human dignity, a dignity that finds itself maligned by the nonrecognition that economically vulnerable groups have historically been assigned. He seeks to restore it through the eloquent tonality and the aesthetic of his photography. Indeed, this drive to include the excluded within and through photography is the crucial current that both connects his various projects and drives them forward.

In this sense, Salgado seeks, through his work, to counter the grain of current perceptions of migration. Much prevalent discourse around migration presents the migrant in a negative light, as a trespasser of boundaries. The hostility with which migrants are all too often met revolves around the perceived risk of allowing immigrants into the nation. Refugees and immigrants are commonly perceived as infiltrators, conflict ridden by definition and hence problematic. They are further seen as threats to cultural identity and thus often find themselves the target of xenophobic reactions.[61] Immigrants, especially newly arrived ones, are often perceived as a social or economic burden to the host country, and so unleash responses of alarm from the latter.[62] Tabloid newspapers in the UK such as the *Sun* provide ample, if perhaps somewhat exaggerated, evidence of the discourses of mistrust and hostility that define attitudes toward immigrants, refugees, and asylum seekers. The events of 9/11 and the subsequent "war on terror" have not made things easier for migrants entering the West, especially for those who are Muslim. As Bill Jordan and Franck Düvell rightly state, "Concepts such as 'illegal immigrant,' 'economic migrant,' 'bogus asylum seeker' and even 'global terrorist' have entered debates, often without clear definition, research evidence or careful analysis."[63] As others, much that is undesirable—disease, dirt, crime, even terrorism—is attributed to these groups. Indeed, it is not the presence of such groups per se that produces conflicts, but the responses that they arouse in host communities. Underlying such antagonism is an irrational dread of loss of sovereignty, and by extension, of autonomy in its widest sense, or self-control. The overriding response to the idea of immigration is a sense of being swamped by others. Migration, as seen in Salgado's work, is an endless flow of people across space. This movement appears unstoppable and brings with it changes that are at once demographic, environmental, social, economic, political, and cultural.

There is, of course, a deliberate aesthetic employed by Salgado to convey his ideology. A luminous photograph that is part of the section of *Migrations* devoted to images of the breakup of Yugoslavia shows a young mother holding her child as she, along with some fifteen thousand others, takes refuge in a chicken farm in Batnoga.[64] It is one of several taken in this location and forms part of a larger narrative of displaced persons seeking shelter as they can, improvising in the midst of extreme discomfort. The caption to the image explains that these are displaced persons and, as such, they are not formally recognised as international

refugees. Thus, they have fallen into one of many existing crevices in international law and human rights policies. The image is striking and is rich with association, both photographic and metaphoric. It derives its visual force from a classic chiaroscuro effect, whereby light falls solely on the young woman and the infant at the centre of the image while all else remains in shadow. It is this chiaroscuro that elevates the image above the ordinary and infuses it with deep metaphoric significance. All in one, Salgado brings together a documentary exposé of the displacement that is an important part of our very recent history with the great works of Renaissance art, charged as they are with a timeless sense of humanist empathy and wonder. The biblical evocation of this image is also hard to ignore. The woman and her child are part of a large exodus of wandering people, like Mary and Joseph with the baby Jesus, and it is this element of religious symbolism that endows this otherwise despairing image with hope.

There is a great and troubling beauty in the dispossession of this mother and child. To see such beauty and to know that this image was taken in a horribly overcrowded, no doubt foul-smelling chicken farm, most likely devoid of the most basic resources, is to be faced with an irreconcilable contradiction. Salgado often claims that he is a documentarian, but how can this be, given how removed this beauty must be from the reality at the source of the image? This paradox, a hallmark of Salgado's style, is both alluring and problematic. While his aesthetic ensures that his images do not go ignored, in a work like this misery is gilded with the artistry of light. This tension between elements also proves the point that, in order to convey his ideological message, the aesthetic comes in as a useful tool.

A companion volume to *Migrations* is *The Children*. In it one finds the children of the road, born and raised in contexts of displacement, insecurity, and impermanence. This is a collection of nearly a hundred portraits of children, all either migrant, refugee, or displaced. Every image has the same form but, interestingly, with strikingly different effects. In each portrait, the child looks straight at the camera and is framed in an evanescent flash of stillness against the vulnerability of their tender lives. Salgado has stated on many occasions that the project began spontaneously when he was working in Mozambique and found himself surrounded by children who would not let him work because they so wanted to be photographed. "Okay, guys. I'm going to sit here. If you want me to take a picture of you, line up and I'll take a picture of you. Then you go away and play."[65]

The images are compelling. Across the continents, from every part of the globe, we see in this collection the children of the global era, born into displacement, and, before us, our own tomorrows, embodied in their small persons, stretch troublingly out as a long and winding road of uncertainty. *The Children* is a unique and important contribution to contemporary archives of the photography of displacement. Photographs of children alone, seen apart from their families, are relatively rare. Indeed, it is fair to say that extended legal battles in the 1980s and 1990s around the photographic representation of children on their own has led to the exercise of a certain caution in the representation of children. (These conflicts addressed, in part, the possible sexual innuendos contained in such images, particularly when the images depicted children in the nude—and many of the children in Salgado's other photo-essays are nude, if only because nakedness is by force a feature of poverty and dispossession.) If, as Susan Sontag stated, photography can at times be seen as appropriating and imperialist,[66] then taking pictures of children can be seen by some, and according to the particulars of the image, as a form of abuse. In part, this concern about the ethics of photographing children comes about because children are considered too young to control how they are seen or by whom, or to make decisions regarding whether or not they should allow themselves to be photographed by strangers. These portraits by Salgado, however, break with such hesitation and emphatically place the child at the heart of debates on displacement. They make the statement that there are indeed millions of children like these around us, children who live their lives without protection, without care, and without security. The images issue a strong call for responsibility. The collection of images paved the way for Salgado's current work with UNICEF and underlines the humanistic thrust of his work. Images of children, like other images, must be read as symbolic, and therefore imbued with a code that charges them with significance.

With regard to depictions of children, Mary Warner Marien states that it was in the Victorian era that the child came to symbolize innocence and purity.[67] The poignancy of Salgado's portraits lies in the power of the images to suggest the irreconcilable juxtaposition of such innocence and the senseless suffering that accompanies displacement. The intrinsic pathos of the photograph as a medium is intensified by this paradox. As in Roman Vishniac's *Children of a Vanished World*, the children seen in Salgado's book are all victims of circumstances they neither control nor caused. Vishniac's photographs are of Jewish children and were

taken in villages of Eastern Europe prior to the outbreak of the Second World War. Many, if not most, of the subjects almost certainly died not long after these images were taken, and it is this knowledge of an impending death—even more than the obvious poverty experienced by his subjects, children already living, as we know, under persecution—that moves the viewer to look into the frame. Likewise, in *The Children*, the injustices and inequalities afflicting migrants and refugees become distinct through the afflictions of the subjects. Ironically, though, every child seen here is composed, steady, as if looking "through" the camera at us, the supposed viewers. Some of the children are victims of land mines and have lost limbs. Others are struggling to survive wars and genocide. Some others have become separated, perhaps forever, from their families and have become wards of charity. Still others may remain refugees and in transit for life. Nevertheless, the viewer also sees the natural vibrancy of children, the light in their faces, the will to live despite it all. Mara Vishniac Kohn states of her father's images, "We want to look into their eyes and see there the wonder, the hope, and the trust in a future that they would not experience. We think of them, we assure them of our love, and we cherish their memory."[68] *The Children* must be seen as making the same plea, but even more stridently, as well as a plea for action to prevent further suffering. Unlike Vishniac's photographs, seen only many decades after the Second World War, Salgado's images are an indictment of the present. They aim to arouse a heartfelt conviction that something must be done.

The Children has brought Salgado considerable recognition in the international humanitarian community. Some of the images of *The Children*, together with others by Salgado of children in situations of war, risk, and suffering, have been included in a book by Graça Machel, *The Impact of War on Children*.[69] The book charts causes of displacement—for example, the placing of landmines in Mozambique, which prevented entire communities from returning to their homes—and their effects on children. It also focuses on the ravages of HIV and AIDS on children, as well as providing details of the many perils that face children in situations of risk: sexual abuse, exploitation as child soldiers, the loss of limbs, psychosocial ailments caused by trauma, separation from their families, and the need to seek refuge in shelters. Written as part of Machel's work for the United Nations, the volume further outlines the efforts made by various United Nations organizations to improve conditions of life for them.

Salgado's photo-essay in this book, *War on Children*, accompanies the text and provides a means of visualizing the realities faced by these children. The photographs also accentuate the visceral response of readers to the detailed information contained in the text. As such, they act as an invitation to enter into the daily realities of these children. A mother and child flee with what little they have as an air attack takes place. The landscape behind them is barren, devoid of shelter. A lone tree appears blurred, as if quivering from this onslaught of violence. A boy lies on a bed somewhere in Cambodia, the survivor of a landmine. His legs, or what is left of them, are bandaged, his young life now in shreds. In Mozambique, mothers in shelters care for children who are not theirs, children who have been hopelessly separated from their own parents. In Rwanda, scores of child refugees wait in a camp for help. They are perhaps six, ten, twelve years old. There are more children here than can be counted, each one a life that has already been fractured, displaced, uprooted. In Chiapas, Mexico, a little girl, no more than perhaps four or five years of age, her hair swept by the wind, looks at the camera with the wizened gaze of one who has already seen much in life. The caption tells us she is one of many indigenous peasants displaced by conflict in the region. *War on Children* is clearly part of a campaign to stop violence on children. The images reinforce the factual details contained in the book; they also highlight and confirm Salgado's role in the United Nations, particularly with regard to UNICEF's work with children.

It is worth noting, then, that collaboration with various United Nations projects marks an important shift in Salgado's own position as a photographer concerned or engaged with humanitarian causes. His earlier collaborations with Médecins Sans Frontières and with Reporters Sans Frontières were triggered by the same ideological position.[70] Nevertheless, his own ascent to the status of celebrity photographer—confirmed by the international attention received by the *Exodus* collection as well as the success of *The Children*—marks, and is marked by, his participation in the humanitarian work of the United Nations and its international aid agencies, which benefit from considerable recognition and access to resources that are financial, legal, and political. This influence is most noticeable in his ongoing project *Genesis*, which is supported by various United Nations bodies. Certainly, as a United Nations collaborator, Salgado has himself shifted into the heartland of power. If once he was an exile, stripped even of his passport, a migrant, and a struggling photographer, he is now an image maker hailed by the estab-

lishment, no longer marginal but iconic—and hence removed, however inspiring his images may be, from the perils of revolutionary action.

A Trail of Hope

In the wake of *Migrations* and *The Children* came an unusual departure from Salgado's usual extended photo-essays. *The End of Polio: A Global Effort to End a Disease* is a photo-essay by Salgado that, in order to construct its optimistic message of an end to polio, works in tandem with accompanying prose essays by various members of the United Nations' campaign against the disease. The volume is evidence of Salgado's collaboration with UNICEF, as witnessed by the inclusion of a foreword by Kofi Annan, the former secretary general of the United Nations, and it acts as a visual document of the work of the Global Polio Eradication Initiative, itself the result of collaboration between UNICEF, the World Health Organization, and the U.S. Centers for Disease Control and Prevention. The photographs, taken in 2001 and 2002, track the fight to conquer polio in five different countries and chronicle what UNICEF hoped would be the last phase of this disease before its final eradication. Ellen Tolmie, the photography editor for UNICEF, has stated that, after the harrowing experience of many years of photographing human displacement as seen in *Migrations*, Salgado went in search of a happier story for his next project. He sought one, she said, that would speak of success rather than struggle.[71] More to the point, Salgado's images here function as part of the campaign to overcome polio and as such, must be seen as having a mission to achieve. This mission is laid out clearly from the start: at the time when the book came out, the aim of these images, as well as of the book in its entirety and of the campaign itself, was to have brought about the definitive eradication of polio by 2005. The campaign has since failed to achieve this target and the eradication of polio continues to be elusive. Yet Salgado offers words of encouragement: "I hope these pictures can help to provoke debate, to provoke discussion. We will build a big wave, to make people conscious that polio still exists, and that we, together, can finish with it."[72]

The photographs of *The End of Polio* show infants being administered the polio vaccine, the treatment and rehabilitation of children affected by polio, the efforts made by workers to reach outlying regions in order to carry out immunization, and the never-ending struggle to ensure that all children in a given locality have been immunized. As in *Workers* and

in *Migrations*, we see very similar images set in very different parts of the globe. A mother holds her infant as others look on and a worker vaccinates the child. A young child whose legs have been shrivelled by the disease struggles for mobility. A little girl is saved from the threat of this awful disease as we see her small finger being marked with ink by a campaign worker—a sign of hope, for the ink mark denotes that she has been vaccinated (fig. 7). Polio, Salgado shows, continues to haunt the poor—those who live in slums, in crowded environments, near fetid water. It affects those who lack literacy and education, those who live in remote areas away from modern health care, and those trapped in the midst of warfare in countries that are already too poor to offer much social infrastructure. The irony is that simply by administering the vaccine at repeated stages in a child's life, immunity can be obtained.

The images function as a visual text alongside the essays. They show the tragic waste wrought by this disease, as paralysis, pain, and disability halt the progress of otherwise dynamic, young lives. Siddharth Dube, a UNICEF writer, charts his brother's fight with polio and assesses in a deeply subjective and emotional essay the strides made in the struggle to overcome it in his native city of Kolkata. In India, Pakistan, and Afghanistan, the disease persists among the poor, and those involved in the campaign—vaccinators, team workers, and photographer alike—must hunt out communities who resist vaccination or have not yet been included. They must also revisit children who have been vaccinated, ensuring that the necessary numbers of doses have been administered to each child. Chris Zimmerman recounts his experience of taking immunization to a remote part of Sudan where a stray case of polio had been located in the midst of heavy fighting.[73] Workers often face considerable personal dangers as they enter remote regions, face hostility, or find themselves in the midst of war zones. The campaign involves not just UNICEF, but other organizations, such as the WHO. As seen in this book, the fight against polio brings together a host of different groups and fields, as doctors, communications officers, writers, photographers, social policy specialists, and others join forces. It is, in fact, everyone's fight, for the spectre of polio haunts anyone who is not immunized. It is also a fight that reveals that no single humanitarian problem exists in isolation. Rather, to fight polio is also to fight poverty, violence, illiteracy, and disease in general. More to the point, the message that *The End of Polio* seeks to convey is that if a collective effort can overcome polio, then there is hope for the other evils that

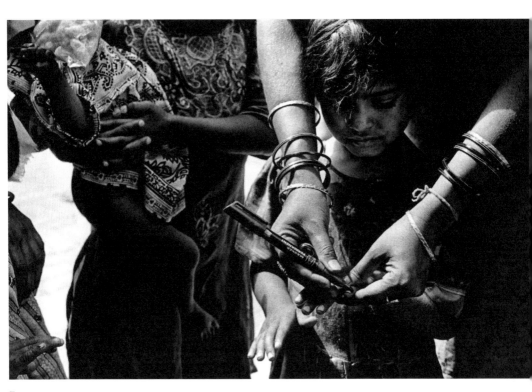

7

haunt mankind. To quote Siddharth Dube, "Yes, the prospect of the end of polio fills me with great optimism. Optimism, because if polio can be eradicated simply because tens of millions of caring people around the world joined together in solidarity, then surely we can end the millions of deaths each year from other diseases for which effective vaccines are already available. Why can't our solidarity be enough to end the AIDS pandemic? To achieve nuclear disarmament? To end war? To finally end illiteracy? To finally end hunger? To finally end all poverty?"[74]

The optimism was, perhaps, somewhat misplaced. What Dube and other campaigners against polio did not take into account is the complex interaction between the various ills, both natural and man-made, that beset humankind. Tragically, since the outbreak this millennium of an ongoing global pursuit of terror and the subsequent antagonisms between extreme factions on both sides, the end of polio is taking longer to come about than expected. A report in the *Guardian* states that, following rumours that vaccination against polio is an American plot to sterilize Muslim children, there has been serious resistance to immunization in Pakistan, especially in the northwest where Pakistan borders Afghanistan.[75] According to this report, the parents of twenty-four thousand children refused vaccination following the spread of this disinformation by extremist clerics. Similar problems have arisen in Northern Nigeria, where religious animosity, in the face of the "war on terror," has led to refusals of the vaccine, seen as coming from the West. Nigeria and India are currently the two countries in the world with the highest level of incidence, with 1,124 and 674 cases, respectively, in 2006. Thus, polio continues to be active in many of the poorer parts of the world. Clearly, the eradication of polio can only be effected when the groundwork of immunization set in place by agencies such as UNICEF, the CDC, and the WHO are then maintained and supported by national governments. Countries with major problems of infrastructure with regard to health care and economic well-being, or countries subjected to strife and warfare, such as Afghanistan, fall short of the standards expected of them by international agencies and organizations.

A map of global polio cases as of February 2007 shows the disease to be active in Asia and Africa.[76] Clearly, polio is now a third-world disease, an affliction of the global south, associated even at national levels with questions of social class and economic disempowerment — for in countries such as India, immunization is now routine for children born into middle-class families. The fact, then, that polio has been

"conquered" throughout the more prosperous parts of the world is an indication of the unfair degrees of suffering through disease afflicting those in poorer parts whose lives are already negatively affected by economic hardship. Polio becomes inflected with much more than suffering through disease—it is also a form of suffering through poverty, through inequality, and through neglect.

The hopeful note that concludes *The End of Polio* has, thus, yet to materialize into fact. Neither polio, nor war, nor hunger, nor any of the other ills of mankind that Dube mentions have been overcome. Salgado's pursuit of what he deemed to be a hopeful story has not led to any breakthrough on this front. To read about polio and then to look at the images of *The End of Polio* is to see in this photo-essay, as in *Workers* and in *Migrations*, a hymn to mankind as community and an homage to collective efforts.

In particular, and as an extension of his portraits of children born into displacement in *The Children*, *The End of Polio* presents us with numerous instances of ordinary disabled children leading, in the course of the everyday, enormously courageous and unique lives. Not many photographers have dwelt on disability. David Hevey, whose images of disability in his exhibition *Giants* showed disabled people as part of society and not as outsiders to it, is one of few who place disabled people at the centre of the lens.[77] Hevey's work portrays the disabled, allowing them room for expression and expressiveness. Through their disabilities and through images that are at times hard to look at but harder still to ignore, Hevey's subjects speak loudly to the camera, demanding regard and attention. There is in Hevey's work a strident politics of representation. Even fewer photographers have dwelt for any great length on disabled children. Much representation in the media, be it through visual or other means, seeks to alter perceptions of the disabled as outsiders or as others.[78] Ashwin Bulsara, a writer for the Media Diversity Institute in London, states that perhaps what is most important for disabled people is not to evoke sympathy but to have, quite simply, "the right to be ordinary."[79] The children of *The End of Polio* are not ordinary. Framed in luminous tones, they too, like the subjects of *Migrations*, are graced by Salgado's lens so that the life force and inventiveness of even the most affected shines through. The mere stretching of a leg by a child in India whose limbs have been twisted by polio becomes a superhuman feat. The mobility of a disabled woman is a matter of sheer wonder, as she rides on a bicycle fitted incredibly with a chair, whose wheels she turns

through handle bars ingeniously attached to them, so that, despite the atrophy of her legs, she can cycle down rough tracks in the countryside in the Democratic Republic of Congo.

The End of Polio is both an essay on suffering and one on hope. Either way, it is not so much about overcoming a specific disease—the sheer fact that the disease resists eradication signals the failure of such an endeavour—as it is yet another visual meditation on humanity as a team, one made up of children, polio victims as they grow up, campaign workers, and others engaged in the fight against polio, connected across distance by common fears, pains, and hopes. The idea of solidarity ensues from this collection, as does that of collectives and communities, of courage and struggle, of determination and endurance. Given the fact that polio today most often strikes the poor, this photo-essay also dwells troublingly on the intersections of preventable disease and economic disempowerment; in other words, on issues that highlight the injustices, as regard health and well-being, of class difference across the globe. The question of responsibility remains unanswered.

The Larger Whole

Genesis, Salgado's current project, underlines his attempt to argue for a holistic vision of man and nature. In what may seem a surprising departure from the hitherto man-centred focus of his lens, Salgado has marked what he says will be the last decade of his photographic career by turning increasingly to questions of nature, and by attempting to offer images, taken in unspoilt parts of the world, of a balanced relation between man, beast, and nature. In his own words: "We are living in disharmony with the elements that comprise the universe, as if we too were not similarly formed, as if we were purely rational beings. We are disregarding the spiritual and instinctive qualities that until now have ensured our survival. We assume grave risks when we distance ourselves from our natural roots, roots which in the past always made us feel part of the whole."[80]

This preoccupation with the environment is, indeed, one that reflects growing concerns about the ecological crises brought on by industrialization and globalization. If vision—that active exploration of the world around us even as it changes before our very eyes—is about orienting ourselves toward the future, then there is little doubt that environmental concerns and major shifts in man's thus far disruptive re-

lation to nature should be central in our sightline. As global warming impacts ever more decisively on our landscapes and climates, environmental issues have hit the forefront of global concerns in the twenty-first century as never before. A heightened engagement with the environment and with attempting to alter man's view of his relation to land manifest themselves in a variety of ways in Salgado's most recent and ongoing projects. Paramount among these are two projects currently under way: the first is the rebuilding of the Atlantic rainforest driven by the Instituto Terra in Salgado's native Aimorés and the other is his current, and last, extended photo-essay, *Genesis*, which takes his viewers to places, creatures, and people who have persisted in traditional ways of life since premodern times in the face of industrialization and globalization.

If Salgado's images of man in the midst of industrialization highlight a persistent beauty, then this deliberate aesthetic no doubt points to a harmony that must be sought, despite displacement and dispossession. A living example of this precept is the Instituto Terra, on the outskirts of Aimorés, Salgado's hometown in Minas Gerais.[81] In 1999, Salgado and his wife purchased his family's farm, the Bulçao Farm, from his father. Once upon a time, the land that this farm stood on had been covered with the Atlantic rainforest, itself home to a large variety of animal, bird, and plant life. By the time the Salgados took over this land, over 93 percent of the forest had been destroyed.[82] The demise of the rainforest here marked the end of a whole ecosystem in a territory larger than the land area of France. Not surprisingly, numerous forms of life in the forest had gone with the trees, which were felled for cattle farming, timber exploitation, and the construction of a railway and that of a dam. In short, a series of man-centred and economically driven projects have, in the course of the twentieth century, seriously undermined the rainforest and led it to a state of near extinction. As a result of such environmental deterioration, the nearby River Doce, once a major river in the region and now deprived of the shelter provided by trees, has diminished greatly in volume.

The Instituto Terra is a nonprofit foundation directed by Lélia Wanick Salgado and aimed at rebuilding this rainforest. On its nearly seven hundred hectares of land, it houses a nursery where over a million and a half trees have been raised from seed to sapling. By the time of my visit in August 2006, nearly a million trees had been planted in the surrounding lands. The foundation itself has a manicured garden, the land-

scaped contours ablaze with different kinds of flowers all year round and surrounded by red earth and green foliage. It also serves as a teaching centre for courses in sustainable methods of farming. Many of the students are from local families involved in agriculture. The sustainable methods they learn at the Instituto Terra will be applied to their own lands and to the farming methods they employ. The institute serves the region in other ways too, acting as a cultural centre linking Minas Gerais and neighbouring Espíritu Santo. The emphasis is very much on the diversity of the local, on rebuilding local environments, and by extension, enhancing local lives.[83] Central to the work done here is environmental education, restoration, and sustainable development. Funds have to be constantly sought for this project and, clearly, Salgado's international status as a photographer has been crucial in obtaining the necessary support for keeping it alive. Contributors include Brazilian as well as various international bodies, as diverse as the government of Asturias in Spain and the International Finance Corporation—the latter being a member of the World Bank, ironically, a part contributor to the River Linking Project in India that privatizes water and encloses it.[84]

Alongside the work done at the Instituto Terra and in the wake of his role in UNICEF, Salgado has established links with United Nations Environmental Programme (UNEP). UNICEF and UNEP are primarily responsible for supporting his current project, *Genesis*. Salgado has stated that this will indeed be the last major photo-essay of his career. Launched in 2004, it is envisaged that it will run for about eight years, by which time Salgado will be nearly seventy years old. As such, as this book is being written, this project is incomplete, and so no overall assessments of it can be made. Yet it already raises important questions in the context of engaged or concerned photography. *Genesis* focuses on the undeveloped spaces of our world, not touched by industrial development. In accordance with a contract signed with the *Guardian Weekend* magazine, the photographs of *Genesis* appeared for some years on several occasions, sporadically bringing readers into view of this vast environmental portrait. To quote Salgado in an opening essay published in this magazine (as well as on the website of the UNEP) as a frame for the coming images, "The world is in peril, both nature and humanity. Yet this cry of alarm is heard so often that it is now largely ignored. International conferences are routinely organized to debate global warming, sustainable development, water resources, destruction of forests, endemic poverty, the AIDS epidemic, housing needs and

other facets of the global crisis. But the daily struggle for survival of the majority of humanity and the appetite for comfort and profit of the minority mean that, in practice, these fundamental problems are tackled only superficially. We have lost touch with the essence of life on earth."[85]

One can assume, therefore, that *Genesis* is an attempt by Salgado to redirect us to this "essence of life on earth." According to a statement by the UNEP, Salgado's photo-essay will have four parts or chapters: "Creation," representing the elements of nature that give life, such as water or air; "Noah's Ark," focusing on animals that have resisted "civilization" and endured through time, such as the giant turtles of the Galápagos Islands; "The First Men," depicting tribes that persist in premodern ways of life; and "The First Civilizations," which will show examples of societies that remain organized as the first human groupings were.[86] The premise of all these chapters is clearly that man has alienated himself from his natural habitat. As a result, nature is in a state of impending collapse, one that will inevitably lead to man's own demise.

To date, *Genesis* has taken Salgado to the Galápagos Islands, presented in the *Guardian Weekend* as a sort of "wilderness at the beginning of the world"; to the seas off the coast of Patagonia, where he took photographs of right whales; to Antarctica on a much publicized voyage aboard the 120-foot yacht *Tara*, once owned by America's Cup–winner Sir Peter Blake (shot dead on the yacht by pirates); to the Xingu Indians of his native Brazil, far removed from the industrialized world; to the stillness of the Namib desert, populated by lone animals and nomadic groups of cattle herders; and to the Dinka tribesmen who persist with "natural" ways of life, namely farming and cattle raising, despite the proximity and influence of the war surrounding them in southern Sudan, which locates them on the very border zones of the modern world.[87]

Given that *Genesis* is still under way as a project, no large-scale exhibition has been held of it. Instead, the images appear internationally in the press, as do reports of Salgado's many unusual travels that form part of the project. The topics of the photo-essay's four "chapters" are clearly seen in the range of images of *Genesis* made available to the public. The artistry of light and tone that is a hallmark of his photography is now applied to images representing a premodern world. In the Namib desert, sloping dunes of silvery sand roll miraculously before our eyes. On a dune crest, two lone gemsbok stand in stillness, to catch any pass-

ing gust of air. Not even the wind, it would seem, visits this place. The image is striking and eloquent: no footprint marks these virginal sands, no traces of man or buildings are in sight. The singularity of place and the infinity of time are framed here. A sense of stillness and eternity unfolds from the image, in implicit but sharp contrast to modernity's mad, meaningless descent into chaos and self-destruction.

In this way, *Genesis* concentrates on undeveloped spaces of the globe, untouched by industrial development. If these spaces have been left unspoiled, then presumably this is because they are not rich in resources, and are hence not exploitable. Modern man, in his technocratic path and in his zeal for conquest and power, has not converted these places to usefulness. Left undeveloped, the margins of the modern world that Salgado now visits remain in another age, in literally a different historical period, one that predates modernity and the overwhelming grip of capital. These places do not feature in the map of the developed or developable world. As such, they offer glimpses of another kind of relation between man and environment. In the Namib desert, for example, we see nomadic tribes who leave no permanent mark on the environment. The Xingu Indians of Brazil appear in Salgado's images as blending in with their surroundings, in harmony with water, fish, foliage. Their unselfconscious nudity emphasizes the natural. The Dinkas of Sudan also appear as one with their landscape: a tall, naked man leans against a tree, his legs entwined like the branches overhead (fig. 8). A harmony stretches out between his limbs and those of the tree. Both are bare, elongated, graceful. He is surrounded by his cattle, a life source from which he is inseparable. His hut with a thatched roof stands next to where the cattle graze, the clouds overhead white and shining like the backs of the cows. There is in this image and others like it an emphasis on the harmony of man in nature. Of the Dinkas, Salgado states in a brief essay accompanying the images, "The identification of the Dinkas with their cattle is complete. In the morning, they collect the cows' urine and use it to wash their faces and to flavour and preserve the milk they drink. They collect cowpat, dry it in the sun and burn it at night; the smoke keeps the mosquitoes away and the ash, smeared over animals and people, is a protective against insects and parasites."[88]

Despite this harmony, we know that the Dinkas live amid the violence of civil war in Sudan. Salgado reports that the sole signs of industrialization that he noted among them was the presence of Kalashnikovs, weapons now used instead of spears for warfare. This detail, of itself

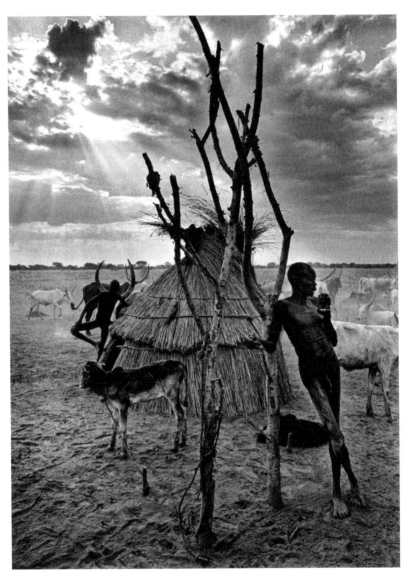

8

perhaps incidental, nevertheless brings to light numerous questions. For if *Genesis* is a visual meditation on forms of relation between man and the world that are different from those that predominate in modern ways of life, then this photo-essay in the making is also an exploration of the peripheries of modernity. Furthermore, this exploration is one that digs back in time, to premodern norms, practices, and values. It upholds the "natural" versus the "social" or the "economic," but without offering the viewer a bridge by which to make that move. Indeed there is no clue as to whether the global majority, harnessed to industry and technology, could ever turn to this other way of life. There are also no images as yet in *Genesis* that expose the damage already done to the earth. There are no images here of melting snowcaps or glaciers, no oil spills on beaches, no encroachment of desert, or parching of earth. Instead, we have nature in all its abundance and variety, home to man and beast, plentiful, generous, vital. Salgado's lens has merely shifted from the upheavals of modernization to the relative quiet of premodernity. Yet we see also the propensity even in premodern man to embrace the ills of industrialization, for why else would the Dinkas so eagerly drop their spears and pick up Kalashnikovs? Furthermore, does not the very fact of spears, or Kalashnikovs, as the case may be, point to an underlying penchant for violence that marks the human? To what extent, then, can Salgado, or indeed any other photographer, step out of his own historical moment and provide a God's-eye view of the world as it was or should be? More to the point, what practical purpose in the face of looming environmental disaster does such a representation serve? If we acknowledge the perils of global environmental changes and the urgency of making environmental concerns a priority, how do images such as these, that offer breathtaking images of "another" world to which most of us in the developed or developing world have no links, serve to show the way to saving the planet? How does what is, in effect, a photographic archaeological expedition, awesome though it is, help to secure the future, when it does not directly address the environmental wreckage wrought by modernization and its attendant practices?

Genesis, in my limited view of this work to date, is proof that no image or photo-essay of Salgado's works on its own. In order to make sense and be understood, it needs to be viewed against the backdrop of Salgado's other photo-essays—*Migrations*, for instance, with its insistent depiction of upheaval, struggle, displacement, and disorder, or *Workers*, which generates questions of alienation, nonrecognition,

and the sweat-drenched grit of hard, monotonous labour. The photographs of *Genesis*, in contrast, are still and calm. They show almost idyllic scenes: nature at rest, animals at play, mankind ensconced within the environment. In a contradiction of terms, the photographs release a kind of utopian nostalgia for a peaceful world far removed from that of the average viewer. When seen by themselves, the publicly released photographs of *Genesis* do not have overt relations to the sociopolitical contexts of late modernity, save those made clear in Salgado's own words that frame the images. If *Genesis* has a pedagogical mission—to show viewers how far they have strayed into disharmony with nature—then it can only be fulfilled via contrast with Salgado's previous work; without this vast panorama of displacement in mind, the images risk falling into the category of breathtakingly beautiful, but ultimately idealist, photographic ecotourism. However, when I look at these images against the backdrop of his previous projects, I see unfolding before my eyes a powerful vision of what we, as humans, have eschewed in our zeal for supremacy: oneness with our surroundings. As Salgado declares, "*Genesis* is without doubt my last great personal adventure. . . . I have spent years showing the dignity of mankind. Now I want to show that of nature."[89]

Genesis is also, one cannot but note, the first book of the Bible. The biblical resonances of Salgado's *Genesis* aptly highlight a debate that at once is closely tied to environmental issues and also has its roots in interpretations of the book of Genesis. This debate is also at the heart of Salgado's efforts, for his purpose in exploring alternative relations between man and land is ultimately aimed at questioning the values that accompany the globalized, materially ambitious, and power-hungry way of life. The question at heart is what man's place is in the framework of the world as a whole.

This is an issue that has fomented much debate. The philosopher Peter Singer has approached the subject by examining a quote from Genesis: "And God said, Let us make man in our image, after our likeness: and let them have dominion over the fish of the sea, and over the fowl of the air, and over the cattle, and over every creeping thing that creepeth over the earth."[90] This statement, according to Singer, has debatable interpretations: on the one hand, it implies a man-centred universe, where man alone is made in the image of God; on the other, many would say that it should not be viewed as a license to do as we will with the earth. Yet, Singer states, the fact that God drowned every creature

but those saved in Noah's ark in order to punish mankind means that "it is no wonder that people should think the flooding of a single river valley is nothing worth worrying about."[91] Singer writes against dominant mores in the West whereby environmental values are shaped by human interests, arguing instead for a much greater sense of value to be attached to animal life, so that interest and worth is more equitably distributed across different forms of life on the planet. In this context, Singer draws connections between Judeo-Christian teachings and the course of modernity.

Numerous scenes from Salgado's photography recall episodes in the Bible. They also recall his earlier work—penguins making their way up a hillside may evoke the miners of the Serra Pelada, as a gorilla looking into the camera mirrors a subject from *The Children*. Yet *Genesis* marks a shift away from a man-centred universe, as seen in his earlier, unswerving focus on the human condition, to one that celebrates creation in its entirety. Underlying this shift is the message that only by adopting such a view can man save himself from ultimate extinction, for he cannot survive without the natural resources around him. By seeking out the far corners of the earth that have been overlooked in the race for modernity, Salgado points toward the lost harmony of things.

Can man, in his condition of exile, really hope to regain that lost paradise? Perhaps not. Unlike the photography of Ernst Haas, for example, who sought through his book *The Creation* to joyfully invoke imaginings of early life, *Genesis* is not an merely an elegy to a paradise lost. *Genesis* is a serious study of the margins of the earth, peripheral spaces that raise the interrogative on centres of power. *Genesis* does not issue an invitation to revisit the modernist nostalgia for an impossible purity of being. Rather, it urges viewers to question the concept of civilization by regarding it from the edge. In this way, and like in his previous photo-essays, Salgado once again takes the viewer through his photographs to the limits of modernity. From the peripheral position of the photograph, one is able to consider the concept of civilization through a form of vision that is not so much exploration as it is deconstruction. In many ways photography is a marginal medium, one that offers the mask of reality through the artifice of representation and so hovers between the two. The restless move of the margin, the potential of images to make us question and to think, lies in this peripheral role of photography—always absent, always removed from the reality it evokes, yet proffering a kind of presence, while also positing other frames, other

images that traverse and intersect the photograph before us through imaginative but silent transpositions of time and place. For *Genesis*, these other images must be those from *Workers*, *Terra*, and *Migrations*, for it is in this juxtaposition that we witness the impending and surely insane apocalypse unleashed on us all by modernity, industrialization, and late capitalism.

In Solidarity's Name

It should be clear from the discussion thus far that Salgado's work, when considered as a whole, fights for a kind of solidarity across the planet. Regardless of where he points his camera, there is little doubt that his target is intentional. Until he began *Genesis*, many assumed that Salgado was above all a photographer of human displacement. Now one can see the ulterior motive behind his representations of displacement, namely a holistic desire to forge community and solidarity between man, beast, and nature. This focus reveals myriad subjects, living in specific contexts, landscapes, and cultures, but connected umbilically to the earth and, by extension, to one another. As such, this focus is on collective possibilities; this invitation to enter into the debate or, more to the point, to join forces in a common struggle to make this a better world, is a call to vision. It is thus curious, perhaps, to refer to Salgado as a documentarian, though this is a term that he himself uses. True, he does travel distances to photograph people, animals, and places. However, his images are not just about what they show: they are about what they suggest or project. They are imbued with a powerful aesthetic. This quality stands out, draws the viewer in, and leaves an imprint on the viewer's mind. Salgado's work invites, above all, envisioning. He is an image maker, one who goads viewers on to imagination. His aim is to forge a new vision, not of a specific place or a specific group, but of the causal structures of the planet as a whole. His images lead viewers to the threshold of possibility. Reality is refigured and turned into visions of what could or should be. Ideologically charged, his work offers an arresting blend of an almost Marxist emphasis on the revolutionary powers of the often ignored, always posed against the backdrop of a larger planetary upheaval, and a mystical, even quasi-religious, ability to exalt the ordinary into awe-inspiring, extraordinary visions, bathed in shards of translucent, silver light.

2

Engaging Photography

Between the Aesthetic and the Documentary

> I went to an exhibition in Barcelona of African art. What I saw
> there were everyday things—cooking pots, household objects,
> things from everyday life. They were practical objects, but there,
> removed from their social contexts, they had become art objects.
> This is also what I do. I photograph everyday life. I am there, in the
> moment. My photographs show reality. But then the photographs
> can be seen as art, even though they are documents.
> SEBASTIÃO SALGADO, in interview with the author,
> Amazonas Images, Paris, December 11, 2007

AS I LEAF THROUGH the initial pages of *Workers*, I encounter the
gaze of Edna Aparicia da Silva. A Brazilian sugarcane worker, she sits
in the middle of a cane field on what must be a makeshift stool during
her lunch break. She still wears the protective uniform that her job re-
quires: a hat, leg shields, a long-sleeved shirt, despite the heat. I see
her sitting down after a long morning of hacking cane. The slant of her
shoulders, the curve of her back, speaks of the weariness that besets
her. I imagine her, like the workers in the adjacent images, bent over,
thrashing the long rods, raising the machete over and again in wide,
powerful strokes that cause the cane to shudder and fall. I imagine it
strewn on the ground and in our mind's eye I see her struggling to lift
the long, unwieldy poles that contain within them the sweetness of

this earth. I imagine the midday heat and rising within us then are the same hunger and the thirst that Edna must feel. She is to me at once a heroine, a "warrior," as Salgado terms her and others like her,[1] engaged in a primitive, almost primeval, struggle between man and his environment, and a victim, one more link in a long history of exploitation, branded by the scars of slavery. She is one of millions of *boias frias*, the Brazilian term for the nameless workers of this world who take a small tiffin of food with them to their places of work to see them through the day. Seated next to her are two others, also sugarcane workers, dressed like her and eating their cold lunches. Enveloping them in this private moment of rest is the uniformity and anonymity of sugarcane production. Like so many of Salgado's subjects, Edna looks out at me from the photograph, across the numerous geographical, social, political, and economic frames that divide her world from ours. Her eyes are still and focused, her demeanour grave.

A silence descends on me when I return her gaze.

What Can I Say?

In the BBC Omnibus video *Looking Back at You*, Edna sits leaning against a doorway, a copy of *Workers* on her lap. An unexpected juxtaposition confronts me, as I watch the video, between this glossy book that lies on our table or sits on my shelf and its twin placed in Edna's hands in the rough, impoverished context that is hers. Her frayed T-shirt provides an unsettling backdrop to the immensely beautiful images in the book, images that celebrate the perseverance of the human spirit in the midst of labour and hardship. I note the dry, brown skin of her hands against the sheen of the photographs. Edna leafs through the pages of sugarcane workers, representations of lives such as hers. She stops to look briefly at photographs of herself and other sugarcane workers and then moves on to the section on tea, which takes place in Africa, another place, another product, but the same socioeconomic inequalities.

"What do you think of the fact that this book sells for around $120 in America?" asks the reporter.

"$120? That's a lot of money . . ." Edna replies.

She looks down at the photographs and turns the pages. Then she looks up and smiles wryly: "What can I say?"

The question is pertinent. It is also one that courses through this book, providing fallow ground for thought. What can be said about the

role of photographs that claim to document social reality in the contemporary world and also claim a place in the market for artwork? In what ways and by what means can images that transform the grit of social reality into highly aestheticized representations be read? In turn, what statements do such photographs make of the world and to whom do they speak? What, in the final turn, is the impact of such photographs on the way we, as viewers, think, see, and act?

This chapter aims to explore the complex, unresolved tensions that emerge from Salgado's work between, on the one hand, socially engaged, documentary representation via the still photograph and, on the other, overt espousal of the aesthetic combined with marketability. In the face of conflicting opinions on and around the ethics of representation, debates around the aestheticized representation of social reality will be considered in the larger, overriding context of postmodernity and capitalism. These issues in turn touch on critical debates on cultural representation that have developed over the twentieth century, and any attempt to grapple with them must inevitably refer back to the crucial theorizations of aesthetics engaged in by Walter Benjamin and Theodor Adorno in their efforts to disentangle the complexities of culture, art, and politics in the modern age.

Arguably, Benjamin and Adorno departed in different ways and to different extents from a common theoretical ground of Marxist thought, with its concomitant emphasis on the social and on labour. This commonality translates into a concern with history—rethought in their case against the grain of fascism—which is, in my view, also axial to Salgado's work when considered in terms of global capitalism. So too is this concern with history relevant to the photograph as a medium per se, by definition a trace of lived experience, the flash of a moment now deceased. The key question posed by this chapter revolves around the potential of Salgado's photographs to render, rewrite, and re-present history, an aspect of Salgado's work that I explore here in the context of debates around the aesthetic in socially engaged photography, and more specifically in the next chapter. How can socially committed documentary inhabit the same frame as liberal aesthetic? How can the poverty of the displaced subject be reconciled with the market value that images of such subjects command? To what extent can the lived experience of suffering or injustice be conveyed through photographs that must also be seen and treated as works of art? To whom, in whose defence, and by what means do they speak?

Primitivism, Documentary, and Art

Salgado is by no means treading new ground when he converts the rough realities of the less privileged into photographs with exceptional aesthetic appeal. Indeed, in so doing, he recalls endeavours in visual culture that predate his photography by several decades. He also thereby frames the dichotomies of modernity, through which the demarcations of document and art, the civilized and the primitive, and the European and the non-European are blurred, placing a question mark around the very premises on which modernity purports to function. Western visual artists have often taken their inspiration from art created by those they view as "other." Salgado's statement, given as the epigraph to this chapter, calls forth the efforts of the primitivists, who sought to revitalize the limitations of modern art and rationality through a turn to artwork which supposedly lay outside of the boundaries of the modernized world. From the late nineteenth century onward, artists such as Paul Gauguin, Pablo Picasso, Constantin Brancusi, and the surrealists all looked to various forms of non-European visual art in a bid to cross the boundaries of the artworld as they knew it.[2]

The very idea of "primitivism" is, of course, poised upon the notion of that which is primitive, and hence not part of the "civilized" world. This dualist and typically modernist premise often pointed artists in the direction of non-European, especially African, art forms such as sculpture. Oceania was also a place of interest for the primitivists. What they sought was the tribal and the non-modern, and they used these aesthetic parameters and paradigms as inspiration for their own work. The result is that much "modern" Western art is the hybrid consequence of the artistic intercourse between the European and the African, the modern and the non-modern, the "civilized" and the "tribal." In the way the hybrids of postmodernity often do, the resulting artworks often throw questions back onto the very modern premises that led to their creation in the first place, in unexpected and very postmodern modes.

Primitivism is primarily associated with art, but photography's documentary efforts have often followed the geocultural routes laid down by the primitivists. It may well be, however, that the politics of photography do not coincide with those of art, simply because photography always takes its cue from reality. When Salgado speaks of the transfer of everyday African items to the exhibition hall and when he likens his work to this crossing between the utilitarian and artwork, he brings

to light a perspective on his photography in which document and art collide in postmodernity through a focus on the realities of the global south. However, because photography is still thought to be primarily rooted in documentary and because the modernist imaginary still resists the blurring of distinctions between document and art, his work is both politically provocative and objectionable to some. Their discomfort is exacerbated because Salgado's work also straddles the boundaries of social class and economic well-being. His images pit the disenfranchised subject from the global south against the well-to-do viewer from the global north. In so doing, and as I argue in this book, they also issue a call for engagement and regard that is put forth by and through the aesthetic. This directive, as I see it, is one of the prime drives in photography such as his.

Herein lies a difference between photographers such as Salgado and the primitivists. The latter sought to extend and reimagine possibilities for modern art. The Eurocentricity of such art was not diminished by their efforts, even by the likes of painters such as Gauguin, who spent much of their lives "elsewhere." To some extent, they did open spaces for otherness in European visual culture; mostly, though, they will be remembered for enhancing and revitalizing modern European art through an appropriative turn to alterity. Photography, in contrast, has no fixed geopolitical frame. It challenges the very premises of modernism and opens visual representation to multiple and unexpected dimensions that are at once cultural and political.

An Other Subject

The video clip in which Edna views herself represented in *Workers* confounds any presumed demarcations separating the viewer from her as the subject that is viewed. Those who have seen the video can only ask themselves how Edna might relate to the image of herself. Her ambiguous answer—*What can I say?*—leaves much room for speculation. Nevertheless such ambiguity is precisely what Salgado might seek: for in that brief scene where the impeccably finished volume of photographs is juxtaposed against the harsh grain of Brazil's sugarcane plantations, that moment when "our" world shifts to approach "hers," when the focus of the questioning lens turns from "her" as subject to "her" now positioned alongside "us," as viewers, we glimpse a double framing that occurs in the act of photographic representation. It is not Edna

as subject who is framed in the last instance, but Edna as viewer. The response that is sought through the image must ultimately be that of the viewer. What can the viewer—Edna, you, or me—say of what she or he sees before them? Therein lies the final target of the photographer's lens.

In order for the photographer's lens to transfer its focus from the subject of the photograph to the viewer, though, the image must first take us beyond the frame of our own lives. The image must itself transcend the confines of closed, visual statement and enter the interrogative in order to release the act of viewing into a moment of epiphany. Such epiphany implicates the viewer, who is caught in a flash of translation, indeed translocation, of the self. The photograph has thus to establish a range of contexts, questions, and meanings that are at once interlocked and expansive, through which the viewer imaginatively travels. If the photograph is by definition a medium with migratory potential, defined by its propensity for dissemination, then it also must force on the viewer a migration that unsettles the safe or established parameters of the latter's worldview. To so force a displacement on viewers, albeit via the image and the imagination, is to engage them in the course of a different light.

The elision from "them" to "us" may occur instantaneously, indeed in a flash, in the act of viewing a powerful image, but it is complex and problematic. Numerous questions come to mind with regard to photographic encounters and journeys, but perhaps the most crucial one concerns the radical, if multi-hued, location of the visual in our contemporary world. Writing in the mid-twentieth century, Berenice Abbott, the American photographer and academic, states, "The world today has been conditioned, overwhelmingly, to visualize. The *picture*, has almost replaced the *word*. Tabloids, educational and documentary films, popular movies, magazines and television surround us. It almost seems that the existence of the word is threatened. The picture is one of the principal mediums of interpretation, and its importance is thus growing ever faster."[3]

Abbott's assessment of the overriding importance of the visual in the contemporary world places the image at the nexus of the historical movements that typify our times.[4] Modernity, marked by the proliferation of the visual, is perhaps best apprehended by the photograph, a cultural medium whose historical development has progressed in tandem with the course of our era itself. Not surprisingly, the contradic-

tions of modernity—its utopian narrative of a linear and progressive history combined with the upheavals and displacements of its practices, its "maelstrom," as Marshall Berman so aptly put it[5]—are reflected in the medium of the still photograph, which selects, dislocates, and projects even as it proffers the guise of an unbroken realism. Postmodernity, with its acceleration of spatial complications and temporal disruptions, is marked by the spread of capitalism around the globe. As transnational connections have increased and as capital has consolidated its encroachments on global terrains, so has the visual taken on an ever-increasing importance in the negotiation of culture and politics in daily life. Cultural media are also subsumed in the commodification imposed by capital—the advertisement, with its larger than life, eye-catching, and desire-inducing images, being perhaps the example *par excellence* of such capitalist appropriation of the visual. The photograph, symbolic by definition, ambiguous in meaning, and defiant of interpretation, has since its inception been subject to the demands of modernity—and hence, capital. According to Mary Warner Marien, Lewis Hine had a distaste for the photo-essays of *Life* magazine, which, to his mind, fetishized reality.[6] Hine preferred instead to present his images and accompanying text in a nonlinear fashion, thereby creating the "photo-story" that was held together by ideas. Nevertheless many of Hine's own images were structured in their presentation.[7] Evident here is the challenge faced by many photographers in attempting to overcome commodification. At the same time, photographs have the potential to overturn such "fetishes" and to bring into view kaleidoscopic constellations of significations arising from within their frame, to release historical imagination.

If photographs are symbols of lived reality, they are also metaphors. This tension is particularly relevant in the case of the photodocumentary. The alignment of photography with realist representation has both elevated the medium's instrumental value[8] and stripped it bare of its imaginative potential. Writing on what she calls the "industrialization of photography," Susan Sontag states that this "permitted its rapid absorption into rational—that is, bureaucratic—ways of running society." The photograph thus becomes a tool for the modern organization of society: "No longer toy images, photographs became part of the general furniture of the environment—touchstones and confirmations of that reductive approach to reality that is considered realistic. Photographs were enrolled in the service of important institutions of control,

notably the family and the police, as symbolic objects and as pieces of information."[9]

When information, as opposed to imagination, is at play, then the image becomes confined to the two-dimensional. Thus, all reference is seen to be concentrated within the frame, and the image comes to signify nothing more than what meets the eye. Furthermore, the photograph as document must contend with the proliferation of other visual media, such as newsreels, documentary films, and television, leading to a plethora of informative images that threatens to benumb or satiate the viewer's sensibility. Nevertheless, what distinguishes the still photograph from other visual media is precisely its stillness. The appearance of boundedness, of the frame, serves only to invite a transgression of the same. The force of the photograph as a cultural medium derives from the challenge that it presents to interpretation, or, in other words, to a single reading. John Berger, in this context, states that photographs defy property value—that is, fixation—because they are reproducible.[10] In a subversive move that is typical of modernity's many unfulfilled attempts at stability, the photograph can co-opt its own stillness and force a refiguring of the status quo through the infinite multiplications that it may undergo, both in its dissemination and in the perceptions or perspectives that it offers to the viewer. This resistance to fixation can also be seen as the invitation that photographs may issue to engage with the complexities of time and space in postmodernity. When this happens, then the photograph, a fragment per se of lost time, may well interject into the present with the imperative of history.

Debates and Paradigms

Not everyone would agree with this characterization. It is important to recognize that a long-standing and unresolved debate exists between those who critique the aesthetic in documentary photography and those who are compelled by it. Indeed, tensions between, on the one hand, scientific realism of the kind afforded by the technology of photography and, on the other, the aesthetic have a long history that harks back to the nineteenth century. From the start, the photograph has stood at the nexus of these tensions and exemplified them. The very mutability of the photographic medium inevitably means that no resolution can be reached to this debate; yet, it is vital to analyse and understand such diverse perspectives if the multidimensionality of aesthetic photodocumentary is to be appreciated.

The twentieth century witnessed the spread and rise of photographic documentary in tandem with the increasing aestheticization—and by extension, the rising art value—of such images. The result has been a deep and growing rift in the reception of such photography, especially when bearing in mind the overriding contexts of neoliberalism that many auteurs of such work espouse and that many critics of such work decry. The artist and critic Martha Rosler, for instance, provides important ways of thinking through and against the aesthetic in documentary in her essay "In, Around, and Afterthoughts." She identifies two moments that mark the documentary image: the immediate one, where images are selected and framed as testimony to lived realities, and what she calls the "aesthetic-historical" moment, less definable in its boundaries, in which "the viewer's argumentativeness cedes to the orgasmic pleasure afforded by the aesthetic."[11] The first moment marks the lifting of the image from the grit of lived experience; the second denotes its transposition to the realm of the aesthetic, which affords merely pleasure and the veneer of engagement with the grit from which the image was selected. What Rosler signals here is the chasm that separates, on the one hand, the sense of social commitment that led the photographer to select the image in the first place and, on the other, the migration of the subsequently aestheticized image away from its historical context, as it becomes subsumed within the realm of the aesthetic. Indeed, Rosler states that this disconnection from lived time translates into a timelessness or "aesthetic eternality" that is ahistorical and so without engagement. At play, explains Rosler, are the power relations between dispossessed subjects and a neoliberal rhetoric that is "safe" and distanced from activism. We see that the aesthetic affords the sheen of credibility to the image, thereby legitimating it and so abnegating its subject. According to Rosler, "The Right wishes to seize a segment of photographic practice, securing the primacy of authorship, and isolate it within the gallery-museum-art-market nexus, effectively differentiating elite understanding and its objects from common understanding. . . . Thus, instead of the dialectical understanding of the relation between images and the living world, that I referred to earlier—in particular, of the relation between images and ideology—the relation has simply been severed in thought."[12]

In Rosler's view, cultural legitimacy gained via aesthetic appeal strips the documentary image of any potential to bring about change, turning it into a commodity that is then housed in elite spaces to proffer the guise of activism. She calls this the "liberal documentary," one that

makes generalizations about the condition of "man" as a universal, removing thereby the historical possibility of the struggle for change.[13]

Rosler wrote this essay in 1981, prior to the new dimensions of space created by digital technology. What would she make of digital photography and, in particular, of the digital self-representation that circulates on the web and remains clear of economic profit? Is it the authorial stamp of a photographer, such as Lange or Salgado, what she objects to? Or is it that aestheticized images of social realities supplant activism through the surface seduction of film? Is it that a "radical documentary," as she refers to a documentary that has the potential to incite change, cannot really exist within the marketplace? If Rosler eloquently marks out her concerns around the aesthetic, then she does not make explicit what form of visual representation would actually be appropriate for bringing about a programme of social change. Nor is it totally clear what exactly constitutes an image tied to activism, as opposed to one that is aestheticized and hence timeless and disengaged.

Rosler's writing unsettles my responses to Salgado's work. It imposes itself onto my line of vision and causes me to rethink his photography. By adopting her view, I see no future for Salgado's highly aestheticized images, no possible exploration of any historical, ethical, or political potential in his work. Would it have been better, I ask myself, if, instead of aestheticizing the starving in Africa or the landless peasant or the refugee on the road, Salgado had not brought these images to our attention at all? Or is there a way in which he could or should have done so otherwise? Is there a "correct" way to document via photography? What do I see in his images and how do I read them? Is the aesthetic necessarily divorced from the activist? Or can they be reconciled? Is not the aesthetic somehow tied to the ethical, the political?

A Stillness So Intense

If Salgado is today the world's most celebrated photodocumentarian, then one wonders what aspect of his skill elevates him so much above and beyond the creators of countless images of social reality, of less fortunate people and places, of wars and suffering, that bombard the line of vision of those who live in today's information society. What is it that makes one stand still before an image of Salgado's, be it of the epic saga of Brazilian mine workers, of the drifting silhouettes of famished Africans, or of the child living in the deprived conditions of a refugee camp who looks at us with earnest eyes? What is it in his images that high-

lights and celebrates the human spirit in the midst of degradation and poverty? More to the point, do such images veil the specificity of their historical contexts and offer instead a hymn to mankind that devolves into myth and rhetoric?

There is no doubt, to my mind, that some images cause us to visualise in a way that many others do not. We pass on a daily basis from image to image as we read newspapers, leaf through magazines, watch television. Yet, and often in ways unbeknown to us, some images impose their reflexivity on us, forcing us to search beyond the confines of what we see or know. Roland Barthes, in his seminal text on photography *Camera Lucida*, writes extensively on what it is that distinguishes what he calls the *unary*, or frozen, one-dimensional photograph, from that which somehow pierces the viewer. The unary photograph strives for unitary coherence and thus issues a single reading. It aims for a singularly undisturbed passage from reality to image and so refuses the refraction of its frame. Most journalistic photographs, he stresses, tend to be unary. Like the newspapers in which they come, they interest the viewer but leave no mark: "News photographs are very often unary. . . . These journalistic photographs are received (all at once), perceived. I glance through them, I don't recall them; no detail (in some corner) ever interrupts my reading: I am interested in them (as I am interested in the world), I do not love them."[14]

Instead, the photograph that wounds, that attracts or distresses, is one that bears the fissure of what Barthes refers to as the *punctum*. This, he states, is often a detail, insignificant of itself but one that arouses a visceral reaction in the viewer. Such details, he goes on to say, "'prick' me."[15] Small as the detail may be, it comes to occupy the image. Furthermore, it transcends the image and leads the viewer on to imaginative travel:

> However lightening-like it may be, the *punctum* has, more or less potentially, a power of expansion. This power is often metonymic. There is a photograph by Kertész (1921), which shows a blind gypsy violinist being led by a boy; now what I see by means of this "thinking eye" which makes me add something to the photograph, is the dirt road; its texture gives me the certainty of being in Central Europe; I perceive the referent (here, the photograph really transcends itself: is this not the sole proof of its art? To annihilate itself as *medium*, to be no longer a sign but the thing itself?), I recognize, with my whole body, the straggling villages I passed through on my long-ago travels in Hungary and Rumania.[16]

There is much to note in Barthes's words. As the viewer of this image, he feels himself transported to the reality of the subjects. Unlike the unary news photograph that he glances at and then dismisses from his mind, the dirt track that the gypsy and the child stand on beckons him and displaces him from where he is. He too is compelled to take up the road and embark on the migratory pursuit of an *elsewhere* and *another time* via the photograph. This transportation is made possible because of the verisimilitude of the photograph, its adoption of the mask of reality—the notion of the photograph as mask being one that Barthes also develops—taking on such a force of credibility that the viewer is caught unawares. The photograph invests the viewer with a history that he imagines, one that he gleans through the revelatory power of the image, and that he then enters into and assumes as his own. This fragment of lived experience transfers itself from the subjects of the image to the viewer. As Barthes points out, the photograph shifts from being a medium to being the "thing itself." In this play of deception, of mask, of the suspension of one reality—whether this be that of the viewer or that which is framed in the image—and the emergence of another apparent one, the suggestion of which is poised on the frame, the photograph exercises an art that cannot be ignored. The magic of the punctum, its ability to steal into the heart, the very body of the viewer, is made possible, not through the photograph's documentary ability to record reality as it happens, but through its artistic potential to awaken the imagination of other realities. More to the point, the punctum is also a reminder of vulnerability—that of the subject, the image, and the viewers.

The suggestion, implicit in Barthes's account of the photograph with punctum, that photography can be an art, invested with an aesthetic that beguiles the viewer, is not new. Nor, for that matter, is it one that finds consensus. Indeed, the question of whether or not photography should be considered an art, of whether or not photographers should strive towards artistic expression, is an area of long-standing debate, one that becomes particularly heated when complicated by the documentary import of images. Berenice Abbott was a strong believer in the destiny of the photograph to act as document. While she championed Atget as being a master of realist photography, she also derided all those whom she accused of having deflected the medium away from its "real" and realist role as a document of the here and now. She stated that, unlike poetry, painting, or dance—in short, unlike art forms—the

photograph selects and frames the details that make up reality. In this intransigent promotion of realism in photography, she was locked for much of her life in disagreement with all those whom she considered to be the "villains of photography."[17]

One such villain in Abbott's view was Alfred Stieglitz, who famously proclaimed the art value of photographs in his journal *Camera Work*.[18] Stieglitz, in stark contrast to Abbott, whose view is negative on the matter, positively likens the photographer to the painter, since despite the former's technological reliance on the camera for producing the image (as opposed to reliance on a line of continuity between eye and hand), both creators call on his or her sensibility in order to select, frame, and develop their image. The images that appeared in *Camera Work* were inevitably chosen by Stieglitz and served to support his belief that photography was indeed a fine art. For much of his life, Stieglitz's involvement with photography extended to include painting and sculpture, confirming his view that there existed a common artistic thread among different forms of visual representation. More to the point, Stieglitz was a relatively early, though forceful, campaigner for recognizing the aesthetic potential of photography. It is worth recalling that the art world at the time resisted accepting photography, deeming it to have solely the documentary function of representing reality through technological means. In such a context, Stieglitz was a pioneer in exploring and confirming the artistic and aesthetic potential of photography. Indeed, Stieglitz underlined over and again what he perceived to be a unique aesthetic, beyond that of painting or sculpture, which the medium possessed.

Stieglitz turned to the writings of Dr. Peter Henry Emerson for confirmation that photography should indeed be accorded a place in the realm of art.[19] Writing as he did in the late nineteenth century, Emerson's affirmations must be read against the prevalent uses of photography at that time in the construction of discourses of science. Taken at face value as a wholly realist document, the photograph had by then become an invaluable tool in the furthering of the Western-centred fields of knowledge typical of the modern age. Emerson expressed the revolutionary call to consider the artistic potential of photography thus: "A great paradox which has been combated is the assumption that because photography is not 'hand-work,' as the public say—though we find there is very much 'hand-work' *and* head-work in it—therefore it is not an art language. This is a fallacy born of thoughtlessness. The

painter learns his technique in order to speak, and he considers painting a mental process. So with photography, speaking artistically of it, it is a very severe mental process and taxes all the artist's energies even if he has mastered technique. The point is, *what you have to say and how you say it.*"[20] By likening photography to painting, or indeed to writing, as he did elsewhere, Emerson foregrounds its expressive potential. If, as he states, the point of the photographic effort is "what you have to say and how you say it," then photography certainly stretches far beyond the straight parameters that Abbott assigns it.[21] Indeed, today photography is perceived not merely as a realist document, but as invested with symbolic significance.

What surfaces in this debate is the aesthetic potential of the photograph. Even Abbott, with all her documentary rigour, stressed the importance of selection in framing an image. The photograph, she states, "should be a significant document, a penetrating statement, which can be described in a very simple term—selectivity."[22] Such penetration can also be perceived as the potential of the frame, which, through its deliberate and considered definition, invites the viewer to look both into and beyond the subject.

For Whose Good?

In interviews, Salgado often emphasises the ethical and ideological impetus behind his work, based on his understanding of global economics and social inequalities. Thus, in the video *Looking Back at You* (2000), he states, "We are building a society that produces more and more for consumption, but there are less and less consumers. I hope that we can work it out." However, he seldom comments on his own obvious and unwavering focus on the aesthetic, though this is of course a striking feature of his work. Indeed, this is an aspect that makes it unique, as important in terms of the impact made by the images as the underlying global vision that framed them. Emerson's alignment of photography with art is particularly applicable to Salgado's work. His images evoke Renaissance paintings, perhaps most obviously because, despite—or indeed, owing to—the abject struggles faced by the subjects, they actively seek out and celebrate the grandeur of the human spirit.

In his essay published in *An Uncertain Grace*, a collection of Salgado's photographs, Fred Ritchin calls the photographer "the lyric documentarian"—a contradiction in terms that is highly laudatory, but

that simultaneously isolates an area of acute tension in the reception of Salgado's work.[23] How can an image meant to be taken as a document also be lyrical? And if it is lyrical, then how faithful is it to the reality that is being documented? These questions touch on a troubling issue, linked to the incomplete realist endeavour to faithfully document reality,[24] an endeavour defeated by the inevitable reliance on symbol and image to convey, via the representation, not reality, but the *semblance* of reality. A yet more troubling question comes to mind when considering the fact that the dispossessed and the displaced of today's world form the majority of Salgado's subjects: is it right or acceptable that such lyrical images take as their basis the inequalities and displacements that affect millions across the globe?

Ritchin's term applies to Salgado what Emerson has already pointed out: namely, that photographs work at a symbolic level that enables them to offer an aesthetic to viewers akin to that of the painting or another work of art. This is a feature of Salgado's work that most viewers will readily acknowledge. Ritchin contends, "There is, enmeshed in his document of the moment—on Latin American peasants, famine in Africa or his current project on manual workers around the world—a resonating lyric, a sense of the epic, an iconic landscape. The former economist invokes a poetic sense of struggles so profound that, in large, moody prints, the forces of light and darkness, of life and death, are summoned in scenes reminiscent at times of the most dramatic Judeo-Christian symbolism."[25]

For many, it is precisely this quasi-mythical dimension of Salgado's images that is most arresting. Yet, bearing in mind that he is a photo-documentarian depicting the social realities of millions spread around the globe, the following questions posed by the journalist Nicholas Wroe want an answer: "Photo-journalism at this level continues to raise many problematic moral and aesthetic issues, and Salgado's unprecedented commercial success has made him something of a lightning rod for criticism. Is it right that such misery should appear on swanky gallery walls? Is the only person who gains from these pictures the photographer himself? What place do $100 photographic books have in a debate about poverty?"[26]

Wroe points out that although Salgado has brought the plight of starving millions to the attention of the world, his efforts have also brought him personal wealth and fame. Indeed, is it not the case that the most direct and tangible benefits of Salgado's images—despite the active har-

nessing of his work to humanitarian causes through his agency—have gone to him and his family? Salgado has spoken of his reactions to such criticism: "At first, I was shocked. I rang my lawyer, I said to him 'What shall I do? Should I sue? Or what? What does this mean for me, my work?' But then I realised that it doesn't matter. Different people say different things. You just go on doing your work, you do what you are supposed to do. You carry on."[27]

Perhaps the most stinging and widely disseminated critique of Salgado to emerge since his rise to fame is that of Ingrid Sischy, a staff writer at the time for the *New Yorker* and the former editor-in-chief of *Artforum* magazine. Sischy published her response to Salgado's *An Uncertain Grace*, as well as to an exhibition of his photographs of oil wells in Kuwait, held at the International Center of Photography in New York, in the *New Yorker* in September 1991.[28] Thanks to the article, she successfully turned herself into a prominent, and undoubtedly strident, censor of Salgado's photographic efforts, which till then had only received acclaim in public.[29] To date, her name remains emblematic of the kind of abrasive criticism reserved for those who dare transgress into the murky realms of representing other, less known, less privileged, or disempowered realities and then go on to receive international acclaim for their achievement in the name of art as well as humanism.

Unflinching before the views held by the large, world-wide following that Salgado had acquired, Sischy issued a litany of accusations against the photographer, countering on various grounds the very ethical fundament of his work. Thus, she claims that the poetic representations of his subjects undermine the latter rather than dignify them. The shockwaves produced by this article still reverberate and form the bedrock of the debate that this chapter examines. Regardless of whether one agrees with her or not, it is unquestionable that Sischy's article is noteworthy, if only because it raises key issues around the location of the photodocument in the larger context of late capitalism and the juncture of photojournalism and art. By extension, it also raises questions on curatorship and the relations between the elite space of the photographic gallery and the uncomfortable grit of the reality that permitted the images in the first place. In other words, and as Nicholas Wroe asks, how do books that cost $100, books such as the one held by Edna in the video clip described at the start of this chapter, relate to realities where such sums of money are totally unaffordable, realities as removed from the materially endowed, capital-driven centres of global hegemony as

Edna's unruly thatch of sugarcane? What links the "concerned" viewer of Salgado's images in places such as the International Center of Photography to, say, the bereft who inhabit the cracked earth of famine-stricken Ethiopia?

Sischy begins by querying the validity of exhibiting a photojournalist's work in a museum. Her premise appears to be that an impervious division exists between categories of photographer, the fine-art photographer being distinct from the commercial photographer, who in turn is distinct from the news photographer. In her view, photographers on assignment cannot be considered to be artists, and she therefore asks how it has come to be that these boundaries have been blurred in the case of Salgado. Furthermore, she isolates what she perceives as "a promotional tone" in the exhibition at the International Center of Photography.[30] Also on display, she states in a critical tone, was the issue of *Time* magazine in which the Kuwait photographs first appeared, together with an article commending Salgado on his achievements. In short, Sischy accuses Salgado of usurping the harsh reality of his subjects in order to promote himself. She further states that he borrows well-known figures from Judeo-Christian iconography in order to construct what she refers to as "his visual rhetoric" of images that recall religious art. Such work, she says, is "sloppy with symbolism."[31] Yet, she also accuses him of constructing a formal beauty in his photographs, of being far too concerned with the composition. For Sischy, Salgado's greatest failing is his choice to render his subjects in terms of beauty: "Salgado is far too busy with the compositional aspects of his pictures—with finding 'grace' and 'beauty' in the twisted forms of his anguished subjects. And this beautification of tragedy results in pictures that ultimately reinforce our passivity toward the experience they reveal. To aestheticize tragedy is the fastest way to anesthetize the feelings of those who are witnessing it. Beauty is a call to admiration, not action."[32]

Salgado's supposedly transgressive crossing of sealed categories of photographer—whereby he is an art photographer, a news photographer, and a commercial photographer all at once—results, in Sischy's view, in an aestheticization of his subjects, which ultimately alienates them within the frame. The result is a foreclosure of any possibility of proactive response from the viewer. For Sischy, Salgado fails to achieve his aims as a concerned photographer because of his method and style of representation. Sischy carries her critique of Salgado further, accusing him of turning tragedy into cliché through a supposed pursuit of

the "picturesque," the visually arresting, which renders his photographs inappropriate to the contexts they seek to represent: "We can be sure," she states, "that if truly appropriate images should ever surface they will not be so 'beautiful' that they could work as packaged caring."[33] In her severe criticism, Sischy's fixation on the inappropriateness of representing the disempowered via highly aestheticized composition becomes the critical pillar on which her assessment of Salgado's work rests. While Sischy expresses her criticism of Salgado in no uncertain terms, she does not offer any guidelines for how, in her view, photojournalism ought to present itself—save, that is, to suggest implicitly that it should not be excessively beautiful.

While her argument stands its ground, what becomes evident is that it is based on certain clearly defined demarcations between photographer and subject, first world and third world, self and other. Such concrete delineations also determine her view of what forms the central theme of Salgado's work: her accusation that Salgado aestheticizes tragedy implies that, in her eyes, tragedy forms the core focus of his lens. This, as many viewers will likely agree, is only partially correct. While Salgado does hone in on the plight of the global dispossessed, he would no doubt argue that the real focus of his lens is the hope and the potential that lies within humans, however abject their conditions of life may be. His later work, namely his coverage of the mission to conquer polio and his current project on the natural wonders of our world, make explicit an engagement and a sense of possibility that have always been underlying aspects of his work. Anyone who views Salgado's photographs and sees in them a celebration of life will also perceive Sischy to be afflicted by a certain tunnel vision. Her perception of Salgado's images is based on a fundamental pessimism, that tragedy is an end in itself. Her arbitrary separation of subject and viewer, confounded by the video in which Edna the sugarcane worker regards images of herself and her ongoing history in *Workers*, is an obliteration of possibility that confines Salgado's subjects to their unfortunate fates.

The polarity of Sischy's views, in which categories and classes of subject and photographer are clearly defined and marked off from one another, leads to a two-dimensional reading that inevitably collapses into the foreclosure of possibility, and hence hope. In this, her line of vision is in contrary direction to Salgado's own with regard to his subjects. Though he is facing them when shooting, nevertheless, his avowed premise as a photographer is one of "sharing" the subject's reality, of

speaking *from* the subject and not *for* him or her—hence his practice of spending long periods of time among his subjects, of getting to know them, of aligning himself as much as possible to *their* line of vision. To place tragedy at the epicentre of his intent is, quite possibly, to misunderstand, or at best to only partially understand, the many dimensions occupied by his work.

Sischy's critique, regardless of whether one agrees with it or not, nevertheless crucially intervenes in the ongoing debates on photography with its objection to the aestheticization of representations of social reality. In sharp contrast to Sischy, John Easterby, who worked alongside Salgado at the Magnum agency, states, "Many pictures from famine or from war border on the pornographic. But if people look at a picture and close their eyes or turn the page you have served no purpose at all. [Salgado's] pictures are beautiful manifestations of the unpalatable. He makes it possible to look at the unlookable."[34] In a similar vein, Nicholas Wroe quotes John Berger's defence of both the rendering of suffering in terms of beauty that is a hallmark of Salgado's work and the biblical echoes that reverberate through several of his images—echoes, it should be said, that have been keenly embraced by Christian charity organizations who find his images useful in promoting their own causes: "'For Christ's sake,' he explodes, 'I mean literally for Christ's sake. I've seldom heard a more half-baked argument. What about all the crucifixions in western art? What about the *Pietá* of Michaelangelo? Half of European visual art until the 20th century was about terrible things that at the same time were beautiful. In fact they were the definition of what people called beautiful.'"[35] These two statements, the one by Easterby and the other by Berger, bring to light the ambivalent location of Salgado's work between art and documentary, as well as the complex ways in which the two genres interrelate. On the one hand, Easterby sees the aesthetic serving the purpose of the document, by making the "unlookable" sightly; on the other, Berger situates human suffering in the context of art, foregrounding art, and hence by implication the aesthetic, as that which is forged from and inseparable from tragedy.

If the location of Salgado's work in relation to art is unresolved, then so too, as we have seen, are readings of it. Berger's words seem to imply that the images that Salgado creates should indeed be viewed as art, and that we in fact understand pain through the aesthetic force of art. What emerges further in this juxtaposition of criticism and praise of the aes-

thetic in photography with realist intentions—by those such as Sischy, on the one hand, and Berger and Easterby, on the other—is the unresolved tension that divides readings of Salgado's work. Clearly, those on both sides acknowledge the indisputable: namely, that the sheer volume of his corpus and its breathtaking global span make it impossible to ignore. Yet, by the same token, the questions must be asked: what good do such images do for those whom they represent? Should representations of human struggle and suffering be represented in terms of beauty? More to the point, to what extent are Salgado's efforts complicit in reinforcing or furthering the very historical and political contexts that they seek to uncover?

An Ambivalent Beauty

This black-and-white image is unforgettable (fig. 9). It is both shocking and extraordinarily simple: children born into poverty playing with the only toys they can find. The toys are the bones of dead animals. Laid out with meticulous care, as if they were pieces of LEGO, a shocking contrast arises between the bones and the youth and promise of children. This image from *Other Americas* is haunting. It depicts a commonplace scene, but highlights the abandonment of the indigenous population. It underlines global disparities in wealth—the toy industry, we must not forget, has burgeoned in the course of the twentieth century, as childhood in developed countries is nurtured as a special time of life and large amounts of wealth are spent on and generated from the giving of pleasure to children. Global similarities are seen here too: with or without "proper" toys, children across the world have the same imaginative potential. It is a reminder that, across the globe and despite huge inequalities, people have more in common than not.

That is not all. This image has a force that well exceeds what it displays. The tonalities range from deepest obscurity to the ray of light coming in from the doorway and illuminating the bones. There is a metaphor here, surely: one that highlights the role of the camera, bringer of light. The image rescues these children from total obscurity; it displays their abandon and also their presence. The camera as doorway opens up their space. Yet where, if anywhere, does it lead them? The child lying across the doorway in the scene appears blocked. The photograph announces both death and life. Its beauty is ambivalent, troubling, and strong. Is this the power of the aesthetic? What statement, if any, does it make?

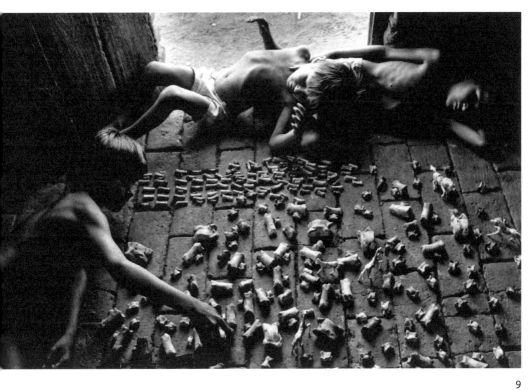

I wonder about the etymology of *aesthetic*: of feeling, of *perception*. This definition suggests that a link exists between aestheticization and perception. What have I perceived in this image? Has it spoken to me? Has it altered me in any way? How can I translate what I sense or perceive into a response—a form of activism or engagement, perhaps? Would "anaesthetic" documentary images prevent me from perceiving at all, as anaesthetics generally do?

The Critical Debate

It goes without saying that the world around us, *our* world as we perceive it and as it shapes us, intervenes in how we see. The interpretations given to an image, the significance read into it, may well owe more to the viewer's line of vision than to any intrinsic meaning contained within it. And so, what becomes apparent is the fluidity of the visual, whereby meaning is constructed from the multiple and changing intersections of personal and communal histories, angles of vision, and established parameters of thought confronted now with a new play of light. The photograph cannot be seen, therefore, as a statement of any single sort, but as an invitation to question, to associate, to translate, indeed to transgress. A dynamic exists not only between the viewer and the subject of photographs—or indeed between the viewer, the subject, and the photographer, obscured as he or she may be by the camera— but also between the viewer, the subject, the photographer, and the world or worlds to which they belong. Any act of viewing is also an act of translation, of displacing meaning onto new horizons of historical and temporal conjuncture. Acts of viewing, and the interpretations to which they lead, must also be considered in the larger sociohistorical contexts in which they are produced. Sischy and Berger, two of the most commonly cited commentators on Salgado's images, are poles apart. Enveloping them, nevertheless and despite the chasm of their differences, is the larger global context of late capitalism, which also frames Salgado's life and work.

If, as Salgado so often states, his work aims to intervene in current debates on globalization and its concurrent emphasis on capital, ownership, and profit in disregard of the human or even the humane, then such intervention must also be seen to emerge from, and indeed to endorse, this same larger global context. The aforementioned critique of Salgado's work would not stand its ground were it not for the fact

that Salgado's photographs must be viewed as one more product of late capitalism, to some yet another example of the perpetuation of self-aggrandizement of one powerful minority over the teaming disempowered majority,[36] this time in the guise of a "concerned" photographer who gleans his global stature from the misery of millions. After all, is it not true that the cost of purchasing a volume of his photo-essays would feed several of his subjects for days, months, or even years? Clearly, Salgado's focus on the dispossessed actually renders him vulnerable to the accusation that he exploits the very contexts and people that he represents as being exploited. While a fashion photographer, for example, as someone whose work unabashedly aids and abets the promotion of capital, receives little or no criticism for promoting and disseminating the cultural objects and images of late capitalism, a photographer such as Salgado, who seeks to critique or intervene in the course of the latter through his work, exposes himself to a web of complex accusations based on the intricacies of "writing against" capitalism from within.

The issue is hard to fathom. Yet, what is at stake here is clear: can culture steer clear of appropriation by capital? To what extent are all cultural representations subsumed within a larger system of global capitalism,[37] and to what extent can these cultural representations respond from within in order to offer different perspectives? If the practitioners of cultural production must themselves survive in an overwhelmingly capitalist world, how can they extricate their work from the contexts that generate such a world, even if their aim is to construct alternative historical perspectives? Furthermore, does the espousal of an overt aesthetic detract from such efforts? If so, would it be fair to say that, for example, the poet Pablo Neruda's arresting cry for an acknowledgment of indigenous histories in the Americas in his tender and moving *Canto General*, which is at once an immensely lyrical love poem for America and a majestic celebration of a land and its peoples, is weakened politically by its awe-inspiring poetic magnitude? Or on a more prosaic scale, should Eduardo Galeano, when writing about imperial exploitation in Latin America, have dehumanized his prose, throbbing as it is with the pain of a continent torn asunder by long histories of violence, in order to make it somehow more accurate? Must we reject Berger's point about Michelangelo and inversely read that pain presented via art remains trapped within its frame?

A triangular relation emerges through these questions between social reality, documentary representation, and the overall contexts of moder-

nity and postmodernity, which is also by definition a relation between politics and aesthetics within capitalism. The unresolved issues at stake fundamentally question the possibilities for ethical representation within an overall context of cultural commodification, whereby cultural "texts" become products for consumption and for the promotion of capital. In his book *Between the Eyes*, a compassionate engagement with the politics of photography, David Levi Strauss explores the role of the photograph in the contemporary world. He begins by quoting Wim Wenders, author of *The Act of Seeing*: "The most political decision you make is where you direct people's eyes. In other words, what you show people, day in and day out, is political."[38] Connecting Strauss's examination of photography, which ranges from social documentary to propaganda to personal photography, is an underlying humanism that frames the medium in a common global light. For Strauss, this context is specifically that of modernity as we know it today, where politics, and by extension ethics, human rights, and questions of justice, are trapped within the failure of democracy, itself stifled by the overpowering drive toward profit making. In this overwhelming spread of capitalism, the pain of human struggle—which is a direct consequence of the non-realization of democracy in its fullest sense, lived out in terms of needless and avoidable human suffering—becomes disregarded, forgotten, of little or no import.

Strauss seeks out the power of photographs to counter the grain of objectification and thus to remind viewers of specific histories of struggle. He begins by taking up what he calls the "documentary debate," the relation between the aesthetic and the political in the specific context of Salgado's work. For Strauss, if a representation is to be compelling, then its political content must be expressed via a deliberate aesthetic, what he refers to as its poetics. On this point, Strauss takes up his position vis-à-vis Sischy, using her critique in order to raise the problematic of the aesthetic in documentary photography. Clearly, from his point of view, it is not just *what* you show people that matters, as Wim Wenders states, but, indeed, *how* you do so. Thus, in order to "direct people's eyes," as it were, the aesthetic force of representation must exert its power. Strauss writes in defense of aestheticization: "To represent is to aestheticize; that is, to transform. . . . This goes for photography as much as for any other means of representation. But this is no reason to back away from the process. The aesthetic is not objective and is not reducible to quantitative scientific terms. Quantity can only

measure physical phenomena, and is misapplied in aesthetics, which often deals with what is *not* there, imagining things into existence. To become legible to others, these imaginings must be socially and culturally encoded. That is aestheticization."[39]

If, as Strauss states, aestheticization is tranformation, then it is also translation, whereby what is represented through the image relies on *form*, and not merely some attempt at faithfully reproducing content (an impossibility per se when one takes into account the defining force of the frame), in order to intervene across differences in social settings. Such acts of intervention must be interpreted in terms of their ideological thrust, so that choosing the form of an image is also a political assertion. Photography, perhaps the most versatile of cultural media and so universally accessible, is perhaps the most translatable of "texts" and hence the most prone to aestheticization. By extension, the photograph, aestheticized and inviting of imagination, becomes a potent political tool for alternative thinking, for thinking in terms of difference. Strauss writes of photography in the very real contexts of the atrocities and genocides of the late twentieth and early twenty-first centuries. Foremost in his mind, therefore, are the alarming hegemony of the United States, the global war on terror, and an ever more widespread capitalism, with its growing economic and political inequalities. In these contexts, the photograph is powerful precisely because its propensity for aestheticization allows it a malleability and a translatability not found in other visual media. In a polarized and unforgiving world, the fluidity of the still image casts ambiguities and questions into our minds, forcing us to interrogate both ourselves and the mental frames that define our sight.

If photography is by definition a modern medium, one whose development and dissemination has grown in tandem with the accelerated complexities of modernity and its numerous sociocultural processes, then its spread across the globe and its role as a defining feature of modern life is undeniable. So too is the fact that we live today in a world that is both surfeited by the image and unimaginable without it. In this excess of the visual that surrounds us, the image is inextricably tied to the capitalist way of life that it heralds and promotes. Iconic of and framed by capitalism, the still image is often itself captive of the machinations of late capitalism, a prime example of which is the advertising industry (and the countless images that it forces on us, promoting a consumer lifestyle where happiness depends on the ownership of ob-

jects that are always better, always new). The culture industry foists its visual icons, stylish or striking as these may be, but temporally fragile and spatially scattered, on viewers. In turn, the surfeit of images leads to the inuring of vision, and the imaginations and sensibilities of viewers become dulled. Meaning is presented as given, boxed and stagnant. Images are thus rendered *unary*, to borrow Barthes's term— closed, trapped within the frame. This stagnation and freezing of photographic potential is precisely what Salgado wishes to work against. In an interview with him, he stated, "I hope that the person who visits my exhibitions, and the person who comes out, are not quite the same. I believe that the average person can help a lot, not by giving material goods but by participating, by being part of the discussion, by being truly concerned about what is going on in the world."[40] The aesthetic works by way of invitation to participate in the big debates of our times. Salgado's images beckon loud through the aesthetic in a global context of excessive and ephemeral imagery.

It is at this edge of historical breakdown—at this point of the failure of the image to speak of an *elsewhere*, a *beyond*, when it becomes appropriated by capital and rendered entirely replaceable, as most of the products of modernity turn out to be—that the debate over the aesthetic in documentary representation reaches its climax. In the kaleidoscope of images that confront us on a daily basis, some images stand out, mark our vision, haunt us with their spectral force, and beckon us back. These are images with the potential to invite a response in terms of engagement from the viewer. And, what is more, it is not necessarily the drama of what they *reveal* that compels us so, but, indeed, the drama of what they *suggest*. It could be argued that such drama must be staged if it is to be seen and acknowledged. The photograph as theatre needs to be mounted, framed, placed under a spotlight.

It goes without saying that Salgado's images must be viewed in the context of the grave risk of forgetting that epitomizes postmodernity.[41] How many of us can remember the many still images that undoubtedly crossed our lines of vision today? Were they photographs in newspapers, on advertisements, billboards, bus stops, the walls of a living room through which we passed? How many of those images have drifted across our sightline without engaging us at all? Overtaken by the moving image in its many forms (the television newsreel having, in particular, dealt a life-threatening blow to the photodocumentary, which lived its heyday via news magazines, such as *Life*)[42] and rele-

gated to a status that is at times akin to that of wallpaper, the photograph is largely taken for granted. It often serves a purpose beyond itself, one all too often linked to the marketplace or to the certification of fact (my identity is confirmed because my face matches the image on my passport), and it rarely, very rarely, but certainly sometimes, takes the viewer to the edge of its frame. A confluence of diverse elements can be found on this thin borderline: questions of authenticity, art, representation, capitalism, and modernity as an age of unequalled specularity converge to turn the frame of the socially engaged photograph into a site of multiple and complex relations. Furthermore, the fluxes and shifts brought on by modernity's numerous restless strivings affect such relations and turn them into processes that mutate and alter, developing new dimensions and increased levels of complexity. Modernist in its origins and still regulated by the structures of form and content, the still photograph nevertheless must contend with its circulation and reception in the unstable, confusing, and pastiche-like cultural contexts of postmodernity. The tension between the aesthetic view and the engaged view thus becomes hard to resolve.

Nor is this debate a recent one. While it may show a heightened tension in the current age, it has prevailed as a chief concern for those who uphold the validity of reason. That which is aesthetically pleasing has long been perceived by many as being the antithesis of the reasonable, the political, or the engaged: indeed, and as Jay Bernstein describes in his essay on Theodor Adorno, in classical times, Plato banned the poets from his ideal state precisely because of a supposed incompatibility between the sensual, that is, that part of us that responds to and delights in the aesthetic, and the rational, dictated by the faculties of the mind, which was supposedly removed from the senses.[43] In so doing, Plato was also acknowledging the force of the aesthetic, though clearly he was at the same time, and perhaps arbitrarily, viewing the latter as a deterrent to the exercise of reason. Such divisions, pivotal as they are to the later imaginations and discourses of modernity, were also explored in their diverse ways by the artists of the Renaissance, by the romantics, and of course, in the twentieth century, by the modernists and the surrealists. If the twentieth century has witnessed the unparalleled course of modernity, and concomitantly of capitalism, through its numerous sociocultural, economic, and political changes, then artistic endeavours in this period have also systematically crossed and so challenged any arbitrary separation of art from reality. Visual culture is a prime

example of such crossings. More specifically, and as can be witnessed through Salgado's work, photography as a medium renders such oppositions ambiguous.

At a theoretical level, the development of aesthetics, as much a philosophical enquiry into the formation of modern, enlightened reason as into art itself, owes much to Adorno. In his key text, *Aesthetic Theory*, Adorno states, "Art is rationality that criticizes rationality without withdrawing from it."[44] He thus stresses both the critical potential of art—its ability to release debate and questioning, to invite *other* views or ways of thinking—and its inseparability from reason, and hence from all that reason presupposes to the modern mind: reason as the foundational stone from which modernity departs. Published in 1970, *Aesthetic Theory* owes much to the critical debates that took place between Adorno and Benjamin prior to the latter's death in 1940.[45] This dialogue was closely linked to the debate on the loss of aura, Benjamin believing that mechanical reproduction leads to the erasure of an object's aura—the technologically reliant and easily reproduced photograph being a prime creator of such loss—and Adorno insisting on the enduring, transcendent potential of the aesthetic.

The debate on the aura forms a key nexus in the development of critical theory, and hence aesthetics.[46] During his time at the Institute for Social Research in the 1930s, Benjamin wrote a series of articles for their journal, the *Journal for Social Research*. Their publication resulted in a correspondence between him and Adorno, in which Adorno offered responses to his work.[47] Amid the many critiques and comments that Adorno made of and on Benjamin's writings was a recognition of what he termed a "theology" at the heart of Benjamin's work, one whose absence he noted in the more recent journal articles. This, in Adorno's view, was the aspect of Benjamin's work that most intensely signified his engagement with the dialectics of the social and the economic. In short, it was in the "theological" aspect of Benjamin's writing that Adorno located the Marxist engagement. This theological aspect can also be perceived as Benjamin's concern with human experience, itself a reworking of a Kantian concern, whereby he both takes up and expands Kant's notion of experience. It could also be understood as an attentiveness to the mythological, the mystical, the magical, that which stands outside of defined reality. Benjamin spent the last decade or so of his life working on *The Arcades Project*, an exploration of what he called the "mythology" of Parisian architecture in order to uncover aspects of

nineteenth-century history. The launching pad for such a project was indeed the particular interpretation that he gave to Marxism in terms of the experiential: "The question is, in fact: if, in a certain sense, the base determines the thought—and experience—content of the superstructure, yet this determination is not a simple mirroring, how—leaving aside the question of its causal origin—is it to be characterized? As its expression. The economic conditions under which society comes to exists comes to expression in the superstructure."[48]

Central to this question of experience, articulated by Benjamin in terms of his interpretation of Marxism, is the notion of aura. For Benjamin, the aura is "a strange weave of space and time" and "the unique phenomenon of a distance, however close [the object] might be. If, while resting on a summer afternoon, you follow with your eyes a mountain range on the horizon, or a branch which casts its shadow over you, you experience the aura of those mountains, of that branch."[49] Experience therefore becomes the means through which aura is perceived, be the source of such aura natural or created. The experience of aura derives from viewing that which is distant, removed, and yet demarcating one's sightline. In the case of art, for Benjamin, the experience of aura is linked to a quasi-religious viewing, a glimpse in the artwork of that sacred link between religion and art that was central to representation in premodern societies. Invested by the viewer in the unique work of art, therefore, was a sense of the religious or magical, that which was removed from and beyond the daily realities of premodern life. For Benjamin, modernity and the mechanical reproducibility of art led to the weakening of this link, and hence to the decay of aura, tying art instead to a more social context of industrialization and the expansion of capital. An initial reading of Benjamin can lead to the mistaken view that he bemoans the loss of aura. In fact, Benjamin welcomes this decay, heralding instead what he sees as the politicization of art through its release from ritual (and, by derivation, magic, religion, and the mystical): "For the first time in world history, mechanical reproduction emancipates the work of art from its parasitic dependence on ritual."[50] If aura declines with mechanical reproducibility and the entanglement of art and politics, then the death of the aura, for Benjamin, announces a new dimension for art.

It is crucial for the concept of aura that at this point of the death of the aura as Benjamin perceives it, Adorno steps in with his critique. If, in his correspondence with Benjamin, Adorno had pointed out a reli-

giosity, a sensibility to the mystical as one of the strengths of Benjamin's early writings, then it is this element that he takes up in the name of the aura. How, Adorno asks, in the modern age, when art is invested with the politics of our times, can one distinguish it from political propaganda if it is not through a persisting form of the aura that shines through? Thus, just as Benjamin announces the decline of aura, Adorno takes up his argument for its transformation, at once pointing out a weakness in what he sees as the binary opposition of aura and its loss in Benjamin's argument and repositioning the concept of aura, instead, under the umbrella of the Hegelian concept of *Schein*. Despite the association with ritual and religion, a view that he shares with Benjamin, Adorno rescues aura in modernity through his perception of a progressive element in *Schein*, itself described as "an index of art's characteristic as an epiphany, a mode of manifestation of the truth."[51] Art, thus, is that which points to a beyond, to something more than itself, through an aesthetic that both outstrips the aesthetic of reality and also is linked to reality through a web of social signification. The social, and in particular social labour, provides art with a means to a dialectic for Adorno, thereby forming the driving force behind his theories on aesthetics. By the same token, it is the philosophy of aesthetics that allows the transcendent in art, its "truth-content," as Adorno termed it, to be salvaged.

Despite a joint concern with the concept and despite their dialogues and correspondence that linked their work, Benjamin and Adorno conceived of the aura quite differently. For Benjamin, it announced the mysterious, the remote, the magical; that which belonged to another time and place. For Adorno, influenced as he was by Hegelian idealism, aura was of itself revelatory of truth-contents in modernity. Far from being removed from the world, the aura, imagined in terms of Hegelian idealism but transposed to the social in Adorno's thought, was to be found in art itself and was thus a product of the social. It was also the means to new historical understandings. For Benjamin, the loss of aura in modernity released the work of art from tradition and invested it with a political charge. Aura itself was perceived in and through experience and not the result of the artistic production of modern society. Indeed, for him the latter was devoid of aura. As he pointed out in his letters to Adorno, aura was not confined to art, but could, as in his example of the mountains in the distance or the branch of a tree, be perceived in nature. A key difference between the two theorists' thinking

on this subject is that Adorno's focus was on the artwork as the epicenter of the aesthetic, while Benjamin located the aesthetic in terms of experience, that is, in terms of the viewer's reception of what is observed, be this nature or art. Furthermore, Adorno insisted on truth-content as the historical release of art, while Benjamin stressed the political charge of modern art. On another note, Adorno understood art not so much as a reproduction of reality, but as that which sheds light on the latter. Benjamin, in contrast, stressed the mimetic nature of modern art, its reproducibility, and its reliance on the mechanical and the technological.

If the question of aura remains unresolved, it has not gone away. On the contrary, the concept of aura has become central to our intellectual approximations to the aesthetic and, in many ways, it continues to shape our thinking in terms of art, the relation of art to social and other realities, and the politics of art. Benjamin died an untimely death, but Adorno carried his reworking of *Schein* in terms of aura forward to forge the field of aesthetics, a philosophical endeavour to grapple with modernism. In his retracing of the Benjamin–Adorno debate on aura, Robert Kaufman locates the notion of aura as central to contemporary critical thought. Aura, he declares, crucially "registers the potential of a collective subject's labour power and agencies."[52] In this statement the theories of both Benjamin and Adorno coincide. Connecting Benjamin's analysis of the loss of aura in modernity and Adorno's rescue of it via a repositioning in terms of the transcendental potential of modern art is a joint moment where they share the view that aura is conjoined to the labour of a collective or social grouping. Thus, the critical thought that the notion of aura generates is linked to the Marxist notion of socio-political praxis, and hence the political force of this concept. Following Adorno's trend of thought, if the aesthetic is that which houses modern aura, then it becomes vital to Marxist dialectics. To quote Kaufman: "Adorno therefore argues that those currents in twentieth-century art and criticism that emphatically celebrate an 'anti-aesthetic,' and that one-sidedly indict or eschew auratic aesthetic autonomy in romantic or nineteenth- or twentieth-century objects of study, thereby contribute—however unwittingly—to the destruction of genuinely critical response."[53] Additionally, at the heart of both Benjamin's and Adorno's notion of aura is, as Kaufman points out, the practice of lyric abstraction. Regardless of whether the aura sheds a quasi-religious light or whether it reveals truth-contents, it does so through an aesthetic of

lyricism. Both Benjamin and Adorno focused on experimental lyrical poetry in their explorations of modernity and aura. It is precisely through their studies of Charles Baudelaire—a key text on this theme being Benjamin's essay "On Some Motifs in Baudelaire," in which he traces aura to its collapse only to acknowledge the force of the lyrical, a force that can be interpreted as auratic—that these questions are pursued. It is also precisely through such means that Adorno points out to Benjamin that the apparent collapse of aura in the age of technical reproduction is also the signal for a modernist repositioning of aura in terms of lyricism.

Aesthetics and Photography

Photography, as Benjamin clearly recognized, provides a crucial testing ground for the question of aura. Reliant on technology and infinitely reproducible, the photograph is at the forefront of the plethora of cultural media of modernity, is the iconic symbol of postmodernity, and is without par in its propensity for simulacrum, dispersal, and manipulation. Photography did not come into existence in order to replace painting or indeed to serve the cause of art. It announced the mirroring of reality through technology and so promised a degree of fidelity hitherto unknown in visual representation. Interestingly, so common and so dispersible is the photograph that of all cultural media, it is perhaps the one that has least been theorized. Unlike cinema, the photograph seldom represents a world in itself; unlike the painting, it is not a unique work of art; unlike sculpture, it is not forged by the human hand. Its wide accessibility and the ease of its reproduction make it a democratic medium, defiant of class distinctions. Nevertheless, and in the same ways in which photography has been put to bureaucratic or scientific uses, it has also been turned into a key form of visual art. The careful processes of selection, framing, and lighting turn the photographic image into a window of time and place that arrests, suggests, and invites. The photograph steals into the viewer's heart in a way that a painting would find hard to achieve, not because of any superiority per se with regard to conveying a visual message, but simply because it tells of a past time, a moment of reality turned into trace and shadow. At the same time, this scrap of memory invites the imagination to project and to visualize. As visual representation, photography competes on par with traditional art forms. A close link exists, after all,

between fine art, and all that this connotes, and all visual representation via the image.

Philosophical attention to photography has been scant since the time of Benjamin (the theorists' names that come foremost to mind are those of Barthes, Sontag, and Berger), and yet the burgeoning of the field of visual culture in the latter half of the twentieth century has placed new emphasis on philosophical recognition of the links between knowledge and sight. The philosophy of art, known in other words as aesthetics, owes much to photography and its exploration of the visual. In turn, photography is theorized through the same discursive pathways as other types of visual art, and hence becomes engaged in an ongoing dialogue with such visual media, be these painting, cinema, or art installations. In these ways, the photograph offers within its frame a confluence of the diverse perceptions of aura engaged by Benjamin and Adorno. At once plebeian and elite, mechanically reproduced and artistically expressive, mimetic and original in its point of view, implicated in the capitalist impulses of modernity and yet empowered on occasion to critique the same, interrupting the present with the traces of the past and addressing the viewer in a constantly shifting present tense, the photograph speaks both of the death of aura and of its relocation in a transcendent aesthetic.

Salgado's work is emblematic of these different dimensions inherent in the photographic medium. Berger is by no means the first to compare his images to works of art. Indeed, numerous responses have compared them to the work of Hieronymus Bosch, among them Strauss's reaction to Salgado's famous images of Brazilian miners.[54] His images are also, in some unmistakable ways, reminiscent of early photography—not so much the daguerreotype as the ambrotype, whose tonality was also often enhanced by hand, with the use of a painting brush. As Salgado's photographs tour the world and feature in the most elite galleries of metropolitan centres, there can be little doubt that his efforts to visually represent the dispossessed have led him to seriously confound boundaries between document and art. Furthermore, and as Sischy pointed out, he is also a commercial photographer, one who openly supports his projects as a documentarian and artist through such work.

Today's neoliberal climate and the cultural complexities of late capitalism make it hard to disentangle the different facets of Salgado as a photographer or to extricate his documentary work from the marketplace. At the same time as engaging with the market, he is also a sup-

porter of nongovernmental organizations and other groups working to establish a more just socioeconomic order across the globe. In concrete terms, his support is rendered visible through his free donation of his photographs to such organizations as the Movimento Sem Terra for their use. Over and above the diverse spheres that frame them, Salgado's images have an aesthetic quality, an artistry of tone and light that have become synonymous with his name. Relevant to this discussion are both Ritchin's and Strauss's appraisals of Salgado's work, in which they underline the poetics of his vision.

The debate on the aura becomes all the more potent when regarded in hindsight, as postmodernity witnesses an extreme intensification of the contradictions of modernity. Furthermore, if Benjamin and Adorno wrote to one another against a backdrop of fascism, and if their tracing of the aura was an attempt to rescue history in the face of domination, then the overbearing grip of the neoliberal market today makes the question of aura and its potential to release history extremely pertinent; at the same time, and in disturbing contradiction, equally pertinent is the question to whom and by what means can such history speak?

As I began ruminating on these questions that inform this chapter, and by what I deem to be an uncanny coincidence, an unusual exhibition of Salgado's work was held in the UK. Paul Arden, formerly the creative director of the global giant among advertising firms, Saatchi and Saatchi, and owner of the private art gallery Arden and Anstruther in a small village in West Sussex, was exhibiting his collection of "Salgados," some of which had never before been shown to the public, throughout June 2005.[55] The collection of approximately seventy to eighty "Salgados" brought together diverse aspects of the photographer's work. In a brief article in the *Independent*, Arden describes his reasons for collecting Salgado's images: "What I like is that Salgado not only tells a story, but that he has a slightly graphic eye, so he makes the pictures look good. They have a style to them, in terms of their composition, as well as the interest of their commercial content."[56] This exhibition differs from the norm with regard to exhibitions of Salgado's work in the fact that, by dint of his former post at Saatchi and Saatchi, during which time he commissioned commercial work from Salgado, Arden has among his collection images taken by Salgado that belong to a publicity campaign for Silk Cut cigarettes. Two of the images accompany Arden's piece in the *Independent*. They come as a shock. The global trajectory of tobacco is, after all, not so dissimilar to that of sugar. How

could Salgado, who, in *Workers*, takes us to the tobacco fields of Cuba, where men and women engage in the painstaking labour of preparing tobacco, now promote the very brand names and products of consumerism that leave such workers unrecognized? Furthermore, should an engaged photographer become involved in the promotion of cigarettes, proven to be harmful to health?

Arden proudly exhibits Salgado's "concerned" images alongside his "commercial" ones: clearly, the criteria here are purely aesthetic, each image having been chosen for its art value. These photographs are both unlike and similar to images that I have seen elsewhere in his photo-essays. In one shot in Papua New Guinea, a row of scantily clad mud-men hold a screen of silk as if it were a shield. Like the Brazilian miners of the Serra Pelada (also covered in mud), the mudmen remain anonymous, representative of their ethnicity, each a part of the larger group. But unlike the Brazilian miners, who speak powerfully of and against industrialization and globalization through the exploitation of human labour in the name of capital, these mudmen signify community, tradition, and ritual (that auratic world signaled by Benjamin), not the ravages of modernity. They remain connected holistically to the earth, not subsumed by it, as the miners are. In primitivist mode, their images signal concepts and practices that have been lost to modernity. The masks covering their faces are in stark contradiction to their near-naked bodies. The images both reveal and shroud. If the photograph itself can be viewed as a mask, then highlighted in these images are the myriad levels of the mask, apparent in the mud caking the men's skins, clothing their bodies, as it were, and in the face coverings and the silk screen — itself, in the context of cigarettes, a cliché for the brand name and the smoke screen of the cigarette. Forcefully making these men into the others by the sheer exoticism of their culture (distant to the presumed modern, perhaps even urban, smoker of Silk Cut), the basis on which the images themselves were commissioned, the photograph nevertheless reveals the gap between the product that is being advertised and the imagined mask of authenticity, proximity to nature, and tradition that the image apparently boasts. Arden explains: "The Salgado pictures shown here are from a 1988 Silk Cut advertising campaign. I was in charge of the account as creative director, when Peter Gibb, the art director, came to me with this idea. He thought it would be fun to have the mudmen using silk as a shield or target. He commissioned Salgado and they went off to Papua New Guinea."[57] However, as Arden goes on

to state, the images did not make it into the campaign. Indeed, they unleashed objection from the Advertising Standards Agency, which "banned the pictures on the pretext that they were offensive to ethnic minorities."[58] He does not state why they were seen as offensive. In fact, as Martha Rosler states, images of mudmen had been used before to similar ends in adventure advertisements for the Canadian Club brand of whisky.[59] For Rosler, such images of "natives" offer routes for sentimentalist affiliations and lead to a mythification of those considered other. Objectifying in this way, the images of the mudmen fail to represent them and are turned, instead, into mere tools that support the spread of consumerism.

Matthew Soar has much to say on the matter.[60] As a student at an art college in London undergoing training as an advertising art director, Soar went to a talk by Arden, who enthusiastically offered the students previews of the advertising campaigns that he had commissioned, including the Silk Cut campaign by Salgado. The images clearly belong to the same collection that Arden now owns. Soar also analyses the campaign that Salgado took part in for Le Creuset cookware. If in the images of mudmen Salgado uses a style similar to that he used for the Brazilian miners (after all, this campaign was shot in 1988, just two years after the Serra Pelada photographs), then in the Le Creuset campaign, Salgado's aesthetic is recognizably that which is prevalent in *Workers*: images of iron factories, with furnaces blazing as the iron pots are cast, depict workers engaged in the arduous battle with steel. The images bring forth the same wonders of steel that are present in the images of *Workers*, and the factory workers here, as in *Workers*, are agents of fire and light, their lives subsumed by industrialization, and yet each is connected to the other by a creative process that appears wondrous, almost magical. Salgado recalls, "When I was a boy, I would travel with my mother to Belo Horizonte, the capital of my home state. We would go by train, and we would have to change trains. Then, at a certain moment, we would go through the Vale do Aço, the Valley of Steel, where the great complexes of Minas Gerais were located. And it was then that I would see the spectacle of fire lighting up the night, chimneys throwing out vast clouds of fire—and nothing impressed me more."[61]

Although the same poetic vision that fires the photographs of steel workers in *Workers* frames the Le Creuset advertisements, the latter also bear the witty captions that single them out as commercial works: "Casserole Provençale: 8lbs pig iron, 2lbs sand, 2 lbs coke, 1lb enamel. Cook in factory for 30 mins at 800°C (or Gas Mark 24). Glaze, then

enamel. . . . Re-heat. Leave for three days. Serve."[62] Soar's essay questions the ethics of "concerned" photographers who largely anonymously engage in commercial photography: "Is advertising photography to be understood as photojournalism's 'dirty little secret'? . . . When I tried to reach Salgado at his Paris office, Amazonas Images, to ask him some questions about his advertising work, his assistant replied via email on his behalf. In part the message read: 'He has done it on some rare occasions because it allowed him to support financially at the time journalistic photo essays, but it is so seldom that he does not believe he is a good example, his experience in this line of work being far too limited.'"[63]

Soar states that Salgado's credibility as a concerned photographer would surely be harmed if his advertising work were to be more widely known. In holding this view, he espouses the same boundaries defining categories of photographer (commercial, journalistic, artistic) that Sischy holds. Soar points out the mutual benefits to advertising agency and photographer alike in maintaining the anonymity of the photographer: the latter gains a substantial income and the agency gains use of the exceptional photographic talent of these hidden "big names" to support their campaigns. Consumers see the advertisements and mentally associate the images with the named work of the concerned photographer, thereby investing the object of the campaign with a certain ethical value that it may well not merit. Soar states that all those concerned in this relation—the photographer, the advertising company, their clients and consumers—stand to gain cultural capital. However, "the perennial losers in this transaction," he says, "can consistently be identified as the subjects within the ads themselves, whose likenesses are paraded first before a hidden audience of unaccountable intermediaries and then in front of a doubly alienated audience of consumers."[64]

Soar's argument stresses demarcated categories, labels, and contexts in which photographs circulate and are viewed. His accusation is strong: namely, that the subject is denied an agency in these images. To reinforce his point, he cites the case of Lewis Hine, who insisted that his images should never hang on gallery walls, for the viewers who visited galleries were interested in art, and not in social issues. Clearly, a shift in context, from newspaper to gallery, for example, does transform the implications of an image. Yet, it is possible to question the inflexibility of Soar's critique of Salgado, precisely because Salgado, unlike Hine, is working in the cultural context of late modernity.

Julian Stallabrass, in his insightful essay "Sebastião Salgado and Fine

Art Photojournalism," explores the debate on this hybrid genre of photography. He stresses that indeed, unlike Soar's example of Hine, who worked in a century totally unlike the present one, when photography was at the vanguard of visual culture, the photojournalist nowadays has to resort to art galleries precisely because of the decline in conventional modes of distributing photojournalism. If earlier photographers could rely on magazines, then today, the immediacy of television has rendered the latter redundant. This is all the more the case for the photodocumentarian, for unlike the photojournalist who snaps an event in the making, he or she is engaged in the telling of a story through a series of images that weave a visual narrative. A clear contrast can be found in Salgado's own work. His most "seen" photographs, the ones that did the rounds of the world in the matter of just a day, were, of course, of the attempted assassination of Ronald Reagan, chance shots taken because he happened to be there at the time. Yet these images, with all their shock factor, are "one-offs," entirely different in their effect or in the response they evoke from his photo-essays, which are several years in the making. The decline of magazine culture has meant that photo-documentarians—and Salgado's vast output of detailed images in series after series surely confirms the fact that he is, in fact, more a documentarian than a journalist—must seek other venues to make their work visible. Equally, and for the same reasons, they need a certain flexibility of role in order to achieve financial viability, and thus make their "concerned" work possible. It may be worth noting in this context that while Sischy and Soar criticize Salgado for breaching the boundaries between commercial work, ethically engaged work, and documentary, they do not suggest how else he might have proceeded. Should he, in fact, have abandoned a photography of engagement in order to wholeheartedly embrace the commercial circuit or would it have been acceptable if he continued as an economist—surely also implicated in the ventures of the free market—and thus financed his photography? Does the critic of capitalism have to stand outside of it, and if so, is this at all possible? Postmodernity, with its stress on role play, performance, and multi-sitedness, imposes on even the most rigorous photographer the need to adapt and improvise his or her existence, and hence the craft. It should then come as no surprise that the documentarian turns on occasion commercial or that the journalist produces fine art. Nor, indeed, is it surprising that an image shot for commercial purposes should have the same luminosity or the same emotional impact on the viewer as that

which counts as document—or that both should, ultimately, find their location alongside one another in a fine art gallery.

There are numerous examples of the ways in which Salgado has sought to marry his ethical interests as a photodocumentarian with his commercial and artistic ones. An interesting case in point is his ongoing collaboration with Illy coffee.[65] As the website for the project *In Principio* demonstrates, the three-part photo-narrative of this extended commercial, shot by Salgado from 2004 onward in Brazil, India, and Ethiopia, is both an ode to sustainable development and fair trading practices and to Illy as a coffee brand. To quote the website, the story told "is a backward photographic journey, a tale about how coffee is harvested, dried and selected bean by bean. It is also a tale of men, stories, landscapes and harmony." Notable, though, is the fact that the opening page of the website has a photograph of Salgado in a coffee plantation with Andrea Illy, son of the founder of the Illy business and present chairman of the company—a reminder that this is a business collaboration as much as it is a campaign for a fairer and better world. Illy, it should be noted, may well adhere to standards and practices of fair trade, but it is not a member of the World Fair Trade Organization. As the film *Black Gold* shows, there is a long way to go as yet in order to achieve fair remuneration for coffee growers in Ethiopia—and, one can infer, in most other coffee-growing parts of the world.[66] According to Ashley Seager's report in the *Guardian* in 2007, even supposedly "fair trade" brands such as Starbucks, a member of the World Fair Trade Organization, fall far short of what could reasonably be deemed fair trade: while growers of the best Ethiopian coffee earn $1.60 per pound of coffee grown, Starbucks, at the other end of the trade spectrum, makes about fifty-two cups of espresso from the same pound, selling for a total average of $160.00.[67] The result is that growers often live in conditions of extreme hardship, without shoes or access to clean water, schooling, or health care, and are often dependant for their survival on aid from the United States. Indeed, according to Seager, Starbucks's annual turnover of $7.8 billion is only slightly less than Ethiopia's gross domestic product. As for Illy, their website does not mention exactly how much growers earn through collaboration with this firm. Nevertheless, they reiterate that it is fair.[68] Rather than present itself directly as a promotion of Illy coffee, the website states that it is the result of a joint tribute paid by Illy and Salgado to coffee growers.

The photographs serve to frame and so centralize those who all too

often are eclipsed in the pulsing markets of the coffee trade. Clearly, one reason Salgado is a particularly apt partner in this gesture is his own prior connections with the international coffee trade. Similarly, his support of sustainable development, as evident in the environmental regeneration project undertaken by the Instituto Terra, together with the courses in sustainable farming taught by that organization, align Salgado with Illy's own professed commitment to sustainable coffee growth. On the website, Salgado is quoted as stating, "My great hope is that my photographs help people understand that behind the coffee we drink there are millions of people all over the world who cultivate it, who harvest it and who have the right to their dignity and consideration that they deserve." With this in mind, *In Principio* offers viewers this backward journey from coffee cup to coffee bean and hence to the sources of the coffee we drink. What is more, the aim is to project Illy as a company that is concerned with sustainability, the welfare of the worker, and harmony between material production and natural resources.

The implicit associations that arise from these images are, in fact, of a similar ilk to Salgado's photographs in *Workers* of tea, cocoa, and sugar producers; *In Principio*, therefore, complements the focus on raw goods production that forms the first section of *Workers*. They are also, as it happens, curiously reminiscent in the sense of order, harmony, and pleasure they project to the images of coffee plantations in Brazil taken by the turn-of-the-century photographer Guillherme Gaensly, in which the coffee growers appear in an almost pastoral scene of harmony between man and nature—despite the fact that at least one of the coffee pickers is a small child.[69] However, the *In Principio* images of coffee production are also quite distinct, subtly merging as they do photographic representation of sustainable growth with the unspoken ideology of marketing. Certainly, the images both closely resemble and yet sharply deviate from those, for example, of cocoa production, which appear in *Workers*.[70] In those photographs, cocoa workers appear as if subsumed by the act of production. From the time of harvesting the bean, when child labour is often employed, as evident in one of the images, to the laborious picking of the grain from the shell, to its transportation to centres where it will be fermented and then dried in the sun, workers find themselves at the mercy of large international corporations and international markets over which they can exert little or no control. The three images of cocoa production in *Workers* make clear the ex-

ploitation of the human in the name of capitalist production. In his captions to these images, Salgado reminds the reader that while international cocoa prices have fallen in the West, the price of chocolate never has. Profits rise for transnational cocoa companies while producers and growers lose out. Furthermore, methods of production seldom take into account questions of sustainability.

In contrast, Salgado's images of coffee production, taken for Illy, project notions of order, respect, and harmony. The first three sets of images, shot first in Brazil, and then in India, and Ethiopia, show the journey from plantation to coffee cup as a controlled process, where attention has been paid to the well-being of workers and the land. From the neatly landscaped layout of the coffee plantations themselves to the clearly organized lines of production where workers are seen in collaboration and cooperation with one another (and hence, by extension, imagined to be so with their employer), the plantation fields of Illy are a world removed from the exploitative environment in which the humanity of the worker is all too often obscured. *In Principio*, we are told, tells the story not merely of coffee but, more importantly, of the diverse people and places behind its production. Thus images to date come from Brazil, Ethiopia, India, and Guatemala. Indeed, while the process may be the same everywhere, nevertheless, distinct differences can be noted between the workers in the four sets of images, so that the specificity of local cultures, geographies, and ways is foregrounded. Thus, *In Principio* interestingly combines Salgado's ethical and political concerns with his commercial work. This collection of images also poses the same problems that can be said to emerge from his photoessays, namely the tension between elements of the commercial and the committed. The tale of harmony seen here is impelled by Illy's need to market its coffee as different and better than other brands. Nevertheless, the fact remains that Illy is a brand of coffee that only the wealthy can afford to consume. Sold at over £5.00 a tin in most British supermarkets, it is double the price of fair-trade coffees that do not partake in such heavy marketing. Clearly, like the Illy company itself, Salgado attempts to combine his own line of vision and his ethical commitments with his need to engage in commercial work. In so doing, though, he implicates his own work even further in the very capitalist contexts that he seeks to critique.[71]

It must be concluded, then, that modern classifications and categories come under challenge in the face of cultural and socioeconomic

shifts and fluxes. This is particularly true in the face of globalization, a process that reinforces mobility and new, constantly updated forms of visual and other communication. In this context, homogeneity of any sort becomes hard to sustain, and clear-cut distinctions of supposedly separate categories and markers of difference become uprooted and blurred. If globalization, as a key historical process of late modernity, can be envisaged firstly as cross-border relations, then it impacts upon various dimensions of the sociocultural and the economic, affecting collective and individual lives. The still photograph, overtaken some-what by the moving image, against whose immediacy it cannot com-pete, owes its survival to its tenacity and flexibility of usage in the face of change. The shift from magazine or newspaper to gallery as the site of its display has inevitably meant that a certain artistic elitism is im-posed on the medium, if only—but certainly not solely—for the sake of being noticed. As a result, photographers too have to resist confinement to any single category of photographic practice and must view them-selves instead, no longer as artisans of the image, as purveyors of lived realities, as merchants of the visual, or as artists on par with painters, sculptors, or even poets, but, in fact, as any or all of these and more, as the context demands.

Furthermore, one needs to take into account the role of art in an ex-ceedingly specular age. If spectacle and the visual have featured promi-nently in modernity, then this late phase witnesses a proliferation of the visual that threatens to surfeit the viewer. The gallery remains a lone, modernist space where art, elite in form, as Adorno would have it, can be distinguished from the plethora of images that surrounds us. Ironi-cally, then, the modernist medium of photography must retreat to the art gallery if it is to be viewed, not as passing surface image, but as a serious engagement with reality—that is, in terms of the modern vision that framed the medium in the first place. This, and not the television screen or the newspaper—fleeting, disposable surfaces on which images appear and disappear from moment to moment or day to day—becomes the protected space where concern can be witnessed and experienced. Furthermore, the flickering images around us, a disjointed pastiche of flashes of light and colour, fail to sustain a coherent narrative. In this, they are symptomatic of the disjunctures of late modernity, where nar-ratives falter and fragment. The photo-essay, where images weave into one another, where the viewer traces and retraces the lines of a story as the essay progresses, belongs, as it were, to another time—the time of

a less self-conscious, more paced modernity. The gallery, or the glossy book, becomes the principal context within which such stories — and very importantly, the messages they contain — can be sustained.

Tracing the Aura

In considering the multi-sited nature of Salgado's work — the apparent contradictions of engagement and commercialism, of documentary and art — the aura, as defined both by Benjamin and Adorno, comes into view. Rather than focus on the tensions of their unresolved debate, it might be more productive to see how Benjamin's notion of the aura is given new life by Adorno's reconceptualization of it, and to see where the nexus, that centrifugal moment of regeneration, lies between these two conjoined yet diversely mapped theoretical imaginings. In their modernist precision and attention to detail, in the overwhelming grandeur of the stories they tell, and in the artistry of their form, Salgado's images bring to the fore many aspects of the aura present in both Benjamin's and Adorno's theorizations.

The magical or religious element in the unique work of art that Benjamin identified as auratic is very noticeable in Salgado's work. The larger than life, biblical element exists not merely in the composition of specific images — bringing to mind that well-known image of the miner covered in mud and resting for a moment from his work, leaning against a pole, the lines of his body against the pole reminiscent of Christ on the cross, the worker symbolic of human sacrifice to the God of Mammon[72] — but also in the vast thematic spectrum covered by his photo-essays. Mysticism and spirituality are foregrounded in his earlier work, the lyrical, somewhat decontextualized images of *Other Americas* being a prime example in their exploration of an indigenous spirit that infuses the American cultural landscape, despite oppression through the ages. They are likewise present in the grand images of *Workers*: the factory workers, the steel workers, the shipyard workers, forging the goods of consumption from raw materials, which they pass through fire and transform.[73] By focusing on the alchemy of industrial labour, Salgado brings forth a wonder in the viewer that the consumer goods of our modernity are indeed magical in their processes of creation. Yet such religiosity, seen not in terms of ritual but rather in terms of the spirit, the magical, and the wondrous (as is suggested by Salgado's work), is by no means disengaged from social reality. For, if the span of his lens

is such that Salgado must be seen at some level as a "global" photographer, then it goes without saying that his vision is equally defined by his Brazilian origins.

In the context of Latin America, its long history of struggles in the course of modernity against domination by the United States and exploitation, Salgado's aesthetic vision, his images that present the aura to viewers, are also images that fall in line with the liberation theologists of his epoch. Religion, politics, and ethics combine here to form a potent reimagining of man's relation to humanity and to God. Through a political engagement that influences all aspects of their work, the liberation theologists depart from a vision of religion rooted in the struggle for justice for the common person. Foremost among their concerns is the struggle for land reform in Latin America. Ernesto Cardenal, the Nicaraguan priest, poet, and politician who famously earned the displeasure of the Vatican for his radical socialist stance, is a prime example of a Latin American liberation theologist who both crosses boundaries of art, politics, and faith and is engaged in the twinning of politics and aesthetics.[74] The power of lyric in his verse—who can resist the sorrow and the seduction of, for example, his *Coplas a la muerte de Merton*?—combines with his vision for a new Nicaragua, one that inspired the solidarity campaign in the late 1970s, which led to the overthrow of the dictator Anastasio Somoza Debayle. In *Terra*, Salgado includes photographs of Father Damián, at once a priest and a Marxist in sympathy with the landless, as he leads a mass among his followers, many of whom are involved in the Movimento Sem Terra. Religiosity, apparent overtly only very occasionally in Salgado's work, but omnipresent in the wondrous luminosity of his representations and in the biblical expanses of his themes, is inevitably linked to mankind, humanity as a force engaged in a common struggle for survival and as a wondrous source of potential.

The aesthetic in Salgado's work, deliberate, unmistakable, and tied to the political, derives its force through means similar to those outlined by Adorno when tracing the aura. In writing about modernism and aesthetics, Adorno stressed the attention to form in art. Unlike Benjamin, who, as an inveterate *flâneur*, wrote of culture in terms of the everyday, Adorno shifted his artistic focus to elite forms, classical music being a prime example. According to him, it is via a deliberate espousal of the aesthetic that the truth content of art can be released. Such truth content bears within it new historical possibilities.[75] As Stallabrass signals,

a key feature of Salgado's work—despite his former association with the Magnum photographic agency, whereby he became categorized as a photojournalist—is "a deliberately backward-looking, individual artistic style."[76]

Perhaps most striking in this context is his mastery of the dramatic force of black and white. No consideration of Salgado's aesthetic can ignore the impact of the tonality of his images. Salgado always photographs in black and white for his own photographic projects. As our eyes move from deepest black to purest white, across swathes of stone, silver, and moody shadow, we find ourselves called back again and again to the image before us. Salgado combines his use of black and white with the very high resolution of detail in his images. The result is a nuanced movement of light that turns his images into works of art. In the video *Looking Back at You*, we see his team at Amazonas Images in Paris at work, carefully touching up his images in order to perfect the subtle play of light and shade. The artistry is undeniable, as is the aesthetic impact of these images on the viewer. The somber, mellow tones of black and white combined with the perfection of angle and frame that are a signature of Salgado's style turn the images into sculptures of light. Whether it be in photo-essays as different from one another as *Other Americas* and *The End of Polio* or in the moving human saga told in *Migrations*, the dramatic force of black and white confronts the viewer, turning each image into a statement that is at once specific and applicable across contexts.

Most obviously, the use of black and white separates Salgado's photographs from the colourful swirl of images that pass before us every day. Ansel Adams, whose commentary on photography remains instrumental to students of photography to this day, famously stated, "The negative is equivalent to the composer's score and the print the performance." It is well worth taking this statement into account: black and white, as the photographer Frank Van Riper declares, "will always bring me deeper." Nevertheless, he says, "Color will always give me a fascinating look at the surface of my world."[77] The formal effect of using black and white is to draw the viewer in and to engage him or her in the subject, who can then claim the right to make an imprint on the viewer's vision.

As a somewhat arbitrary example of the contrasting effects on the viewer of colour and black and white, I take Charles Bowden's volume *Juárez: The Laboratory of Our Future.* This collection of photographs of

a border town between Mexico and the United States carries the work of several photojournalists, all of whom have shot in colour. Like some of Salgado's publications, this book too carries an essay by Eduardo Galeano, as well as a foreword by the committed and outspoken American academic Noam Chomsky.[78] There is a commonality of concern in this volume and Salgado's work. Yet the differences are also stark. The images show the sordid, often violent, and tragic underbelly of industrialization that marks this threshold to the first world. By implication, the indictment on the nearby first world is strong. Colour brings out the violence and tragedy of Juárez, the heat and the dust acting as jarring symbols of hopeless lives trapped in a hellhole of violence and exploitation. The subjects of this volume are abandoned. The images are bright with a glaring sunlight, the colours strong and almost repellent. Poverty appears here as dead end, without hope. Placed alongside Salgado's images in *Terra*, for example, or even *Migrations* (even though many of the subjects here are on the road to nowhere), the metaphoric contrasts of black and white versus colour speak strongly. There is no poetry in this volume on Juárez, no lyric, no song of hope—only despair, bloodshed, and tragedy. Ironically, the colourful images are bleak whereas Salgado's black-and-white ones open onto hope.

The dynamic of potentiality that shines through in Salgado's work speaks eloquently of the possibility for change. This emphasis on social, economic, and political transformation is one, as I have demonstrated in this chapter, which speaks from *within* the heart of capitalism. Salgado, as artist, documentarian, and commercial photographer, is clearly enmeshed in the social and economic contexts of the age. To suggest change, therefore, to suggest an *other* possible way, his work must present to viewers the possibility of transcending this historical moment of late capitalism. It does so from within and is fraught with contradictions. It offers no solutions; it merely raises questions. Yet his message reaches out to many who are compelled by his work. His questions are important. The impulse that sets such a vision free, that releases the transcendent universality of his call for engagement, is reliant on his deliberate development of a heightened and recognizable aesthetic. Far from being ahistorical, such universality is a pathway for engagement across contexts. It is at this point that Adorno's reworking of the aura comes into focus. The Marxian impulse in aesthestic theory lies in its engagement with the social. Art, formalized yet implicated in the social context, releases a new vision.

It is also at this point that we can turn back to Benjamin and his Kantian focus on the experiential. Indeed, the lack of resolution to the debate between Benjamin and Adorno works in photography's favour. For Benjamin, aura was encountered through experience. It was, furthermore, that experience of wonder lived by the beholder of aura. In the chaotic, shifting, and mobile world of late modernity, perhaps the sole visual medium that invites the act of beholding is the still photograph. Luminous and transcendent, the still photograph has the power to transport the viewer and to suggest possibility. In this engagement lived via the experience of the visual, one encounters the force of the aura, for it implicates viewers in what they see.

It can be argued that it is in fact through the aesthetic, and not despite it, as his critics would have it, that Salgado offers viewers a route to engagement in the global debates that does not only concern the subjects of his images, though it concerns them too. The aesthetic arouses an affective, sentient response in the viewer, one that is emotionally and intellectually engaged. This combines with the rational response sought from the document. The result is an implication in the contexts and struggles that are suggested by the image, one that stems from perception, as in the aesthetic. To perceive is to know, to understand, to see. Furthermore, such perception relies on the sentient. The word *aesthetic* also denotes that which is refined, tasteful, artistic. In this confluence lies a useful reminder that aesthetics as a philosophy of art is also a critique of the Enlightenment-based philosophical practice of privileging rationality, which foregrounds reason and the intellect, in opposition to the senses and the emotions.[79] Beauty, art, and refinement open inroads for viewers to the experiential and lead to new perceptions. When such an aesthetic also carries a social engagement, as in the case of Salgado's work, the perceptions wrought by the aesthetic reflect back on the viewer in a way that anaesthetic—desensitized, realistic, unary—images never could.

Beyond the Aesthetic

There are many questions that lie beyond the aesthetic, but remain closely tied to it. Salgado's work may take its cue from the same humanist drive that prompted *The Family of Man* exhibition in New York in 1955, with its attempts to encompass humanity within the frame of photographic representation.[80] Wide though the sweep of his lens is, it

nevertheless frames key issues and re-presents them in terms of his aesthetic. The reaction of viewers is clearly visceral to start with. Beauty touches the heart, arousing the senses with its relentless insistence on the seed of promise in all life. If sight is a sense, then its perceptions bleed into our other senses, into the heart of feeling.

Emerging from the sentiments aroused by the aesthetic are the many questions that must be faced and that return to cross our sightline long after we have moved on from the image: questions of how we think about history and power, of how we see, of how we act. The aesthetic is a film that hovers before my eyes, drawing me to the image, and marking me as separate. And like all veils, it engages me to look closer, it makes me want to tear it apart, to lift it and see within. Yet the veil persists and with it, my imagination. The following chapters attempt to trace the aesthetic in Salgado's photography on to these other arenas of history, ethics, and power, where we, as viewers, find ourselves framed by the aesthetic in close implication.

3

Eye Witness

On Photography and Historiography

> Before going to a school for photography, go to a school
> for economics, sociology, or anthropology to try to have an
> understanding of history, of the historical moment that is arising.
> And from there, make photography a way of life.
> SEBASTIÃO SALGADO,
> in interview with *Programa Roda Viva* (Brazil),
> April 22, 1996 (author's translation)

A YOUNG MOTHER SITS on rough bedding laid out on the ground as she holds her baby and looks up at the camera (fig. 10). When viewers look into this image, they are first struck by the tiny infant in her arms, then by the challenge of her eyes as they claim their gaze. She is a refugee, the caption states, on the move through southern Sudan for several days before arriving at a camp in Kenya.[1] She has given birth just recently. Her surroundings are makeshift, exemplary of the tenuous circumstances of her life. Uncertainty faces her and the child. As one looks at this image and many others like it that feature throughout the extraordinary gamut of Salgado's work on displacement, recognizable patterns begin to reverberate in ricochet fashion across Salgado's numerous photo-essays and across the globe: mothers and children on the move, babies born into migrancy, parents struggling to keep their

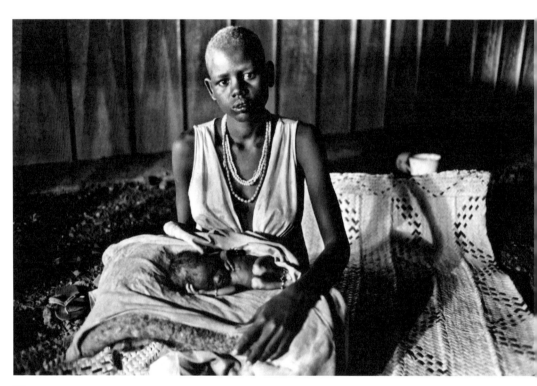

10

children and themselves alive. On another page, there is the image of a woman sitting on a train track, her child tied to her back, her meager belongings thrown on the ground next to her. In the background and around her everywhere is desolation. The people of the road rest where they can, as they can. At times the mothers and their babies are Sudanese, at other times they are Rwandan or Kurdish or Croatian. It does not matter. Only the skin tones and hair colour vary, as does the landscape. The human predicament is the same. It is one of vulnerability, of engulfment in larger contexts, of economic uncertainty and ongoing struggle. The specificity of their contexts and histories, as seen in these images, stands alongside the commonality of their despair, the mettle of their resolve. Salgado's work is a vast visual chronicle of human perseverance in the face of displacement and dispossession.

But where have I seen this motif before? Through some involuntary mental move, I slot Salgado's images into a preexisting mode of engaged documentary photography, one I have already encountered and absorbed elsewhere. There is some abstract type at work here that I recall, a category to which this image belongs. As a result I am, I realize, subconsciously prepared for what I see, terribly moving, indeed shocking, though it is. Unwittingly, I have filed Salgado into a mental archive of photographers engaged in social documentary, photographers whose work seamlessly feeds into one another's so as to construct an ongoing visual narrative of our times. Some are names from a previous century—those of Walker Evans and Dorothea Lange; others are more contemporary, such as James Nachtwey, Steve McCurry, Alfredo Jaar, Susan Meiselas, and Miguel Rio Branco, to name but a handful.[2] While steeped in the frames of Salgado's images, an image I recall once seeing stirs in the back of my mind. I go in search of it. It is ubiquitous to my mind, iconic in its symbolic power, and yet I have—shockingly—momentarily forgotten the photographer's name. Nevertheless, the imprint in my mind of that image primes me to receive this one of the young African mother and her newborn infant. It is so similar in theme and message, and yet so different in setting. In this elusive photograph, a migrant mother holds her waif-like children close to her and looks out at the camera and beyond. Their hair is unkempt, their faces smudged and lean. Around them there is only dust. Yet there is a resolve in her expression, a will to see herself and her children through this despair. Set in a different time and place, the image nevertheless arouses the same visceral response in the viewer, that of human empathy. In this sense, it

transcends the specific and becomes universal in its ability to signify. It is an iconic image of migrancy. Sometime later, I find the photograph. It is, of course, by Dorothea Lange, taken in California in 1936, one of a set of images that turned the migrant mother into the face of the Great Depression. In the decades since then, the image the *Migrant Mother* has become *the* visual point of reference for the history of those times.

It is also *the* single, most important human reference point of the Depression. When, from the distance of Europe in the twenty-first century, I read facts and figures about the Depression, I find myself turning over and again to the image of the migrant mother and her children in order to humanize my knowledge of that time—a time that I neither lived nor knew. The facts and figures tell me about economic decline; the migrant mother's face speaks to me of human struggle, of pensive determination.

This chapter considers the ways in which Salgado's photography, with its broad socioeconomic panoramas of the twentieth century and early twenty-first, allow us, as viewers, to rethink, question, and challenge the authority generally granted to the idea of history. Historical discourses and narratives circulate constantly in our midst, and we rely on them for a sense of knowledge about the world around us and the events that have shaped it. Seldom do we question the constructed, and hence contingent and changeable, nature of such knowledge. By this, I mean that a study of Salgado's wide-ranging photography opens onto a questioning of the ways in which history, like photography, is imagined and constructed. In the process, photography poses a challenge to conventional presuppositions of linear, coherent, and authoritative historical narratives. Instead, in the postmodernist style that typifies the medium, it posits history as scattering, collage, and contingency. Thus, as I argue in this chapter, such photographs of the margins present complex and plural challenges to the idea of history, so that this notion comes under scrutiny and is forced into revision and renewal. The subversive potential of such challenges lies in the displacement of conventional loci of power through new perspectives and angles of vision. Also, photographs enter the psyche of the viewer through means that lie outside of rationality: they evoke an affective or sentient response as well as a rational one. Their effect is at once rational and nonrational. Indeed, the latter often precedes the former. In this sense, I aim to explore through Salgado's work the notion that historiography—the process of shedding light on the past through the writing of history—mirrors that other process of illuminating the past, namely

photography, or the act of writing with light. Furthermore, an ongoing process of interplay exists between historical and photographic vision, so that both are marked by flux and fluidity. Moreover, vision, both historical and photographic, is open-ended. The interplay of established or handed-down knowledge with the sentient impact of the image leads inevitably to a refiguring of the former. This inconclusiveness, brought about by the ways in which photography challenges, unravels, and refigures historical master narratives, is what makes the practice of photography necessarily a political act. Of relevance here is both the place of Salgado's work in established traditions of photodocumentary and the challenges made by such photography to established notions of history. Also of extreme relevance is the aestheticization of Salgado's work, which, I argue, crucially contributes to its historical thrust precisely because his work calls on the pre-sentient, visceral, emotive, and imaginative responses most often aroused by artworks. It is in this way that Salgado's work differs from merely informative images that fail to claim the viewer's empathetic vision. Nevertheless, the historical relevance of Salgado's work is, in my view, not so much in what his images show us of the past, or of our times, but rather in this curious parallel that emerges between photography and historiography.[3]

The inconclusiveness of the photograph, the limitations of selection, and a consideration of the frame as a horizon of possibility, to name but a few aspects of photography, all align themselves with similar features in the writing of history. Rather than being true and authoritative, historical narratives reveal their constructed nature and their contextual contingencies. It may be worth adding here that the etymological root of *photography*, as in the act of writing with light, goes beyond this notion to that of shedding light on what is as yet unseen, unvoiced, unwritten. To so shed light on the unknown or unnamed is also the historian's endeavour. What is selected, however, or seen, will inevitably depend not merely on the subject, but also on the quality and angle of light, the aperture, the clarity of the lens, and the point of view of the historian-photographer.

Motifs and Symbols
BEYOND THE DOCUMENTARY AND THE AESTHETIC

Both within the history of documentary photography and also within the much longer history of art, there exist sets of motifs or visual pat-

terns that are charged with symbolism. Salgado's work often calls on these, especially on those image patterns that have religious associations—think, for example, of his image of a miner in the Serra Pelada leaning against a pole, reminiscent of Christ on the cross. If Lange's *Migrant Mother*—an image shot as part of documentation for the Farm Security Administration (FSA)—moved millions, then it was because it brought with it echoes of biblical visions of the Virgin Mary, also a destitute and displaced young mother. The artistic and emotive force of this visual motif has been proven through artworks hailing from the medieval period onward. Thus when encountering Salgado's images of mothers and babies (always in the majuscule, as archetypal figures, thanks to the distinctive tonality that marks his work), we immediately apply to them the numerous meanings, connotations, and references that have emerged from a preexisting family of images to which they partly adhere and which haunt our collective visual memory. It is through such a process that we realize that our own vision is seldom untainted or virginal: on the contrary, it is inevitably historically produced and defined. In turn, how we see and what we see will shape the course of our own historical awareness. What emerges is a curious interplay between vision and history.

The ubiquitous nature of the photograph—and in this context, I refer to photography that has a documentary, even pedagogical mission guiding it—means that most of us, regardless of our own backgrounds and interests, have imbibed over time numerous images and accompanying associations that predetermine the way we read even those images that come fresh to our eyes. Furthermore, while the viewer may engage in the many debates that arise from and around Salgado's work—debates on the aesthetic, on the photographer's self-assumed mission to represent, on questions of vision and recognition, to name but a few—in fact, these debates have their own trajectories and are not new. They have arisen before in and around the work of other photographers and, as such, have accompanied the course of documentary photography itself. As the Brazilian photography critic Boris Kossoy explains, photography has its own iconography, from within its own trajectory as well as from that of painting, which inflects readings of images.[4] The influence of this iconography cannot be underestimated when considering the relation between photography and history. Thus, historical narratives and events are often recalled or imagined via the visual, through key images or figures, in the same way as the *Migrant Mother* has come to represent

the Depression. To question the materiality or historical relevance of such images—long divorced as they are from the realities of their subjects—is, in my view, to deny not so much their historical resonance but the historical invitation that they bring to the viewer. Yet the ambiguity inherent to the photograph as a medium, its migrancy and multiple significations, almost always mean that no single historical narrative emerges from the still photograph. Instead, we encounter multiple narratives, the photograph as a space of historical intersections and multiple possible significations.

Attitudes to the aesthetic in Salgado's work will no doubt affect the extent to which its historical potential is recognized. What is more, no consideration of the aesthetic can be divorced from the overriding forces of the market that give it its legitimacy, perpetuity, and possibly even much of its raison-d'être. This conflictive aspect of his work immediately suggests grave differences of class between photographer, subject, and viewer that invite critical examination. My argument for historical potential in Salgado's work does not preclude the larger contexts of neocapitalism of which his work is a part. Instead it aims to open up the possibility of re-visions of and challenges to existing structures via his work. To do so means to tease out the nuances of a form of cultural production that straddles the boundaries of document and art, and in so doing, both fulfils and contravenes its stated mission of solidarity with the marginal.

Abigail Solomon-Godeau states in her book *Photography at the Dock: Essays on Photographic History, Institutions, and Practices* that traditionally the aesthetic has been seen as a separate field from the political and the two are indeed often perceived as oppositional. Nevertheless, cultural history offers proof that this has not been the case. Thus, she points to "the dense interweave of the social, the political and the economic, and the economic with the cultural in the production and reception of cultural artefacts." The result is the emergence of historical narratives that are at once "seamless, disinterested and authoritative."[5] Furthermore, such narratives serve to establish cultural parameters and values that attain universality.

Despite its technological genesis, photography has attained the power, like great works of art, to release universal discourses, precisely because it so deftly combines the technological with the aesthetic. Thus, we have art histories of photography. The umbrella of the aesthetic serves to generate a succession of artists in photography,

whose works then ensure the continuity of histories of authority and universality. In this sense, the cultural artefacts that are generated by an overriding capitalist context are not merely formed within it, but also serve to extend and perpetuate this ideological system. By this logic, the subversive potential of Salgado's images must come under scrutiny and, indeed, will be nonexistent for many viewers who resist his aesthetic. Solomon-Godeau states that her purpose has been to trace "the processes whereby cultural practices conceived quite deliberately as anti-idealist, materialist, and socially engaged can be reprocessed, so to speak, to yield virtually their antithesis."[6] One cannot help but think that vital though it is to uncover such processes, they affect not merely cultural practices but academic ones too. Indeed, though to degrees that vary sharply from those affecting Salgado's work, these processes colour the production and reception of Solomon-Godeau's own critique, as they do those of, say, Martha Rosler. The academy is, after all, as much complicit in the maintenance of circuits of power, with their concomitant directives as regards the production of knowledge. Salgado's images should, according to this argument, slot solely into the market without any further historical, ethical, or political import. Apart from anything else, the aesthetic—with all that it connotes in terms of ideology, power, and class difference—would hang like a veil over the imaginative and always unvoiced potential of the image. The image would then be trapped in a chasm between the failure of realism and the exaltation of the aesthetic, neither document nor artwork, neither humanist and revelatory in its projection nor indexical and informative as a document is intended to be: it would be no more than a shallow adjunct in a catalogue of many to the manufactured desires and self-perpetuating impulses of the market. Most disturbingly, Solomon-Godeau's work would lead one to believe that a hybrid cultural artefact, such as the aestheticized documentary photograph, lacks materiality. Such an absence of the material can only indicate a historical void.

At this point, it is worth turning to Allan Sekula, who reminds the reader, in his essay "The Body and the Archive," that in the photograph, "we are confronting . . . a double system: a system of representation capable of functioning both *honorifically* and *repressively*."[7] This ambivalence of photography shows itself not merely in the readings projected but also in the very medium itself. Photography began, states Sekula, by downgrading the privileges attached to portraiture, yet it failed to extend the challenge to class differences. Via its long

uses in science, medicine, and anthropology, photography has come to present alterity, that which is marked as other and, by extension, as inferior. Thus Sekula shows us how catalogues of alterity are produced through photography. Through his focus on portraiture, Sekula traces links between the body and the formation of the archive. In particular, he states that "in structural terms, the archive is both an abstract paradigmatic entity and a concrete institution. In both senses, the archive is a vast substitution set, providing for a relation of general equivalence between images. . . . The capacity of the archive to reduce all possible sights to a single code of equivalence was grounded on the metrical accuracy of the camera."[8]

Two points ensue from this quote. First, the aesthetic in photography that is social in context but does not seek to ground itself in the realist may well throw the organizational powers of the archive into disarray. This is so because a fracture occurs within the image itself, a split between the factual and informative, on the one hand, and the veiled, the nuanced, and the insinuated, on the other. This fracture causes a dissonance within the image, throwing on it a double light that is ambivalent, stirring, and as yet without articulation, one that disrupts the rationalist, organizational, and hence controlling thrust of documentary realism. Second, and as Sekula notes, Michel Foucault rightly pointed out that the regulatory sciences were not entirely repressive and controlling, but also reformist in their control of the body.[9] The reformist intention is without doubt paramount in Salgado's work. For this very reason, it is also true that he has catalogued via his photo-essays the marginal, the displaced, the unrecognized. That this effort aligns him with the establishment is best noted in his associations with the UN, a hegemonic global body, and also with prominent business concerns, such as Illy. Certainly, volumes such as *Workers* and *Migrations* offer archives of subjugation and displacement. However, as Sekula states, there is also an honorific element of photography that must be noted in Salgado's work. Thus, the establishment of alterity through his images resides not merely alongside but, crucially, as an inextricable part of the attempt to represent those who have been abandoned by the very establishment that Salgado at once belongs to and critiques. Add to this the fact of the aesthetic in his images that runs counter to the rationalist mission of the documentary and, not surprisingly, a plethora of possible readings emerges.

To vindicate historical potential, the viewer thus needs to move be-

yond distinctions of categories, such as the documentary or the aesthetic. In fact, the very context of late capitalism and, indeed, postmodernity that surrounds Salgado's images renders such fields fluid and malleable: it is precisely through this indeterminacy of concrete identities and categories that we need to seek out the re-visioning of historical potential, that ability of images to allow us to think history "otherwise." This argument for historiography, and its parallels with photography, is precisely about the inconclusiveness, contingencies, and fluidity of historical knowledges.

Photodocumentary and Poetic Vision

Despite its signature style, Salgado's work is not unique in presenting dichotomies. In fact, it falls into a clearly established alignment of photodocument and historical charting. I take as my starting point Fred Ritchin's reference to Salgado as a "lyric documentarian," which was discussed in the previous chapter. Salgado is by no means the first documentary photographer to be referred to in this way. When Ritchin employs this description, he is making a gesture, albeit not overtly, to the legacy of Walker Evans. In 1964, Evans gave a lecture at the Yale Art School, where he later became a professor of photography, titled "The Lyric Documentary."[10] He subtitled his talk "Aesthetic Autobiography," thereby bringing together for the first time, and in his inimitably innovative way, the apparently contradictory concepts of documentary, on the one hand, and the lyric and the aesthetic, on the other. Until then, documentary photography had been seen as a separate category from lyric photography. Evans, however, wished to stress the fact that his images, while being documents of social reality, were quite distinct from ordinary visual documents, such as police photographs or visual records of accidents—that is, images that are merely two-dimensional and closed to the imagination. The oxymoron "Lyric Documentary" highlights the emotive and visceral force of his work, making him a pioneer in the crossing of this apparent boundary between the aesthetic and the documentary.

It also highlights the contradictions inherent to photography that both records reality, thus constructing a visual archive of subjects that are then categorized as other, and arouses an empathetic imagination. Walker's phrase has since become the title of a recent collection of his photographs, put together posthumously and including essays by him.[11]

His detailed and nuanced focus on his subjects and his ability to bring to the fore inspiring visions of the spirit of mankind earned him praise from many. In particular, it is worth noting that Evans focused on the everyday and the ordinary, on low-income groups and communities struggling to survive. His subjects were the common folk of America and his images have since become iconic of his time. The poet William Carlos Williams, it is said, admired his power to make the poor "worthy in their anonymity."[12] More to the point, in subsequent decades, Evans's work has, like Lange's, come to be weighted with historical significance for its ability to re-present the Depression. In this, we can surely see a link with Salgado's work. No doubt another commonality that must be acknowledged is the market value that is attached to such images.

Evans's work is now classic and Salgado too is classed a master photographer. As such, their images largely circulate in elite spaces and have become valuable assets to whomever "owns" them—so that, ironically, a print takes on the guise of an "original," and, as a desirable and fetishized commodity that remains buoyant in the market, refutes the infinite power of technological reproduction that produced it in the first place, refutes mutability, and also refutes the democratic and egalitarian potential of photographs to travel across contexts. Furthermore, "a Salgado" or "an Evans" is, in terms of the market, no longer an image linked to the subject it represents, but an icon bound to the name of the photographer.

The inevitable ideological undercurrents in lyric photography pave the way for multiple, contradictory, and new discourses with which to articulate and imagine the course of documentary photography. Clear links can thus be drawn between the "master photographers" who forge and maintain aestheticized documentary, as can commonalities of background and perspective. Lange is relevant in this context not merely because she, perhaps more than any other, created the blueprint of the displaced mother and child. She was also married to Paul Taylor, an activist-economist, and her focus on migrant farm workers was very much the result of her long-standing collaboration with him. In her work, one finds yet more similarities with Salgado, as man's relation to land, and displacement from it, become an extended preoccupation. Here too is a concern with the environment, as Lange and Taylor together set out to document the drought in the Midwest that occurred in the 1930s. The result was *An American Exodus: A Record of Human Erosion*. While the images were hers, the text was written and edited by

him, including, significantly, the words of the subjects. This meant that the subjects were able to speak through the images, an act of empowerment made possible by Taylor and Lange, despite the fact that the work would ultimately be linked to Taylor's and Lange's names, and not to those of the subjects they framed. The concept of "exodus"—also the title given to Salgado's exhibition of the images from *Migrations*—is central to Lange's work, as it is to Salgado's. Lange, like Salgado, believed that images could help to redress inequality. Needless to say, her image *Migrant Mother* has since become an icon of the Depression. The FSA was able to send it out to press members across the United States, and the image had the force to move numerous viewers to acts of charity. It was with some embarrassment to Lange that the subject of her image, the migrant mother herself, survived the dust bowl to tell the world that she had never received any income whatsoever from the countless reproductions of her image. If this is shocking, then this is precisely because *Migrant Mother* is now so eponymous an image that it has become *the* timeless representation of the Depression, and it is through her grim resolve, through the despair and the affliction that we see in her and her children that many born in subsequent decades have come to imagine the history of that time. In this sense, and as Rosler has emphasized, *Migrant Mother* is a photograph representing not the subject per se, but the universal condition of those caught in her moment of history.

In addition to the shared similarities with Lange, many parallels can be drawn between the work of Salgado and that of the photographers of Evans's generation. Of prime importance is the coincidence of economic awareness and photographic representation. With the Depression beginning to appear as a long-term problem in the United States, documentary as a visual form made more sense than ever. It became a means of creating awareness and of overturning the generally held view of America as the land of opportunity. This capability became most evident under the aegis of the FSA. Initially named the Resettlement Administration, this initiative was part of President Roosevelt's New Deal to fight the Depression. As the name suggests, it was an umbrella agency that worked to resettle displaced farmers into more economically worthwhile forms of work, many of which were industrial. This new economic agency employed Roy Stryker, himself an economist trained at Columbia University and a student of Rexford Tugwell, a former professor of economics at Columbia University who became the

head of the Resettlement Administration, in order to arrange and supervise the visual documentation of the FSA at work. Stryker was himself not a photographer, but through his organization of a truly massive archive of images of the Depression emerged for the first time the deliberate overlap of economics and photography. In this, Salgado's work is indisputably linked to this earlier effort. Indeed, Salgado's practice of viewing the world through a lens shaped by his training in economics could not be closer to Stryker's idea of using images to portray the economic struggles of the Depression. Furthermore, it was Stryker's idea to ask his photographers to depict the Depression, not through some grand visual scheme, but by honing in on the local and the specific. Even now, when we think of the Depression, we recall the faces of the sharecroppers, the sight of families seated around rough tables, sharing meager meals; we recall hands worn by long years of work, the grim set of people's mouths in the face of adversity. The images of the FSA — and many of the key photographers' names have since become iconic of photodocumentary, such as those of Dorothea Lange, Walker Evans, Marion Post Walcott, Jack Delano, and Arthur Rothstein, to name but a few — have left a crucial legacy for the genre of photodocumentary.

There is an unseen but undeniable link between the visual representation of economic realities and the forging of specific visions of ideology — and, by extension, of intervening in dominant historical narratives. Stryker's aim was to transmit via photography the good work of the FSA, thereby gathering public support for Roosevelt's New Deal. In so doing, a specific vision was forged for America. The traditions of photodocumentary precede the FSA, of course. While the work of the FSA was groundbreaking in its sheer amplitude, the vision behind this large-scale project was not in itself so new. This was a vision that drew on the traditions established by the likes of Lewis Hine, whereby documentary was primarily emotionally persuasive and whereby the subjects, simple folk though they inevitably were, became heroic. Moreover, representation of the labour force and of marginal groups, together with a belief in the force of photography to trigger social reform, could already be found in the work of Hine.

Indeed, it is no doubt fair to say that few photographers can match the genius of Hine in the field of photodocumentary. Trained as a sociologist and first employed at the Ethical Culture School in New York, Hine harnessed photography to his social concerns. He pursued his subjects with a relentless drive, fuelled by his desire to change society for

the better and to bring important social issues to the viewer's attention. It is interesting to note that many of Hine's concerns are also shared by Salgado. For example, Hine's best-known projects focus on child labour, immigrants, and workers in the modern world. His world, however, was largely limited to the United States, with much of his better-known projects located in New York. Nevertheless, Hine did briefly undertake a project in Europe, where he worked with the Red Cross in the aftermath of the First World War in order to document refugees and displaced persons. Thematically, therefore, numerous overlaps exist between Hine's work and Salgado's. In the latter part of his life, Hine shifted his focus from that of revealing exploitation or displacement to focusing on the dignity of labour. In this too there is a similarity of vision with Salgado.

Hine's many projects are worth examining here, if only because many of the themes he explored visually are similar to those seen in Salgado's work. Salgado has mentioned the impact that was made on him as a child while traveling by train from Aimorés to the city when he passed steel mills at night. He talks in quasi-magical terms of the billowing flames and the workers he saw inside the factories, subjects that ultimately figured in his work. Hine too photographed steel mills and also greatly stressed the dignity of the worker, his craftsmanship, his mettle. As Salgado has received UNICEF support for his images of displaced children, Hine, in his time, was commissioned by the National Child Labor Committee, a private agency, to document children at work. This was when no national laws existed regarding child labour. Hine provided words to contextualize his photographs of children, often incorporating his subjective line of vision or narrating something of his encounter with the child in question. In comparison to Salgado's, however, Hine's style is restrained and relatively unadorned, his children often minute in comparison to the machinery at which they work. Of course, Hine did not benefit in his time from the advanced aesthetic techniques that are at Salgado's disposal.

Interestingly, Hine's persistently documentary style did not mean that he remained dryly realist or that he refrained from moving the viewer through metaphor, association, or symbolic persuasion. Restrained though he may have been in terms of the aesthetic, it is, nevertheless, clearly there. Like Jacob Riis, Hine also photographed tenement dwellers. His image *A Madonna of the Tenements* shows a mother seated in a chair, a child on her lap and another at her knee.[13] Her complexion

is ruddy, her hands work worn. More than anything else, it is her ex-pression of silent thoughtfulness that fills the picture. Here again is the time-tested motif of mother and child, one that has clear biblical reso-nances of the Virgin Mary and the baby Jesus, which draw the viewer's sympathy.

Hine's work also shows careful attention to composition. Like Sal-gado, Hine focused on workers and the almost superhuman, definitely wondrous force of labour. In the process, he called on time-tested Judeo-Christian symbols and associations. He sought to move and to engage. His book *Men at Work* is a unique testament to the construc-tion of the Empire State Building, in which the men appear as athletes, dangling on ropes high above the ground as they build. Hine's vision is spare and lean, but it is also inspiring because it is visually magnificent. Despite the fact that Hine had much in common with Riis in regard to a shared effort to harness photography to social concerns, and despite some similarities with the hard, modernist thrust of the Soviet pho-tographers, Hine was a visionary. His images still speak of a fraternity of mankind, of struggle, of hope, of progress. In this we can no doubt glimpse Salgado's indebtedness to his legacy.

There is a long record, therefore, of social photography being tied to the pedagogic, the inspirational, the visualized. Images of this genre did not portray as much as they inspired. As such, they became in-fused with symbolism that was historic in nature and thus opened up discourses for nation building along new lines. It is thus clear that the photographic interventions made by these photographers from the early twentieth century paved the way for later socially engaged pho-tographers, such as Salgado. Their work also constructed the discourses and, to use Pierre Bourdieu's well-known term, formed the *habitus* via which such work would be perceived and read.

What is notable in the context of such representations of displace-ment is the fact that documentary photography is inevitably more than just that. Socially committed photographers seek to redress imbalances and create awareness. They seek out the materiality of the world and turn it into visions of inspiration. In this they are not alone. Poets do so too, albeit from across the presumed divide between the documen-tarian and the creative artist. Think, for example, of the work of Francis Ponge, whose prose poems are steeped in the everyday and yet are un-forgettable for their selectivity and ability to elevate the ordinary to the extraordinary.[14] Ponge's work offers another example of the lyri-

cal materiality that is also part of the work of photographers who espouse a deliberate lyricism or aesthetic, as does Salgado. So does, for example, Pablo Neruda's simple but elegant *Odas elementales*, these poems being prime examples of the hybrid conjuncture of art and solidarity, whereby everyday items such as the humble onion are exalted and so reveal their uniqueness. Equally, in the work of the Martiniquan poet Aimé Césaire, one finds not poetry as a genre apart, but rather the indivisibility of poetry from a politics of race, from intellectual engagement, and from the struggle to rewrite colonial history. Furthermore, there is an aspect of temporality in poetry that is also of relevance to poetic images: as Aristotle reminded us in his *Poetics*, "The poet's function is to describe, not the thing that has happened, but the thing that might happen, i.e., what is possible as being probable or necessary."[15] Thus, the principal focus of the poetic, whether verbal or visual, is on that which is possible now or in the future, and not on that which happened in the past. Poetic photography, as opposed to any supposed "objective" document, thus complicates the linearity of past, present, and future; it also presents the mutability of these temporal categories. As a consequence, it impacts on our sense of spatiality, for time and space are surely the two axes on which constructions of knowledge and identity are balanced.

To photograph is, in a sense, to create new imaginary spaces. To photograph the underbelly of late modernity, as Salgado does, is to visually foreground that which has remained without access to representation. It is thus to create new visions—important ones, as these have remained too long relegated to invisibility. A crucially relevant point here is that his photographs inevitably frame those who have failed to receive recognition or representation from states, governments, and global bodies. In whatever way that they can, his photographs thus intervene in the cracks within modern nation-states and hegemonic global alliances. They also bring to light shards of reality in the same way as an archaeologist would seek meaning in ruins. What emerges is knowledge, not in any coherent form, but as disjuncture, as that which is fleeting, partial, and unfinished. It is in this vein that Salgado presents *Workers: An Archaeology of the Industrial Age*. In this photo-essay, the varied images form a global collection of visual artifacts that interweave meaning into one another across space and context. Thus, socially engaged photography can be viewed as a sort of archeological endeavour that strives to piece together forgotten histories. It is an act of digging between estab-

lished spaces in order to uncover unseen, forgotten ones. This act of rescue gains narrative significance when images are organized into collections, as in *Workers* or in any other photo-essay or exhibition, so that meaning is transferred and grows from one photograph to another. Historical narratives ensue, not so much from individual images as from the contexts and frames within which they are viewed. Critiques of Salgado's *Other Americas* often revolve around the lack of labeling—that is, textual framing—that would historicize the images. Without captions, they floated before the eye, merely presenting alterity as silenced and in search of nomination. Images acquire meaning not just through what they portray, but also through the contexts in which they are seen: that of the gallery, the photobook, the museum wall, the surrounding page. When they are framed by words, labels, and captions, these elements restrain the mutability and unknowability of the image.

As signification builds from one image to another, still photography reveals its propensity for montage. In Salgado's case, the narrative complexity of his work is compounded by the variety of spaces his work occupies and also by the weave of one photo-essay to another. Furthermore, a strong comparative element exists in his work through its sheer geographic span. Numerous narratives emerge, and with them diverse forms of archives. The photographic archive is, after all, the product of deliberate collage. The ensuing narratives can be edited, recast, altered. In this way, the histories that emerge also reveal their propensity to be edited, reformulated, re-presented. Photo-essays are, in this sense, visual archives that aim to reveal overlooked aspects of our times. These archives, through their very consolidation as collections of images, put forward representations of those who have been made other by history. In so doing, they construct new historical narratives and new insights. Thus, they both restrain knowledge and release it. If the photographs do not function as faithful documents of reality, they do succeed in bringing attention to global realities.

Questioning the Document

It appears that as viewers, we can often distinguish the aesthetic in images. It is not so easy however—contrary to what one may think at first—to identify what exactly constitutes documentary realism in a photograph. That which is real is by definition always elusive in a photograph, which is after all only ever a copy of the original. Indeed,

our ideas on realism have shifted with the years. Ironically, it was perhaps photography that first fuelled the zeal for realist representation through its ability to copy reality. As Jay Prosser reminds us, "We have traveled from a notion of reality as reproducible (the naïve or credulous realism ushered in by the Renaissance) to a notion of reality as hidden or subjective (the first half of the anti realist turn in modernism) to a notion of reality as impossible or invented, or more radically as an effect of representation (the second half of anti realism in postmodernism)."[16] Prosser continues to explore the splitting of the sign, so that focus shifts increasingly in postmodern contexts onto the signifier, thus obscuring the signified. The result is the loss of the referent, of that which bears the weight of reality. As that which is real disappears from view, obscured by the increasing centrality of the signifier, the latter becomes charged with a sense of loss—that lack that Jacques Lacan labeled the "real." The "real," in Lacanian terms, is not that which is real, but the persistent absence thereof. It defies articulation, and hence representation. The "real" thus haunts attempts to represent; it is the veil of absence through which any representation is perceived. And so we see the trajectory of realism from the hopeful early dawn of Realism to the mournful latter-day acknowledgment of its impossibility. We see too that the signifier, in its predominance, its urgency, and its ubiquity, can take many forms, all of which inevitably rely on some form of the aesthetic. In this sense, the aesthetic of the signifier *is* its form—always already separated from reality.

It is not hard to connect the psychoanalytic idea of lack to that of loss in photography. Photography always denotes loss—if only of the moment that is, that was. Its deep pathos, its subjective hold, its melancholic enchantment, all derive from this void. Thus, in the same way that language and expression stem from the realization of lack, so also does vision—photographic, historical, and imaginative—arise from the sense of loss. This loss is nothing more than the impossible obscurity in representation of that which we deem to be real.

This premise of the impossibility of realist documentary is the basis on which any questioning of historical certainties can take place. Realism, thus, is at very best a goal for representations, not a starting point. Reality, and hence history, is never contained in an image: it is suggested by it. While realism can never be fully achieved, the debates around it and the aesthetic continue to be fuelled; moreover, these debates are inevitably about degrees of realist nonattainment, not about

absolute realism or the lack thereof. Salgado's images, located in this grey zone of the interrogative, bear historical potential only when the viewer abandons rigid expectations of documentary austerity and enters instead into the uncertain and often multi-hued dynamic between realist endeavour and the inevitability of the aesthetic.

It is interesting to note that the more obviously aestheticized the documentary image, the more susceptible it becomes to debate and disagreement. The more raw its grain, the closer its message is to the surface, and the clearer or less complicated it is, the less it provokes antagonism or reproach. At times, even the simple fact of colour, as opposed to the grandiose and inevitably distanced scheme of black and white, can inject realism into an image. Take, for example, Salgado's images of the Movimento Sem Terra (MST) in *Terra*. The collection serves as a visual hymn to celebrate a kind of solidarity of the dispossessed that defies the oppressions of feudalism and capitalism. Contrast these images— almost always of people in groups, working together, hopeful against the odds—with that of an image by Luis Vasconcelos that appeared as the centre-spread photograph in the *Guardian* on March 13, 2008.[17] A lone woman is clutching on to her naked baby, struggling to stay on her feet as police move in to her settlement and physically oust her. She is, the caption says, a member of the MST, occupying land in the Amazon region of Brazil that is about to be reclaimed by its owners. The police have arrived to dismantle and disperse the landless. Their black boots, as they sink into the mud, contrast violently with the desperate vulnerability of the woman's feet in flimsy flip-flops and of the nakedness of her child. The riot shields cover the policemen's faces, while the woman and her child are without protection. The mud, the fear, the repression by the state are stark. The symbols of oppression are unmistakable here, and the image appears to be truly an Instamatic snapshot witness to a reality that would otherwise go unseen by the rest of the world. The image is credible if shocking, its grain rough, the grimace on the woman's face almost a scream against the institutionalized violence of state oppression. To come upon it in the course of flicking through the pages of the newspaper has an effect akin to walking down the street and witnessing a violent incident. One pauses, one looks, and takes stock. There is an obvious and very direct materiality here, a sense of entrapment for the subjects that is infernal. Unlike the heightened aesthetic of Salgado's images, here there is heat, sun, dirt, and despair. The bright orange in the woman's skirt contrasts sharply with her grim cir-

cumstance. The image is entirely local, specific to its subject. Hence, it is removed from the viewers' own contexts. The subjects here are truly other, and shocked as I am by the image, I see it as a powerful but localized instance of eloquent photojournalism. It makes its impression on me, and yet it is not surprising in the context of images of its ilk that have appeared before in this centre-spread and the newsprint that is to be found in the pages both before and after it. Presented to me, as it is, in a daily newspaper, I am both shocked and untouched. I am, after all, inured to the idea of shocking news. Tomorrow I expect to find another image, also with impact, in the same paper—as I did yesterday.

In contrast, the black-and-white images of *Terra* show the perseverance of the MST, their tenacity, the collective will that rises above the harsh constraints of the material. The images are inspirational, meant as much for their subjects in this sense as they are for other viewers.[18] This heightened aestheticization of dispossession is, I believe, at once the Achilles' heel and the powerful source of historical potential of Salgado's work.

Archaeology and the Archive

The curious absence of psychoanalytic applications to studies of documentary photography—despite the fact that debates around documentary photography often focus on questions of the aesthetic, itself by definition of impact to the psyche—means that arguments such as Rosler's or Solomon-Godeau's do not consider the question of "lack." Instead they focus on the larger ideological contexts in which images circulate and within which images are subsumed. A rare example of an attempt to bring together notions of representation from various theoretical angles can be found in the work of John Tagg. He argues throughout his book *The Burden of Representation: Essays on Photographies and Histories* that the interpretation of a photograph depends largely on the semiotic and social processes applied to it. Tagg's work is important because it questions the means by which certain images—those that play a part in the construction of institutions—are deemed realist. Arguing that photographs are not faithful records of reality, Tagg explores the ways in which notions of realism nevertheless have tied photography to power. By interrogating the history of photography, Tagg opens up the question of historical production, especially the crucial role of photography in it. He demonstrates that traditions construct the way photo-

graphs are seen and used, but that in turn, the subsequent positioning of photographs serves to further or alter traditions and institutions, so that photography becomes a tool in the making of power.

Of relevance here is the idea of the archive. At once informative and authoritative, the archive promises to deliver information on the past that is otherwise out of reach. What is more, it does so in a coherent and organized manner. In light of Tagg's and Sekula's arguments, photographs when organized into archives help constitute, institutionalize, and consolidate modes, discourses, and practices of knowledge, which in turn translate into structures of power. Photographs are thus located within specific institutions and sets of power relations. More to the point, the question of interpretation in documentary photography is not so much a matter of the image itself, as it is of how it is historically located by its creators and viewers within a network of social practices, collectivized sensory and psychological responses, value systems, and power relations. As a point of fact, photodocumentary has been instrumental in the establishment of social, legal, and other state institutions and must therefore be seen to be a crucial tool in the building of the nation-state (and thus linked ideologically to the establishment). Nevertheless, it must also be borne in mind that there is, in the encounter with the image, a prediscursive moment when the *punctum* of images—the product often of a deliberate, selective, or aesthetic decision on the photographer's part—interrupts, diverts, or diversifies the expected course of hegemonic modes of response. This moment of vision is at once deeply subjective, historically oriented, collectively powerful, and paradoxically rational and irrational. Photographs, often described in terms of trauma, are interruptions to the normal order of things.

In the context of history, Salgado's work serves two prime functions: first, to offer a vast visual archive of economic and social trends in the twentieth century and early twenty-first; and second, to highlight the camera's ability to function as an archaeological tool that sheds light on forgotten, overlooked, or unseen aspects of these historical periods. Both the constructions of archives and the pursuit of archaeology have in common their concern with the past. Perhaps what differentiates them, though, is that while the archive presents a neatly ordered and readily accessible narrative of the past, archaeological findings often throw up new and unexpected shards of information about the past, which may either strengthen the existing archive of historical informa-

tion or else force changes to it. Thus, while the archive presents history as a master narrative, the pursuit of archaeology assumes that history—and by extension knowledge—is unfinished, in the making, always to be revised. The very existence of archaeology as a discipline undermines the idea of historical coherence.

Photography dwells in the ambivalent dual zone between the archaeological endeavour of shedding light on new findings and the ordered archive that presents history as polished fact. In this sense, it is both reliant on and understood within established historical frames and also constantly challenging these through new narrative interpellations. Hence, photographs offer a space of intersection between different articulations of the past. They also posit the overlap of temporalities, rendering knowledge in the present always uncertain, poised for change, and subject to alterations via new manifestations of the past. At this juncture, it is also worth noting that in many ways Salgado, as a photographer-explorer of otherness, is a visual archaeologist, while his wife Lélia, as editor and director of his work, constructs the archives in the form of books, captions, exhibitions, and other ways of making his work public.

Genesis, set in far corners of the earth as yet undisturbed by modernity, is no doubt the most obviously archaeological of Salgado's projects in terms of its attempts to recover aspects of a prior way of life that persevere in the face of industrialization and globalization. The photographs are a reminder of another historical era, a premodern one, and so must be viewed as representations of the remote traces that linger in the present of premodern existence. In theory, then, the images of *Genesis* must come across as startlingly different from Salgado's earlier work. In many ways they are. There is a stillness in these images, a quiet that contrasts with the movement and bustle of previous photo-essays. Contrast, for example, the images of the Namib desert with those from *Sahel*: the gemsbok are still as statues on the sand, their silhouettes almost too perfect to be real (fig. 11), while in images from *Sahel*, people traipse desperately through the sand in search of a way out from their misery. Yet uncanny similarities of composition arise between different photo-essays, as for example, between some images of *Genesis* and *Workers* or *The Children*. The paw of an iguana spreads out on the ground like a human hand. A whale dives into the ocean, its tail spread out in perfect symmetry, like that of a plane.

Historical periods that are normally perceived to be distinct sud-

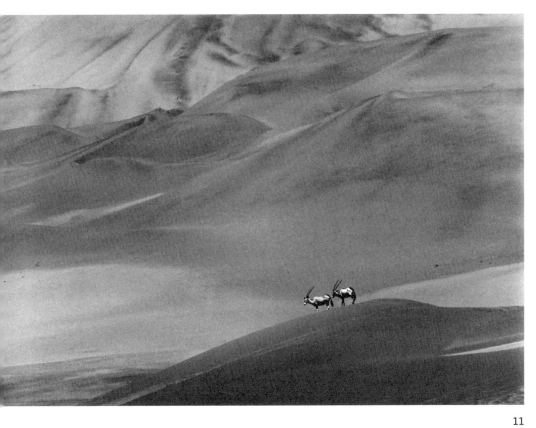

11

denly seem to overlap, throwing into disarray our established notions of modernity. Precisely as Salgado attempts to portray premodern forms and ways of life, the very patterns and compositions that he used to examine modernity and postmodernity re-emerge, cast in new frames but also revealing startlingly unified modes of selection by the photographer, and hence the auteur-photographer's singular line of vision. The result is the apparent superimposition of one historical frame on another, complicating in true postmodernist form any neat divisions between premodernity and modernity. What we see as a result is that if our reception of photographs is historically determined, then, in turn, photographs can confound our notions of historical linearity. We see too that we are subjected to a photographer's particular line of vision. What remains elusive is historical truth or certainty.

In this way, it becomes clear that photography and historiography are both about the construction and orientation of vision. For, ultimately, Salgado's work does not aim to "reveal" the past or to offer historical archives, but to pave the way for a better world. This ideological impetus requires the construction of specific visual narratives that foreground the displaced. In line with the French philosopher Paul Ricoeur's view that history and fiction are both narratives of the past that we write in order to make sense of time and so orient ourselves in the future, photographs too are ultimately not so much about the past as they are a way of enunciating and so rendering coherent the otherwise incomprehensible dissolution of time.[19] They are constructs that have contexts and aims, just like the fictional and historical narratives that Ricoeur highlights—and for him, history as construct is indeed a form of fiction, for memory, both collective and individual, is only ever those traces that can be rescued from the overriding force of oblivion. The photograph's temporal thrust, like that of history, is not so much about mapping the past for its own sake, as it is about doing so in order to orient the future in a particular way: photographs open spaces of vision into the future.

A Blinding Frame

In 1985, during the famine that afflicted the people of the Sahel, Salgado took a photograph of a woman who had reached Mali from the region of Gondan, which later formed part of his photo-essay on the famine in Africa (fig. 12). The image is pristine in its adherence to simplicity. Yet it is deeply troubling. The tonality of black and white both sheds

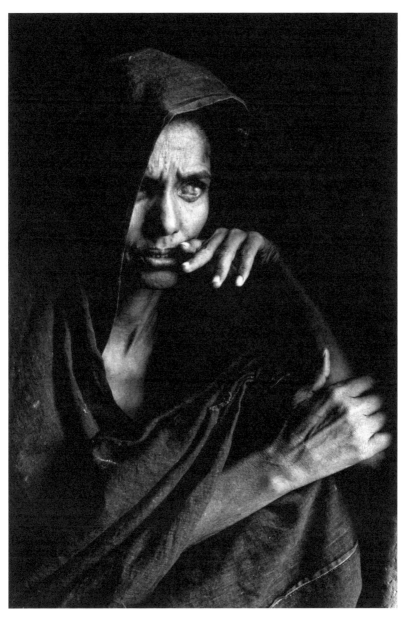

light and obscures. The subject is alone, solitary in her dispossession. My response as viewer is contradictory, fraught with tension. I see, I resist, I imagine an instance of human suffering that claims my line of vision. The woman arrests my eyes and yet remains elusive to me. She is remote, distant, a figure whom I contemplate but cannot know. I must read her image in the light of my own experience and from my affective response to what I see. Dressed in a traditional way, her head and shoulders are covered with a shawl. One hand is thoughtfully placed against her cheek and the other rests on her bent knee. She is still, still as the photograph in which she appears. Try as I might, I can only see this woman's image in the half-knowledge that I carry in my memory of her history. I read into her troubled brow and long, lean arms the starvation of a people; I see in her lined though still young face the despair of her affliction. Nevertheless, like the great paintings of the Renaissance that speak in timeless fashion of a common humanity that arises both out of and beyond their times, the woman's face haunts me with its beauty and its solitude. Her features are chiseled, her lips fine, her brow furrowed. In her distress there is an elegance that strikes me. The tones of light in the image are somber and deep, imbuing the image of the woman with a greatness that lifts her above the ordinary.

If, as Roland Barthes states, there is a *punctum* in this photograph, an element that pierces my heart and pains me, it is not my knowledge of her famine or even of the long road of dust that she must have walked till she reached this refugee camp. What hurts me the most is the screen that shrouds her vision. From under the shawl that covers her brow and part of her face, her cloud-covered eye looks out in unseeing oblivion of the photographer. I turn the pages of *An Uncertain Grace* till I reach the short caption at the back: "89. With dead eyes worn out by sand storms and chronic infections, this woman from the region of Gondan has arrived at the end of her voyage. Mali. 1985."[20] I look for the same image in the new edition of *Sahel: The End of the Road*, published by the University of California Press in 2004. This time the caption is slightly more hopeful: "Page 97. Goundam region, Mali. This woman, blinded by sandstorms and chronic eye infections, has finally reached her destination. She will survive, thanks to the aid she receives from now on. Mali, 1985."[21] Nevertheless, my anguish at seeing this image does not abate.

Perhaps she will survive, perhaps she did survive, but did she regain her sight? More to the point, had her circumstances been different,

would she have lost her sight in the first place? I turn back to the image and brace myself to look into her unseeing eye. If I do not know her, if I feel I cannot know her, then perhaps it is because a filter of thick cloud separates her eyes from mine. She remains, therefore, forever veiled from me. My mind races to advertisements that I have seen in the media from charities asking for support. I remember the mention of cataract operations carried out in refugee camps, of trachoma and the needlessness of eye disease that blinds so many people in the third world. I even remember images that accompanied these advertisements, photographs of children and older people in India, cyclone victims in Bangladesh, Sahrawi refugees in Tindouf, perhaps even the Sahel—ones that I saw and moved on from, images that left no conscious trace on my mind. At the time, I received the images in a matter of fact way, the distress of *others*, not me. Now, this woman's blindness steals into my heart. I ask myself why this image draws me to it so. Is it the artistry of its tonality, the elegant formality of its lines? Is it the stark drama of black and white that evokes the merciless extremes of the desert? Or is it the fact that this woman can never see this image of herself just as, presumably, she could not see Salgado taking her picture? Is it that I, with the power of my sight, can see somewhat into her history and so partake at least imaginatively of it, but she, in her sightlessness, is barred from looking back at me and so from entering my world? Is the cloud that covers her eyes the frame that both engages me and fences me off from her?

Blindness is an odd and troubling subject for a photograph. It is almost an indecent one. For how dare we, as viewers, witness moments in the lives of others who cannot see themselves? I recall Paul Strand's famous photograph of a blind woman in New York standing against a wall with a sign saying "BLIND" hanging around her neck.[22] There too the shock came from the troubling contrast of a camera that could see and a subject that could not. What mitigates that image, though, and persists as a problem in Salgado's one of the woman in Mali, is the degree and quality of aestheticization. Strand's woman is dour, unenhanced. The grimness on her face is entirely understandable. It is in keeping with her predicament. Salgado's woman, however, appears transcendent, her blindness a veil for her almost transhuman stillness, her image arresting because it appears as the caesura between life and death, absence and presence.

In Flashes and Movement

Is this woman's image an instance before my eyes of the "victim photography" that Rosler points out? Is her image devoid of historical potential because of its transcendence? Or is it that the former is veiled as are her eyes?

Historical elusiveness is radically different from the refusal of history. Rosler's point that the aestheticized photodocumentary presents universalized images of the human condition that deny the struggle to alter history—and indeed, even close off the possibility of such a struggle—is a useful starting point for considering the entwined processes of historiography and photography. If we take this point and consider it against Walter Benjamin's concept of aura in the work of art, or indeed, of Adorno's focus on elite art forms—precisely those that circulate in enclosed and privileged spaces, such as, in the case of Salgado's images, the gallery or the museum—then we run up against a web of theoretical contradictions that must be confronted. Aestheticized images that circulate as "documents" are, in Rosler's view, ahistorical and nonactivist. They fail therefore to represent. Rosler ends her article "In, Around, and Afterthoughts" with a query about whether or not "real" documentary, as opposed to "liberal" documentary, can ever come into existence.[23] Certainly she does not believe that real documentary, as that which exposes abuse, domination, oppression, and the lack of recognition, exists as yet. Rosler denounces the celebrity status accorded to the photographer, raised by dint of his photographic endeavour to the place of a hero, which diverts the course of his or her work. Instead of exposing social realities, such liberal documentary serves to uplift the photographer, to whose name the images are inevitably linked. Added to this is the context of capitalist exploitation of the subject as the documentary-artwork gains entry into commercial circuits. This phenomenon leads to her coinage of the now famous phrase "victim photography," which she uses to describe works in which moralism, in the well-intentioned but fundamentally liberal aim of social concern from a safe distance via photography, takes the place of a revolutionary politics.[24] In this sense, perhaps one can deduce that for Rosler, any documentary or activist image that does succeed in its stated aim is that which *ensues from* reality—and not that which *paves the way for* new or different realities.

The question remains as to whether the potential for historical re-

newal in an image lies in its aesthetic of translucence or in its grain of grit. There is also the question of whether that which appears to be grit is indeed a certain type of aesthetic. Rosler's focus is on the distinctly palpable issues of social class and politics that frame the making and seeing of documentary images. In contrast, Walter Benjamin long ago recognized the fact that the photograph acts as caesura, the flash of an instant before the moment dies. It is this precariousness of the image, poised as it is on the brink of extinction, that gives it a poignancy to which we, as viewers, respond. And, in turn, it is this poignancy that intervenes in our historical imagination, disturbing the coherence of established linearity and positing a visceral dimension to our own understandings of history that acts as an important precursor to ethical relation. This visceral dimension is also the rebellious element in photography, that which poses a challenge to reason via its grip on the heart. And reason, we know, forms the basis of the modern project, part of which is to separate the document from the work of art and knowledge from feeling.

Photographs are a travelling medium, scattered and without rooting. Their significance can alter according to context. They confound any expectations of coherent and linear narrative. The eye of the viewer betrays its adherence to such regulated forms of seeing, as precisely through its dissociation from lived reality—that is, in its selectiveness and enhancement of partial realities—the still photograph points to new horizons of vision, to new ways of seeing. If Benjamin linked the photograph to the rise of technology in the modern age, and hence to the loss of aura as that unique and "strange weave of space and time" that was contained in the portrait, then it could be argued that the hybrid merging of document and art that we witness in Salgado's work aims almost self-consciously to retrieve that aura, to raise the image over and above the coarse grain of reality in order, ironically, to better perceive it.[25] Despite the loss of aura, Benjamin recognized the value of photography as a route to envisioning history.

As Eduardo Cadava has pointed out in his seminal *Words of Light: Theses on the Photography of History*, Benjamin relied on the language of photography in order to articulate his vision of history. In his introduction, Cadava writes, "Benjamin's entire corpus can be said to be organized around his effort to analyse these 'new structural forms of the subject matter' in relation to the questions of reproducibility that inform his reflections on the technical media. His recourse to photo-

graphic language forms an essential dimension of the historical physiognomy of his writings but also signals his engagement with what for him is the fundamental event of modernity: the production of the image. It is the task of the historical materialist, he tells us, to analyze the stratified network of socio-political relations within which such production takes place."[26]

Thus, for Benjamin, Cadava explains, history was not a stable, linear, and coherent narrative that remained immutable through space and time, but an elusive, fleeting, and chameleonic imagination of the past. Its imagination in the chaos of modernity came via the photograph. Mimesis, caesura, translation, travel, flashes, and brief illuminations all form some of the scattered routes through which he attempted to articulate his understandings of history. These are also facets of the photograph that reveal the ways in which photography can intersect with and contest the established master narratives of history on which the rational basis for much modern endeavour rests. In this context, historical approximation appears not so much as that which is contained in linear and coherent historical narratives but as the sentient and also rational struggle to interpellate and question them.

In this sense, it could be said that photography is intrinsically linked to the development of new historical discourses. Few theorists have explored the intersections of photography and historiography as well as Benjamin's contemporary Siegfried Kracauer. In his *History: The Last Things before the Last* (cowritten with Paul Oskar Kristeller), Kracauer takes as his starting point the instability and mutability of historical discourse and the enabling potential of photographs to proffer new points of view. Kracauer worked extensively on questions of visual technology—most especially film and photography—and history.[27] In the course of his writings, his view on photography shifts from an early consideration of it as modern technology ("a secretion of the capitalist mode of production") to a later focus on its almost utopian ability to offer aesthetic release from the grip of technological capitalism; this later view yields to an examination of the ambivalence of photography.[28] In this, he found that the medium is akin to the writing of history, in that it reveals tropes of uncertainty that subverted attempts to contain reality. For Kracauer, historical writing is about inquiry into the past—and not about *recounting* the past. While embarking on this book (his last), Kracauer stated: "My historical studies are progressing. I have made a discovery that affirms my choice of topic. . . . The his-

torian has traits of the photographer, and historical reality resembles camera reality."[29] Of relevance here is the selectiveness that characterizes both the writing of history and the making of images, as well as the idea that representation is dependent on perspective and point of view. Kracauer underlined what he saw as "intelligible patterns" in historical material, which he compared to "found stories" in documentaries.

The historian, Kracauer asserts, is in fact an "artist-historian," whose formal interests impose patterns on historical material, akin to the "artist photographer," who also imposes a creative and ordering perspective on the phenomenal world. Neither, he states, can in fact fully achieve the call of his vocation, for both are implicated in historicity or the movement of time. It becomes impossible to render the phenomenal world abstract. Yet both are called on to provide true and accurate accounts, with an objectivity that is always elusive. As such, the historian and the photographer alike are involved in sustaining a fluid and shifting dynamic between lived reality and its attempted recording. "Perhaps the most important function of history is to gather fragments of the past in an uncertain light and for uncertain ends," he states.[30] Kracauer calls for an acknowledgment of the fragmentary and mutable nature of historical knowledge.

The germ of this view was indeed present in his earlier work *Theory of Film: The Redemption of Physical Reality*, in which he emphasized the mediation of film and photography between the viewer and the transient events and phenomena of the world.[31] In *Theory of Film*, however, the medium offered redemption from the crisis of reality via the aesthetic, as well as an approximation to the former through representation. Throughout his work, Kracauer sought ways of approaching modern reality via the visual. Always partial and incomplete, photography to him nevertheless played a crucial role in developing both engagement and understanding. For Kracauer, the provisionality of history is best witnessed via photography, also an intermediary between reality and knowledge, which is at once a selective recording and art—or artifice. Despite the partial and incomplete roles they perform, Kracauer insists that both history and photography intervene to make familiar that which through the passage of time would have become abstracted into oblivion—namely, what he refers to as the transient phenomena of the outer world. Most importantly, the fluidity of photographic representations brings to light the fluidity of historical ones. As Dagmar Barnouw explains, "Kracauer . . . wishes to explore how photo images

with their peculiar openness to the visible world can present representational concepts in ways that enable a plurality of viewers to appreciate, with the freshness of these concepts, also new, surprising aspects of a world that had seemed familiar, and to respond to them in different ways. Kracauer's emphasis, then, is on what viewers can *do*. He focuses on the enabling potential of photo images . . . which is available also to the 'taker' of these images, the photographer who is also a viewer."[32] Kracauer points to the photograph as a site of mobilization of agency on the part of the viewer. This is a very important point, and one that I hope to pick up in the final chapter of this book, as it underlines the political potential of images.

Viewed within established circuits of discourses and practices, in other words, viewed within established historical patterns, the photograph does not merely adhere to these systems but also takes the viewer by surprise. This nonconformity of images, this ability to shed new light on the very historical contexts within which they are viewed—a force that is derived no doubt from the melding of the realist with the aesthetic—is the historical challenge that must be borne in mind when regarding photographs. Kracauer and Kristeller stress the former's view that history is never that finalized narrative of authority that we so often imagine it to be, but "an intermediary area" that is necessarily incomplete, open to revision, and malleable: "One may define the area of historical reality, like that of photographic reality, as an anteroom area. Both realities are of a kind that does not lend itself to being dealt with in a definite way. The peculiar material in these areas eludes the grasp of systematic thought; nor can it be shaped in the form of a work of art. Like the statements we make about physical reality with the aid of the camera, those which result from our preoccupation with historical reality may certainly attain to a level above mere opinion; but they do not convey, or reach out for, ultimate truths, as do philosophy and art proper. They share their inherently provisional character with the material they record, explore and penetrate."[33]

The stress here falls on the interaction between the material and the discursive. Photographs play a central role in this historical dynamic through their ability, according to Kracauer, to render familiar that which is abstract, to make "this earth our habitat"—if only for a while.[34] This is a kind of temporary universality that is diametrically opposed to the ahistorical universality that Rosler, for example, critiques in aestheticized photodocumentaries. Indeed it draws the his-

torian—both the photographer and the viewer—into a flow of engagement with the materiality and mutability of new and different contexts.

At the same time, and very importantly, it signals the impossibility of containing the material or defining it. As Elena Gualtieri states, the photographic or historical endeavour is ungrounded "alienation from territory, from belonging . . . it is alienation as extra-territoriality, undermining the very ground we walk on."[35] Written toward the end of his life and expressive of his condition as exile, Kracauer's last work reflects his experience of historical instability and nonterritoriality lived out in terms of the crisis of modernity that had led him from Germany to the United States. In the "anteroom" context of the photograph that he describes, always a space that can be rewritten on, there is then this chance to encounter reality in transit and to engage with it. The material encounter via photography is always uncertain and incomplete. The attempt to represent reality photographically, as Salgado does, or historically, as the historian would, derives ethical validity from this awareness of being tentative, always in rehearsal. Yet, it is also the medium through which reality, by definition in the past and thus irretrievable, can best be imagined. Later in this chapter, I return to this core point about the open, shifting materiality of photographs.

Alchemy of Vision

When Kracauer points out the uncertainty that marks both historiography and photography, he also highlights the fact that both endeavours take place at the margins of objectivity. It is from these margins that the argument for historical potential in aestheticized photodocumentary takes its cue. At the heart of such a view is the notion that photographs are somehow magical or forceful in nonrational ways. By this, I mean that rather than being flat objects that serve as contained image-spaces, photographs intervene in the subjectivity of the viewer to release vision and forge imagination.

There is nothing new in this. From the time of its inception, photography has been imbued with the mystical and the magical—with that which stands outside of rationality. As Simon During points out, early photographs were part of magic shows.[36] His claim that modern culture is, to a large extent, the result of technologically produced magic places the visual and photography at the centre of such a phenomenon.[37] In tandem with the onset of modernity, the advent of photog-

raphy marked a decline in religious belief and a rise in secular thought; yet we see that photography also became the terrain on which the remaining vestiges of religious, nonrational belief could take root. Secular cultures, which privilege rationality and objectivity, paradoxically look to the still photograph for awe and enchantment. Throughout the ages and in the many forms of play between light and darkness that have ensued, from magic lanterns to the camera obscura and the camera lucida, photographs have required viewers to surrender themselves and enter metaphorically into a dark space in order to better perceive reality illuminated.[38] Perhaps this is why Benjamin was able to identify the aura of premodern portraiture in early photography. The very act of writing with light is, after all, wondrous and magical. This aura of enchantment injects the medium with a super-human power that invokes the divine. To gaze at a still photograph is to be struck by the force and inventiveness of light, its ability to make present that which is absent, to conjure new visions of time and place.

In this sense, photographs have a life force that yokes them to our imaginations and imbues them with agency. The viewing of an image is a form of engagement from which the viewer cannot remain separate, for the image springs to life on being regarded in and through the viewer's imagination. In his *What Do Pictures Want?*, W. J. T. Mitchell argues that images are in fact animated and driven by desire. This quality lies at the heart of their ability to influence us. Through references to iconology and religious uses of images, he suggests, "Perhaps, then, there is a way in which we can speak of the value of images as evolutionary or at least co-evolutionary entities, quasi-life forms (like viruses) that depend on a host mechanism (ourselves), and cannot reproduce themselves without human participation."[39] Quasi-life forms, like full life forms, reveal via the image their life force, or agency. What emerges from Mitchell's argument is a dissociation between, on the one hand, the market value attached to an image, linked to questions of demand and supply, and, on the other, the worth or relevance of that image in terms of its reproducibility. This latter term refers not to the material reproducibility of an image, but to its ability to reproduce itself via transmutation and travel, to plant a seed in the mind of the viewer, and to so affect her or his consciousness of reality. To dwell on an image is to enter into a dialectic of desire. And this desire, according to Mitchell, is, at its most basic, for a kind of questioning: "What pictures want, in the last instance, then, is to be asked what they want."[40]

Even as he states this, Mitchell shows an awareness that this idea of

images having a life force could relegate his argument to premodern notions of totemism and idolatry. If located within the modern scheme, then this question would be labelled as fetishistic. Either way, the question "what do pictures want?" runs against the grain of modern rationality. Yet we do not need to turn to Mitchell to realize that this specular age of ours, characterized by postmodern contradictions of time and space, is indeed witness to the crossovers of religiosity and rationality indicative of the many failures and splinters in the modern project. It is in this context that photographs trigger an oscillation between reason and passion.

By extension, the still photograph is, as Benjamin points out in his discussion of aura, both a product of modern technology and also a departure from the coherent and rational bases of this very modernity. It is crucial to understand that photographs offer us a syncopated experience of time and space, shifting between an alignment with the tenets of our reason and formalized knowledge and countering them with a curious dynamic that challenges these elements. Photography may be a product of the technology that characterizes modernity; nevertheless, its significance dwells not so much in its technological prowess as in its contradictory movements toward and away from religious or non-rational forces in the mind of the viewer.

Contrary to the term we use to denote it, the still photograph is seldom still: it moves to a double beat that complicates readings of even the most objective images. A curious counter-time to modern rationality is experienced via the photograph. The linear narratives of history that we take as the norm are interrupted and splintered by this unexpected intervention of the prescient. As a migrant medium, it constantly crosses the boundaries of objectivity and rationality. This is why photodocuments need to be grounded by accompanying text; equally, this is why text as documentary comes to life and turns three-dimensional via the still image.[41] What happens is a shifting between reason, on the one hand, and wonder and sentience, on the other. If the photograph is a caesura or an interstitial text, then it can draw the viewer into ambivalence and indeterminacy.

In Light of the Baroque and Magical Realism

We encounter in the aestheticized documentary photograph a kind of magical realism. This is particularly so, in my view, of Salgado's work, where the aesthetic is so heightened that the subject acquires a sym-

bolism that exceeds the particular. This magical realism—an enhancement of reality so that it approaches the super-human or magical—is symptomatic of the work of many postcolonial writers and artists. The trope itself developed in the 1920s as a response to the modern emphasis on rational objectivity and, like surrealism, it sought to probe the boundaries of the rational. The fact that in the decades subsequent to its emergence it should have been appropriated by numerous postcolonial writers and artists in Asia, Africa, and most especially Latin America is indicative of its ability not only to convey hybridized non-Western responses to Western thought, but also, in response to colonial impositions of Eurocentric discourses of thought, to appropriate and re-fashion Western forms and genres so that they better reflect the contexts that are being represented. Magical realists splice reality and fantasy in such a way as to transform and regenerate. They do so through the deliberate crossing of the boundaries of objectivity. The ways in which they do this are varied and culturally distinct, yet they all have in common a persistent disrespect for the rational while simultaneously flirting with it.[42] The resulting cultural artefacts denote a hybridity born of dissonance and difference.

In Latin America, the Cuban writer Alejo Carpentier set the terms for Latin American varieties of magical realism with his expositions on *lo real maravilloso*, wherein objective reality fuses with the mythologies, traditions, and imaginations of Latin America's hybrid and uneven cultural mix of the Latin, the indigenous, and the African. Carpentier writes, "The marvelous begins to be unmistakably marvelous when it arises from an unexpected alteration of reality (the miracle), from a privileged revelation of reality, an unaccustomed insight that is singularly favored by the unexpected richness of reality or an amplification of the scale and categories of reality perceived with particular intensity by virtue of an exaltation of the spirit that leads it to a kind of extreme state. To begin with, the phenomenon of the marvelous presupposes faith."[43]

Nothing could, in fact, be a closer description of Salgado's way of making photographs. His images are wonder inducing, breathtaking in their scale and in their amplification of the subject, to the extent that to contemplate them is at times to experience a quasi-religious moment of epiphany. They depict reality as miraculous—the miracle often being that of everyday human survival. Surely, then, they are magical realist.

As I have mentioned, this genre developed and continues to develop in various parts of the world, mostly via literature and film. It is im-

portant to note that magical realism challenges the common, Western assumption that humanism is based on the universal principle of rationality. If there is anything made evident by magical realism, it is that humanism needs to be contextualized and historicized, for "rationality" can, according to context, include the irrational or magical. This understanding, then, will impact on perceptions of what constitutes historical and other types of knowledge. Though writing on film, as opposed to photography, Fredric Jameson's study of magical realism sheds much light on the concept that is useful for this discussion. In particular, he refers to Carpentier and states that magical realism for this writer stressed "a certain poetic transfiguration of the object world itself—not so much a fantastic narrative, then, as a metamorphosis in perception and in things perceived." Jameson goes on to state that magical realism leads to an engagement with history, but one with "holes, perforated history."[44] This idea of history as porous, open to new mixtures, fits somehow with that of history as rehearsal as put forward by Kracauer. For Jameson, magical realism depends on a "type of raw historical material in which disjunction is structurally present; or, to generalize the hypothesis more starkly, magic realism depends on a content which betrays the overlap or the co-existence of precapitalist with nacscent capitalist or technological features."[45] To elaborate on this point, it is worth adding that we are talking here not merely of overlap or coexistence but also of inextricability of mode: that is, the very idea of magical realism brings with it a sense of contradiction and flux, if not struggle, that is inherent. With regard to photography, there is something of the magical anyway in its relation to reality, for the photographic act both cuts the moment and offers a framed reflection of it. The flash of the camera shatters and reproduces.

In the context of Salgado's work, while he is most often viewed as a global photographer—which in many ways he is—what remains often obscured from critical attention is the fact of his Latin American, and more specifically Brazilian, background. Of relevance here is the nexus between Latin American baroque and magical realism. In his essay "The Baroque and the Marvelous Real," Alejo Carpentier establishes the links between an aesthetic of the baroque and magical realist endeavour as central to Latin American cultural identity.[46] Lois Parkinson Zamora calls attention to this overlap as well, stressing that it straddles prose and visual art.[47] The baroque was transported from Europe to Latin America in the seventeenth century, only to be appropriated and

reinscribed with inflections of the local, the indigenous, and the African in the course of its transplantation to the Americas. The result is a hybrid cultural form that continues to dominate architecture and visual culture in very striking ways.

As the Argentine-born theorist Néstor García Canclini has written, hybridity is a strategy present in Latin American culture to "enter and exit modernity."[48] Perhaps the most salient feature of the baroque style is the resonance of the florid, the nonrational, and the magical in the everyday. Baroque architecture, for example, offers a visual challenge to the very idea of modernity. "In Latin America and the Caribbean, modernity is haunted by the return of its antithetical, premodern other: the Baroque," states Monica Kaup.[49] She explores the ways in which Latin American modernism and, more specifically, Brazilian modernism attempt recoveries of the baroque transported from Europe, so that colonial inheritance is appropriated and reinscribed. The baroque is a quintessential aspect of Brazilian culture and very much a part, therefore, of Salgado's cultural inheritance. Much "modern" Brazilian architecture—the work of Oscar Niemeyer, for instance—is indeed reminiscent in many ways of the baroque established some two hundred years ago or more in Brazil. Indeed, there is a local historical trajectory at play here, one that runs counter to the divisions of the rational from the irrational, or magical or the premodern from the modern. O Aleijadinho, Brazil's greatest baroque sculptor, architect, and painter, was a mulatto from Minas Gerais, Salgado's home state, who lived in the eighteenth century. Aleijadinho's works—created despite the fact that he was increasingly prey to a crippling disease that affected his extremities to the extent that the very existence of these works speaks of awe-inspiring survival against the odds—show how European baroque traditions were incorporated into local artforms to create New World baroque, the result of the hybrid encounter between premodern and modern temporalities, cultural assertions, and imaginations.[50]

On a more contemporary front, an interesting comparison arises when Salgado's lyrical images are considered alongside the work of Haroldo de Campos, one of Brazil's most important intellectuals. At once poet, theorist, essayist, and translator, Campos was a key figure in experimental poetry, whose work resonates across the globe and across linguistic differences. Best known for having formed, together with his brother and others, the Noigandres group in the 1950s, which later published a journal under this same name and established a vein of poetry

known as concretist, Campos took his initial cue from Ezra Pound's ideograms to create poetry in the form of visual constellations in his native language. Through concretism, words gain formal, and not solely semiotic, significance. By bringing together the verbal and the visual, as well as through his work as a translator, Campos reinvents and revitalizes poetic forms. He engages in dialogue with earlier modernist forms of Brazilian poetry and frames literary creation in terms of a dialectics of difference. Concretism, for Campos, runs a course alongside the neo-baroque and transcreation, a process where translation, theory, and criticism meet. The baroque acts as a rich vein in his literary and theoretical production. Writing on Brazilian literature, Campos states, "Ever since the baroque, that is, since always, we cannot think of ourselves as a closed and finished identity, but rather as *difference*, as *overtness*, as a dialogic movement of difference against the universal."[51] For Campos, the baroque signifies both hybridity and dialogue with alterity, as well as the appropriation of difference. It is a differential practice that is also one of translation. Brazilian baroque, as he sees it, is defined by three accents: those of tradition, hybridity, and creative translation. According to João Almino, for Campos, Brazilian literature, marked by the baroque, is the result of "the critical devouring of a universal cultural legacy, carried out not by the submissive 'good savage,' but by the challenging, aggressive, 'bad savage,' who synthesized universal codes through processes of transculturation."[52]

If Campos has literature as a prime concern, then it remains intrinsically linked to the visual, for concretism turns the spotlight onto words as visual forms as well as bearers of meaning. Visually and semantically, words pave the way for "telling the other and telling oneself through the other, under the sign of difference."[53] No better phrase could help to identify the thread of the baroque in Salgado's work. The pronouncement of the aesthetic in his photographs stresses the formal and semantic qualities of the image. He too places his work in the crosscurrents of photographic tradition and photographic translation. In transferring the modernist impulses of photodocumentary to the marginality of the global south, in appropriating, recasting, and extending preexisting photographic preoccupations, the baroque in Salgado's photography becomes an indispensable modus operandi. It is an artistic and political tool of the marginal. This aesthetic is at once style and message bearer, the gesture *of* and *to* alterity. Palpable in Salgado's work is the vibration of the dialectic of difference.

There are also interesting differences between Campos and Salgado in their framing of the baroque. Campos writes of the construction of a corpus of national literature. Anthropophagy features large here in terms of the literary appropriation of European forms that are translated, appropriated and transfigured to become part of the national body of literature. Photography urges a different spatial relation to alterity. The other in and through the photograph cannot be cannibalized: it remains distinct and open to regard. The stress falls not on the construction or enhancement of an individual or collective self, but on questions of regard and relation. If Campos suggests an internal frequency in the dialectics of difference, then Salgado's photography always forces the viewer to look outside, beyond the margins of the self. The movement of difference is discernible in both, but the crossing of subjective, affective, and epistemic borders is distinctly pronounced in the case of photography. When Campos writes of Brazilian literature, he highlights the ways in which the baroque acts as an aesthetic or philosophical parameter of the nation in the making. He offers an insightful model into postcolonial cultural formation and questions of difference. Salgado's photography instead directs the baroque to global, indeed planetary, relevance. His work offers it, weighted as it is with the inflections and dissonance of Brazil's cultural history, as a mode of relation across planetary difference. The baroque of Brazil, hybrid, dissonant, and fantastic, reaches out to the disenfranchised across the planet.

In seeking to understand the relevance of the aesthetic in Salgado's work—and not only to enter into the historical possibilities that it opens up—one needs to consider it not only in light of North American traditions of photodocumentary but also in light of the baroque and the magical realism of his native Brazil. The importance of this dualism was highlighted during Salgado's visit to the Doreen B. Townsend Center for the Humanities at the University of California, Berkeley, in 2002, and responses to his *Migrations* that foreground the baroque in his work can be read in the occasional paper that was subsequently published by this centre.[54] To quote the Caribbean writer and theorist Édouard Glissant, "Baroque art was a reaction against the rationalist claim to penetrate the mysteries of the known in one single, incisive, uniform movement. The stone with which baroque art disturbed the rationalist pool was an affirmation that knowledge is never fully acquired, a fact that gives it all its value."[55] Hybridity and creolization are, for Glissant, important

routes toward the subversion of dominant historical discourses. They open avenues for the assertion of new, hitherto marginalized voices and histories. Baroque art incorporated the magical, the mythical, the non-rational, and the excessive, all ways of challenging the boundaries of European rationality through non-European metaphors, while also adhering to them. In particular, religious imagery, Catholic in origin and creolized in transit, offered lush ground for the baroque.[56]

Think, for example, of Salgado's image of three girls dressed for their first communion.[57] The white of their dresses and the clouds in the sky overhead frame the round innocence of their young faces. These girls are indeed about to receive the sacrament; to gaze at the image is also, in a curious sort of way, to mediate on a reflection of that sacrament, so that the girls become, not the receivers, but the purveyors of the purity associated with the religious ritual. In this sense, the photograph is transcendent. At the same time, there is a strong contextuality to this image. To my eyes, it could never have been taken in Europe. Precisely because of the almost self-consciously heightened aura of this image, the ornate swirls of white nearly moving in the background like angels' wings, it speaks loudly of the magical, the excessive, the baroque—the transposition of Catholicism to the New World and its subsequent reformulation in terms of local mythologies and visions. My aim here is not to categorize Salgado's work as solely "baroque." Rather, it is to question the relevance of specific labels and categories in trying to read photography via the aesthetic. Equally, this elaboration of what should be a representation of children that offers a clear and uncomplicated reading points to the many complexities of Latin American cultural representations that both adhere to and depart from realism. The image destabilizes normative oppositions between the realist and the fantastic, as magical realism often does. And in this double movement, a key element of Salgado's work, there is a stirring of historical disjuncture that turns history into unfinished business.

Looking in Reverse

An acknowledgment of the agency of images impinges on questions of history when one begins to think of photographs as both magical, and hence deviant, and also as subsumed within dominant historical discourses. Consider, for example, this image of an Indian girl, one of a series of portraits in *The Children* (fig. 13). The basic details provided—

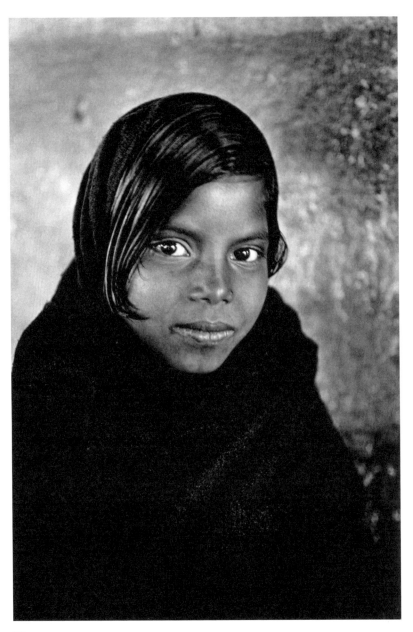

13

some idea of the child's situation and where the portrait was shot—do not allow the viewer to enter into the specificities of that child's own history, and yet this is not the point. To look at this image is not to see this child: it is to feel that she somehow sees us. Her gaze transcends the surface two-dimensionality of the image to search ours out. It is not her eyes that falter, but ours perhaps. There is very little in the image to reveal any aspects of this girl's life, and the sole information we have is the short line at the end of the book that explains that she is an orphan from a tribe in southern Bihar—indeed, none of the portraits in *The Children* bears the subject's name or personal details, an aspect of this collection that has at times been criticized but that Salgado insists is crucial to allowing each portrait to speak. Nevertheless, in the context of the body of work within which this image is seen—that of *Migrations* or the exhibition *Exodus*—it is clear that what we have before us is meant to be the interjection of the marginal.

If all the children in this collection of images are marginal and hence subaltern, then what predominates is the diversity and complexity of that which is considered subaltern—its myriad faces, contexts, and histories. One also notes the fact that the marginal, or those presumed subaltern, are not without the ability to interrogate via the gaze. In writing on Salgado's work, and his images of children in particular, Else Vieira stresses the motif of a direct gaze. Her claim is that in each instance, the child's face invites the viewer not to look into her or his own particular story, but rather to consider these larger contexts of which the subject is a part. For Vieira, the eye motif is linked to the absence of rooting or the material lack of the subject, so that "an eye motif inhabits the geography of this absent (mother)land."[58] The child's face asks the viewer to interrogate not his or her story per se, but the larger history of which the child is a part. This in itself contradicts the very idea of subalternity as that which cannot speak, suggesting that even if the subjects have no voice, they do have eyes that demand of the viewer to bear witness. More to the point, if subalternity is often conceived of as that which is an interruption of history—that is, as that which resides outside of a historically acknowledged, and hence dominant, frame—then images such as that of this girl challenge this notion, not merely through the visibility of this child in terms of the photographic representation, but furthermore through her apparent gaze at the viewer.

Taking into account Kracauer's stress on the fluidity of historical discourse, and also taking into account Mitchell's insistence that images

are able to raise questions, what we can see in this photograph of the Bihari girl is a gaze in reverse—and, with regard to parallels between photography and historiography, this then becomes the visual parallel of the attempts made by the scholars of the subaltern studies group to "write in reverse." In this sense, Salgado acts as intermediary here, so that the eyes of a child act as a reversal of dominant power relations. The photograph proffers a challenge to historically defined forms of seeing that locate the child as object of *our* vision, relegated to the margins. His attempt is clearly to lift children out of subalternity—and hence invisibility as regards representation—and to offer the photograph as a platform.

It goes without saying that there is never any single way in which an image must be viewed. The eye motif we see in *The Children* and elsewhere in Salgado's work lends itself to Rosler's notions of victim photography as much as to Vieira's interpretation. Indeed, those who are not drawn to Salgado's work may find it a vulgar and overly sentimental appropriation of innocence by a celebrity photographer. Others, more able to appreciate Salgado's wholehearted support of the landless movement and other social causes, will see a deliberate inversion that is crucial, if the will to history of those to whom subalternity is ascribed by those in power is to be noted. In this sense, the eye motif is a revolutionary symbol, akin to the sickle, that seeks to alter the course of history. Perhaps it may be useful to remind oneself of Salgado's former links with Marxist groups and his ongoing support for the MST. In this light, his work as a photographer becomes a route to historical intervention: "When I was a student in Brazil, I was involved with some Marxist groups. My way of seeing things is social. I am interested in having a debate to see how we can make things better for the majority of people."[59]

The eye motif in Salgado's work brings to mind the work done by John Beverley to explore notions of subalternity and representation in the Latin American context.[60] While Salgado's photography spans contexts that are global, nevertheless, the relevance of this study to his work lies in Beverley's pursuit of how and to what extent the academy or those who belong to the establishment, as Salgado clearly does, can represent the interests of the subaltern while also implicated in the very contexts that they seek to redress. Beverley refers often to the work of Ranajit Guha, the founder of the Subaltern Studies Group in India (though he took the term *subaltern* from the Italian Marxist Antonio Gramsci), but

transfers the issues at stake to the Latin American context.[61] He engages with a series of Latin American texts in order to tease out the voice of the subaltern that is filtered through them. Both for Guha and for Beverley, the concern from the start of their academic endeavours was to question historiography, or the ways in which history gets written. In particular, their work is fuelled by a questioning of what Guha calls "elitist historiography," which fails to accord presence to those who do not fall into the elite classes. While subaltern studies is particularly focused on the historiography of postcolonial nations—where colonialist and bourgeois-nationalist elitism reigns, with a series of concomitant repercussions on race, ethnicity, and gender—Salgado's focus on globalization and the mobilization of global capital in the favour of a global elite and to the detriment of the global displaced makes his work parallel in some ways to that of Beverley and Guha.[62] Indeed, if these scholars' focus is within nations and regions, then Salgado extends this to the global. In this sense, *Workers*, for example, positions the viewer to reflect on the networks of alliance across nations that maintain hierarchies within and without individual nation-states.

By facilitating representation to the subaltern, Salgado, Guha, and Beverley are interrogating the status quo by which history is written. In all their work, the aim is ultimately to interrupt the linear, teleological narrative of historical development with the alternative temporalities and modes of being of the marginal. These interruptions then become the interjections and claims to recognition made by the voices and by the presence of the hitherto unacknowledged subaltern. To quote Guha, "The historical phenomenon of insurgency meets the eye for the first time as an image framed in the prose, hence the outlook, of counter-insurgency—an image caught in a distorting mirror."[63] This distortion can also be thought of as a kind of "writing in reverse"—or, more to the point, a "looking in reverse."

The eye motif that dominates these portraits of children supports the notion that the children are looking back at the viewer, and so turns the photographs into spaces of insurgency against the hegemonic historical discourses and practises that have assigned the subjects to the periphery. This consequence, though, is not restricted to images containing the subject's regard: it courses through the whole of Salgado's work. Turn, for example, to some of the opening images of *Workers*—those of sugar and tobacco. Everyday commodities for consumers across the globe, these are also quintessentially Latin American and Caribbean

products that are emblematic of both the imperial enterprise that flourished (and flourishes) in the region, as well as of the ill-recognized and exploited labourer. The images are idyllic, perhaps excessively so; so too are Salgado's own words on his images: "I knew warriors of the cane fields in Cuba and in Brazil. . . . They are gentle and they are aggressive. They rest, they laugh aloud, they stretch out on the ground."[64] He also states of tobacco that "working with tobacco is sweet and gentle. It can be compared to making bread: it is ancient, meticulous, exact, unique work."[65] How, the viewer may well ask, do these sentimentalist words and aestheticized images help to offer historical vindication to the worker? Or is there a rhetoric at play here of words and image? If so, what is the underlying message?

On the surface, there appears to be a bifurcation between Salgado's intentions and the effect of his work and thoughts. Yet to bear in mind the baroque in Latin America—that excessive effusion of emotionality that exalts the nonrational as if on the crest of a wave—is also to witness the dual role played by such images in their historical interventions. At the heart of these images is a conflict, that between the reality from which the image has been forged and the destination of the final representation. Every viewer will find herself regarding, not the photograph as document (surely, no one believes that the sugar-cane worker is a "warrior" by choice), but rather the photograph as a space of struggle between elements that contradict and combine to form the whole. These elements are the coarse, even painful, grain of the everyday countered by the eulogistic rhetoric of the aesthetic.

Salgado's images are *not* solely aesthetic: they arise from the contradiction between source and reproduction. And that aestheticized "whole" that is the end result is in no way even or unified but indeed a deliberate sense of disjuncture, a conflict of reason and sentience, of historical uncertainty. Salgado's role here is one of mediator between opposites. He both plays to the elitist imaginary and unsettles it. A consideration of transculturation, a concept central to Latin American subaltern studies, helps make sense of this paradox.[66] For Fernando Ortiz, the Cuban author of the now classic text *Contrapunteo cubano del tabaco y el azúcar*, transculturation is the dynamic and uneven relationship of elite and subaltern classes, of antagonistic groups that are in mutual implication, whereby the everyday, the local, the particular, and the specific or ordinary entwines itself with and influences otherwise elitist social and historical processes. Every image of Salgado's comes alive

through a conflict of class. This antagonism is not merely one of an elite contemplating the misery of others; it is also the discomfiture of class conflict and the stirring of historical disquiet. To think of history in terms of transculturation is to accept the imperative of the collective and the quotidian. As the title of Ortiz's work suggests, transculturation is not lived harmoniously. Equally, we see in the apparent bifurcation of Salgado's work a restlessness, the counterpoint of the marginal in its movement up and against the hegemonic.

On Historical Potential

The question still arises as to how the historical intervention made by photography moves from the visceral and magical to the epistemic. Consider this image of a little girl at a makeshift school run by the MST (fig. 14). Her gaze at us as we watch her learn to write is precisely about her attempts to make the shift from subaltern contexts of nonrepresentation to hegemonic ones. In this act, she, like the photographer and the medium that allow our eyes to meet hers, both challenges and subscribes to the historical discourses and practises that confined her to the periphery to start with. Paradoxically, if the image affects us in nonrational ways—and for this, we must indeed be receptive to these— its aim is also to effect changes to the reason-based course of historical master narratives that surround us. For it goes without saying that the intended course of this and other images is to traverse the epistemic line that divides a randomly selected image, mere archaeological fragment of alterity, from membership in organized and accepted historical discourse as found in archives. In order to achieve this aim, the image must command notice. To look at an image, however, is in many ways to engage in the practice of history.

In her book, *History in Practice*, Ludmilla Jordanova states that history is never free-standing but reliant on contacts, conversations, borrowings, and imaginative frameworks. No historical narrative is therefore complete; history by definition is open to amendment and extension. Jordanova emphasizes the burgeoning of multiple approaches to writing history that have flourished in late modernity, bringing with them new slants, new topics, and new sources. In discussing challenges to traditional approaches to history, Jordanova lays emphasis on the historical potential of visual culture—but only, she warns, if historians are able to use such sources critically and not engage in the "unskil-

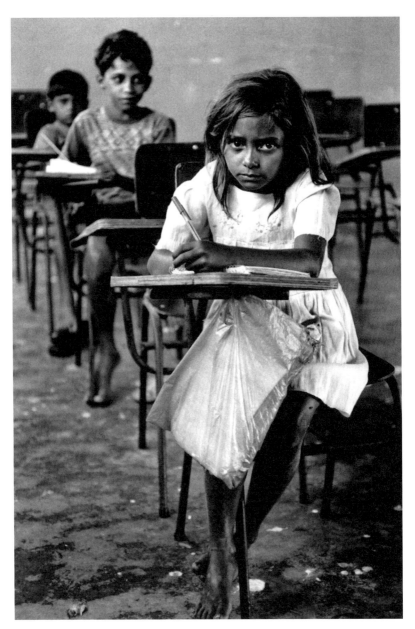

14

ful manipulation of images to lend 'authenticity' to historical text."[67] Furthermore, historians are involved with politics when engaging in the writing of history, and hence with power. History is akin to knowledge, and access to knowledge is access to power. In turn, power is best measured through practice. History is ultimately therefore about sets of practices, rather than being a coherent theory or a unified narrative.

Salgado's wish to cut the moment with a shot must be seen as a form of practising history, as must this child's desire to gaze into the camera. Both are instances of history in practice—or, to use a more apt word, performance. There is also a nexus point when the eye of the viewer is held by the performance of the image. By this I refer to the inherent theatricality of photography, the power of the medium to take a slice of reality and transform it—yes, through an aesthetic—into that which is mounted or framed. A crucial shift between the visceral and the epistemic occurs at the moment when performance, or performativity, is witnessed.

In her book *Raw Histories: Photographs, Anthropology and Museums*, Elizabeth Edwards explores the notion of performance in the context of the still photograph. She describes it as a heuristic device, one that aligns the photograph to theatre and thus offers up what she refers to as the "raw materiality" of the photograph.[68] This rawness of the image, for Edwards, renders it multilayered and shifting. Open to diverse perspectives and interpretations, the still photograph always suggests more than it reveals. In its fluidity, it also oscillates between the visceral and the epistemic, acting as a passageway between the two. Here we also encounter the materiality of the image, its propensity to release history. This potential in photographs is concerned not so much with retelling the past or that which is "other" with fidelity as it is with "performing" its own agency with an eye to the future. The photograph is both a textual representation and a spur to imagination. It reveals the hinge joining reason with nonreason. As Edwards states, "This is the site of their historical potential."[69]

Few would contest that the drama contained in Salgado's images is intense. The theatricality of his aesthetic is what renders his images notable, of art value as well as of commercial value, and also thus of historical value. The silver light of his images is also the shimmer of loss, and in this sense of loss that shrouds the image, there is a kind of enchantment. What we witness in Salgado's photographs is never merely what we see, but a certain unknowability, as well as a prescience, that

yokes the imaginative force of the image to narrative structures and discourses of knowledge that circulate in our midst. It is in this ephemeral juncture, as much a fracture as it is a meeting point, that the sentient—that visceral, even magical, force of the image—translates itself into the epistemic. For it is also at this delicate point that the incompleteness of master narratives of history becomes apparent, as do the interventions of small histories that come to us via the photograph. So too emerge the small questions that these images pose, forcing us to reckon with epistemic uncertainties. The coherence, uniformity, and authority of knowledge all reveal a porosity with the influx of the everyday, the local, the private, the particular, the as-yet-unseen, and the solely imagined. History emerges *other*wise, unfinished, plural. In this instant of possibility, frames are overcome, otherness is recognized, and the historical interventions of photography emerge into light.

4

Just Regard

On Photography, Aesthetics, and Ethics

> We must have a responsibility to
> provoke a debate about the times that we are living.
> There are many questions and we must try to answer them.
> SEBASTIÃO SALGADO, in interview with the author,
> Gallery 32, London, September 10, 2007

AMONG SALGADO'S BEST-KNOWN IMAGES are those of the Serra Pelada gold mines (fig. 15). They are at once jarring and wondrous: jarring, because they depict as few other images do the curious geometry of the anonymous when harnessed, like worker ants, to endless productivity; and wondrous, because rising simultaneously from the silver tones of black and white is the energy of the subjects, both individual and collective.[1] Despite the odds, the images relay with extraordinary lucidity a sense of the agency of the worker.

In light of the preceding chapters, which explored the relevance of the aesthetic in relation to documentary photography and to historical imagination, this chapter traces the crucial question of ethics that flickers in Salgado's photographs. By using the term *ethics*, I refer not solely to discourses, rules, or actions, but rather to a prediscursive and preconceptual terrain, which conditions and supports such conceptually and linguistically determined responses to photographs. In con-

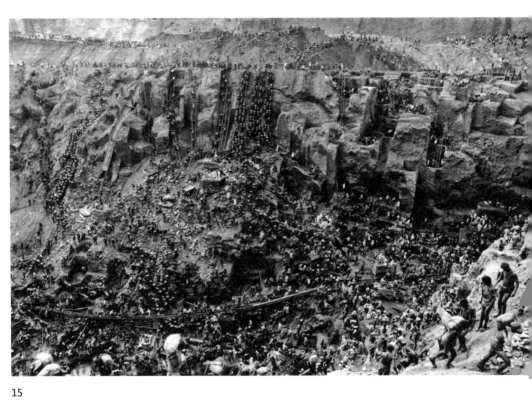

15

tinental philosophy, ethics is often theorized in terms of the self's responsibility to the other. As is well known, philosophical critiques of subjectivity have displaced the centrality previously accorded to the epistemological subject and emphasize instead relation with the world and others that is primarily preconceptual and prediscursive. This treatment of ethics gravitates around a sense of responsibility to the other—and responsibility, here, implies also the ability to respond to the other.

The Question *Why?*

Of relevance is a point that was elaborated in the previous chapter: the sentient, the instinctual, or nonrational response to the image is the wellspring of not solely historical possibility, but, along with the latter, of ethical feeling, response, and relation. Ethics, then, is not about an unharnessed transcendence of the self, but about response to the other. It is that openness toward alterity whereby the self seeks to engage with the interrogative of the other. In this sense, it should be understood that ethics is not about moral judgement or closed statement. It is the openness of the interrogative, a questioning of epistemic and cognitive boundaries that supports the ability to respond in the face of alterity. Inevitably, and as John Berger points out in the video *A Spectre of Hope*, the question that is posed to us by Salgado's photographs is "why?"[2] This posing of a question disturbs our epistemic notions of the self, makes us reflect on ourselves, and takes us beyond where we are, in a search to find a response to the questions that images pose to us. Equally, therefore, ethics is about promise—the promise of a response. This moment of promise that comes about through engagement with alterity seen through a photograph is brief and tenuous; it rides on the surge of humane response and is a mere ember of possibility that must be secured, or else it will easily flag and so die.

Clearly, for such promise to be fulfilled, ethics must be tied to the discursive, the agreed, the normative, the rational. Numerous philosophers have sought to articulate ethics in rational terms. Yet, the ethical response almost always stems from the prediscursive, from a move that shifts the self from its certainties in its quest to respond to the question "why?" Nevertheless, ethics, when put into practice, is more than a prediscursive move; it requires an established discourse based on reason and judgement. As Alphonso Lingis states, "Ethics is a rational discourse dealing with the ought; it elaborates the experience of being

obligated. It deals with the question of how to deal justly with other human beings."[3] In order to be articulated and acted on, ethics must be tied to the discursive.

Ethical Value and Exchange Value

As Lingis goes on to state, questions of ethics have become vastly complex in postindustrial civilizations. Contrary to the general assumption that the realm of ethics is far removed from that of material interests, the overriding prevalence and power of the latter in the historical junctures of modernity—and even more so in postmodernity—have meant that this supposed space between ethics and material interests may be hard to discern. Salgado's work, like much that has journalistic and art value, circulates to a great extent in the marketplace. Inevitably, therefore, it colludes, as already noted, in part with the very ideology, system, and values that it questions. The predominant discourses and practices of modernity make ethics, viewed as an open-ended willingness toward questioning and self-questioning, hard to articulate or enact. Critical thinking, or the space from which to critique hegemonic modes, is severely endangered in this day and age by the predominance of a unified capitalist ideology ruled by market values. The language of ethics, necessary if the ethical impulse is to be translated from unvoiced response to mode of action, has been reduced likewise to that of the market. As Robert Hullot-Kentor points out, the languages of wealth and ethics have been the same since the start of the modern age and have become entirely inseparable since the end of the Cold War and the global spread of unopposed capitalism: the moral good is twinned with the idea of "goods" and "fair share." Hence we have what he refers to as the "dynamic of the decay of ethics in its relation to economics."[4] In other words, as questions of wealth become increasingly pertinent in a world ruled by the marketplace, so questions of ethics come to be eclipsed and subsumed. As a result, there is no outside space from which to articulate a perspective or ethical response.

Writing of film, Hullot-Kentor makes the point that exhibition value and exchange value are crucially linked in the context of the visual aesthetic. This overlapping has always plagued photography, itself a product of the modern age, and is the ground on which so many of the debates touched on here and elsewhere rest. There is tension, unresolved tension, in the overlapping of the ethical by the aesthetic, first and fore-

most because the aesthetic is so allied to the market, itself viewed as the anathema of ethics. Additionally, there is the question of whether the practices and discourses of ethics can even begin to be articulated when these themselves are inseparable now from the practices and discourses of the marketplace, to the latter's advantage. Thinking ethics through from sentient response to political interaction with alterity becomes, then, both extremely difficult and pressingly urgent.

Perhaps a way to begin is to probe beneath the language of ethics and exchange in order to identify the germ of ethical response. Photographs, through their dual allegiance to both the art market and sentient stirring, seem to prove the point that, if the discourse of ethics has been usurped by the marketplace, then it has not been entirely supplanted. Instead, the question of ethics pulsates unattended and in complex embroilment with the interests of the market. The space of the photograph is a good starting point for teasing out the possibilities of ethics in the context of discursive and practical entanglement with the capitalist contexts where, as many would say, ethics have little or no platform. By way of an initial definition, it could be said that ethics speaks of a justice whereby the self recognizes and responds to the other, thus acknowledging its presence or being. This humanistic sense of what constitutes ethics has numerous ramifications. At a pre-discursive level, it is a responsive gesture that shakes the epistemological foundation on which we construct notions of the self. The ethical call or question unsettles. It signals, in its simplest terms, the perception that alterity exists and must be acknowledged. At a more pragmatic level, the urge to respond to the ethical call is a precondition for political action.

On Sentimentality and Voyeurism

I am keenly aware of the many criticisms and concerns that have been expressed in so many quarters about precisely the opposite of this notion of the photograph as a site of ethics—that is, the belief that aestheticized photodocumentary in general, and Salgado's work in particular, not only defeats its own purposes, but actually amounts to a violation of the ethics of representation. I refer here not merely to Ingrid Sischy's criticisms, but also to those of, for example, the French art historian Jean-François Chevrier who, in a guest column in *Le Monde*, accused Salgado of "sentimental voyeurism."[5] In his searing article,

"Salgado ou l'exploitation du compassion," Chevrier accuses Salgado of using his subjects in order to construct through his work a monument to compassion that offers on the surface a "pseudo-epic" of humanity but actually draws attention not to the subjects, but to photodocumentary and to the photographer himself. "One could not be clearer," he states. "Each image, each snapshot, and thus each character is a moment in the grand Narrative, or the group Photo, whose principal and exclusive hero—the only one who expresses himself and speaks History—is the photographer-narrator."[6] Chevrier accuses Salgado of freezing his images in History, where there is no room for movement, and hence for hope. This view is diametrically opposed to that held by John Berger, who, in the film *Spectre of Hope*, emphasizes the hope he perceives in Salgado's images.[7]

Another critic of Salgado's, this time writing with specific reference to his large-scale work *Migrations*, is Susan Sontag. She states, "Salgado's migration pictures group together, under this single heading, a host of different causes and kinds of distress. Making suffering loom larger, by globalizing it, may spur people on to feel they ought to 'care' more. It also invites them to feel that the sufferings and misfortunes are too vast, too irrevocable, too epic to be much changed by any local political intervention. With a subject conceived on this scale, compassion can only flounder—and make abstract."[8] The question of compassion as a response to photography in lieu of an ethical response will be considered later. Suffice it to say for the moment that Sontag, like certain others, believes the "rhetoric," or rather aesthetic, of Salgado's photographic style to depersonalize and "globalize," and hence render anonymous the subject of the image. Critics who are fellow Latin Americans with Salgado have taken this point further. Thus, the Latin American academic Raúl Antelo voices concern about the elitism of Salgado's artistic procedures.[9] Like Sontag, Antelo accuses Salgado of a kind of global stereotyping of poverty, but also of producing the kind of artwork that positions itself, not with politics, but with the market.

The fact is that aestheticized photodocuments are complex in their economic and social allegiances. This is not to say, though, that they necessarily lack an ethical content or indeed are unethical. The problem of ethical response to the image more often lies with the viewer. Needless to say, it is far easier to move on from images of suffering with a certain sense of denial or a shrugging of responsibility than it is to engage with the disquiet that they arouse. Furthermore, our rela-

tion to such images must be understood within the context of visual media, and the global market within which such images—and we, as viewers—circulate. As Stanley Cohen points out in his *States of Denial*, "The truth is that the sheer dimensions of mass suffering are difficult to grasp, and even more difficult to retain."[10] What is more, the suffering of others is usually presented as a "story"—something we should be concerned about, but that is happening elsewhere. The concern that is felt in response to such images is tempered by a "moral distance" or emotional remoteness between the subject and the viewer.[11] Additionally, the media needs to constantly bring out fresh stories in order to maintain its own momentum. The images that form part of these disaster stories are inevitably endless, predictable, and met with emotional fatigue or desensitization on the viewers' part. Cohen situates the media in the context of the global market, stating that, in fact, this diminishing of concern is precisely what the market targets. Much of Cohen's focus is on images seen on television—that is, ones that flit before the viewer's eyes and are seen as solely "newsworthy" and not as artworks in any sense.

When considering Cohen's views with regard to Salgado's work, we need to bear in mind that our relation to images seen on television is fundamentally different from how we respond to images seen in galleries, photography books, or other spaces where they are portrayed under the aegis of the aesthetic. While one may be inured to news images, aestheticized images that can be reflected on at some length must be considered separately. However, the question of how successful images portraying the suffering of others might be in arousing ethical response remains thorny and complex.

There is, no doubt, a very real danger of foreclosing the ethical possibility that images offer. Furthermore, the inextricability of market interests from social ones often renders Salgado's work problematic, even if this has been a feature of photography since its inception. Through their early dissemination in the *Sunday Times* and numerous other newspapers, including the *New York Times*, Salgado's images of the Serra Pelada circulated widely, catapulting his name into the limelight as creator of this awe-inspiring photography. In one stroke, the images confirmed him as artist and concerned photojournalist—and, in the eyes of some, as opportunist. Ian Parker, a staff writer for the *New Yorker*, has followed Salgado's career over several years, even accompanying him on various trips and watching him at work. Parker cites

the well-known photography editor Colin Jacobson as pointing out that Salgado made his name on the strength of these images from the Serra Pelada.[12] The result was that he was able to secure funding to support his subsequent six-year project on manual labour, which resulted in *Workers*. Indeed, an interesting vector is found here between the widespread distribution of Salgado's work in the press and the creation of the elite exhibitions and expensive books where the images of *Workers* can be found.

It seems clear that for Salgado, widely disparate forms of circulation of the image only serve to enhance one another. By these means, the ethical question issued by his images is posed across a variety of contexts and to a variety of viewers. It is also thereby nuanced, varied, diverse in its outreach. There is as well, as Erina Duganne points out, the implicit belief that wide circulation will ensure that a maximum number of viewers will identify with the humanistic content of his images.[13] This understanding, as Duganne explains, helps to further establish Salgado as a "concerned photographer." This term, originally coined by Cornell Capa to commemorate the photographic efforts of his brother, Robert, and others such as David "Chim" Seymour, later came to signify those whom, as Capa stated, placed photography as central to their missions as "witness-artists."[14] The work of such photographers also led to the rise of the photo-essay, as seen in *Life* magazine, for example, that aims to both inform and reform.

The discomfiture that some may feel on viewing Salgado's aestheticized photodocumentary of the displaced derives also from the odd nexus of witness and artist. Concerned photographers, such as Salgado or Henri Cartier-Bresson, inevitably produce beautiful photographs of unfortunate subjects.[15] Their claim to relay witness depends also on the deliberate aestheticization of the image. In the process, the representations of subjects are manipulated and rendered artificial—as, dare I say, is always the case with photographic representation. What is more, and as Martha Rosler has pointed out on more than one occasion, many argue that attention thereby falls not on the subject herself, but on the sensibility of the photographer who makes art out of eye-witnessing. The appropriation of documentary photography into the realms of fine art is seen by many to be an ethically questionable practice—all the more so when one considers that little or nothing from the material benefits of such artwork feeds back to the subjects themselves.

Think, for instance, of Steve McCurry's famous portrait of the "Af-

ghan girl," Sharbat Gula, now a woman in her late thirties living in rural Afghanistan, a country with one of the highest indices of poverty in the world. While the image, which grabbed world attention by appearing on the cover of *National Geographic*, has turned McCurry into an iconic name, the subject herself has gained relatively little from the widespread circulation of her photograph.[16] Sharbat Gula's image becomes all the more arresting when one contrasts the brilliant gaze of her emerald eyes against Western feminist discourses on the forced veiling of women in Afghanistan under Taliban rule.[17] Her eyes look out from the frame, beautiful and dazzling, but also as if challenging the viewer to respond. In the light of global tensions prevalent in the early twenty-first century, this photograph of Gula can also be seen to have helped establish a scheme of vision around alterity in the form of Islam, women, and veiling, thus framing the ways in which we view subsequent photographic works on related themes, such as Haleh Anvari's photographic installation *Chador-Dadar*.[18] Equally, the bright colours and the bared face of the Afghan girl contrast dramatically with Cartier-Bresson's famous photograph of veiled Muslim women praying in Kashmir and yet, from an Orientalist perspective, it seems also to somehow fit into the discursive frame set in place by this earlier image.[19] Gula's portrait is rich in metaphoric significance for many Western viewers: it symbolizes the potential that lies in the hidden faces of Afghani women who remain unseen and invisible to the world.[20] Yet Gula herself leads a life far removed from such brilliance or daring. Indeed, no one knows what her own views on veiling might be. What is more, any gain she has made from the image is not because of any rights she retains over it, but due to McCurry's own generosity. Thus, he has paid for her children to go to school and has also funded a trip to Mecca for her.[21] As Duganne points out, "In the face of massive suffering in Afghanistan, using such an image for humanitarian purposes seems inevitable and even laudable, but there is irony and ethical tension in the situation as well. . . . Has anyone asked Sharbat Gula her opinion?"[22]

Of course, this question could be adapted for many of Salgado's subjects as well. In this context, I take note of the view shared by Abigail Solomon-Godeau, and Allan Sekula that aestheticized photodocumentary draws attention to the compassion of the photographer rather than to the subject of the image.[23] What comes into view is the concerned photographer's concern and the subject herself remains eclipsed. The photographer is preeminent, while the subject of the image, always re-

placeable, given global indices of suffering and displacement, wanes from view.

I also bear in mind that photodocumentary came into its own in alliance with Eurocentric colonial expansions, and also with anthropology's attempts to define, locate, and know the other. Indeed, photography became a vehicle for demarcating and identifying alterity. Photodocumentary cannot be separated from processes through which discourses and ideologies emerge, and there is no doubt that a physical, and quite possibly socioeconomic and political, division exists between the photographer and the viewer, on one side of the camera, and the subject, on the other. If photography were as wholly realist as many expect it to be, an ethical discomfiture from such disparity would certainly be in order. However, the spilling over of photographic realism into art makes such a response questionable. Beauty and suffering have long been conjoined in art, as indeed in religion, and speak to an eloquent discourse of ethics that has long been established in the history of art. This is a discourse that specifically thrives on the juncture of apparent opposites. It is also one that proponents of ethics seldom take into account. The general assumption, indeed, is that the aesthetic deceives: it cannot represent ethically, for it is fundamentally dishonest.

Questioning Categories

Photography, in its dual role as document and artwork, certainly confuses or conjoins categories of beauty and suffering, of aesthetics and ethics. Alongside and countering the grain of such unevenness, the camera also acts as a mechanism of transmission, both breaking up and reshuffling unities of time and space and relaying the past into the present, while simultaneously gesturing to the future. Demarcations on which the previously discussed arguments on ethics are based lose their linearity and clarity when this happens. The premise that subjects are discrete unities, composite and distinct from one another, needs to be re-examined. Analytic arguments and discourses based on premises of logical linearity cannot encompass the contradictions and complexities of how photodocuments function. Nor do they sufficiently explain the engagement or dynamic between the subject of the image, the photographer, and the viewer. This is particularly so in the case of photodocuments containing that Barthesian element of *punctum*, or ability to arouse visceral response. Precisely because photography is always

poised at the brink of the unknown and the unknowable, the rational and the nonrational, it begs a rethinking of the criticisms that have come its way. No photograph, however realist in appearance, is without guise. Even the most realist of photographs is in itself proof of selection, and hence framing. Photographs are, in fact, more aligned to painting than they are to reality. Close scrutiny reveals the inevitable presence of selection, of the photographer as agent, and of the aesthetic process that the image has undergone. Always present in any photograph is the intervention of the photographer, who has, after all, constructed the image and so determined the ground on which questions of boundary arise. Furthermore, as a cultural "text" of late modernity, the still photograph fosters both reflexivity and fracture, which are characteristic of this period. The case for this is particularly strong with regard to Salgado's work, given its quintessentially Latin American mix of the baroque and the modernist. Neither the ideological nor the lived processes of modernity in Latin America have followed smooth courses. Indeed, modernity from a Latin American perspective is, as we have already noted, riven with the challenges of its own counterpoints.

In making this point, I seek to address the varied aforementioned criticisms through drawing on the dialectic and the dichotomy, established in the previous chapter, between the sentient and the rational that occurs through visual perception of aestheticized images. Also relevant is the dual movement found in aestheticized photography that doubles as artwork between the rational and the nonrational, as the latter acquires its own agency and turns three-dimensional and performative. It is through the performance of the image that the agency of aestheticized representation is revealed and it is through these means that viewers make the ethical move that opens up their established epistemological parameters in response to the demands of the image. It is important to note here that the photograph impacts the viewer on two interconnected levels: the aesthetic and the ethical. A misreading of the role of the aesthetic, as is often the case with Salgado's images, leads to a misreading of the ethical dimension of his work. At best, a misreading of the aesthetic translates at the level of ethics into notions of compassion or pity, both of which are ends in themselves and do not open the viewer to alterity. At worst, such misreadings negate the ethical possibility of aestheticized images.

Clearly, the photographer has made very deliberate choices when it comes to the aesthetic. Salgado has repeatedly used a black and white

palette for his photographic projects, and his images all bear a recognizable signature tonality and play of light. These stylistic choices direct and shape a nuanced ethics of vision. It is, then, precisely by working through a heightened and deliberate aesthetic that Salgado turns his images into spaces where ethical questions may arise. Underlying these movements are important questions of ontology, whereby the photograph acts as a medium that awakens viewers to agency that lies outside of themselves, to the presence of being that is not their own, inducing them to respond to the question of the other that comes from beyond. These processes emanate not from the subject, but from the image. In referring to photography as a borderline medium, I point as well to this tremor in the still photograph; it oscillates between the statement and the question, the two never dissociated but always dependent on one another.

Criticisms made of Salgado's work most often arise from this confusion of the aesthetic, which leads to a further confusion between compassion or pity and ethical response. There is also present in such misreadings a kind of modernist dualism, one that separates reason from emotion, intellect from feeling, subject from viewer, and politics from transcendence. The limitations in such perspectives lie in the fact that images are material, but not solely so. Their very materiality is rich in historical and ethical possibility, which makes them also magical, spiritual, and transcendent. This chapter works against such modernist dualism. Without seeking in any way to deny or erase difference (be this between the viewer and the subject or the subject and the photographer), I wish to tease out the ways in which photographs act as a shifting, mediatory space—constructing *relation* between opposites, conjoining aesthetics to ethics and seeing to responding—for this, I believe, is the ground on which an ethics of the visual rests.

Epistemological Disturbance

As an economist-photographer whose work critiques the impact of modernization on local people and places and thus foregrounds questions of inequality, injustice, and displacement, Salgado employs his images to remind the viewer that regard and response are necessary if redistribution and justice are to follow. In this context, what comes to the fore in Salgado's work is an appeal for a global dialogue of responsibility, one that particularly acknowledges the local, the specific, the oft-

ignored, the seemingly irrelevant. If Salgado's work inspires millions, it is because it offers the possibility of an ethics of vision, one that gives viewers the chance to be open to response. His images pose before us much more than the contexts and people they purport to document: overriding the documentary effort is the aesthetic one, whereby photographs stir far more than they recount. Poised on the threshold of this heightened aesthetic is the question of ethics posed to viewers, one that requires of them a response by way of return. Ethics, then, is the subtle stirring that may lead us to envisioning.

The previous chapter linked the aesthetic of Salgado's photographic representations to a renewal of historical consciousness. A consideration of ethics now builds on the latter, linking this renewal to the disturbance of epistemological certainties and the stir of ethical response. History is knowledge and, as such, a subject of epistemology. The rethinking of history implies, therefore, a rethinking of epistemological notions. The ethical question posed by the image is what forces this to happen.

Of course, and as already established, Salgado's work is solidly related to social contexts. Part of the reason why Salgado's images of the Serra Pelada are so "successful" is the eloquence with which they exemplify extreme examples of human displacement in the context of modernity. The relentless shades of grey that impose a steely ruthlessness on the harsh conditions experienced by the miners combine with camerawork that both marks out the human form and dwarfs it against the rising landscape. This eloquence derives directly from the contexts and conditions that Salgado photographs, as well as from how he constructs his images and juxtaposes them with one another, so as to forge a coherent and convincing—and little known—narrative of capitalist exploitation. However, these images do not just tell stories. While Salgado's photographs tell real stories, in the long established photojournalistic traditions of *Life* and other magazines, unravelling them, they also do much more: on the one hand, they point beyond the frame to larger contexts and, on the other, they confront the viewer's sightline with queries, and not affirmations.

The images of the Serra Pelada series exemplify this point. The story is at once universal and grand, one of class difference, disenfranchisement, and exploitation, a saga that engulfs all those involved, it would seem. If these images are aesthetically imposing and if they speak rhetorically, they also stem from specific contexts. Indeed, these photo-

graphs of the Serra Palada depict scenes that are, so to speak, the tip of an iceberg: they have a clear-cut historical location in the chain of transnational ventures embarked on by Brazil's debt-ridden economy in the 1980s. There is, thus, an epic here of ill-thought capitalist expansion, one that fits right in, as we have seen, with Eduardo Galeano's perspective on Latin America's relation with the West.

The ecological consequences of the decimation of the Amazon region are not unknown today. In the pursuit of Brazil's rich deposits of iron, manganese, copper, lead, gold, bauxite, and diamonds, the mining industry has played a central role in the harnessing of the debt-riddled Brazilian economy to global economic networks. In particular, the 1980s witnessed the start of the Brazilian gold rush, with the discovery of gold in the Serra Palada. The race for gaining wealth had its impact at numerous levels. In the first place, and as the ongoing struggle of the Movimento Sem Terra (MST) will attest, Brazil continues to be plagued by feudal practices of land ownership, whereby large tracts of land remain in the grip of a powerful minority. In turn, private ownership of land translates into political and economic systems at a national level that do not favour the peasant. Combined with new incentives for mechanized means of agricultural production, this has lead to the increasing impoverishment of peasants, who are thus forced to turn to other ways of making a living.

Landlessness, a major feature of life in Brazil and elsewhere in the developing world, is by definition the lived experience of dislocation. Landlessness is displacement—to cities, mines, and wherever else there might be the chance of work. In the 1980s, over a quarter of a million workers flocked to the gold mines in search of work. Wages were low and competition high; the miners worked and lived in overcrowded conditions for extremely low pay. Needless to say, the profits made by the gold industry bare small relation to the wages earned by the workers. Salgado's photographs document only some of the consequences of this discovery of gold. The mining industry established itself with little regard for environmental practices, and mining processes led to the pollution of the region's rivers, with large quantities of mercury poisoning the waters. The influx of miners into the region led to the further pollution of the waters, which received human litter and waste. Animal life in the regions surrounding the mines was also disturbed, if not destroyed, as was vegetation.

What is interesting to note is that photographs can seldom testify to

such social and economic contexts by themselves. They need to be exhibited in the right places and accompanied by the right texts in order to construct specific narratives, such as of the Serra Pelada, that are both contextually bound and indicative of wider practices of capitalist exploitation. Only through adequate contextualization, rather than by direct statement, can these images directly target the narratives of success and wealth that accompany the numerous lucrative ventures of late modernity. Nevertheless, the force of the Serra Pelada images at least partially derives from the close-up views they offer of social realities in this place.

Perhaps more than any other industry, mining is distinguished by its relatively invisible position in the chain of development. It takes place away from developed zones or urban centres. Furthermore, peasants who turn to mining for a livelihood radically alter their relation to land and nature, involved as they become in extracting riches rather than nurturing or caring for the land. In the ransacking of nature for material ends, human life, as seen in these photographs, also becomes no more than a tool for the procurement of wealth and power. Displaced from land, home, and family, miners risk their lives for an industry that barely acknowledges their contributions.

It is interesting to note that while numerous studies exist on mining as a key aspect of capitalism, relatively few focus specifically on the human experience of mining in terms of its impact on local communities, lifestyles, and traditions. Few also examine the effects of mining on land and nature or on the alterations it may have caused to man's relation with them. Yet mining constituted a definitive aspect of modernization, taking off as it did in so many parts of the world in the modern period, though such activities were almost always tied to European, and hence imperialist, interests. To date, very few perspectives exist of mining as a grassroots experience. Salgado's images are forceful precisely because they offer such a viewpoint. Miners, it would seem, are physically and metaphorically disregarded, buried alive and rendered silent. Even cultural texts on and from mining are relatively rare and hard to locate—the photographs of Welsh miners by W. Eugene Smith, the modernist novels of D. H. Lawrence, a coalminer's son, and the anguished lilt of the *cante minero* in flamenco traditions, arising as it did in the mining regions of Almería in southern Spain, being some of few that exist. Even in such texts, though, there is a reiteration of the dehumanization of the miner that results when poverty, desperation, and

greed collide. All three, of course, are symptoms of a system propelled by capitalist desire. We see this very strongly, for instance, in the work of the South African photographer Peter Magubane, whose images of gold miners in his country reveal the subjugation of these workers to the business of prospecting.[24] Ultimately these images address, not the specifics of place and context, but the larger, more global logic of capitalism, which carries with it an inherent logic of exploitation. What is forceful about Salgado's Serra Pelada images is the fact that they expose to view the bare elements of the mechanics of capital. Through their emphasis on the harnessing of the human and the collective to extraction and production, they leave open to view the relation of labour to commodity.

More importantly, the Serra Pelada images are forceful because they also highlight in the miners an agency that rises above subjugation. In this they stand out in stark contrast to, for example, Magubane's South African miners, who appear stripped of autonomy. The difference is not merely that we have the miners' points of view. Nor is it that we have, as seen in some of the images in this series, the grand overview of what takes place, where the human becomes ant-like in the vast landscape of production. Nor is it a combination of these factors. It is that the images speak over and beyond the specifics of the frame, directing a question to the viewer about a globalized system that implicates us as well and that we, as viewers who benefit from this chain, are responsible for maintaining.

Take for instance, this portrait of a *garimpeiro*, a no doubt precariously self-employed miner from the Serra Pelada (fig. 16). Covered as he is in mud, rendered almost subhuman by circumstance, nonetheless, his eyes penetrate the camera, his gaze almost too direct to bear. If the mud covering this miner's body yokes him to the earth, so that he seems almost at one with it, then, equally, his eyes project a strong presence. The photograph frames the drama of survival, lived out every day by so many around the world whose lives are spent in close contact and struggle with the earth. An odd tension ensues from this image: on the one hand, the earth that covers the miner's skin removes him from us, as viewers, and renders him other; on the other, his eyes challenge ours, as if to gauge us. And so, staged here is the dilemma of how to confront the other's gaze, of how to meet his eyes—this, above all else, being the viewer's responsibility. The image is theatrical, the encounter intense . . .

The miner looks out at me. He locks eyes with me.

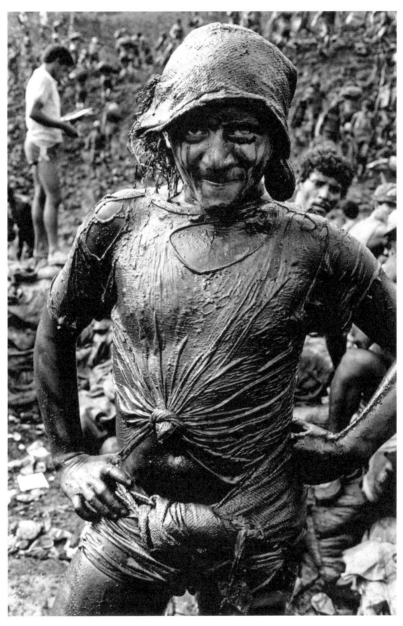

16

After-images

This image of a miner from the Serra Pelada forces the viewer to pause. It shocks. It unsettles. There is strength in this man's stance, strength and resilience. There is also immense poverty. His torn T-shirt and the filthy rag that he has wound round his loins scarcely cover his body. He is clothed instead in slime. How old is he? One cannot tell. Rivulets of wet mud stream down his face, like tears. But he is surely not crying. No, he is looking out at us. Something about his look fills us with discomfiture. His smile—is it really a smile?—seems to be one of scorn, of defiance, perhaps of even recognition. What thought accompanied that smile as he paused for Salgado to take his photograph? What would he think now if he were to see people in a gallery looking at his photograph?

I want to move on from this image, but I keep going back. The man follows me with his eyes, with his cryptic smile, even as I turn to look at Salgado's other images. The aesthetic of the image affects me even after I have moved away from the image. A kind of haunting takes place: the photograph resurrects itself in my memory long after my sightline has moved on. The image has an aftereffect—an afterlife. It is both terrifying and haunting, as are most of those that Salgado brought back from the Serra Pelada. The photographer's role here has been to bring back testament, not so much of a living subject as of a living question, one of ethics, which burns to be posed.

Via the aesthetic, itself a semiotics of the image, the representation of the subject is turned into sign, one that raises inquiry. Through the discourse of this aesthetic, an imagined relation of intersubjectivity, forged in terms of a semiotics of the visual, emerges between the viewer and the photograph. No doubt the man himself is in reality quite different. The mud on his skin is, after all, a mask. Like the very medium of the photograph, it hides his real skin from view. Perhaps he is even ordinary—though not in this image. The photograph has transformed him, taken him beyond himself, and transposed him onto the sightline of people whom he will never know. In his essay "Salgado, Seventeen Times," Eduardo Galeano writes, "Salgado photographs people. Casual photographers photograph phantoms."[25] Yet here we have an instance of Salgado turning the human into the super-human; of elevating this miner to a stature and strength that surely outstrips his realities. In this, Salgado has taken artistic license with reality. Galeano views this as an

act of commitment: "Charity, horizontal, humiliates," he states. "Salgado photographs from inside, in solidarity."[26]

The Mexican photography critic Laura González Flora argues that photography must be seen as a kind of painting with light.[27] This likeness with art, she states, must be understood within a larger ideological and cultural paradigm that predetermines it. The logical and the objective—in other words, the rational—can no longer be separated from the aesthetic. Nor can my rational response to this image be easily disentangled from that odd tightness that it has provoked in my chest. Numerous responses crowd in, some rational, others more sentient, others beyond the reach of words. This would not have happened without the aesthetic. Indeed, it may never have happened if I had stood face to face before this miner. I may have passed him by, not noticed him. The aesthetic has forced the viewer to look; it is what makes the image. Indeed, the image may be dependent on such an aesthetic to function at all.

On Ethical Possibility

Through the aesthetic, an intersubjective relation is forged, one that is established via the posing of the ethical question. The aesthetic of the image is what places this question in the viewer's sightline. It is what supports this imagination of intersubjective relation. The force of this image derives from its ability to issue this call for a response from the viewer to the subject from within a context of difference; it is a call for a response that ultimately reflects back on the viewer.

In Portuguese, the very name Serra Pelada—a hill that is bald—is indicative of the ransacking of peripheral spaces and peripheral social classes that constitutes mining. If photography can intervene in redressing this imbalance of centre and periphery, it is, at least in part, through its dual drive to at once emphasize and disregard borders. It is through the posing of a question that intersubjective relation is forged, and with it the openness needed to address the question of ethics. By this statement, I mean not only the many borders that photography straddles— those of art and document, absence and presence, past and present, and darkness and light—but also those of self and other, knowledge and uncertainty, centre and periphery. Multiple temporal sites come to the fore through photographs: they signal at once death and possibility. The temporality of the photograph is neither past, nor present, nor future, but all of these. Photographs signal both loss and renewal. They carry a

temporal openness over and beyond the linearity of history as we tell it. Photographs also posit the importance of the frame in delineating the image, while silently gesturing to what also lies excluded and beyond the frame. In so doing, they signal the infinite inconclusiveness of representation, the constant spilling over of image into possibility.

There is in the photograph a certain immanence, the suggestion of potentiality. Ironically, therefore, photographs as traces of the past also always gesture toward a future that is in the making, one that lies beyond the limits of the image itself. In this sense, photographs suggest refiguring, rethinking, reconstructions. If photographs are filled with the pathos of loss, then equally they suggest in tacit and visual ways the vulnerability—indeed, the mutability—of the many frames by which we code the world and locate ourselves. They highlight the fragility and the porosity of our epistemic beliefs and structures. In our visual imagination, frames open onto yet more frames, as structures of signification reveal their interconnectedness and lead us out of ourselves, out of our supposed certainties, to follow the traces and engage with the questions that images reveal.

To look closely at a book of Salgado's photographs or to visit a photographic exhibition of his work is often to enter into a complex labyrinth of images that compel us to look beyond ourselves, to seek and to make connections when confronted by the question of ethics. The frames of these images open up perspectives and points of view, leading us to cross the boundaries of what we think we know. To engage with images is also to interrogate the frame, to cross the border—and to do so is also, by extension, to think in terms of difference so as to respond to the other whose presence is signalled by the image. Yet it is also to find that on the border, or on the edge of the frame, difference translates into contiguity: responding to the other becomes a way of responding to oneself. The ethical question posed by the other forces the self to question its own epistemic parameters, to rethink the self. To think of the self not so much *in opposition to* the other as *in terms of* the other. In the other's terms. Thinking of the self, therefore, *through* the other. Metaphorically, therefore, the photograph enacts a crossing over and also a crossing back, so that the question of ethics returns to us.

Our responses to what we see are never conclusive. They are dialogic.

The Gaze Refracted

In terms of visual representation and perception, it is often assumed that the gaze establishes and distinguishes the viewer from the viewed. The gaze, on which both the taking and the viewing of photographs must depend, is at the heart of criticisms about visual representation. It is also at the heart of statements such as Jean-François Chevrier's accusation, directed at Salgado, of voyeurism. The frame of the image is such that the subject of the image—or the object of the gaze—is always, and primarily, other. Yet, the space of the image is also one where the self comes into engagement with this other through the act of seeing, for without this point of contact, the subject, removed in time and space, would remain unseen, distant, and no doubt ignored. If the other is important, it is because this intimacy of contact throws the boundaries of the self into turbulence, into question: the question of morality opens up through seeing. The very act of seeing, in this context, constitutes an engagement with the object of vision.

Yet academic studies often associate the gaze with objectification—the very antithesis of what one imagines ethical relation to be. The gaze has numerous connotations in a range of disciplines across the humanities and the social sciences that link it to the viewer's reification, power, and self-aggrandizement. It is well known that Jacques Lacan explored the role of the gaze in the mirror stage, central to the formation of the self. Michel Foucault has written of the gaze in the contexts of medicine and prisons as a chief means of controlling, organizing, and disciplining the mad, the sick, and the unruly. Feminists and film theorists, such as Laura Mulvey, have related the gaze in visual culture to the male-dominated objectification of women, thus reinforcing the parameters of patriarchy. And Cornel West has written of how a dominant white, Eurocentric gaze helps to locate and identify racial otherness. Whatever the case, there is no doubt that the gaze is most often linked not only to power but also to fixing, and so containing, the possibilities of that which is its object. A common and seldom questioned assumption, therefore, is that differences of power arise between subject and viewer and are affirmed via the gaze. Photographs, of course, are dependent on the gaze for their very existence. Perhaps this is why, in the English language at least, so much of the language of photography is also taken from that of violence and power: to "take," to "capture," to "shoot," to "freeze," to "frame."

The significance of the gaze in terms of the photograph is paramount. However, it should or can be thought of quite differently. This requires moving beyond the notion that the gaze can only ever have one role: that of empowering the viewer. The gaze has largely been theorized in terms of the subject; however, a consideration of the gaze in still photography allows the opportunity to rethink the operation of the gaze in terms of the intersubjective. In this light, the gaze ceases to be single and instead must be thought of in the plural.

Such plurality, as we shall see, disturbs rather than reinforces the epistemic centrality of the self. As Catherine Lutz and Jane Collins have shown, the photograph is a space where numerous gazes intersect. In their very interesting, though unusually quantitative article "The Photograph as an Intersection of Gazes: The Example of *National Geographic*," they state that seven different types of gaze can be found in the photograph. Taking their examples from the documentary images of *National Geographic*, Lutz and Collins isolate the initial photographer's gaze; the institutional gaze, by which images are edited; the readers' gaze; the academic gaze, which seeks to find knowledge in and through the photograph; the non-Western subject's gaze; and that refracted gaze of the image's subject shown in a surprising number of images. Perhaps the most interesting part of their essay is that which deals with the non-Western subject's gaze. "There is perhaps no more significant gaze in the photograph than that of its subject," they state.[28] Lutz and Collins cite film theorists who argue that the non-Western subject's gaze serves to "short-circuit the voyeurism identified as an important component of photography."[29] Moreover, they state, the subject becomes approachable, not distanced or remote, though the portrait also depicts them as different and separate. Class differences are at work here as well. "This interpretation," they say, "is supported by the fact that historically the frontal portrait has been associated with the 'rougher' classes," so that a predominant form of less empowered subjects look back into the camera, while more subjects who are elite or socially established tend to look away.[30] While this may be so, it seems clear that the sheer variety of gazes that intersect in the photograph complicate simple, static, or even unified definitions of the gaze. The gaze is inevitably plural, multidimensional, and shifting. It is dynamic, open to change and alterability. A useful reminder of the importance of this plurality comes to us from John Berger, when he states simply but eloquently, "The relation between what we see and what we know is never settled."[31] By consid-

ering the very notion of the gaze in terms of multiplicity, knowledge too becomes plural and multipliable. Importantly, in the context of an ethics of vision, both possibility and questioning can result from such plurality.

To label Salgado's work as voyeurism or to accuse him of usurping the platform provided by the image is thus to gravely simplify the complexities of the situation. The sheer plurality of gazes prevents unified readings of a photograph. Indeed, not only do the diverse types of gaze recorded by Lutz and Collins intersect within the frame of the photograph, but in fact, they inevitably do so in such a way as to refract perspectives and release a shifting dynamic of the visual. This is not to say that the object of the gaze ever ceases to be other; quite simply, without the object as other, the gaze itself could not exist. Rather, it is to state that the complexity of the gaze, its sheer plurality, foregrounds alterity. The other, viewed in terms of the image, overshadows the self. The act of looking at the image renders the alterity inherent in the photograph dynamic, releasing its potential to challenge the priority of the viewer. In this moment of crossing, the image reflects back on the viewer, posing the question that arises within all ethical relations: the question that interrogates epistemic certainties. This dynamic needs to be acknowledged if we are to move beyond reductive dismissals of aestheticized photodocumentary that fail to recognize the potential for ethical awakening via this genre.

The Mirror within the Frame

The intersection of gazes in Salgado's work must mean that the image is not one single thing, but that which comes to life in distinct and subjective ways according to perspective. This process is no doubt complex. The photographs have been framed by numerous gazes, first by him as photographer and then by Lélia as editor, not to mention other possible intermediaries. As a result, each image is not one single thing, its meanings always contingent on perspective. The plurality of the gaze, and hence of vision, challenges the very notion that meaning can be contained in an image, or in a series of images: instead, it posits the notion that interpretation too is plural, open-ended.

Reading a photograph thus becomes a form of provoking questions, one that is intersubjective in that the questions arouse a response. In considering questions of ethics in photography, perhaps the most im-

portant element is the force of certain images to mobilize the imagination, and this ability is itself dependent on selection, composition, and quality of aesthetic. Hence, the form or quality of aesthetic is at the starting point of the interpretive movement. I say quality of aesthetic, and not aesthetic per se, because clearly all photographs are representations and so contain some form or other of aestheticization. If Salgado has been the recipient of unusually stinging criticism as regards aestheticization, then inevitably this reflects back onto the aesthetic style determined by him and Lélia. At play here are questions of tonality, light, and artistry, as well as a distinct language of visual rhetoric, of unmistakable tones from black to white, which weave meaning between images and series of images.

These are also the very qualities that place Salgado in a small but supremely elite league of master photographers. Writing of Cartier-Bresson's photographs of China, the French philosopher Jean-Paul Sartre explores the notion of the picturesque, that quaint and exotic otherness assigned so often to the Orient by those in the West. He marks out how the French, and hence Western, viewer begins by noting the way in which these photographs differ from stereotypical images of China but then discovers the extent to which the images fall short of the picturesque: "Cartier-Bresson's photographs never gossip. They are not ideas, but they give one ideas. Unintentionally. His Chinese are disconcerting: most of them never look quite Chinese enough."[32] Sartre foregrounds the "material truth" that images bear. And for him too this element is ensconced in class differences, colonial differences, economic differences. He encounters commonality in the face of difference through this materiality of photographs, in which he begins to see that "poverty is the best distributed thing in the world: we have no shortage of poor. Admittedly, we have abandoned the habit of hitching them to sedan chairs for them to carry the rich; but are they any the less our beasts of burden for that? We harness them to machines."[33] The Chinese of Cartier-Bresson's book of photographs *China in Transition* share realities with the miners of Salgado's photo-essay on the Serra Pelada that override their geographic, racial, and cultural differences. Like Cartier-Bresson's Chinese, Salgado's miners too fall short of appearing totally other. A tension exists in Salgado's photograph of the *garimpeiro* between the miner's economic circumstance, on the one hand, and the power of his gaze, on the other. "Pictures," Sartre declares, "bring humans closer together when they are materialist, in other words, when they begin at the beginning, with bodies, needs,

work."[34] In other words, photographs come to life when they construct a relation between the viewer and the imagined subject of the image. This relation is one that is sustained by the passage of ethical questioning from the image to the viewer.

Perhaps what is most worth noting in Cartier-Bresson's work is the fact that he employed a very deliberate aesthetic of selection, composition, and tonality in constructing his images.[35] In this, Salgado's work can be said to be like his. Both photographers pay keen attention to tonality and metaphoric possibility, though their individual styles are in fact quite distinct. Their images are selected from reality and ultimately lead the viewer to reflect on it; however, such is their aesthetic or artistry that the images lead the viewer not to "see" reality in them, but rather, to re-view reality in terms of alterity. In this paradox, we encounter the curious oscillation of the still photograph between mimesis and revelation.

If photographs are selections of reality, then often this selectiveness sheds light on aspects of reality that go unnoticed. Through photographs, we glimpse the unseen. In this, they are transcendent. They cross objective boundaries, forcing the viewer also to transcend and so question the epistemic boundaries of the self. This movement that comes about through the still photograph is dialogic, based on a premise of intersubjectivity. Curiously, therefore, questions of selection and the aesthetic that have been determined by the photographer are necessary conditions for such intersubjective relation—the responding to the other via a questioning of the self. In the same way as Cartier-Bresson's Chinese do not look Chinese enough, according to Sartre, so it is that Salgado's subjects challenge labelling. Instead, and as Sartre lays out, the image of the Chinese other reflects back onto the viewer, causing him to discern commonalities. In so doing, he feels the pull of the subject through the engagement of viewing. He feels also the mystery and unknowability of the other. It is according to the same dynamics that Salgado's mud-covered miner does not look other enough.

This failure to present the subject as entirely other is the result of an aestheticization that injects the spiritual, the baroque, the magical, and the mysterious into representations of mundane, sordid, or painful subjects, thus rendering them transcendent. It is not that the viewer sees himself or herself in these images: rather, it is that these images, through their ability to transcend, lead the viewer to regard the world she knows in the light of the unknown and unknowable other.

What is crucial here is this idea of relation with alterity. The gaze in

such an instance does not objectify; instead it is deflected by the image to contexts outside of the frame, while also dwelling within it. And this visual connection that is forged with and through those who are other is the enactment of an ethics of photography. For just regard is, above all, the search for a response to alterity, the basis for ethical relation. Faced with difference—that of self and other, subject and object—when viewing the displaced subjects of Salgado's images, the mutability of our own world is glimpsed in the loss witnessed in the world of the other.

Ethical Regard

I have argued that an ethics of regard comes to the fore through Salgado's work. Central to this argument is the way in which alterity is viewed via the image. In response to the criticisms of Chevrier or Antelo, divergent as they are, as well as to the debates around photodocumentary that have flourished in North American contexts, I posit this notion of a specific kind of relation to alterity. Nowhere in these various arguments is there a consideration of the power of the image to compel the viewer to place his or her epistemic beliefs in question. Instead, the image is seen as a two-dimensional text that distorts or falsifies. Manipulation is always assigned to the photographer, who, in alignment with the viewer, retains a position of power over the subject. This manipulation extends, it is thought, to the photographer usurping from the subject a place in the limelight.

There is no doubt that, at least to some extent, this is so. However, it is by no means entirely the case. Nor is it so straightforward. Of course, the photographer is able to select, frame, and direct the course of the image in a way in which the subject cannot. Of course, the photographer gains recognition from his or her images. Yet, while there is an initial dynamic between the photographer and his subject that is seminal to the creation of the image, this is later complicated by the processes of production and dissemination. The enhancement of the aesthetic, its style, its semiotic scheme, all enter into play here.

If the two-dimensional print is able to gain a symbolic relevance that is three-dimensional, this is because it has an agency that is at once aesthetic, ethical, and political. This agency is not that of the photographer, nor is it of the subject: it is an agency that is fashioned via the processes of selection and production that build on the photograph's germinal relation to reality, while also being entirely reliant on the aes-

thetic in order to do so. It is also often an agency of the image that has been constructed with the willing participation of the subject, who, by agreeing to be photographed, consents to the release of her representation, so that the image may assume a life force of its own. Furthermore, precisely because the photograph lacks originality, being technologically produced, and is different in this sense from traditional artworks, it has a more immediate relation with the viewer in that it purports to transmit reality, without ever fully doing so. The resulting "construct" has several aims: to convey difference, to exercise an aesthetic, to target the market, and to impact the viewer. It does so by usurping the position of subjectivity and forging a relation with the viewer that is intersubjective. The guise of authenticity in relation to reality endows the photograph with an agency that is enhanced and rendered dynamic by the aesthetic. In this sense, it is the image that takes precedence over the photographer or the subject. It proves its own raison d'être by being meaningful to the viewer. Infused via the aesthetic with a kind of hyper-reality that—paradoxically—lends the semblance of authenticity to what is of course never more than mimesis, the photograph commands attention and belief. And so, it is the image that draws the viewer out of herself if she is to give due regard to its presence: for the image has a presence that is its own.

What must be noted, then, is the fact that the image gains its position of authority via the aesthetic. At work in the intersubjective relation between the viewer and the image are questions of power. However brief the moment may be, the image holds sway over the viewer, facing her with the question of alterity and so challenging her epistemic tenets.

The Semiotics of Difference

When a slice of reality is selected and framed—frozen, as it were, in the very act of passing and then transformed through a deliberate aesthetic—the image stands out. It captures attention in a way that would never have happened if that slice of reality had not been prised from the seamless passage of time. That very process, however, splices the photograph from the subject, who has already moved on. As photography is, in some sense, a plastic art, the inevitable split that separates reality from representation manifests itself in the gap between the subject and his or her image. The same subject may invite different portrayals, depending on the photographers' points of view and the processes of pro-

duction that the images pass through. Ironically, then, it is the very artifice of these photographs that acts as a semiotic system for their materiality. Most importantly, photographs, despite being constructs, provide a space for encounter. They also provide a space for difference. It is this combination that facilitates the intersubjective relation with the viewer.

The image of the miner that hangs on the wall of an exclusive art gallery in the heart of a Western metropolis is, of course, far removed from the moment in which the image was frozen; its outreach is not the same as it would be in a book, next to specific text or on the walls of an office of the MST. Thus, the Serra Pelada images carry a very different subtext when seen as large, framed photographs in an elite art gallery as when seen, for example, as tattered posters on a wall in the office of Justiça Global, a human rights organization offering legal aid to the displaced in Brazil.[36] Likewise, photographs from the *Terra* project very different discourses when seen in the São Paolo headquarters of the MST, in the office of Justiça Global, in Terra Prometida, the improvised MST settlement that I visited outside Rio de Janeiro, on the gallery walls of the Barbican Centre in London, and in the glossy pages of the book of the series. The same image in each of these contexts has a different aesthetic impact, a different ethical relation with the viewer, and different political message. By this token, it is evident that images must be considered within the larger symbolic structures and semiotic contexts in which they appear. In each case, the question the image poses will differ.

Equally, different photographers may come up with many different images of and perspectives on the same subject. Thus, the miners of the Serra Pelada have also been the subjects of images by, for example, Salgado's fellow Brazilians Claus Meyer (who, according to John Mraz, was the first to photograph these miners and did so in colour[37]) and Miguel Rio Branco, as well as by the New York–based Chilean artist Alfredo Jaar. They are also featured in the opening sequence of the film *Powaqqatsi*.[38] Each of these representations of the Serra Pelada and its miners is radically different. The film *Powaqqatsi* opens onto a visual narrative denouncing industrialization and the ruptures and decimations of modernity. The images of the miners serve both to represent and to question the notion of progress, a key facet of modernity. Interestingly, therefore, this film uses visual reproduction, in the form of a seemingly endless series of images, as a way of mirroring and critiquing industrial reproduction.

Claus Meyer, a German-born photographer who spent much of his career in Brazil and was once a member of the prestigious Black Star agency (before starting his own agency, the Tyba Agência Fotográfica in Brazil), used colour photography in his work to bring out the vivid richness of colours and the vibrancy of light in Brazil. His images of the Serra Pelada are dappled in hues of red and gray. They form part of a life-long portfolio of Brazil in the twentieth century. The Serra Pelada images, mottled like pebblestone, fall in line with Meyer's overriding focus as a photographer on landscapes, stones, and nature.[39]

Like Meyer, Rio Branco shoots the Serra Pelada mine from further afield, representing the men in groups, as part of a chain. His images present the copper and reddish tones that appear elsewhere in his images of Brazil. In this way, his Serra Pelada images become contextualized within a larger family of images of Brazil. In the earthiness of their colour, they are quite unlike Salgado's more abstracted black-and-white photographs. As Lélia Wanick Salgado and Sebastião Salgado state in their brief essay on his work, "As Brazilians, we also view Rio Branco as a profoundly Brazilian photographer."[40] Indeed, the burnt russets of his images throw a particular light on Brazil, one of blood and violence, desire and vitality. Rio Branco's photographs of the Serra Pelada show the miners in this same light, dwarfed against the mighty swell of the mountainside. We find in his work great suffering, the grain of everyday life among Brazil's disenfranchised, but also beauty and a profound poetry. In this context, David Levi Strauss observes, "Long before Brazil was a country, it was a colour. . . . The colours in Rio Branco's images often work like dyes, saturating and staining what is around them. . . . The colours are carnal, in a way that makes everything seem alive, or once alive."[41]

In a completely different mode, Jaar's images, part of an installation titled *Out of Balance* (1989), deliberately seek out the faces of the *garimpeiros*, or miners. They appear covered in gold dust, a figurative gesture, no doubt, to the venture of which they are a part. As with his other projects, Jaar makes no attempt to act as a documentarian. Instead, he calls on realities in order to construct his art installations, which aim always to channel artistic expression toward ethical awakening and political awareness. Jaar's work is thus driven by an ethical impetus that foregrounds the role played by aestheticization in provoking an ethical response in the viewer. His work is also profoundly and overtly political, as can be noted in his long-term project on Rwanda. Precisely by

resorting to art, he is able to shed light on social and political injustices, particularly those that often go silenced or unrecognized by those in power.

It is curious to note thus that although all four are Latin American photographers with common ethical concerns, Meyer, Rio Branco, Jaar, and Salgado have very distinct visual styles. By juxtaposing their respective images of the Serra Pelada—many of which have similar compositions that mark out the dwarfing of men by the landscape—one encounters the open-endedness of photographic representation. As fellow Brazilians, Salgado and Rio Branco share a common focus on the disempowered, but their visions and what their work suggests is strikingly different, yet oddly complementary. Rio Branco brings out the raw pain of suffering; Salgado brings out spirit and hope. It goes without saying that both visions are relevant, and therefore, that no single line of vision can ever encompass a whole.

Photographs thus speak to one another. Within the larger frame of Salgado's immense portfolio, the Serra Pelada images are only a part of Salgado's own photographs of mining. He has spent long periods of time in Bihar, India, and has produced several images of Bihari miners, their families, and the conditions in which they must live. Among this set of images, there is a composition of three Bihari miners that closely echoes an image of Welsh coal miners taken by W. Eugene Smith.[42] Merely by juxtaposing Salgado's image with Smith's, one is confronted by the curious commonalities between these Welshmen and Indians—commonalities that once again cross boundaries of geography, race, and culture. In each image, we see three men, their faces smudged with coal, poor, entrapped by circumstance. They have more in common than not. The compositions of the two images are strikingly similar; so too is the sociocultural problematic they present. To look at Smith's photograph and then at Salgado's is also to feel the impact of that composition across time and place.

Poetics of the Unseen

In his wonderfully moving essay on Rio Branco, "Between the Eyes," David Levi Strauss declares that "the camera doesn't *think*, it recognizes. It shows us what we already know, but don't know that we know."[43] It is this crucial statement that I wish to highlight: the idea that knowledge is not limited to what we are consciously aware of, but in fact extends

much further. Knowledge, or awareness, is neither entirely within the grasp of rationality nor confined entirely to what can be rationally articulated. Strauss's statement suggests that knowledge is in fact linked to sentience, instinct, and an underlying sense of the ethical that surfaces when we view otherness framed in the photograph. If the camera is able to confront us with the unknown known—that which is at once familiar and unfamiliar—then it does so by presenting alterity in the form of the photograph. The viewing of a photograph always somehow entails stepping out of time and place to dwell on another world that is framed in the image. As Sartre has shown, there is a moment of recognition that comes through engagement with photographs. A moment of coming face to face with difference, only to then find relation through such an encounter.

Clearly, such relation requires an act of imagination on the viewer's part. However, as Richard Kearney notes, our contemporary cultural contexts of postmodernity are so saturated with images that viewers are increasingly less able to exercise their imagination via the act of viewing.[44] Curiously, therefore, the wild proliferation of images has led to the decline of imagination. Images have been rendered faceless, turned into simulacra.[45] This accords with the aforementioned view held by Stanley Cohen that the most common response to images of suffering is denial.[46] The endless proliferation of such simulacra has led, in Kearney's view, to a crisis in contemporary poetics, resulting in the breakdown of imaginative encounter. This breakdown implies thus a loss of vision, as we turn an increasingly blind eye to the images that float past our eyes. As a result, the ethical encounter that was possible through a poetics (in other words, an aesthetics) of the imagination, fails to blossom.

Salgado's work inevitably must be located within this historical juncture of postmodernity. I argue that it is precisely because his images are not realist that they suggest and facilitate an ethical engagement with the subjects and contexts of reality. Postmodernity turns images transient, insubstantial, all too forgettable. Vision fails, as the viewer is inured and turns a blind eye. It is precisely this loss of vision that Salgado's work seeks to counter through reiterated reliance on the aesthetic. Salgado's photographs should be seen as an attempt to step outside this endless cycle of simulacra through the interjection of an aesthetic strong enough and distinct enough to distinguish them from the crowd. Indeed, the majestic sweep from black to white in his

images, the translucence of their tonality, the ample but profound embrace of his lens and its ability to confer a lost dignity, all suggest a refusal of any easy passing over of the image. This is because he calls on an aesthetic tradition in visual culture, most notably that of chiaroscuro and sfumato in painting and black and white in photography. As Ernst Gombrich notes in his seminal work *The Story of Art*, sfumato lends an aura of mystery to the work of art, a double light that is also the trace of alterity.[47] Through this language of black and white, Salgado intervenes in semiotic and discursive fields, creating meaning through his images and thus pointing, not to what can be seen, but to what is unseen. These semiotic fields are numerous and overlapping. Intervening here is the language of art, of religion, of economics, all translated into visual aesthetic. As such, his work is not so much a capturing or reworking of what is seen, but an evocation of what is unseen. It is this oscillation between the seen and the unseen, subtle but intense, that makes his work so arresting.

Face to Face

In a postmodern context where images circulate and mirror each other, the need for a radical alterity becomes all the more pressing. Kearney turns to the work of Emmanuel Levinas in an attempt to retrieve the face of the image in the midst of a world where images have become faceless.[48] He seeks out the play of imagination, the coincidence of ethics and poetics, that occurs in the encounter of the self with the other. The other, in its priority over the self in the moment of encounter, poses a question that awakens our sense of responsibility. Faced with difference, we find our ethical surge toward that which is separate from us. The face, for Levinas, denotes a trace of the other, and not the other itself. The other remains forever elusive, enigmatic, unknowable. The object of our gaze is thus not objectified but rendered *human* through this unknowability—in the same way as the wonder of never fully knowing the other reflects back on us and renders us more human in our response and in our newly awakened responsibility.

While we are unable to know the other through her face, according to Levinas, the face nevertheless "speaks." It does so by presenting a trace. The trace, he explains, "shines as the face of the other."[49] A distinct religiosity is present in Levinas's thoughts; the unknowability of the other is at once human and divine. When the face speaks, it does not say any-

thing in particular: that is not the point. Rather, what matters is that the face speaks. What matters, as Levinas has repeatedly pointed out, is the saying, not the said.

In light of this view, we could argue that in the context of images, it is not the seen that matters but the unseen. This notion relates also to the idea that the gaze could always be different. The onus of responsibility in photographs thus shifts to the viewer. This is a radical departure from the stance taken by so many critics for whom responsibility lies neither with the subject nor the viewer of an image, but with the photographer. If photographs, as traces of something larger and elusive, are important, then this is not so much because of what they depict as because of what they induce in the seer. Like the face of the other, the aestheticized photograph leads us to transcend our epistemic stance in the prescience that the other before us remains unknowable and unreachable. Implicit here is a striving toward a response to the question that is present. It is this question, that of ethics, which draws out the unseen.

Interpretations of Levinas's philosophy of language reveal a widely held view that in writing of the "face-to-face," he meant the lived, the corporeal, the tangible. His views on art and aesthetics remain more ambiguous. In the course of his essay "Reality and Its Shadow," written in 1948, Levinas draws a distinction between art and being. The former, he declares, uses images as substitutes for the latter.[50] Yet, he states, images lie outside of time and thus cannot replicate being. As such, if being flows into becoming, then the separation of art from reality leads to a rupture in the process of becoming. Indeed, for Levinas, art belongs to the realm of the said, while being, if it is to transcend into becoming, is always poised on the verge of saying—that is, on that vital brink or epistemic fault line where ethical response is possible.

Levinas displays here a typically modernist separation of reality from representation. The face-to-face he describes, which leads being to ethical becoming, is widely understood as non-artistic and non-linguistic— and this, we must assume, would exclude the visual semiotics of lightwriting. Yet, as Edith Wyschogrod argues, there is also some ambiguity in Levinas, for in his writings, he reveals an appreciation of the ethical potential in the aesthetic. There is even a likening of the aesthetic to the divine. By marking his references to the philosophy of Søren Kierkegaard on transcendence, to the obscure poetics of Maurice Blanchot, and to the visually charged writings on memory of Marcel Proust,

Wyschogrod notes how Levinas did in fact acknowledge the possibility of ethics in an aesthetic that presents alterity.[51] Visuality and questions of light and darkness (the chiaroscuro and sfumato of writing), linked as they are to memory and oblivion, are central to the work of both Proust and Blanchot. Levinas acknowledges the transcendent potential of such work, relating it to religious notions of transcendence. Wyschogrod points out that Levinas calls on these writers' work to argue that ethical response to the other is also the gesture of ethical possibility.[52] Such a gesture acknowledges not only the difference but also the superiority of the other. Indeed, Levinas's view of the other always carries with it a sense of the holy. The ethics of alterity signifies an act of prioritization, a raising of the other above the self.

If Salgado has on occasion been accused of glorifying misery, then his work could also be viewed as suggesting a Levinasian gesture of ethical reaching out to the other—one from the photographer to the subject with the added intention of arousing a similar sense of wonderment, that gateway to the ethical, in the viewer. In interpreting what Salgado does through the philosophy of Levinas, his work must be located in its postmodern contexts. The photograph ceases to be merely an object and is instead an intermediary space of intersections that flow into and cross one another. It acts as a sort of window through which the viewer can relate, not to the subject as such, but to the imagined subject. While the photograph is also a material object, its aesthetic lends it a contradictory temporality fluctuating between absence and presence, the seen and the unseen.

Despite the surfeit of images that marks the postmodern world, the power of the image to posit such ethics is probably stronger than ever. This is because the very ubiquity of the image has more than one consequence. It does not merely nullify our ability to see: ironically, at the same time as vision is nullified, it becomes more relevant than ever, as the visual becomes the predominant semiotic system through which we navigate our worlds. This phenomenon has led in part to a larger awakening to the possibilities of the visual, a broader horizon within which images are interpreted and understood. This enhanced degree of possibility relates directly to the ability of images in postmodern contexts to suggest rather than to say—for with the postmodern breakdown of coherent narrative comes the undermining of the *said*, and hence the failure of art to make statements that can be rooted and stable. Instead, and in line with Levinas's emphasis on *saying*, images take on a

generative force, a being-ness that imbues them with the potential for ethical relation. As postmodernity blurs the boundaries between reality and representation and as photographs become increasingly part of the everyday experience of life—indeed, as life is increasingly understood in terms of the visual—so Levinas's ambiguity on the ethical potential of art becomes less applicable to photography.

Within this contradictory context of postmodernity, Salgado's work is notable because it achieves through the aesthetic a certain isolation and uniqueness of the image that makes it seem nonrepeatable. This is achieved, as stated, through the reliance on an aesthetic that partakes of the aesthetic of painting, itself embedded in a historical context. So, unlike much contemporary photography that foregrounds the image's ability to mimic postmodern fluidity, Salgado's images evoke a different temporality. This deliberate aesthetic that Salgado employs allows for an ethical provocation to take place. His images become noteworthy. They demand response. This, as Levinas has indicated, occurs not through emphasis on representation, but through an evocation of the unknown and the unseen that frames the question that arises when the other is encountered.

Rescuing the Aura

The epiphany of alterity that Levinas writes so much about, that question of the ethical, is only possible if the image can make its mark—that is, stand out from the vacuous flow of everyday images and actually be *seen*. For this to happen, it must deploy an aesthetic strong enough to stand out from the general swirl. Salgado achieves this through the dexterous tonality of his images, which require the viewer to step back from more generalized cultural and specifically visual contexts. His use of the aesthetic is an attempt to reconstruct the aura of the work of art, which awakens the possibility of response to the unseen.

As the philosopher Vilém Flusser points out, black and white are abstractions that lift the image from the everyday. By stepping back, the viewer can *see* the image and so lend herself to ethical imagination. This in turn leads to ethical conceptualization. As Flusser explains, "Black-and-white photographs embody the magic of theoretical thought since they transform the linear discourse of theory into surfaces. Herein lies their peculiar beauty, which is the beauty of the conceptual universe. Many photographers therefore also prefer black-and-white photographs

to colour photographs because they more clearly reveal the actual significance of the photograph. i.e., the world of concepts."[53] Aestheticized photography subdues and subverts our cognition and hence the ethical positions we assign ourselves as cognitive and epistemic agents. The image, part document and part work of art, forces an awakening of the ethical possibility in us as sentient subjects via aesthetic intervention. We must thus query our own epistemic suppositions and realign our cognitive frameworks accordingly.

Salgado's images respond to the crisis of ethics in postmodernity. The potentiality in his images—and it is important to remember that all we ever glimpse via the aesthetic is this potentiality—is because they arouse the need to rescue ethics. In so doing, they rescue the unseen, the invisibility and absence of ethical questioning. The heightened aesthetic of his work is, then, a means to address the urgency of the need for ethical questioning. Numerous philosophers have come to debate this quandary of ethics; a few visual artists do so too through their images, as is evidenced by the work of Salgado, Jaar, and Rio Branco, to take only a few examples.

Indeed, if we approximate Levinas's notion of the face-to-face through the work of Salgado, this is not because his work is ethical as such. How could it be? It is at once commercial, artistic, elite, socially engaged, and humane. It is no single thing. We approximate the face-to-face through Salgado's work because it *suggests* the ethical to the viewer, who responds to the image and the possibility of ethical relation that it proposes.

Precarious Ember

In keeping with the Judaic traditions from which he hailed, Levinas explicitly employs the language of religion—biblical and illuminated by images of fire—in much of his work. Indeed, religiosity, understood as a mode of transcendence, is inseparable from fire. Yet the fire that Levinas attends to most is not that which is large or burns bright; rather, he points to the ember, the hidden glow that opens onto the future.[54]

The ember, like the frame of the image, is ambivalent. It falls short of a fire, though it has the potential to turn into one. Equally, it could die out, extinguish itself into obscurity, and so sink into death. Either way, the ember transcends itself to become otherwise. In this, photography links itself to fire. Light emanates from the photograph as possibility.

The precarious light of the ember is glimpsed in the ethical light of the photograph, also precarious. Through his use of the aesthetic, Salgado makes possible the glimpsing of that transient light. There is a likeness, then, between the flickering of embers and the photograph. The ember flickers between light and darkness, between that which can be seen and that which remains unseen, that which may grow or die. In its precariousness, it bears great potentiality. It is also fleeting and vulnerable, in need of rescue; the same is true of the photograph. The flickering of the still photograph between the seen and the unseen signals the pulse of ethical possibility.

Many contradictory factors conspire to create this ethical possibility. Photographs are seen as sacred in many cultures; they also bear a special relation to notions of truth. Yet they are constructs, re-presentations of sections of reality made possible by technology and artifice. In this they are deeply ambivalent. Vision is not just about what one sees before the eyes, but also about what lies beyond the eyes, at the horizon of the image. It is directed by the unseen, the prescient, and the imagined that appears both within and beyond the frame as much as by the seen.

As the French philosopher Jean-Luc Nancy has shown, the image recedes even as one approaches it.[55] It is intimate and remote at once, sacred and hence separate. From a philosophical perspective, therefore, images can only be understood via a split logic that is ontological as well as phenomenological. Images manifest being as well as incite being. Much depends on the aesthetic of the image and where that aesthetic speaks from. Images, Nancy states, never exist on their own. There is always "contagion"—with text, with contexts, with performance. He states, "To tell the truth, where is there not contagion? Each mode is a mode of giving presence to an absence that threads its way in every direction . . . and this absence in incessant absenting puts all the modes into contact at their borders."[56]

In the same way as Levinas points to the uncanny in the face of the other, Nancy notes the uncanny, the unknowable, in the image that presents itself to the viewer. Nancy's idea of contagion can be linked to Levinas's notion of the ember. Both imply the crossing of boundaries and, in the context of the photograph, both evoke the swift passage from light to darkness that typifies the medium. The photograph is a space of contagion between absence and presence, the seen and the unseen, the cognitive and the visceral.

Take, for example, this image of refugees from Rwanda making their way in Tanzania during the massacre of Hutus by Tutsis in 1994 (fig. 17). The image is shrouded in mist, the long line of people snaking their way along the riverbank is dwarfed by the early morning sky. The image on its own tells the viewer nothing of the genocide from which these refugees have fled; there is no shocking image here of war or bloodshed or suffering. Unlike, for example, Alfredo Jaar's Rwandan art installation *The Eyes of Gutete Emerita*, this image does not accuse us of negligence to Rwandan suffering or speak to a specific political context. Yet, there is an almost biblical evocation of the long and winding road, one that speaks poetically and with extraordinary beauty. The photograph is moving, uncanny. We see only the hazy silhouettes of the refugees as the mist rolls in from left to right. It is an allegory of displacement and despair, of struggle and survival. The silver rays that reflect back from the water—they lace the image with a magical, even spiritual light. The image is profoundly metaphoric even as it calls for our attention. It is both geopolitically vague—indeterminate, were it not for the caption that comes with it—and intensely memorable, even haunting. The subjects of the image do not represent Rwandans as such, but victims of forced displacement as a whole, enveloped, as is so often the case, in a mist of oblivion.

If this image provokes the ethical, then it is not toward a specific people or group but to humanity in general. And it does so by revealing the intimate bonds that tie ethics to aesthetics. It also reveals the bonds between ethics and politics. The ember of possibility or the idea of contagion is located here in the dichotomy with which we view this image: on the one hand, our knowledge of the profound horror that has given rise to it and, on the other, its profound beauty. The fragile line of ethical questioning runs along this dichotomy or line of slippage between the subjects and the image. It confronts us as we look at this image. Perhaps, we learn thus that the ethics of photography is to be found not so much in what is made explicit in an image as in the contradictions and quandaries that images pose to us.

This photograph is also symptomatic of the fact that if Salgado depicts global displacements, he is not by any means a photographer who limits the power of the image to the boundaries of the frame. That—dare I say it—is the prerogative of photographers who make what Roland Barthes has called unary images. Yet it would appear that critics such as Jean-François Chevrier denounce photojournalism, and the work of Salgado

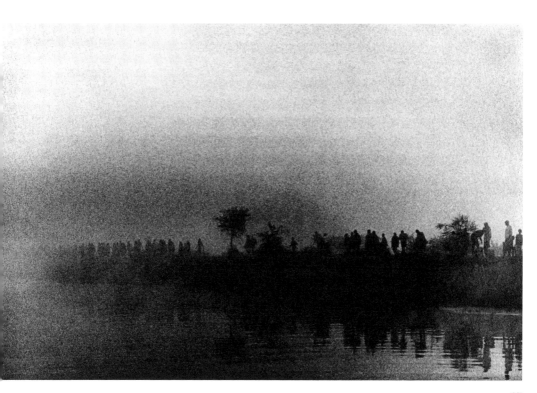

17

in particular, because it is not upfront or explicit enough. The implicit idea here appears to be that photojournalism must distinguish itself from art by being identifiable, specific, and realist. Speaking of Salgado's images of Rwanda, for example, Chevrier expresses his annoyance at the sense of that which is sacred—and hence removed or distinct—that the photographs carry: "A hieratic group of four refugees from Rwanda in Zaïre in 1994. The image was taken 'before dawn' (!)."[57] Yet it is precisely the hieratic or that magical light of dawn in images such as this that calls forth an ethical response. The hieratic is by definition not locatable; it is uncanny and nontraceable. It is a suggestion, both within the image and beyond it; it draws the viewer and arouses a response that is vital if an ethics of vision is to be sustained.

This argument would also form the basis of a response to Susan Sontag, who states that subjects who have not been named in captions are rendered powerless. It is precisely the unnamed, unknown, uncanny other whom Salgado depicts. And this nameless other is also the one who poses to us the question of ethics: can we, as viewers, rethink what we know in light of the other that questions us? What matters is not the specificity of the image, its link to the local and the locatable, but rather its power to release in the viewer an ethical response—that is, a willingness to let go of certainties and seek out what stirs restless at the horizon of vision.

The Visible and the Invisible

The linearity of knowledge is interrupted by this horizon. It is the point where sight bleeds into blindness, where the epistemic blurs and slips into uncertainty. If Levinas wrote of ethics in terms of the face-to-face encounter with alterity, then Jacques Derrida shifted the focus of ethics onto questions of vision in art. In the context of painting and drawing, Derrida's *Memoirs of the Blind: The Self-portrait and Other Ruins* pursues questions of epistemic uncertainty when sight is diminished. Derrida's exploration of the sightline, whereby the hand is an extension of the eye that flounders when it has to draw in the dark, questions the legacy of representation—primarily visual, though applicable to other modes as well—in the light of an acknowledgment of the existence of the unseen. Derrida stresses that the seen and the unseen are not separate and distinct. Instead, a curious connection exists between them, a coupling that is at once fissure, reliance, opposition, and interplay. Invisibility

is thus an inherent part of the visual experience, a fact that we often forget. At any given moment, what we see takes us to the edges of our sight. In this sense, vision, and hence knowledge, is always partial, incomplete, open to re-vision. The seen is riven with the as-yet unseen. By referring to Maurice Merleau-Ponty's work *The Visible and the Invisible*, Derrida recalls that "the invisible is not simply a part of the visible, it is not merely a visible to come, a potential visibility to be reached, or something left to be seen. On the contrary, the invisible is included in the experience of the visible."[58] By this logic, any epistemic certainty is by definition the carrier of its doubt. All representation carries within it the trace of incompletion, and perhaps even of error or misunderstanding.

This concept applies as much to photography as it does to art. Indeed, central aspects of photography, such as selection, perspective, and the play of light, all help to foreground in the viewer's consciousness the inextricability of the seen from the unseen in terms of the complex role between representation and reality played by the photography. A nerve of uncertainty runs through the photograph. From every angle, the unseen crosses that which is seen. This is all the more so in the aestheticized photodocument. The photograph makes obvious the gap between reality and representation, between lived realities and epistemic frameworks. Perhaps it is this aspect of photography that is often most moving. I say moving, because ethical vision is the will to see beyond what can be readily seen. It is also what is most arresting and most unsettling, because this questioning throws back onto us the uncertainties and invisibilities that are rife in our own notions of the self. It is the invisibility of the visible that raises the question of ethics: how to rethink what we know or assume, when confronted by the alterity of the photograph? How to realign our sense of self in light of the invisible otherness that reveals itself not only in the photograph before us but also within us?

Refusing Compassion

The relation with the image is a process. This is why the notion of compassion as a response to the photograph is out of place. When speaking of photodocumentary, it is easy to confuse questions of ethics or just regard with those of compassion. Sontag, among others, points out the "problem" of arousing compassion in the viewer when the subject of

photography is as vast as in the case of Salgado's images. In Sontag's view, the array of nameless subjects cannot arouse compassion, because they cannot be identified as individuals. Compassion requires us, as viewers, to somehow feel we could know the other, name her.

It is curious to note that compassion is often considered to be a laudable sentiment. In the context of photodocumentary, it is often simply assumed to be the "right" response. This view needs to be rethought. Compassion—as the Latinate root of the word suggests—derives from the idea of suffering together. This notion dissolves the distance between the self and the other through an imaginative act whereby the self is imagined in the other's shoes, so to speak. It does not, therefore, imply a move to regard the other who is *separate* and *different*, but rather to be *alongside* the other, even to see oneself in an imaginary leap *as* the other. Sontag is right in stating that Salgado's work does not achieve this confusion. Rather than being a problem, this, I would argue, is its strength.

In this vein, James Johnson offers a lucid study of the ways in which a focus on compassion blocks the politics of photography. Through reference to Hannah Arendt's analysis of compassion, Johnson offers proof that such a response blocks the politics of photography precisely because it arouses so strong a sense of identification between viewer and subject that the space for politics—and by this he means a serious engagement with the structures of inequality or injustice—is lost.[59] Johnson identifies Salgado as a photographer who, unlike Dorothea Lange, James Nachtwey, Diane Arbus, and Walker Evans, breaks the convention of compassion in photodocumentary. According to him, Salgado achieves this through his photographs' establishment of "patterns to suggest or at least to prompt viewers to raise questions about causes and interdependencies. They work, too, to raise questions about responsibilities, rationalizations and redress. While his images may not invariably succeed, they take aim, at least, at questions of politics and causality that, as Rosler, Berger and Sontag all rightly indicate, bedevil photography."[60] Interestingly, Johnson notes how Salgado uses a repeated "representational strategy" in his work, whereby individuals are placed against the backdrop of larger groups or communities. In this way, viewers are gradually introduced to the concerns of the collectives of which individual subjects form a part. Thus, Johnson states, "Salgado places the possibility of solidarity on the table."[61]

There could be few stronger arguments for understanding the ethical

intention in Salgado's work. Ethics is, after all, about possibility, about the will to offer a spontaneous response to that which is different and unknown. In pointing out that, in fact, the organization of Salgado's photographic projects always reveals a "strategy" that juxtaposes the specific or individual with the collective, Johnson's article also acknowledges the subtle, but all important, flow in and through Salgado's work from the sentient, affective, and nonrational to the rational. In the visual narrative of Salgado's photo-essays, individual portraits are juxtaposed with images depicting collectives, so that a subtext of social and collective belonging runs through the essays. The aesthetic in these images arouses an ethical surge toward the otherness envisioned via the images. Rather than being diffused or dispersed, this surge of an ethical response is channelled across photo-essays via the structures present in the latter, thereby sustaining it and transposing it via the viewing experience into an awareness that can both be articulated and reflected on. In this way, both aesthetics and ethics come to be firmly posited in the terrain of politics.

From Ethics to Politics

This alignment runs, in fact, contrary to much current criticism, in which the realm of the aesthetic is seen somehow to be antithetical to that of history, ethics, or politics. In the case of Salgado's work, there is the very obvious fact that his aesthetic is one that overtly espouses beauty. This adoption of an aesthetic of beauty greatly complicates matters and makes criticisms ever more stinging.

For much of the twentieth century, the assumption has been that beauty somehow does not have a place in this fractured historical moment of ours. A critique of the aesthetic has been a sustained feature in the history of art throughout the twentieth century.[62] The anti-aesthetic established itself, at least in part, as a response to the establishment of aesthetic modernism as the cultural manifestation of power. Therefore, throughout the 1970s and 1980s (precisely the period when Salgado began to forge his career as a photographer), the anti-aesthetic became a mode of conveying alternative, progressive agendas. Even if not adopted by mainstream purveyors of culture, such as the media and museums, the anti-aesthetic gained ground among critics, thus firmly planting the notion that ethics and aesthetics are opposed. For much of the twentieth century, the assumption remained in place that because

deliberate aestheticization was an obvious eschewal of realist represen-
tation, it could not be socially or politically engaged.

It was not until the end of the twentieth century that a seminal text,
written by Elaine Scarry, responded to the anti-aesthetic, by now firmly
established institutionally, in order to rescue beauty and place it back
alongside the ethical. In *On Beauty and Being Just*, Scarry not only de-
fends beauty, but also argues that the aesthetic propels us toward jus-
tice. By awakening our sensory perceptions, she states, beauty renders
justice, an abstract concept, more concrete and more tangible. Re-
sponses to beauty thus have, in her view, a profound impact on indi-
viduals and society. Most importantly, beauty foregrounds the vitality
of things, thus making us, in turn, more sentient of the life of others. In
contrast to prevailing views on beauty, Scarry argues that rather than
eclipsing questions of justice, beauty intensifies "the pressure we feel
to repair existing injuries."[63] This may or may not be so. Scarry's work
does not make explicit how exactly we might go about setting the world
right. Yet it did reopen the debate on the aesthetic of beauty and its
ethical and political potential.

Through a series of dialogues between major contemporary theorists,
The Life and Death of Images seeks to probe the relation, antithetical
or not, between aesthetics and ethics.[64] The debates explored in this
volume crucially hinge on that ember of the aesthetic and the ethic in
the image, hung precariously between life and death, between rejec-
tion and response. This book considers images, both photographs and
painting, in this light. Also coursing through the book are references
to the events of 9/11, as well as questions of ethics and the politics of
retribution in the light of the "war on terror," and more specifically, the
photographs of Abu Ghraib, whose widespread circulation and the re-
sulting global response of shock, horror, and repudiation abruptly high-
lighted the relation between photographic representation and a politics
of justice (or injustice). Throughout this volume is the question of art
and life, and its inseparable antithesis, the question of art and death.
Of particular note in this collection of reflections on images, aesthet-
ics, and ethics is W. J. T. Mitchell's reiteration that images have a life.
In his dialogue with Griselda Pollock, both emphasize the persistence
in postmodern contexts of religious iconography and point out the dan-
gers of not adequately recognizing the hold of such images that come
to life via an aesthetic.[65] Also worth noting is Jay Bernstein's argument
that sensory awareness becomes inarticulate and without meaning if

not harnessed to cognitive awareness.[66] Without such a harness, Bernstein contends, a wholeness of experience becomes impossible, as witnessed in the fractured and always partial predicament of modernity. The ethics of art thus confirms the failure of the ethical project, not its assertion. As art is expelled from everyday life, the ensuing rejection of the aesthetic denotes the alienation, and hence failure, of ethics in everyday life. The potential of the aesthetic, then, resides not only in its ability to reveal the ground of the ethical, but also its absence or lack.

Bernstein's work is important because it brings out the question of the relation between art and life, aesthetics and experience. Furthermore, it highlights the importance of harnessing the sentient to the cognitive if aesthetics is then to overlap with ethics. Yet his view is pessimistic, relating images to rupture and death. In her response to Bernstein, Judith Butler notes that one reason stated by Bernstein for the enlivening power of beauty is the fact that beauty is always set against the predominance of death. She follows his line of thought but argues for the aesthetic as that which lives on despite death, not against it: "Not all death follows from war," she states, "and not all deadening follows from representations alone. It would surely be self-defeating to require the deadening forces in order to articulate the task of art as enlivening. But perhaps it is enough to say that under these conditions of modernity, broadly defined, loss and death and what deadens are too much with us, and that to feel the painting's impression on our skin is finally to receive the tactile at the limits of the visual—a triumph for what lives on despite the odds."[67]

The same could be said about receiving the photograph's impression. Photography is both impressionistic and cognitive. By this I mean that the image interweaves the sentient with the cognitive. The photograph is at once writing, mark, and trace. It offers a space within which the sentient conjoins the cognitive, thus allowing for the articulation of ethics. Bernstein aptly points out the need to articulate ethics in terms of the cognitive. The sentient remains unvoiced if not translated into words and actions. It is through the shift to cognition that the ethical, perceived firstly by sentience, achieves pronouncement.

Photographs such as Salgado's—rich in aesthetic appeal but also deeply embedded in social contexts, addressing as they do issues that affect the lives of millions—offer a field in which sentience can shift to cognition. The photograph itself does not do anything. It does not act or alter or redress. It only opens horizons to viewers, which can lead them

out of themselves and the world as they know it to new domains of perception. In line with Butler's thought, the photograph offers the possibility of renewal in a world that would be much impoverished without the aesthetic constructed in terms of beauty. A flow occurs within the depth of the image, whereby sentient perception can be turned into cognitive perception or rational discourse. The moment of prediscursive ethical engagement via the image—that on which much of this chapter has focused—is brief and unthought. Beyond this moment, and even preceding it and surrounding it, are the explicit articulations and enactments of ethics that translate into a politics of vision and action.

At this point, it is worth noting that if Salgado's historical location is that of postmodernity, his images and the structure of his photo-narratives do not consent to that most resonantly postmodern of notions, the idea of the "end of history." This allows him to locate his images in a larger historical logic, only too apparent in so many of his major collections, such as *Workers*. One sees very clearly in his photo-essays the chain of production, exploitation, industrialization, globalization, and capital expansion. The Serra Pelada series is a case in point. In all of these images, the aesthetic sustains the ethical question put out to viewers. Yet, in these series, the subjective is inserted into a narrative of historical guise. In this sense, what Salgado achieves exceeds the limits of Levinas's theorizations, for Levinas wrote of ethics in generalized and ahistorical terms. In Salgado's case, the ethical question is secured in a historical sequence that is suggested by the thread of his photo-essays, and so also in the notion of historical specificity. The combination of images and text that is presented to viewers, the overall structure of his essays, the links between them, the juxtaposition of individuals and collectives, all combine to offer two levels of vision: that of the general and that of particular subjects in particular contexts and in particular times and places.

The larger history of our times is inflected by the all too invisible history of the particular, the oft unvoiced, the oft unseen. Through his deliberate contextualization, in particular the inclusion of texts that locate his images or inform on them, Salgado conveys a sense of the historical and the political. Critics who accuse him of doing away with particularity, and hence effacing the subject, err in not noting the contexts that are made explicit around his images, even as these also rise above the specific, in their distance from these very texts, and address the general. These two levels at which his images and essays work are

very important, because they rescue the ethical moment by proceeding on to the political. As I explore in the next chapter, for Salgado politics is not about dogma or a fixed ideology. Instead, it is the openness to debate, the effort to address and respond to quandaries.

Herein lies the link between his highly aestheticized representations and the fragile pulse of the ethical: in terms of the seen and the unseen, in terms of constructing a frame for ethics, Salgado's work offers a historical and political anchoring via photographic narrative to subjects who in fact are displaced by history, and hence from politics, as it is currently lived.

The Practice of Photography

Toward a Polity of the Planet

Sebastião and I have different roles,
but our work is complementary. We have the same vision.
LÉLIA WANICK SALGADO, in interview with the author,
Amazonas Images, Paris, December 11, 2007

AS SALGADO IS KEEN TO EMPHASIZE, the visibility and success of his photography is the result of a lifetime of collaboration between him and his wife, Lélia. No doubt it is true to say that her efforts are what sustain and direct the dissemination of his work. If her work is conjoined to his, then this relation is also very evident in their shared, not to mention hugely ambitious and successful, project of regenerating the Atlantic rainforest, a project that she conceived of and that he supports though fundraising initiatives. The Instituto Terra does impressive work in its own right. Seen in the larger contexts of the Salgados' work and lives, it gains added meaning. In the context of Salgado's photography, it is surely the translation of the beauty, the rhetoric, and the struggle of his images into pragmatic example.

The Instituto Terra is located near Salgado's hometown of Aimorés, in Minas Gerais, on and around the Bulçao Farm, which his father once owned. The long drive down from the nearest airport in Vitória, in the neighbouring state of Espírito Santo, passes through the valley of the

Doce River, the "sweet river," that flows all the way from Ouro Preto inland to the Atlantic Ocean. This river valley is also the basin of the largest steel complex in Latin America, whose flaming furnaces ignited Salgado's imagination when he travelled past them on the train as a child. It is quite obviously a terrain of slash-and-burn farming that has left the hillsides bald and empty. The sad price of ill-considered modernization is to be seen everywhere. Cattle farming, the market for timber, and the construction of a railway link between Minas Gerais and Vitória have all stripped this valley of its natural wealth. Interspersed with these dry, barren spaces are glimpses of the rich, red earth and rugged trees, heavy with dark, tea-green leaves, that are native to this part of the earth. These serve as reminders of the natural lushness of this region of the Atlantic rainforest that existed prior to the expansion of the consumer market for Brazilian meat, timber, and steel and prior to the forest fires set off by flying sparks from passing trains. They are reminders too of the plant, bird, and animal life native to the Atlantic rainforest, which once populated this part of the planet.

The Instituto Terra has four principal aims: to restore the Atlantic rainforest, to offer educational courses on the environment, to carry out related scientific research, and to promote sustainable development in the region and among local communities.[1] Since the project began in 1991, an ecosystem has been established here that resembles what used to exist. The institute has won numerous awards and the Salgados use both income from photographic work as well as Salgado's status in order to solicit financial support for this nonprofit organization. Lélia Wanick Salgado is the institute's director, closely supported by her husband in this undertaking. As with his photographic work, the project of the Instituto Terra is one on which the two of them collaborate closely. Beyond its stated aims, there is something quite significant about this institute. Its objectives have a close link to its location on and around the soil where Salgado grew up: in a sense, if photography has taken Salgado around the world, then his and Lélia's homeward focus on sustainability and replenishing the environment reveals the inner causality of their life projects. The Instituto Terra nurtures the local environment, the local ecosystem, and local forms of sustainable agriculture. In many ways, its work is a living example of the reform that his photographic work urges; it is a practical example of the work that urgently needs to be done if the displacement made evident through his photography is to be righted.

Obvious connections emerge too between *Genesis*, supposedly Salgado's last major photographic project, and the work of the Instituto Terra. Both are homages to the vitality of the planet, celebrations of natural harmony and balance than can exist with the right care. In turn, these two environmentally focused projects can be seen as new stages in a life-long focus on displacement. If Salgado is best known as a photographer of human displacement, his critique of postmodernity and globalization extends in *Genesis* to a focus on spaces, premodern peoples, and creatures. The overarching aesthetic that marks his work also links *Genesis* to his previous projects. Moreover, the stillness of many of the images of *Genesis* highlights the turmoil of displacement around the globe. The work led by the Salgados in the Instituto Terra offers practical ways of countering this displacement. Indeed, the connections between the two projects, those of *Genesis* and of the Instituto Terra, are both pragmatic and fundamental to all of Salgado's previous work, because they foreground the indivisibility of the social and the human from the environment and from nature.

This chapter argues for photography as a means of working toward a polity of the planet, as seen in and through Salgado's work. This notion of polity emerges from the coincidence of politics and poetics in Salgado's work, so that the image both represents existing divisions and fractures and also suggests alternative possibilities. Politics is what is seen and can be verified in the image; it relates to existing structures and systems. Poetics, the force of the aesthetic, is that which gestures beyond the frame of the image, suggesting always a sense of that which lies outside of articulation, that which is apprehended by the senses and lived in terms of the sensible. For Salgado, the two are crucially linked in terms of a polity that arises from and through the image, for it is the juncture of politics and poetics that allows Salgado's work to rise above the specific, the proper, without in any way losing touch with it.

There is, of course, a tension or contradiction between the ideas of politics and poetics. As the philosopher Jacques Rancière states, we have become accustomed to thinking of politics as being enacted within bounded space.[2] Poetics, in contrast, suggests slippage, porosity, migrancy. The challenge is to rethink politics in terms of movement, in this case in terms of the migrancy of the photograph. The image sustains both politics and poetics because it is framed and so bounded and yet also prone to exceeding these limits. As Rancière writes, "The paradox of the undertaking is that hauling politics onto the solid ground of knowl-

edge and courage entails a return to the isles of refoundation: it means crossing the sea once more and surrendering the shepherds' resurrected city to the whims of tides and mariners."[3] The challenge that the photograph places before us is that of rethinking politics through the open-endedness of limitless poetic space. This requires envisioning the notion of polity, a hybrid space where politics and poetics conjoin.

When arguing for this notion of polity in the context of Salgado's work, my aim is to highlight those discursive and practical paradigms that emerge from his images when viewed in relation to the texts that accompany them, the causes that they are linked to, the work done at the Instituto Terra, and the views and questions that Salgado puts to the public through what he says and writes. A starting premise for this argument, therefore, is that Salgado's images should not be judged as individual images, or even as images that fall into one particular collection, such as *Workers*. Instead, his photographic projects are all interlinked, mutually supportive, part of a larger, planetary vision. Nor, for that matter, should even this vast array of images be seen as confined to the generic frame of photography, for they too are aspects of a larger planetary preoccupation, a sense of solidarity or fellow citizenry that extends beyond the social to the natural and the global.

In the context of photography, it is more usual to focus on the politics of the image. The term *polity* is not one in frequent use. In Salgado's case, however, the term *politics* is insufficient to grasp the all-encompassing spectrum of his efforts—within which photography has its place—to argue for and help construct new modes of envisioning the planet. That which is political here is more about the construction of a new field of vision that questions the status quo and puts forward a planetary dynamic linking people, places, and creatures than it is about the reiteration of a specific ideological stance formulated in opposition to other ideological stances. To apply the term *politics* to Salgado would be too limiting, for his vision operates within a much broader horizon. This is one that exceeds the taking up of specific positions that would perpetuate the proliferation of political antagonisms. Not only is Salgado's photography linked to his numerous other life projects, it is also, as discussed in the previous chapter, the space within which viewers enter into relation with that which is other. Salgado turns the photograph into a space where community and collective belonging can be forged. This coming together happens largely because, in his work, the politics of the image meets with the poetics of the same in such a way

as to leave an imprint on the viewer's imagination. His images inevitably invoke multiple horizons, those of that which is known and that which is subtly sensed, so that viewers find themselves dislocated from engagement in the known or practised sense and experience a newness of vision. For poetics is the invention of metaphor, while politics can be said to be the reiteration and enactment of ideology. The former contributes to reviving and reformulating political discourse. The photograph allows for a new sense of place to be forged—not merely the place of the other, but, more importantly, that of the self in relation to the other. It is in this way that Salgado's work offers an example of photography in the service of a planetary polity.

Genesis is overt proof that Salgado's work is directed by ethical and political concerns, where planetary well-being is high on the agenda. While he highlights differences of species, localities, landscapes, and cultures in his images, nevertheless, there is a larger planetary context within which all these differences are housed that his images always underscore. It is also this overarching context that foregrounds movement and possibility in his work. Viewers see subjects in his images who are very different from themselves in countless ways; yet the aesthetic of the images, with its multiple allusions to that which is timeless, biblical, or in some sense "original," conveys a sense of solidarity, of communion. It follows that this reminder of a planetary polity is in itself a political act on Salgado's part. In part, we have seen this before: his support for the MST and other causes reveals an acute awareness of the disenfranchised. What is most political about Salgado, though, is his ability to convey a sense of solidarity with the other, even when that category extends to animals, birds, and other life forms: this is the reiteration of a polity of which we all form part.

In choosing the term *polity*, I turn deliberately to a concept derived from the Greek term *politeia*, etymologically and conceptually a precursor to the contemporary notion of politics. Politeia lies at the root of the related ideas of polity, politics, policy, and polis. It addresses the notion of citizenship, with its attendant obligations, rights, and recognition. For Aristotle, the term *polity* denoted an assembly of citizens who were part of the larger political processes that kept the city-states of ancient Greece alive. In translation to Latin, it denoted aspects of citizenship. Whatever the case, *polity* addresses the multitude, while also allowing for a sense of differentiation and diversity; it also offers the notion of a larger whole within which people, processes, and practices are in-

cluded. Thus *Polity* seeks to evoke both the engagement of the multitude and the multifarious nature of such engagement.

Most of all, the term *polity*, considered in the context of Salgado's photography, brings into relation, without any threat of erasure, various levels and types of difference: of the local or particular, of the social and the biological, of the human and the nonhuman. *Polity* is a term that foregrounds the importance of such diversity, as well as one that denotes the processual fluxes that accompany the continuous struggle for planetary balance and respect. Polity can only come about through awareness of the other, through a sense of fellow citizenship with that which is unlike. My aim is to address the space of the photograph as one where such citizenship becomes possible. Polity, as envisioned by Salgado, emerges only through a mode of awareness of a broad commonality between both human and nonhuman. This is a space composed of difference, of multiplicity and specificity, and yet it is also one of assembly, of coming together in an acknowledged mutuality of obligation. The concept of polity allows for an inclusion of voices, most especially of those who have been relegated to silence within other, more limited and divisive ideological structures. Also, importantly, *polity* implies a "working together," thereby emphasizing the practical and the pragmatic. Engagement at planetary level occurs in terms of the lived, the embodied, the experienced, and the sensed, as well as the thought through. To live in terms of polity is to engage fully with this idea, to implement it in a variety of ways, as Salgado does. In his case, it is to place photography at the service of such practical engagement, so that vision becomes the lynchpin between practice and imagination, the two moderating each other always.

The backdrop to Salgado's work is the global failure of such a sense of polity: all his work stems from the displacement forced on global human and nonhuman minorities by entrenched ideological structures whose success is, in fact, synonymous with the ever-increasing scattering of the displaced across the globe. Even as his work functions within the marketplace for high art, his photographs, viewed in the larger light of his lifework, question and critique the system that celebrates them. Thus, the ideology and practices of capitalism—despite the many reworkings of the notion of "community" that accompany its self-branding—contradict, through their inherent divisiveness, the notion of a polity. The idea of polity, after all, defies given or specific ideological structures. In the context of photography, and of Salgado's

work, I wish to maintain that there are numerous, supposedly different, even opposed, categories that are embraced by this term: those of the human and the nonhuman, the natural and the cultural, the urban and the rural, the migrant and the landlocked. With their unceasing emphasis on diversity, his images highlight a polity of the living, a polity of being in practice.

If, as argued in the previous chapter, Salgado's photographs ignite an ethical spark through their enhanced aesthetic, then the survival of this fragile moment of possibility must necessarily rely on the pragmatic and the practical. It requires the enactment and articulation of a politics based on vision; moreover, it requires the establishment of a visual discourse that has an import beyond that of the space of the image, or even that of the space between the viewer and the image. In this sense, it becomes clear that Salgado's photography has two aims: first, to create a space of vision via the photograph that groups diverse forms of displacement by selecting, framing, and articulating their silenced histories; and second, to forge a politics of vision that projects outward from the image and into the present and the future, whereby such displacement can be addressed through rethought modes of practice and relation between humans and their environment on the planet. Such a politics of vision—as vision, by definition, is limitless in its horizons— translates into the notion of polity.

The question of relation is paramount in understanding Salgado's photographic efforts. To this end, a reading of Salgado's photographs must be supported by the texts that accompany them when on public display, in exhibitions, and in his books, as well as by his own numerous statements on globalization.[4] Photography becomes a mode of articulation, alongside spoken and written discourses, one that strives to construct a discourse that does not solicit hegemony, where otherness is offered a platform from which to speak. As it can be said that the aesthetic plays a crucial role in securing the ethics of vision, so too is it central to the "politics" of vision. Rather than adopt a specific political position, Salgado opens a space for the aesthetic through his photographic practice. In so doing, the notion of shared experience is invoked, albeit in aestheticized ways, so as to forge relation. Indeed, the space of the aesthetic operates from within a view of shared experience, itself an aesthetic achievement of recognition and recovery. As the Latin American cultural theorist Julio Ramos observes, Salgado's photographs carry out a vitally important mission: through aesthetic

intervention, they offer a platform of visual representation to the abandoned subject whom law and the authorities have failed.[5] The sheer volume of his work and its range ensures that no image can be viewed in isolation; it is always seen as part of a larger collection. Within this breadth of his photographic canvas, each of his images figures, enlarges, and extends the horizon of what is seen to planetary dimensions. His is a project that is life long and large scale. The notion of a planetary polity figures large here, securing the displaced, lending presence to the oft unseen, so that the light of the aesthetic falls on those on the margins.

The discursive is also evident throughout Salgado's work. Strong narrative threads connect images in each of the large collections, and visual tropes recur in all of Salgado's various photographic projects—those of the individual subject, the collective, the group against the land, and so on. Together they lead to a visual language that is common to all of his work, so that a discourse, and with this a "politics," of vision emerges. The aesthetic style adopted by Salgado also offers clear stylistic markers that connect his work to a larger history of visual representation, as well as to the world itself. Indeed, and as discussed early in this book, land is an enduring preoccupation of Salgado's. It was present in *Other Americas*, in *Terra*, in *Migrations*. It is there, most keenly, in *Genesis*. The return to land—his own land—in the context of the Instituto Terra and the revitalization of this land's creative potential for the benefit of an entire region and community, indicates the consistent politics of community and conviviality for which his photography argues.

The subjects of his images are very diverse, yet they share a common situation of alienation. The encounter via the aesthetic with the other forces recognition of this shared predicament. Take, for example, this portrait of a gorilla (fig. 18). The precariousness of its existence, signalled by the inherent pathos of the image, as well as the promise and hope of its being, offers the viewer the ground for relation. Here, as in so many of Salgado's images, we see the subject looking back at us, making its presence felt though the silvery tones of Salgado's black and white, the image a visual force that requires of us a response.[6] At the very least, such a response is the awareness of the presence of the image, one that, in turn, acts as a reminder of the presence of the gorilla as subject.

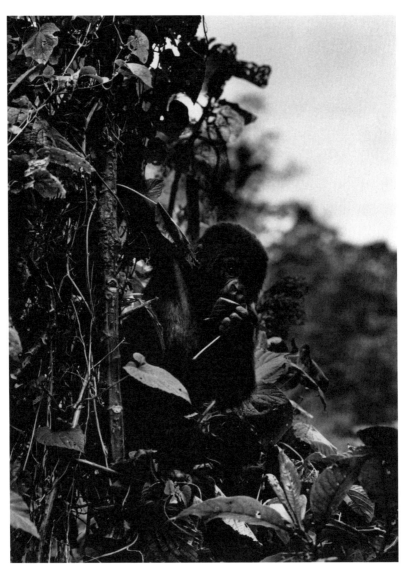

18

On Suffering, Art, and Photography

Despite what I have described thus far, the politics of Salgado's work has been open to debate. In a conference on immigration, exile, and diaspora in Latin American culture that brought together a group of Latin American intellectuals, the Argentine academic Raúl Antelo referred to Salgado's work in closed, rather trenchant, terms: the heightened aesthetic of his work means, according to Antelo, that it follows an ideology rather than a politics of art.[7] Antelo also attaches notions of melodrama and exoticism to Salgado's work, linking him thereby to a fellow Brazilian, the novelist Jorge Amado, whose focus on social issues and marginalized communities is marked by an enduring exoticism—evidence, no doubt, of his own safe distance from the subjects of his work. Antelo's reading of Salgado's work is thus narrow, taking no account of the historical and ethical potential of the aesthetic. Nor does it give weight to Salgado's deliberate and sustained construction of alternative histories through the interplay of individual and collective subjects, and also through the narrative links running across his projects. As a result, the political potential of Salgado's work, when viewed solely in terms of the aesthetic, is lost from Antelo's view.

For Antelo, the aesthetic turns Salgado's images into approximations of kitsch, the very anathema of art that is political. Antelo's position reflects the strong, perhaps even mistakenly narrow, influence of Theodor Adorno's thoughts on kitsch and the media in the age of capitalism. Moreover, Antelo also draws on Adorno's critique of stylization in art when it comes to images of suffering. As a survivor of the Holocaust, Adorno was concerned with the effects of such images. His thoughts display a clear discomfiture with the tension between an ethics of seeing and a politics of safety in images where the viewer is at no risk of entering the displacement or suffering of the subject. In his essay "Commitment," Adorno writes, "The so-called artistic rendering of the naked physical pain of those who were beaten down with rifle butts contains, however distantly, the possibility that pleasure can be squeezed from it."[8] Adorno also reflects on how images of suffering provoke a sense of guilt in the viewer who, like him, has survived after the event. At the same time, for him, they are also reminders of the fact that it is possible to go on, to rebuild life in the wake of trauma. As such, these images confirm a kind of forgetting, a distancing from the suffering they portray. At best, they offer a post-memory. He goes on to state, "When even

genocide becomes cultural property in committed literature, it becomes easier to continue complying with the culture that gave rise to the murder. One characteristic of such literature is virtually ever-present: it shows us humanity blossoming in so-called extreme situations, and in fact precisely there, and at times this becomes a dreary metaphysics that affirms the horror, which has been justified as a boundary situation, by virtue of the notion that the authenticity of the human being is manifested there."[9]

Adorno also stresses the need for stylization, as a way in which art can make sense of the chaos of suffering, but this always diminishes suffering's horror. Style contains the suffering and, as Michael Marder states in his article on Adorno's writings, "*Minima Patientia*: Reflections on the Subject of Suffering," stylization blocks and so transfigures suffering and offers it up for consumption.[10] The memory of the Holocaust frames this view of the relation to art as one where "survivors plagued by this memory and its disquietude neither live nor die but linger on in the frontier between past and present, between suffering and its expression, between ethical recalls and unethical responses."[11] In writing so of literature and art, both Adorno and Marder fail to address the dilemmas that surround photographs. Photography is only partially an art: it has a much more intimate connection to reality, placing the question of how we respond to photographs into more ambivalence—and hence possibility. While Salgado's work is categorized by some as photojournalism and by others as "art photography," there is in this juncture an opportune ambivalence. These dual, and apparently even antagonistic, labels confer on his work both the imagined ties to reality attributed to photographs in general and the visual and ethical possibilities of art that are made apparent by his style or aesthetic. Photographs always invoke more than the content of the image within the frame. In critiquing Salgado's work, Antelo speaks of it in terms of the aesthetic as kitsch that would be art, thus failing to take into account the tensions and links that resonate throughout Salgado's work: photography that works at the nexus not solely of reality and aesthetic, but also as a link in the chain of projects that Salgado has taken up. Photography has an added dimension that stems from a unique dialectic between art, reality, and imagination, housed within an inherent temporal frame of loss: the invitation to the viewer to partake. The space of photography includes those who have been excluded, involves those who would otherwise be uninvolved. Once again, the idea of polity comes to the fore.

Capturing Nature

Genesis is a reminder of the ambivalence of the image and the versatility of its many facets across contexts. Salgado's focus in this latest project on nature and natural spaces calls on a long history of visual documentation of nature and its diverse species. It brings to mind the work of the naturalists, who, since the eighteenth century and in the course of European colonial expansion, carefully created images of flora and fauna. The history of this field of biological and botanical sciences is also a history of vision. By means of observation, reproduction, and cataloguing, the naturalists mapped nature in its finer detail and, in so doing, also outlined the contours of what was perceived as different from nature — that is, the modern project of which they were a part. Through visual reproductions that inevitably bore their own aesthetic, the naturalists proved themselves to be not solely scientists, but also masters of art and experts in the use of watercolours and other materials.

Natural history rose as one of the great disciplines of modernity aimed at empowering "the civilized world." Images and paintings allowed man — predominantly Western man — to know and control nature, especially as manifested beyond the confines of Europe. Following its inception in the late Renaissance and early modern period, natural history helped to shape and clarify the project of modernity over the next few centuries.[12] Indeed, it was absolutely central to this endeavour, for modernity, by definition, implies the scientific and technological "victory" of rational man over nature, over what was deemed primitive and hence uncivilized. For this task, the naturalists were reliant on the skill of their vision. Vision and visual reproduction served a clear purpose — that of demarcating those people, creatures, and places that were the subjects of the naturalists' images from those who, in the course of scientific explorations, observed and created these images. The visual depiction of nature, its "framing," is historically aligned to the division of the Western hegemony from those on its margins, thus separating the modern world from the non-modern. Oddly enough, in subjugating art to botanical science, the naturalists often produced fine works of art, which exceeded their documentary function. Yet they also schooled vision and channelled it.

Logically, therefore, the invention of photography should have vindicated the naturalists' efforts, thanks to the supposed fidelity of photographic representation. As Salgado's images of *Genesis* reveal, however,

though resulting from it, photography turned its tail on science, casting the interrogative on man's supposed rational "victories" over alterity. What distinguishes Salgado's work from that of the naturalists is the intention that directs it. His aim is not to "capture" nature, as if it were other to ourselves or in any way subservient to mankind, but to remind us of the natural that is in us and in the world as we know it. The image points to our base realities and not vice versa. It acts a reminder of what lies on the peripheries of our tunnelled vision and begs to be noted. It presents us with the idea of polity in a bid to reposition our points of view.

For Salgado, *Genesis* is both the culmination of an abiding focus throughout the course of his career on the modernist division of nature and rationality and a return to his own early connections with land and nature. This is a return that we all must make in the modern world if we are to pull back from the precipice that looms in the face of this contemporary moment, that of the degradation of the environment and, with it, the un-sustainability of life as we know it.

Therefore, these images also set the frame for a questioning of the modern project through the unsettling proposition of nature as yet unspoilt, though most definitely vulnerable and imperilled. In this, the gesture of *Genesis* is toward the future. The photographs make us acutely aware of how corralled nature has become and force a reckoning with questions of environmental sustainability, as well as with the vital relation between people, places, and creatures. Photographic aesthetic intervenes in the course of rationality, displacing it and inviting engagement in lieu of scientific observation.

Photography and Politics

Photographs cross the Cartesian divide between reason and sentiment. The mere fact that they are reliant on technology, and are hence "lived realities," combined with the widespread presumption that photographs reproduce reality with fidelity, grounds the aesthetic of the photograph in social and political fields. This is where questions of ethics are articulated and can be engaged. Furthermore, photographs function socially in terms of association with other images, both artwork and photographs, so that it is in fact impossible to view a photograph just by itself. Photographs are always interpellations in existing discourses and modes of viewing. Thus, photographs do not function on their aesthetic

alone: they come equipped with a historical claim that relates directly to their documentary function, as well as to their artistic one. In part, this is because the camera purports to mirror reality, and, in part, this is because every photographer forges the image from his or her point of view, one that is formed within existing schemes of vision. At the same time, the camera raises sections of reality to a new level of power, over and above the ordinary and the everyday, so that the image becomes both an industrial product and a work of art. Salgado's images are exemplary of this mix. In his case, photography is conjoined to his other involvements, those that link his name to humanitarian and environmental causes. Framed by his economic awareness and social concerns, the images, individually and as collections, address planetary concerns via the local and the particular. The reception of the image is thus a hybrid experience wherein the aesthetic opens up to the viewer the possibility—one that may be taken up or not—of engaging with the ethical and of translating this encounter into the political.

There are, no doubt, numerous troubling quandaries that inflect our approach to the work of Salgado and others involved in the representation not solely of alterity per se, but of alterity that combines with suffering, alterity that has in one way or another been displaced. One crucial question that must be posed is that of how we view images that conjoin displacement and art in the wake of the crises and ruptures that characterize our historical moment.

If critical issues and events prompted the writings of Adorno, faced as he and his generation were with the rise of fascism, then a not dissimilar crisis frames photography—and writings on photography—today. Photography, especially of the kind that Salgado practices, is inextricably connected to the contexts in which it is produced, in the same way as it is linked to the photographer's point of view. In an interview I had with him, Salgado stated, "I do not think of myself as political or as an activist. What I do in all my projects is the same thing. It is all part of my life. That's what it is, my life."[13] During his interview with Amanda Hopkinson at the Barbican Centre in 2003, Salgado mentioned the fact that he and his wife had joined the multitudes that had marched that weekend in London to protest against the invasion of Iraq.[14] They no doubt saw this as an act of solidarity for a cause they believed in. By the same token, the "war on terror," unleashed in the wake of 9/11, placed new accents on the relevance of his work and the question of relation to alterity.

A similar effect results from the dawning realization by the end of the twentieth century that human relation to nature must change. This shift in attitude has become even more acute on the heels of the first decade of this new millennium, with the increasing recognition that natural resources are finite and overexploited and that, consequently, ecological imbalance, climate change, and desertification are already well under way. What is needed urgently is, first of all, an awareness of daily practices undertaken by individuals, corporations, societies, nations, and the international community that threaten sustainability and, then, action guided by an awareness of the changes that need to take place if the planet as a whole is to survive.

Genesis intervenes here in an overt way. The images of remote, oft-ignored places and life forms frame the need to think beyond the modern and the urban and underline, instead, the connectivity of life forms and places across the planet. In this way, the idea of a polity of the planet is put forward. At stake is the very notion of development in the terms in which we have been accustomed to thinking of it. Development, as we know it, has also given rise to dependency, turning progress, as it has been implemented, into a differentiating process—one that creates a class of planetary elites and a class of planetary dispossessed. In interviews, as also in his dialogue with John Berger, Salgado reiterates the point that while globalization materially enhances the lives of many, it does so at the cost of the well-being of many more. Thus, economic development as practised along capitalist models is divisive, creating ever greater differences of social class and levels of security. Among today's dispossessed, one must count the growing number of migrants forced into displacement because of environmental reasons.

As always, though, we return over and again to the ambivalence of photographic endeavour, whereby the exclusive status and market value attached to Salgado's work are at variance with much else that surrounds the images. Each photograph shifts between the exclusive and elite world of which it is part and Salgado's own inclination to offer the space of the image as one of recognition for the dispossessed. Salgado's aim, clearly, is not to oppose capitalism—in part, because the space for doing so is nonexistent in the present day. Rather, it focuses on the creation of awareness and a consciousness of the debates he deems important. He works from within the contexts of the market to channel income made by his photography into causes and projects that alter existing structures of power, working instead for the protection of

the environment and for more social equality. This is crucially impor-
tant. As a student in Brazil, Salgado was framed as a Marxist. Indeed,
he has said that he did have contact with Marxist groups in Brazil, in-
volved as he was in the opposition to the dictatorship that was then in
power.[15] Yet, he is not a revolutionary but a critic who asks questions
and raises debates. While his economic awareness clearly indicates a
critical understanding of the historical processes of capitalism, never-
theless, he is not a Marxist in the generally understood sense—and cer-
tainly not in the narrow and often derogatory ways in which this term
was used by supporters of the United States during the Cold War years
to designate Latin American revolutionaries of the Left. Instead, what
appears in and through Salgado's photographic endeavours is a return
to Marx through a focus on questions of political economy, historical
materialism, and alienation. He addresses these questions through
several central concerns: the means and effects of production; issues
of development and industrialization, with their concomitant effects,
not solely on nation-states, but also on regions and communities; the
alienation of humans from nature; the entanglement of humans in sys-
tems of production; and the effects of capitalism on humans and on the
planet as a whole. Photography is the language through which he ex-
plores these themes and creates awareness in viewers. It is also the tool
he employs in order to attempt to address, if not redress, the imbalances
of the global economic system in all their guises.

 In the words of John Berger, writing on the uses of photography, "It
is just possible that photography is the prophecy of a human memory
yet to be socially and politically achieved."[16] The politics of photogra-
phy are always poised on the fragile wing of what may just be possible.
Photography is not militancy: it works at a different level, through the
subtle, often unnoticed interventions of vision and imagination in the
everyday. "Meanwhile," Berger notes, "we live today in the world as it
is."[17] Indeed we do, and Salgado makes no claim in this sense to offer
prescribed solutions to global problems. Yet the political task of photog-
raphy is surely to offer up the space of the frame as a means of inflecting
prevailing discourses, hierarchies, and inequalities and so reinscribing
political consciousness into the everyday. Is it not through the image
of alterity that change can come about? Is not our awareness of moder-
nity made more acute by images of the precarious survival of displaced
premodern communities, such as those of the giant turtles of the Galá-
pagos Islands, the Yanomami of Brazil, or the towering dunes of the

Namib desert? Is it not through the always-open frame of the image that we envision another place, another way of being, an alternative politics of life and of the planet?

Aesthetics and Politics

Awareness can only come through photography that draws the viewer's gaze. Images that fail to impact the viewer glide before one's eyes into oblivion. The aesthetics of the image, the context in which it is seen, the visual dynamic it projects, all contribute to making it memorable. There is, hence, a very clear link between aesthetics and politics. Of course, this is a topic on which Adorno worked extensively. Both the Frankfurt school and Marxist tradition sought to secure a place for aesthetics and politics within the realm of discursive reason, thereby opening up a critique of their distortion through instrumental reason.

Rancière rethinks the relationship between art and politics through a return to the Greek notion of *polis*. In an attempt to outline a politics of democratic emancipation, Rancière distinguishes two related but contradictory terms: *police*, or organizational, normative systems or laws that divide communities into categories, groups, and roles; and *politics*, or the people or *demos* that constitute the community. Regulating the latter is what he calls "the distribution of the sensible," laws that separate and exclude, aesthetically dividing the seen from the unseen, the heard from the unheard, what can be said from what cannot.[18] *Politics*, for Rancière, is the interruption of such binaries in favour of relation based on notions of equality. When aesthetics impact on the *police*, or the distribution of the sensible, there is a disruption of the latter that affirms *politics*. Rancière states, "The aesthetic revolution rearranges the rules of the game by making two things interdependent: the blurring of the borders between the logic of facts and the logic of fictions *and* the new mode of rationality that characterizes the science of history."[19] Via aesthetic rearrangement—and Rancière refers back to Aristotle's *Poetics* as an example—deemed that divisions between categories are disrupted and "testimony and fiction come under the same regime of meaning."[20] Commenting on documentary, Rancière notes how film devoted to what is "real" can, in fact, produce more fictional invention than fiction itself. More to the point, "the real," he states, "must be fictionalized in order to be thought."[21] What this achieves is the effacement of arbitrary boundaries between two supposedly op-

posed logics, those of fact and of fiction. In this way, the models that serve to construct "the distribution of the sensible" can be rethought. The conjuncture of aesthetics and politics matters because it generates fictions that force us to materially rearrange the symbols, meanings, and relations between the said and the unsaid, the seen and the unseen, the possible and the impossible.

Although Salgado does not refer explicitly to philosophy, aesthetics, or politics, his photography shows an intuitive understanding of the role of the aesthetic in politics. The pedagogic mission of his work—to show another face of the planet, to engage the viewer in debate, to create awareness—is undoubtedly political. However, what is political about his work is precisely that he does not take sides. Instead, he presents his photographs as frames within which we can seek out our own reflections by looking at what is other. At work here is the overlap of aesthetics and politics, so that we are led to envision an aesthetic rearrangement of the ideological structures with which we—wittingly or unwittingly—approached the image. What is more, his images intervene in several ideological spaces, always opening up alternate discourses.

In his commentary on Rancière's work, Slavoj Žižek explains that political struggle is not so much rational debate, as it is the inclusion in the polity of those who have been excluded.[22] "The part with no part" unsettles the social order of things. A tension always exists, therefore, between *police*, that which has become established, and *politics*, the turmoil of the unrepresented. The assertion of *politics* is expressed via aesthetics, and thus art becomes inseparable from politics. Although Rancière wrote at length on cinema, and not on photography, his focus on the visual relates his argument directly to Salgado's work. His statements on documentary and fiction are also relevant. Contrary to the assertions made by critics of Salgado's work, such as Ingrid Sischy or Raúl Antelo, it is precisely the aesthetic dimension of Salgado's work—more so than the texts that accompany his images, or his own statements in interviews—that houses the politics of his photography. The two are inseparable.

Con-textualizing the Image

As Salgado has remarked, "Photographs by themselves do not do much, but when you put them next to words, projects, and ideas, they become

so powerful."[23] This sentiment is corroborated by Salgado's many collaborations with organizations that are spurred by a range of causes. Linked to Médecins Sans Frontières, his photographs of the Sahel helped to publicize the plight of the starving in that region. *Terra* not only offers a platform for representation for the landless, but also feeds income back to the MST through Salgado's donations of revenues from this collection. His more commercial link with Illy coffee advocates sustainable development as much as it does the product itself. *Genesis* supposedly aims to show the world as it is in places that modern viewers seldom frequent—or the world as it might have been had we not disturbed it so. Of course, the entire planet has been affected in one way or another by modernization, and it is entirely debatable whether "pristine" spaces do still exist. What matters, in fact, is the imagination of that which was or is pristine through the image. What is also important to note is that Salgado's work does not espouse an overt politics of any sort. It is not linked to a clear-cut political position or to any party in particular.

While his images are rhetorical in their aesthetic, the impulse behind them is not. There is no dogma to be found. On the contrary: a clarity and simplicity of polity direct his work, whereby sustainability, health, well-being, and regeneration are emphasized. If there were an ideology that could be attributed to him, it would be one of respect for the living—one that includes people and places, flora and fauna. What is more, his view pinpoints the connectedness between these supposedly separate categories, as his images become the spaces from which a sense of polity can be drawn.

This synthetic quality is evident, for example, in *L'homme et l'eau*, a collection of images by Salgado put together by Terre Bleue, a French photographic media company that organizes exhibitions and edits books of photography. This collection was first displayed in an open-air exhibition in Paris and subsequently was made into a book of the same title. The images, selected by Salgado from his numerous existing photo-essays, all show the closeness between humans and water in its diverse forms.[24] Those who know his major photo-essays will recognize images from *Other Americas*, *Sahel*, *Migrations*, and others. The images portray water in its many uses, always as a quasi-magical and life-renewing resource, without which humankind cannot exist. The aesthetic of the images depends largely on the play of light on water. From the deepest black of the sea at night to the white foam of spray,

from the dynamic of a waterfall to the churning rage of an ocean in storm, from the stillness of a reservoir to the sweetness of a spring in the woods, water in its many manifestations feeds life, be this of plant, beast, or human. The book is a visual hymn to water, and by extension to nature and to humans as natural beings. As Salgado states in his essay accompanying the book, his aim is to disprove the modern premise that people are somehow separate from nature.[25]

Indeed, this collection of images serves to showcase the direction toward ecological concerns that Salgado has taken in his work. Nature, he states, is now at the centre of his concerns as a photographer.[26] Long years of focusing on humankind have led him to consider the human's place in the larger scheme of ecological balance.[27] Furthermore, this focus on nature and ecology, Salgado argues, puts another slant on the meaning of development: "You cannot have ecology without education, education without health, health without hygiene, hygiene without clean, safe water, water without forests."[28] Thus, development and progress are seen in terms of a balance between natural and social needs, in contrast to more prevalent, capital-centred understandings of these concepts. Such a view places the human in nature, as opposed to considering nature as subservient to the human. Salgado's aim is clearly to alter the established view of humankind as superior and separate from nature. While such a view revolves around people's ability to use rationality, nevertheless, this faculty fails when it does not reckon with the human as a being in nature. By focusing on this, Salgado works to shift both view and vision with regard to what constitutes progress.

In the course of Salgado's career as a photographer, the Salgados as a team have increasingly explored the power of the written word to ground the image. *Other Americas* was critiqued for its lack of captions, but over the years and across several books, Lélia Wanick Salgado has tried several methods of including context—in a separate booklet (inside *Migrations*), alongside images, set apart from them, and more. So too have the Salgados sought interventions from chosen writers, such as José Saramago and Mia Couto, writers and artists who represent the disenfranchised. More recently, in *Genesis*, Salgado's own voice can be heard, his excitement at encountering little-known people and places palpable in his words. Of relevance here is his oft-repeated statement that he does not "take" a picture: "Photography is a great pleasure for me. People give the picture. They see an integration between the camera and the photographer and they give the picture to you."[29]

This perceived integration of subject, camera, and photographer extends to the writers whose words Salgado has chosen to support his images. There is a keen like-mindedness between Salgado, Saramago, Couto, and his other collaborators. For the reader-viewer of his books, text weaves its way into images, and vice versa. Moreover, a commonality of vision turns the photograph into shelter for all who need it, into a polity for those in whose name it is constructed. To quote Mia Couto in his introduction to Salgado's *Africa*: "[Salgado] was more visited than visitor. He was visited by the spirits which evoke the dual banks of the river on which we travel, the borders of the photo and the word, the light of the spark and the shade of the tear. The twofold modes of a continent shaping and reshaping itself into a house which is not just for Africans but is the home and cradle of all humanity."[30] What Couto states of Africa holds true for the rest of the planet as well. Salgado is not alone in being visited: his images and Couto's words— or, indeed, the many texts that often accompany his photographs—are spirits too that visit those who engage with them. The visual narrative of the planet that Salgado's photographic course sustains would not be possible without the rope-like mooring of image to text.

Connections

> For me, it is very hard to dissociate things. I do not consider any part
> of my work to be more important. All my projects are a part of my life.
> SEBASTIÃO SALGADO, in interview with the author,
> Amazonas Images, Paris, December 11, 2007

Salgado's work suggests that the world must be seen in terms of connections. It is notable, however, that when interviewed on the subject of global inequalities, Salgado, like John Berger, identifies the problem in terms of globalization, as opposed to global connection. This is made clear by his many statements on globalization, whereby he highlights the hierarchies, inequalities, and divisions wrought by globalization, not to mention the uprooting of communities. Alternative ways of envisioning connection across this planet are made possible by his photography. Through his images, he emphasizes the need to see relation and connection across difference, thus always presenting photography as a mode of encounter. It is not sameness that Salgado champions, but respect for difference and a readiness to prioritize regard between people

and things. *Migrations* focuses on collectives, as does *Terra* and *Genesis*. Often these collectives are framed by the landscape that they traverse, both part of it and against it. Within them are individual subjects, each unique and different. The images of *The Children* bring this point most poignantly to the fore: often the poses are similar, the angle of the camera versus the subject the same, but each child is different, unique unto himself or herself.

This emphasis on diversity within connection is not unique to Salgado, but it is something that is quite distinct from individualism as valued in the West. Instead, it is an element that can be found in many — often non-Western — philosophies in which individualism, and hence the divisions formed by creating categories, is less valued. Take, for example, the work of the political philosopher Kwame Anthony Appiah. In his *Cosmopolitanism: Ethics in a World of Strangers*, Appiah, himself part-Ghanaian by birth, returns to pre-Cartesian modes of thought whereby divisions of self and other can be overcome. Appiah uncovers the imaginary nature of the boundaries that map the world as many of us see it, arguing instead for ways of redrawing the world in terms of a *polis* of the *cosmos* — a polity of the world. This remapping, for Appiah, is a way of returning kindness to strangers. He writes, "Faced with impossible demands, we are likely to throw up our hands in horror. But the obligations we have are not monstrous or unreasonable. They do not require us to abandon our own lives. They entail . . . clearheadedness, not heroism. Jeffrey Sachs has argued that in twenty years, at a cost of about $150 billion a year, we can eradicate extreme poverty — the poverty that kills people and empties lives of meaning."[31] Appiah argues for a cosmopolitanism that guarantees difference and diversity. Across such difference and underlying it, he reiterates a commonality of the human that should, in his view, override difference and foreground connection. The richness of potential in cosmopolitanism as a philosophy lies in the recognition of both difference and commonality. "Cosmopolitans," he explains, "think human variety matters because people are entitled to the options they need to shape their lives in partnership with others."[32]

Appiah's book is especially notable because it was written in 2006, at a time of deep global divisions, of violent antagonisms between the West and its Islamic other, and of unrelenting "wars on terror," with their concomitant disrespect for human rights and the destruction of civilian lives. His simple, nearly childlike, but eloquent prose puts for-

ward a view of world politics that is almost obvious—but that is also clearly disregarded by current practice. And it contrasts with the angry discourse of the war on terror. At a time when the stranger was ever more a figure of dread and suspicion, Appiah put forward the notion that we have a lot in common with him or her.

Works such as this allow for ethics to be articulated, and so to be turned through such enunciation into politics. In the same way as Appiah forges discursive ground for the figure of the stranger as other, so Salgado's photographic projects have, over the decades, helped enormously to construct alternative ways of seeing the other. The global divisions of which Appiah writes are formed on the same axes of inequalities and violence that segregate and alienate the displaced subjects of Salgado's images. In many ways, the visions of commonality that their respective works foreground coincide with one another.

Articulating Loss

In tandem with its effort to forge connections, Salgado's work responds to growing social, economic, and political difference and loss. The narratives that ensue from his work all express concern with the cost of globalization, as a global minority benefits from a process that displaces a global majority. If the larger canvas against which Salgado's work must be seen is this age of globalization and late modernity, then there is also something in his work that harks back to premodern times, when unities of time and space prevailed. The mark of the aesthetic in his work speaks eloquently of premodern, even religious, art. Of all his projects, *Genesis* most clearly exemplifies this effort to revisit premodern spaces, creatures, and communities as a way of recalling the harmony and natural balance that has been lost through humans' narrow and insistent focus on capital and technological expansion. *Genesis* is as much about such loss as it is about harmony—the loss of ecological balance, the destruction of the environment, and the extinction of numerous creatures as a result of human-centred practices. This loss is not so much a form of nostalgia as it is a grief that is at the core of a politics that struggles to secure the future in the face of the odds of the present.

At work here is a global panorama that extends beyond a focus on people alone. Of course, until *Genesis*, Salgado was often thought of as a photographer of people. More to the point, Salgado's work has often been linked, however much in passing, with that other well-known at-

tempt to knit humanity together via photography: Edward Steichen's photographic exhibition *The Family of Man*, held in New York in 1955. At the time, this collection of images was seen as a wonderful celebration of human commonality. In hindsight, however, several theorists point to the sense of loss that lay at its heart, in its implication that mankind needed to be celebrated if only to ensure survival after loss. As, for example, Abigail Solomon-Godeau points out, grief at the losses of the Second World War lies at the heart of *The Family of Man*.[33] Rather than seeing the exhibition as a triumphant gesture that celebrates postwar humanism, Solomon-Godeau views it as a symbol of postwar trauma. In it, religion and the patriarchal family are recurrent tropes that seek not so much to celebrate what exists, but rather to construct a kind of vision that may help overcome the losses that have been suffered through adherence and enhancement of postwar politics. Viewed again in the strife-ridden global contexts following 9/11, *The Family of Man* appears to Solomon-Godeau as a photographic discourse that reaffirms the ideological models of the mid-1950s, when the world was divided by the Cold War—with the addition that there is in the current context a heightened reiteration of this ideology. This all-American brand of humanism echoes to a large extent the capitalist bent of American society. Thus, even if *The Family of Man* purported to be global in its scope, it was, in fact, a vision of the global family as seen through an American lens.

Something of the same quality applies to Salgado's work: it too stems from loss. However, Salgado positions his work not in tandem with but in contrast to the dominant ideological trends of the present. It questions the depletion of natural resources, such as petroleum, it bemoans the displacement that accompanies modernity, and it counters the ever-escalating mechanisms of production that disregard the imbalances that they cause. As the Latin American cultural critic Julio Ramos points out, Salgado's opposition to digital photography is itself a sign of resistance to the increasing monopoly of the technological.[34] Film and chemical photography remain as vestiges of craftsmanship in times when capital and technology increasingly gain a hold on the medium of photography. Salgado's work remains as defiant evidence of a dying breed of photographic practice, one no longer espoused by the majority. Salgado has expressed his concern that the rapid spread of digital photography marks the demise, in particular, of black and white as a mode of photodocumentary.[35] With it go the skills needed to be a

black-and-white photographer, those of managing questions of density and exposure. Speaking of the 645 medium-format film that he uses for *Genesis*, Salgado expresses the concern that within the eight years he has given himself to complete this project, this film might cease to be available.[36] In purely technical terms alone, therefore, his work must be read against the idea of loss.

Loss prevails as an undercurrent in his work in other ways too: his focus is on what remains often unarticulated and unacknowledged by hegemonic discourses. And so, his photography offers a visual language to that which is denied a discourse. The language of loss is most keenly visible in *Genesis*. Salgado describes with his usual precision that while 46 percent of the planet remains relatively pristine and untouched by "civilization," the larger portion has been destroyed by mankind.[37] Indeed, when one considers the world as an interconnected ecological system, nowhere does it remain untouched in some way, and the signs of degradation are evident in one form or another everywhere. There is a larger global context, one of the world as it is post-9/11, that frames this project.

However, *Genesis* carries an ideology that runs counter to that of *The Family of Man*. This project is not about a reiteration of dominant hegemonies, but about a counter-response to them. As with all of Salgado's work, it singles out the peripheral, the dying, the endangered, the precarious, the minority. It frames it, it aestheticizes it, and it endows it with the rhetorical power—one formed in the hybrid counter-language of the Brazilian baroque—to pose a question. Indeed, the very kind of polity that Salgado's work invokes is forged in the guise of the baroque: mosaic-like and fluctuating, this polity is a hybrid space where differentiation and inclusion merge and are mutually supportive. Salgado's work both offers the vision of such polity and draws attention to its lack. There is loss in *Genesis*, and, even more so, the threat of impending loss. Every single one of the often-idyllic images—the gembok atop a dune of sand, the whale in the water, the Dinka among their cattle—represents the peripheral. In a global context of unchallenged, capital-centred enterprise, that which is borderline is not solely excluded or marginalized—because it is marginalized, it is also the focus of impending consumption. Capital has a way of growing by engulfing its own borders, only to spawn new margins. The last margin must surely be the dregs that are left of the riches of this earth. In Salgado's description of the Dinka, the mention of Kalashnikovs among them hints at what lies

around them, that larger global context of conflict and consumerism in which their own situation is locked. The images of *Genesis* speak thus of loss that exists and also of loss that is impending. The harmony of these places and creatures can be—in fact, most probably will be—shattered any day now. At the heart of *Genesis* lies the reckoning that mankind through its machinations has ensured that there will be no family of man: there is, indeed, a grief at the core of *Genesis*, but it is one that questions the very ideologies that emanate from *The Family of Man*. *Genesis* mourns too a family of the planet, whereby the earth would not be a resource for production, but a place of shelter to be respected by and for all, the human and the nonhuman alike.

Genesis, by this token, is not so much about vision as it is about humankind's collective loss of vision. Of course, the two are entwined. In the same way as photographs complicate temporal separations, so that the past and the future become entangled in them, so too do loss and possibility create the same complications. In the magical flip of photography, somewhere between black and white, we glimpse the translucent shimmer of time as that which would have been translates itself temporally into what could possibly be. In the contradictory language of photography, loss and possibility become entwined.

The Human Animal

> All my life I have been photographing just one animal:
> the human animal. I made the decision to photograph the others.
> To bring the others inside . . . because the behaviour of a crocodile
> is not so different from our own.
> SEBASTIÃO SALGADO, in *Sebastião Salgado:*
> *The Photographer As Activist*, film (2005)

While flicking through the pages of the supplement to a weekend edition of the *Guardian*, a large black-and-white photograph catches my eye.[38] It shows what at first seems just like a human hand, the nails almost immaculately manicured, the fingers outstretched; only the skin appears snake-like, crisscrossed, not quite right for a human. This image of the paw of a marine iguana, one of the last remaining saurians on earth, jolts the viewer into the realization that a curious resemblance may exist between the long-extinct dinosaurs and us humans. At the same time, the text that accompanies the image foregrounds a

major difference between these creatures and us: "The marine iguanas are very gentle and delicate in their behaviour, incapable of any aggression toward other animals. On the contrary, they even let others, like birds or lava lizards, climb on their back. They mingle easily with the cormorants, the sea lions, the fur seals, the pelicans, the boobies and others. When the birds are nervous they pick on the iguanas, who do not fight back. The young sea lions mock them and play at pulling the iguanas' tails, especially while they are swimming. But the marine iguanas just let it go."

This photograph is an image from Salgado's *Genesis*. Like the title of the project itself, there is something almost biblical here—have we not been told that the meek shall inherit the earth? Yet these creatures are on their way to extinction. The earth is too violent a place for them. This paradox is evident in my surprise at how like a human hand this creature's paw is. Has the violence of our ways led us to forget how alike we are, in fact, to the gentle iguana? How vulnerable are we to the very perils that endanger it?

If there is anything revolutionary in Salgado's work, it is the fact that his lens should shift so smoothly from focusing on the human to the nonhuman. With precisely the same visual vocabulary—that of the subject who looks back, the subject who rests on the road, the subject who moves in a collective, the subject etched against a vast sky, the subject caught in the drama of chiaroscuro, the subject devoid of land, the subject alienated in chains of production, the subject who is on the move, the subject under threat, and the subject that seeks a response—Salgado frames human and nonhuman alike. He also employs the same stylistic discourse—the shifting tonality of black and white, the same compositions, the same theatricality of individual and collective subjects, the same silver light—regardless of his subject. Simply by making this move with no explanation, apology, or excuse, he brackets all that is in this planet in like fashion. In so doing, he quietly transgresses one of the most basic tenets of modernity: namely, that man must be set apart from beast. This transgression is also a challenge to established norms of thought. Most of all, it is a challenge to how we view both ourselves and the world.

With it comes the realization that another conception of man and beast may be possible. Jacques Derrida called attention to this divide through his coining of the term *animots*.[39] He points to the fact that by the mere unified term *animal*, we have come to designate all that we

consider nonhuman—and thereby to designate ourselves. This solitary word also obliterates the vast differences that exist among nonhumans, its persistent usage thus indicating the blindness of the human as regards its others. *Animal* is thus a term that bears an inherent weight of philosophical logocentrism, indicative of a position of mastery over the world that man assigns himself. An understanding of the connotations of this word does much more than bring to light the diversity that rightly belongs to the nonhuman, or seek to restore to the nonhuman a degree of recognition. It further poses a challenge to the notion of what is proper, or one's own: in other words, it challenges set notions of the self. Over and again, in *Genesis*, we come across this challenge. The nonhuman nature of many of the subjects turns the ethical question of epistemic uncertainties, as discussed in the previous chapter, into overt political challenge, as the transposition of Salgado's visual discourse onto nonhuman subjects confers on them the same rights to be seen and heard as humans claim. Derrida explains, "Men would be first and foremost those living creatures who have given themselves the word that enables them to speak of the animal with a single voice and to designate it as the single being that remains without a response, without a word with which to respond."[40] By visually bracketing together humans and other living creatures, Salgado achieves two things: first, he highlights the arbitrariness of human-centred divisions that alienate and undermine, as well as undervalue, the nonhuman; second, by bringing all creatures together in one frame, Salgado enables the alienation of the nonhuman to reveal itself as also a form of self-alienation, one that the human has ultimately imposed on himself.

The naturalist David Attenborough points out the fact that there are distinct biblical origins to the notion that humankind is somehow superior to other beings on earth. What is more, he puts the blame squarely on the Book of Genesis, in which God tells man: "Be fruitful and multiply, and fill the earth and subdue it; and have dominion over the fish of the sea, and over the birds of the air, and over every living thing that moves upon the earth."[41] While this may be a matter of interpretation (many Christians will argue that God put man in a position of responsibility on earth, which entails leadership, again putting the accent on the human), there is no doubt that the major processes of modernity—industrialization and globalization—have taken their toll on the planet. They have also fundamentally altered out relation to animals.

John Berger takes this notion of alienation of the animal and historicizes it in terms of modernity and capitalism. In his "Why Look at Animals?" he traces the shifts in man's perceptions of animals from the premodern—where animals were at once mythical, magical, endowed with powers, tameable, and alimentary—to the modern, where animals are tied to the productive and the economic, or else cease to be relevant. Instead, they are at best fetishized as household pets, as objects of the gaze in zoos, as soft toys, or as figures that construct the epitome of capitalism as evidenced by Walt Disney. In any of these cases, not only are animals deprived of their diversity, nor are they just turned into adjuncts to the human and so severed from their natural habitats, but they are also denied recognition of their very nature and their being. The effacement of the animal is best noted in zoos, where animals cease to look back at the public who pay to stare at them. A central aspect of the natural relation between the human and nonhumans as experienced in the wild is the look, one that is fleeting but intense. Prior to the nineteenth century, Berger states, "Animals constituted the first circle of what surrounded man. Perhaps that already suggested too great a distance. They were with man at the centre of his world."[42] Since the nineteenth century, in tandem with the expansion of capitalism, the marginalization of the animal has become complete. Creatures who had real and metaphoric relations to man—as companions, food, religious symbols, purveyors of myth—now suffer physical and cultural marginalization. Yet Charles Darwin's theory of evolution, according to which the human has descended from the animal but is now distinct from it, led such alienation to have inevitable repercussions for man. Perhaps the first serious rupture that occurred in nature was the splitting of human from animal, so that the social and the cultural became reminders of fracture. To lose touch with the animal is, in a sense, to lose touch with what is natural to the self. Bereft of the company of the animal, its presence as part of life, and not adjunct to life, the human isolates himself in egocentrism that fails to see beyond the self. Lost is the look between the human and the animal, a look that had been part of human existence until the expansion of capital and one that is now irredeemable.

The loss of the look marks also the loss of ethical possibility. In the face of this loss, Salgado's photographs of wildlife mediate between modern humans and the creatures on the peripheries of the modern world in a bid to recapture, if not the relation that has been lost, then

at least its memory. In his many descriptions of his travels around the globe in order to carry out *Genesis*, Salgado speaks with repeated excitement of his discoveries of little-known creatures in their natural habitats. There is wonder in his tone, a sense of wonder that has been lost to most of modernity, and one that he seeks to convey through his work. The politics of his photography is precisely this: to decenter the modern viewer, and the large machinery of modern sophistication that engulfs and beclouds him or her, so that a sense of wonder may return; so that the look, and with it the relation, that has been lost between man and his fellow creatures may be briefly glimpsed via the image. Of course, there is a paradox here. To look at nature through human intervention via photographic technology—or photographic art, for that matter— seemingly affirms the supremacy of the human over the nonhuman. Equally, it stresses the urgency of such intervention.[43] In his effort, Salgado confirms the fact that in the midst of so much technology, and, ironically, through a medium born of technology, still photographs offer the last remaining spaces where wonderment can be experienced.

Spaces of Wonder

Salgado's venture in *Genesis* has often been compared to the photography of explorers in the early decades of the twentieth century. When Robert Falcon Scott, the British explorer, made his arduous voyages to the Antarctica during that period, he and his teams took with them a tripod and a camera. Scott's aim had been to be the first man to set foot in Antarctica, but though he did reach it on his second attempt, he was defeated in his goal by a Norwegian team that had arrived a month earlier. The photographs of Scott on his voyage and in Antarctica suggest the role of photography as exploration, as well as documentary. The camera was part of Scott's exploratory ventures. It confirms to us the trials of Scott as our imagination of Antarctica becomes inextricable from our imagination of him as a man—who would not be moved by the diary he struggled to keep updated as he lay frostbitten and dying there?—and as an explorer.[44] The images serve to reinforce the "conquest" by man of this remote tip of the earth. The purpose behind Scott's exploration, as with earlier instances of exploration, was to lay the imprint of not merely the human, but more specifically, Western man on this outlying region.

In 2005, Salgado sailed to the Antarctic Peninsula. His aim, though,

was different from Scott's; it was to step across the chaotic boundaries of modernity in a bid to explore the effects of the latter on these pristine spaces. Of the voyage, he states, "I had gone on to the deck, and I thought I was going to be sick. Then I saw the light and it was so unbelievably beautiful, I forgot about the sickness and got my cameras. Oh boy! The sky is so dramatic, so beautiful, illuminated in front of you."[45] From that trip, Salgado has brought back, among other works, a series of images of penguins on the flank of icebergs. They are striking, of course, because of the exceptional location, and also because the formation of the penguins amazingly replicates the formation of miners on the vertical flanks of the Serra Pelada. Once again, as with the image of the iguana's paw, a curious similarity arises between his images of creatures and men.

What is also curious is the statement made by Salgado that the light was beautiful in Antarctica. The light in his images is beautiful in the same way. In unexpected reversal, the chemically induced light of his photographs, fabricated in the dark room and through man-made processes, is one that is absent from our mechanized, metropolitan, homocentric world, but one that exists in those outlying spaces yet to be seriously touched by man and modernity. In this sense, his images act as imaginations, as well as representations, of realities that lie outside of the lived experience of most of his viewers. In the same way as those who leave the city for the countryside, where the air is fresh, notice what they had not noticed before—namely, the smell of pollution—so it is that throughout the course of his career, the viewers of Salgado's photography have come to recognize a tonality of light that is not in their midsts, but that does exist elsewhere in time and space.

The foregrounding of wonderment in *Genesis* places a distinct political accent on Salgado's work. Wonderment is about the will to look, the eagerness to see that which is other. Wonderment is also about travel, understood in its fullest sense as the letting go of the known and the act of stepping into the unknown. Wonderment is the politics of alterity, the refusal of unifying and alienating terms, such as *animal*, and an openness to seeking out difference. In a bid to stress this same point, the philosopher John Sallis writes on the evocative forces of nature, describing the power of the elemental over man as a kind of "translation into foreign frames."[46] Translation must be understood here in its most pared-down sense—that of literally crossing over to the other side. At the heart of Sallis's phrase lies that most politically fraught of notions,

that of border crossing: the border here is the limit of the epistemic evinced in the notion that mankind is somehow at the centre of this planet. Sallis focuses on several dramatic and beautiful places, yet his book presents them as enigmatic, shifting always between the sensible and the intelligible, constructed by and through the tensions in this opposition, formed through intuition, and evocative of vision: "places that can become scenes of a gathering of sense."[47] Sallis asserts that to focus so on place is also to focus on words and visions, to focus on that which is "held in abeyance."[48] Two parallel currents run through Sallis's work, which he refers to in mythological terms as Thaumas and Electra: wonder and shining.

Wonder and shining also course through Salgado's entire photographic work. They are found in the tonality of his aesthetic, the descent and swell of cloud-like white to ink-like black. The image as topography offers a frame in which to oscillate between the sensible and the intelligible; in entering this frame, a politics of self-translation comes into effect. It is spurred by the look of the startled creature in the wild, as it slips in and out of view, at the edge of the frame, on the horizon of vision. Sallis observes that "nature resists categories derived from human fabrication."[49] Instead, it presents us the world in the richness of its diversity and community.

Needless to say, such a politics, when put into practice, requires a refiguring of the self, and thus of the self's place in relation to other people and places. To quote the Chinese-born geographer Yi-Fu Tuan, "Topophilia is the affective bond between people and place . . . diffuse as concept, vivid and concrete as personal experience."[50] Topophilia can only be understood through experience, not abstractions. Likewise, if photography as a symbolic system of visual codes is an abstraction, it too can only be understood in terms of the practices and performances that ground it. Tuan reflects on the aesthetics of environment in his book *Topophilia*, exploring the ways in which people both define place and are defined by it. He underlines how attitudes and perceptions frame how we view ourselves and where we are, as well as how we view others. The aesthetics of place is inextricably linked to a politics of place, as the aesthetics of the photograph is also linked to a politics of the photograph. Much of Yi-Fu Tuan's work is a protest against homocentrism, in terms of how we humans approach, inhabit, shape, and influence the earth. Writing copiously, Tuan turns to the abstraction of language, as Salgado does to the abstraction of photography,

to retain and argue for engagement with symbolic landscapes seen in images of other places, nature as it is lived, an aesthetics of geography in which mankind is only part of the picture, and environmental politics whereby diversity and ecological balance are prioritized. Veering between *topos* and *photos*, or place and light, both Tuan and Salgado posit another planetary geography that must be argued for.

Perceiving the Planet

> We are living in a moment where we have broken the equilibrium with the planet. We are not paying attention to our intuitive side. We only pay attention to our reason. We have become an urban animal.
> SEBASTIÃO SALGADO, in *Sebastião Salgado: The Photographer As Activist*

The trek toward becoming urban has been long in the making. Obsessed with conquest, power, and wealth, mankind has predicated its notions of civilization on the creation of divisions and hierarchies. This is so particularly in the Western world, long established as the most "civilized" and modern parts of the planet—in contrast, of course, to the global south and to premodern parts of the globe, where the incomplete and fractured course of modernity continues to be most in evidence. As the Polish travel writer Ryszard Kapuscinski notes, the establishment of Western civilization can be linked to a crisis in interpersonal relations with those deemed as other.[51] For precisely this reason, the question of alterity is ever more urgent today, as large-scale processes such as globalization form ever-deeper divisions among people and places, while connecting and fostering a global elite.

One aspect of this phenomenon is the post-Enlightenment focus on reason as the path to knowledge. Unlike the culture of ancient Greece, or most non-European cultures prior to their contact and imbrication with modernity, this prioritization of reason creates divisions in how we perceive the world and, indeed, ourselves. Perception itself suffers as a result, through the arrogance of believing that only what is known through reason matters. Instinct, intuition, bodily sense, and feeling are thus sidelined. The production of alterity in modernity penetrates into the recesses of subjectivity and manifests itself both in the mapping of the world around us and in the mapping of the self. At work here is a politics whereby alterity, as that which is other or different, as well

as that which is deemed other, is both generated and undermined. By consequence, the very idea of polity, understood in a holistic sense to include the excluded, comes under fire when reason prevails over and above sentience and is somehow deemed separate from it.

The work of Maurice Merleau-Ponty is largely devoted to challenging these Cartesian divisions. In the course of his seven lectures on "the world of perception" (published in a collection of the same name), Merleau-Ponty argues for a view of the human as inhabiting a body, which in turn inhabits space and cohabits with other people and animals. "The experience of chaos prompts us to see rationalism in historical perspective," he explains, "to seek a philosophy which explains the upsurge of reason in a world not of its making."[52] Through reference to visual aesthetic—mainly painting—Merleau-Ponty sets out to rediscover the forgotten world of perception and to examine its relationship with reason-based modes of thought. Over and again, he reiterates that the self is housed in a body, and so is in some sense a natural self. By reconnecting with the body, and with the world through the body, we rediscover ourselves.

This rediscovery involves awakening to numerous dimensions of perception: those of space, of sensory objects, of animals, of humans we see as others, of art. While our perspectives are always limited, consciousness of bodily perceptions allows for a more holistic connection with the world. Writing of space and our movements through it, Merleau-Ponty states, "Instead of a world in which the distinction between identity and change is clearly defined, with each being attributed to a different principle, we have a world in which objects cannot be considered to be entirely self-identical, one in which it seems as though form and content are mixed, the boundary between them blurred."[53] In discussing spatiality, Merleau-Ponty refers to the painting of Paul Cézanne, stating that nature can be apprehended through art, contrary to established demarcations that separate representation from reality. This view is crucial to understanding how Salgado's *Genesis* works to construct spatial configurations in the viewer's imagination, whereby the space of the self extends to include that of the nonhuman other whose presence is sensed through the eyes. Like traditional forms of art, photography impacts on perception, challenging boundaries of reason and calling on the senses as well as on reason: as Merleau-Ponty declares, "Rather than a mind *and* a body, man is a mind *with* a body."[54]

Perception, therefore, is reliant on how the body responds to ma-

terial or sensory objects, the photograph being one such thing. Visuality, as Merleau-Ponty demonstrates, offers routes for connection via the imagination, and visual art plays a crucial role in forging such connections. To imagine polity is to expand the horizons of vision of what is perceived. Sensory objects allow for an exploration of perception, this being particularly so in the case of animal life. Alterity, in its various guises, is the ground on which we explore and extend perception. This requires of us a certain transfiguration, as we cease limiting ourselves to pure reason that seeks to master that which stands before it: instead, we enter into ambiguity, as we lay ourselves open to various types of perception—that of the intellect, as well as that which comes to us via the senses and the heart—to catch a glimpse of the fleeting other. Merleau-Ponty observes, "Yet we are not alone in this transfigured world. In fact, this world is not just open to other human beings but also to animals, children, primitive peoples and madmen who dwell in it after their own fashion; they too coexist in this world."[55]

This openness to the other underscores the question of whether the self is ever fully formed. The figure of the other marks the spaces of perception that we have yet to enter. Merleau-Ponty makes the point that Cartesian assumptions of mastery over nature are thus fundamentally flawed, incomplete in their assessment of the rational—and yet sentient—subject. He reiterates the need to turn to art in order to achieve a post-Cartesian re-encounter with the alterity that resides in nature. "The world," he states, "has not been preordained to accommodate our attempts to think and act upon it."[56] The world is constituted of diversity that needs to be apprehended in a suitably diverse manner. The limitations on our perceptions also come to light when we contemplate animals. It is impossible to grasp the originality of nonhuman worlds or the means by which nonhumans map the world. All we can do is be open to the perception that comes to us through diverse means when we engage with the other that is both human and nonhuman.

In Diversity's Name

The argument for diversity has never been as strong before as it is now. As climate change, environmental imbalance, human and nonhuman displacement, and desertification become major issues of the twenty-first century, the arguments for perception—and with it new and different forms of thought—become more pressing. Merleau-Ponty was

ahead of his times in his arguments, which centre on theorizations based on the body and art. Today, his thinking is relevant in terms of the environmental imbalances and conflicts faced by the planet.

The documentary film *An Inconvenient Truth*, in focusing on Al Gore's environmental concerns and work did much, among other cultural texts, to bring home to many a sense of crisis around the issue of global warming.[57] The response of nature to manmade disharmony appears as a resurgence of the natural in the face of long-term abuse. The environmental crisis that is under way explodes the long-held myth of capitalism that the extraction of natural resources could be sustained with no end in sight. These environmental problems have been compounded more recently by the spectre of an economic recession sweeping through much of the world, which reveals the instability of capital and the invented nature of capitalism's many dreams and desires. In any case, the problem is planetary, already affecting the lives of millions and threatening those of the rest. Dissociation from the planetary multitude now becomes an impossibility. The global elite, those of the global north, can no longer confine themselves to their exclusive places on earth, for the earth itself is in peril, as is all the earthly wealth that sustained them in their positions. As Karl Marx has famously said, "All that is solid melts into air."[58] As the worst economic crisis since the Depression looms before us, it forces a reckoning with the premises on which the global hegemony has proceeded.

The issues arising from the ongoing crisis form the core of Salgado's concerns as economist and photographer. In this sense, his work extends and diversifies the humanist trends of photodocumentary, established, as already seen, by photographers of the likes of Walker Evans, Dorothea Lange, and other members of the Farm Security Administration. They were concerned with the migrancy forced on Americans by the Dust Bowl during the Depression: Salgado amplifies this narrative to turn his concerns to the displacement of the planet as a unified biological entity. He is thus not so much a humanist photographer—though his work does fit into those traditions—as he is a bioplanetary one. A central aspect of this role is the emphasis on diversity: the diversity of humans across the globe as only a part of the larger diversity of nature across the globe.

A logical balance exists between Salgado's human-centred focus in his earlier projects and the diverse creatures and communities that form the focus of *Genesis*. The two perspectives consolidate each other,

lending depth and meaning both to perceptions of displacement and also to the political debates that ensue from them. These are not opposed perspectives, but different ones on the same problem: that of the sustained sidelining of bio-necessities in the context of globalization.

Curiously, although the images of *Genesis* are no doubt among the least troubling of Salgado's photographs, they are also in many ways the most overtly political, because they lend new meanings to all his former work and intervene in pressing debates of the moment. In attempting to portray the 46 percent of the planet that remains unscathed by modernity, Salgado achieves two effects. First, in keeping with the biblical name of his project, he reminds us of the diversity that exists in religious narratives—for example, how Noah's ark, in the Book of Genesis, testifies to the coexistence of myriad creatures in civilization's early times, and hence points to the right of creation in all its differences to exist. Second, in a more contemporary light, Salgado creates awareness of diversity and the absolute necessity in biological terms of maintaining and fostering biodiversity. Underlying this is the basic ethical and political tenet of regard for the other.

By creating a visual discourse around diversity, Salgado intervenes in the discourses around development. It is fair to say that development—understood, in tandem with the notion of progress, to be the marker of modernity—has most often had a nefarious impact on the planet. Understood and enacted along the narrow, linear lines of rational thought, development has been assumed to be that which can be measured by capital and technology. This enterprise has pushed many spaces and people of the earth to points of crisis. As the environmental activist and writer Vandana Shiva states, the effects of globalization and the World Trade Organization are felt particularly acutely in the global south, as global trade rules set by the WTO and other major organizations favour corporations over people and nature.[59] This view held by Shiva replicates that of Salgado, who found, when working for the International Coffee Organization, that the prices of coffee beans were set in London, with dire affects on the growers and producers of the coffee bean in Africa.

Contrary to what the word suggests, therefore, globalization is thus an exclusionary project that runs contrary to notions of democracy by rendering resources and knowledge from the global south into commodities in the marketplace, at the cost of destroying or damaging local livelihoods, lifestyles, communities, and landscapes. In her many

articles and lectures, Shiva asserts that globalization is, in fact, a latter-day form of colonization. She analyses in depth several of the problems caused by globalization to localities and people from the global south: the shift from growing food for local consumption to export crops, which adversely affects food security; the destruction of local trade through increased imports, resulting in the loss of agricultural and cultural diversity, as cheap imports destroy local enterprises; the imposition of global patents and trademarks on local goods, produce, and knowledge, leading to the widespread establishment of bio-piracy; the sustained disregard for ecologically sustainable patterns; and the "ownership" of natural resources. In Shiva's view, free trade is a fallacy and development, as it is currently practised, leads to dependency for the global south—those parts of the world that have historically been subjugated to colonization and robbed of their wealth and that are now "recolonized" through economic dependency, debt, and the destruction of domestic economies.

To return to Salgado's collection of images of water, *L'homme et l'eau*, this celebration of water in all its diverse forms and uses, its intimate link with life, its inextricability from all that we know to be living, acquires overt political overtones when we view the photographs in the light of Shiva's comments on water:

> Water has already become the blue oil—commodified, dwindling, yet overused and abused. From a renewable resource it is being converted into a non-renewable resource like fossil fuels. From a community resource it is being turned into a privatised commodity to be traded and sold. The transformation of water into a commodity is leading to its over-exploitation and long-distance transportation. Instead of following the laws of ecology and the hydrological cycle, water is being forced into markets. Instead of following the law of gravity and flowing downwards, it is flowing upwards to money. And as water is diverted, re-routed, mined and privatized, water conflicts are an inevitable result.[60]

Salgado's images of water, playful and celebratory as many of them are, acquire a different light when viewed in terms of Shiva's statement. If there is a palpable turbulence in Salgado's work, if *Genesis* arouses both wonder and pathos, it is because the exalted aesthetic of his photographic representation brings out both the extraordinary beauty of that which is natural and the poignant vulnerability of the same in the face of the relentless ransacking of nature. The tranquillity of the giant

turtle in the Galápagos Islands acquires an aura of tension as we view it in light of the displaced and homeless millions of *Migrations*. *Genesis* is at once utopian and recriminatory. It also reveals all of the planet to be interconnected.

Toward Liberation

While Salgado has reiterated his vision of connections across space and time, he is clearly under no illusions that such connections imply any real degree of parity. On the contrary, and as is so clear from his work, in particular the images from *Workers*, there is a chain of dependency that connects people across the globe through the passage of goods and capital. Thus, old ships are broken down to their parts in Bangladesh, while the steel is sent elsewhere to be reshaped and reused in a variety of ways. Furthermore, connection all too often occurs in hierarchical ways, reinforcing the inequalities of wealth and power. The fluidity of goods and capital is reliant, in fact, on the persistence of a global class difference, reinforced at the lower rungs by a labour force that is tied to production. At the lowest rung of this scheme are the displaced, the dispossessed, the migrant, such as the landless workers of *Terra* (fig. 19), and, in the final instance, nature in all its plenitude.

For an economist who hails from Brazil, such a vision is not surprising. The position of Brazil, as one of the giants of the global south, places it in the ambivalent border zone that negotiates the desires of a global elite through exploitation of the local. The stripping of the land around the Instituto Terra is a case in point. Brazilian society oscillates between the struggle for modernity and the persistence of the premodern, the colonial, the feudal. If hopes for a more egalitarian politics were high when Luiz Inácio Lula da Silva was elected in 2002, following his re-election in 2006, his government veered increasingly to what some would call a position of considerable compromise, whereby social reform—most needed by members of the MST—never came to fruition. It would appear that development, as lived in "developing countries," does not in reality follow the linear logic on which it was predicated.

The unevenness of development and questions of appropriation and exploitation by the global rich of the poor come to the fore through the fact that the world's wealthier countries and several international corporations have now begun the practice of acquiring farmland in the poorer parts of the world.[61] Salgado's concern with land could not be more timely when we consider that thirty million hectares of arable land

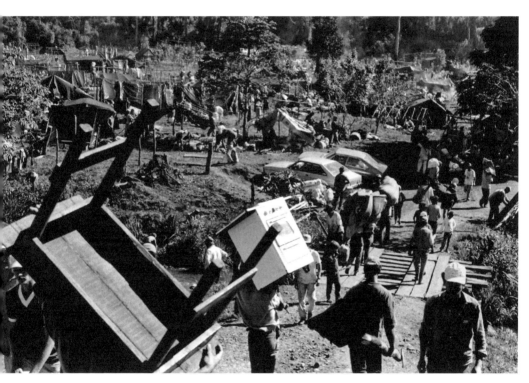

in economically vulnerable countries such as Sudan, Cameroon, Tanzania, and Russia have been purchased by wealthy nations. According to Devinder Sharma, an analyst working on food security, "Outsourcing food production will ensure food security for investing countries but would leave behind a trail of hunger, starvation and food scarcities for local populations. The environmental tab of highly intensive farming—devastated soils, dry aquifer, and ruined ecology from chemical infestation—will be left for the host country to pick up."[62] With more such deals in the making, the concerns that arise are numerous. Not solely is this a form of neo-imperialism whereby the powerful feed off the disenfranchised; this new manifestation of capitalism thrives by neglecting the needs of the local and the environmental, specifically at a time when crisis already looms large. As Salgado rightly points out, "development" as we know it displaces millions and destroys ecological balance. Nowhere is this more in evidence than in the global south.

In a book whose title would be apt for Salgado's work, *The Underside of Modernity*, the Latin American philosopher Enrique Dussel rethinks this notion of development. Dussel believes that the idea of development is a fallacy predicated on a linear sequence connecting the premodern, or the "developing world," to the modern, which fails to take into account the myth of modernity—itself a set of Eurocentric presuppositions that lack a basis in social realities, especially those social realities that exist outside of the West. Instead, Dussel opts for a philosophy of liberation that operates in the passageway between old orders and new orders. Thus, this philosophy dwells on the times and spaces in between the premodern and the modern, so that transitionality becomes a mode of both temporality and spatiality. The Eurocentrism of philosophy itself denies Dussel his rightful place among preeminent philosophers, although much of his work, arising from the context of Latin America, addresses the established thought patterns of philosophy as they arose in the West. This means that for many, he is "a Latin American theorist," at best a theologian who espouses liberation theology.

As with other liberation philosophers, Dussel cannot be regarded as separate from the sociopolitical and economic contexts within which his work arises. Liberation philosophy has a long antecedence in Latin America, going back to liberation theology and even to the discourses of decolonization that prevailed in the nineteenth century. As such, it is linked to the political struggles for independence and autonomy

from colonization. It addresses the development of emancipatory discourses in Latin America despite the fetters, in the twentieth century, of U.S. imperialism, populism across the continent, and the economic subordination that comes with being harnessed to global economic circuits. If Gustavo Gutierrez was responsible for formalizing this school of thought through a clearly laid out "manifesto" of liberation theology,[63] then Dussel has done much to update it to the more contemporary situation of Latin America in the context of globalization. He also removes the concept of liberation from theological realms and places it in more sociopolitical and philosophical contexts, while simultaneously highlighting the theological or liturgical in Marx's uses of language. Thus, religion combines overtly with a politics of the oppressed in both liberation theology and liberation philosophy. In either case, the notion of liberation is born of the historical contexts of colonization and exclusion, combined with the experience of severe economic and political disenfranchisement. So too is this notion tied to the presence of religion, spirituality, and mystical fervour prevalent in the continent. Liberation philosophy is at once theoretical, political, and geocultural.

Eschewing the term *postmodernity*, Dussel advocates instead the concept of "transmodernity." For Dussel, *postmodernity* is a Eurocentric term that fails to include that which falls outside the remit of European modernity. Transmodernity, in contrast, encompasses the alienated, the other, that which has been negated and silenced. It also captures the sense of unfinished transitionality that characterizes Latin America. "Postmodernity is critical, but not enough," he states.[64] The shift to transmodernity enables cultures that had been excluded by colonization to be included in the struggle for utopia.

The central concept of Dussel's liberation philosophy, transmodernity also has direct links to the rise of dependency theory. The latter forms the theoretical framework within which notions of liberation can be understood, because dependency theory specifically addresses Latin American experiences of underdevelopment and dependency. This theory is also at the heart of Salgado's work. Salgado's links with the MST, and their links with liberation theologists and philosophers, are well known. At the core of this concept of transmodernity lies a blend of reason and non-reason: a sort of religiosity that the MST refers to as *la mística*, or mysticism, a fervour for hope that combines the cultural, the religious, and the political. The mística as articulated by the MST is a clear example of the hybridized discourses that emerge when poli-

tics, liberation, and spirituality merge in the already hybrid contexts of Latin American culture. Writing on the mística, Plínio de Arruda Sampaio traces it back to the peasant belief in millenarianism: "The MST's version of mysticism has its roots in campesino (or farmer) millenarianism. All over the world and since the beginning of time, the campesino has been a person that wants to believe in the possibility of a world that is just and in harmony with nature. In the name of this utopia, the rural masses throughout the ages have risen up against the real world. The real world, which is always unequal, cruel and unjust."[65] Crucial here is the idea of harmony in the world and with nature. Christianity mixes with Marxist socialism to form a struggle that is at once cultural, economic, political, and spiritual. In *Terra*, there is a photograph of Padre Damián, the liberation theologist, as he says a mass to followers from the MST. His congregation is formed of peasants dispossessed of the key referent of their lives: land. The act of mass fuses the religious with the political, as liberation theology moves Catholicism away from the elite and established realms of the Vatican to grassroots movements and to activism at the margins. In the larger frame of colonization, oppression, and dispossession, Padre Damián's name recalls that of another Catholic priest, Father Damián Veuster, who lived in the nineteenth century and went from his native Belgium to work among lepers in Hawai'i, and whose memory inspired Mahatma Gandhi, the leader of Indian nationalism, also a movement of the colonized against oppression. In his story too, one can see how the imagined, the spiritual, and the sentient mingle with reason to forge a field of vision where the subaltern and the silenced may be included.

Viewed in terms of the ideas of transmodernity and mysticism, the aesthetic in Salgado's work combines with the narrative of vindicating nature, as seen in *Genesis*, to form a visual adjunct to liberation philosophy. In the face of globalization, however, it is not Latin America alone that has been colonized, but—bearing in mind Vandana Shiva's assertion that globalization is a latter-day form of colonization—the planet as a whole. Nature, of which humans are a part, has been colonized by the forces of capital. Above all, what has been disrupted, silenced, and negated is the balance of harmony between humans and nature. *Genesis*, then, is an attempt to at least visualize this harmony in the field of the photograph, so that its disruption may be superseded by the possibility of a frame within which to articulate protest and suggest alternatives.

Particular, Popular, Planetary

Some—those mired in a typically postmodern fracture of temporality— may find Salgado's attempts hopelessly utopian. Yet his point is not to create a revolution overnight or to abruptly overturn the divergent courses of contemporary histories, but rather to send messages in gradual but insistent ways to the largest possible numbers of viewers. Writing on Salgado's photographs of internal migration in Brazil and of the MST, Mariana da Cunha states, "One of the major qualities of Salgado's work is that it granted the movement with an international projection. However, what is at stake in these images is the familiarity of the photographed with the apparatus. The differential aspect in Salgado is that not only the political actions are privileged. There is a balance between these important events for the movement and the representation of the everyday, in which the depiction of the individuals is so crucial."[66]

Genesis assumes a pioneering role in extending this idea of a "movement" from that which is popular to the planetary. However, the balance that Cunha points to between the political and the particular is also maintained. There is in this visual scheme a deliberate politics of inclusion at play: photography works in this sense to include not only that which is oft unseen, but also to include in the larger narrative of the project a scheme of visibility, a politics that is at once planetary, popular, and particular. Sustaining this vision is the photographer's lens of an economist-historian, so that the images of *Genesis* not only culminate the larger narrative of Salgado's lifework as a photographer but also articulate in visual terms a polity of the planet.

Addressing Salgado during his visit to the University of California, Berkeley, in 2002, a group of academics based in the United States offered their responses to *Migrations*. Among them was T. J. Townsend, who remarked at some length on how Salgado's work reveals both causes and structures.[67] The causes that Salgado points to through his photographs and through his statements are those also found in the work of theorists of globalization, such as Mike Davis, who writes of the proliferation of slums around the swiftly expanding metropolitan centres of the global south.[68] The urban landscapes that Davis depicts are an indictment on globalization's rapid expansion of cities, revealing the ways in which the hurried and unequal amassment of wealth generates a growth of shantytowns on the edges of cities that outstrips urban growth. The photographer Jonas Bendiksen's project *The Places*

We Live also offers powerful insights into the daily realities of life in urban slums in four different parts of the planet, as well as into the dreams of those who go to live there in the hope of accessing the better life to which they are as yet marginal.[69] What is crucial in both Davis's and Bendiksen's studies is the fact that slums proliferate in and around urban centres and are symptomatic of the uneven and unjust distribution of wealth. Peripheral slum dwellers struggle without access to even the most basic of services, battling disease and dirt on a daily basis, living as they do next to decay, excrement, and toxic waste. The picture is bleak, shameful. It is also one that is increasingly prevalent, as large "developing" nations, such as Brazil, China, and India lead the global south in speed of economic expansion.[70]

The focus in *Migrations* on the megalopolis—cities such as Shanghai, Cairo, and Mumbai—does indeed portray such lives and conditions. Precarious lives lived in appalling conditions are evident throughout this collection of images. Nevertheless, *Migrations* cannot be interpreted solely in isolation. It needs to be considered as a sequel to *Workers*, a wonder-filled tribute to manual labour, even as this livelihood wanes, and to the transport of resources, materials, and goods across the world. It is also a precursor to *Genesis*, window of loss, danger, and hope for the planet as a whole. Certainly—and as with the work of most producers of cultural artifacts—Salgado's work points to a specific politics on his part. This ultimately, in my view, is one of hope: hope that by multiple forms of engagement, each individual, each community, and, in the final score, the whole world, if it should so wish, can help to make a difference.

My view that Salgado's work is ultimately hopeful can be corroborated, perhaps, by the work of the Brazilian-German social theorist and professor of law Roberto Mangabeira Unger, a critic of Lula da Silva who nevertheless became a government minister during Lula's second term in office. By proposing the notion of "democratic experimentalism," Unger argues that democracy is the balance between progress and individual emancipation. Such experimentalism, he explains, "is the power to push back the constraints of scarcity, disease, weakness and ignorance. It is the empowerment of humanity to act upon the world."[71] Unger writes in a pragmatic mode, to reshape institutions and to rethink social, political, and economic goals. His aim is, ultimately, to argue for a refiguring of experience in the name of a more coherent, and less conflicted, society. Unger has stated that of all his writings, the one

closest to his heart is the long essay "Passion." His opening words to this text offer a glimpse of what his work is aimed at: "A social world does not become stable until its legal or customary rules can be understood and elaborated as fragmentary and imperfect expressions of an imaginative scheme of human co-existence rather than just as provisional truce lines in a brutal and amoral conflict."[72] Unger is concerned with the social world. His view, though wide and refreshingly innovative, is confined to the social and political contexts of society and humanity. It is relevant, though, precisely because Unger makes room for the particular and popular, always emphasizing the power of the individual, the group, or the local to make small but important changes.

Photography by itself cannot address the detail of human social and political actions. It cannot formulate strategy. It cannot even voice a single, stable point of view, for by its very nature, the medium exceeds the frame. It can depict or portray, it can represent or document, it can review or reshape. It cannot, however, ever limit itself to the discursive, the rational, or the normative—even when these pertain to alternative or progressive agendas. This is so, even when these elements are evident in and through the image. Rancière writes of the inevitable weave of art and politics as encountered in the image: "Photography became an art by placing its particular techniques at the service of this dual poetics, by making the face of anonymous people speak twice over—as silent witnesses of a condition inscribed directly on their features, their clothes, their life setting, and as possessors of a secret we shall never know, a secret veiled by the very image that delivers them to us."[73] In the case of Salgado's current project, it is the planet as a whole that is both revealed and rendered wondrous through the suggestion of a thousand unknown secrets.

The fins of a whale as it dives into the sea are chiseled to almost mechanical perfection, the beauty and the power of its submerged being hinted at in the perfect balance of their symmetry (fig. 20). A smaller pair of fins next to it suggests the family, the group, the community— the solitude and solidarity of beings in even the remotest of waters. The image sustains hope, as it does beauty. It is far removed from social contexts, yet it bears strongly on them.

This sentiment recalls the writing of Rebecca Solnit, who, in her *Hope in the Dark: Untold Stories, Wild Possibilities*, writes persuasively for hope in the midst of so much that has gone askew in the world. As a writer and an activist, Solnit reminds us of the many victories of the

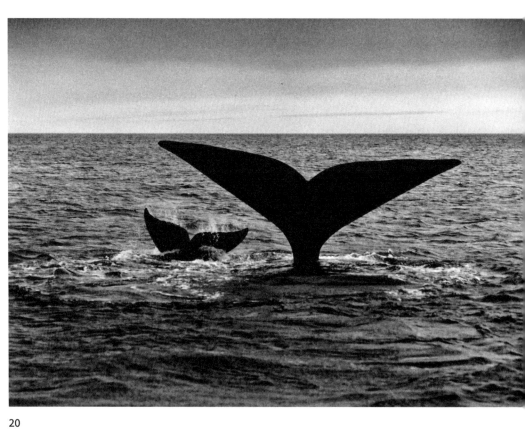

Left over the last fifty years—victories that did not require loud battles and did not come about overnight, but were gentle ones, long in their coming but sure, ones that happened through the coming together of likeminded souls who shared particular visions. Like the whales that are so far away from the multitude, the victories are small, often overlooked. Yet the simplicity of their achievements throws light in the dark. Solnit brings together in her writing many elements that are part of Salgado's work: art, ethics, the environment, and landscape. These are all inseparable in her view, together forming a common means of overcoming antagonisms and divisions in a world where politics is, in the final hour, the acknowledgment that the heart and the mind can only ever be intertwined, as can the self and the other.

Polity of the Planet

At first sight, the images of *Genesis* appear to have little to do with the world as it is right now. Merely a decade of this new millennium has passed and we have already witnessed the deepening of global antagonisms, we have been party to major wars, we live in a world riven by the spectre of terrorism, and, as if all this were not enough, the very ideology that we pursued in the name of prosperity, namely that of capital, has proven in the course of an ongoing recession that its most renowned houses are hollow. Stripped of its gloss, in less than a year, capitalism as an ideology and as a system of global economic practice has shown itself to be unstable, given to insecurity, propelled more than anything by its ability to manufacture dreams and desires. Even this may have now gone.

 In this climate of economic, political, and social uncertainty, photography plays a more important role than ever before. As the old dreams die, so new visions need desperately to be forged. The urgency of the image is stronger than ever now. The secret mystery of the photograph becomes a political necessity. It must be followed, forcing us out of the established frame. Through its focus on alternatives to the only ways of living that most of us know, *Genesis* refreshes the imagination. As the social and the economic fray before our eyes, so nature takes on a new importance. As climate change spreads, so we recall the ties that bind us to nature—and so we recall the responsibilities we have to nature. As global antagonisms grow and violence, sporadic and sustained, multiplies, as warfare accrues ever-increasing complexities, as deserts

spread and flooding becomes routine, the gentle ambivalence of the image offers shelter.

An impacting work that argues a strong case for photography of the disenfranchised is Ariella Azoulay's *The Civil Contract of Photography*. For Azoulay, photography of the dispossessed subject who looks back is a contract that aligns subject, photographer, and viewer, so that photography becomes the means of restoring citizenship to the subject who has been otherwise abandoned. Photographs create spaces for political participation for those subjects who would otherwise be relegated to obscurity. Azoulay's work is located around images of the conflict of occupied territories and of Palestinians subject to Israeli military interventions. As such, her theorizations revolve around one of the most enduring and most seeping wounds of recent times. Speaking of Palestinians, who daily live in and amid the Israeli-Palestinian conflict in conditions of perpetual semi-imprisonment, deprived of citizenship, she states, "In the political sphere that is reconstructed through the civil contract, photographed persons are participant citizens, just the same as I am."[74] The act of viewing, contrary to being some kind of annihilating voyeurism, recognizes and restores citizenship. The photograph does not capture the subject: it opens up a space for recognition and agency. For the subject who is mired in the dark, the light of the image offers hope. What is more, the multiplicity of photographs, the propensity of the medium to travel, allows the subject in some sense to escape his or her confinement and isolation: "The consent of most photographed subjects to have their picture taken, or indeed their own initiation of a photographic act, even when suffering in extremely difficult circumstances, presumes the existence of a civil space in which photographers, photographed subjects and spectators share a recognition that what they are witnessing is intolerable."[75]

What is interesting in the case of Salgado's work, in particular *Genesis*, is that the abandoned and unrecognized subject is that which pertains to nature. This means all of us, all we know. Photography is a means, then, of restoring citizenship to nature, long taken for granted, overridden, abused. In *Genesis*, it is the planet as a whole that looks back at us. Yet citizenship is a social and legal term. It implies a contract between two or more separate entities. The planet is all we really know: in the mind's eye, in living memory, it came before us and will survive us. The contract put forward by Salgado's photography has no end in time. Nor can it be forged on an individual basis. The invitation

of photography is for a communal engagement, one that weaves sub-
jects, those within and without the frame, those who are human and
those who are not, into collective relation.

Planet of Hope

> I do not work alone. I work with Lélia, with my team in Paris,
> with people I collaborate with. . . . Not being alone gives us
> the power to keep going. To have hope.
> INTERVIEW WITH SALGADO,
> Amazonas Images, Paris, December 11, 2007

As we engage with the images in all of Salgado's work—that of the go-
rilla, the iguana, the child, the displaced person, the goods in transit,
the landless community, the ocean, the sky, the trees—the planet opens
itself to us, with us, in an endless panoply. We feel the pain, the sor-
row, the struggle, the hope. We become part of a pact borne out by the
image. There is a tryst here, a covenant of trust that brings subject, pho-
tographer, and viewer together in what is much more than a contract.
For a contract is only ever for a certain length of time. It has a beginning
and an end. It is lived out in a social setting. It has legal overtones. The
vast panorama of Salgado's lens, the range of themes he touches on that
build on one another, and the endless possibilities of rearranging and
reviewing his work mean that the sustained viewer cannot easily be-
come disengaged. Instead, the viewer becomes included in the space of
the image, enfolded by the circle of the polity. This, then, is the frame of
vision that Salgado suggests to us: that which includes all involved and
also leaves ever open the infinite possibilities of the image.

Introduction

1. Detailed biographies of Salgado, with precise dates, are available from his agents, as well as from the offices of Amazonas Images. Likewise, Salgado's *An Uncertain Grace* provides a good account of his achievements up to 1990.

2. In the video *Looking Back at You*, Lélia Wanick Salgado outlines her husband's introduction to photography via the camera she purchased for her studies in architecture. This video also displays some of the ways in which her work, as director of their agency Amazonas Images, complements and projects his.

3. See the Magnum Photos website, http://www.magnumphotos.com.

4. Russell Miller, *Magnum*, 243–93.

5. Ibid.

6. Ibid., 256.

7. Author's interview with Salgado, Paris, December 11, 2007.

8. Amanda Hopkinson's interview with Salgado, Barbican Centre, London, June 2003.

9. Jonathan Cott, "Sebastiao Salgado," 619.

10. Galeano, in *Salgado and Galeano* (dir. Goodman).

11. Interview with Salgado, London, September 10, 2007, and interview with Lélia Wanick Salgado, Paris, December 11, 2007.

12. Interview with Salgado, London, September 10, 2007.

13. Memorial da América Latina, *Programa Roda Viva*, unpaginated (my translation from the Portuguese). The program ran from June 11 to 28, 1996.

14. Salgado's discussion of his working materials can be found in ibid.

15. Alessandro Pasi, *Leica*.

16. Mraz, "Los Hermanos Mayo."

17. See *Leicaworld: Photography International*, 2/2005, 7, 27–32 for more on the work of these two photographers.

18. Reuters, "A Master's Message to Man," *Sydney Morning Herald*, August 31, 2005, http://www.smh.com.au/.

19. *Looking Back at You*, dir. Andrew Snell.

20. The same print was for sale in both venues in September 2006.

21. See, for example, the Artprice website, http://www.web.artprice.com.

22. Berman, *All That Is Solid Melts into Air*, 16.

23. Jameson, *A Singular Modernity*, 94.

24. Delanty, *Modernity and Postmodernity*.

25. Heilbrun, *Towards Photojournalism*. Heilbrun was also the curator of the exhibition *Vers le reportage*, which ran in the Musée d'Orsay in autumn 2007 and on which her book is based.

26. Ibid., 8.

27. Gautrand, "Looking at Others," 628.

28. Ibid., 630.

29. Goldman, "The Aesthetic," 181.

30. The paintings of the futurists, such as Giacomo Balla or Umberto Boccioni, offer an interesting exploration of the notion of the aesthetic. In the years that led to the outbreak of the First World War, futurism cultivated an aesthetic that conveyed movement, speed, and technology. Theirs was an aesthetic that suggested displacement and violence in often quite disturbing ways, so that the viewers too felt displaced by and through the artwork.

31. Adams, *Beauty in Photography*, 14.

32. Ibid.

33. Grosz, *Chaos, Art, Territory*.

34. Ibid., 23.

35. Maynard, "Photography," 485.

36. Jean-Claude Carrière, "Tres sorpresas," in Itúrbide, Rai, and Salgado, *India, México*, 27 (my translation from the Spanish).

37. A brief interview with Janah about his work on the Partition is available on YouTube. "Sunil Janah's Photographs of India," YouTube video, 6:20, posted by "KamlaBhatt," September 22, 2007, http://www.youtube.com. Janah's focus overlaps with Salgado's in its strong social consciousness and its focus on land, peasants, and poverty.

38. See Rai, *Raghu Rai's India*; and Singh, *Privacy*.

39. See, for example, Goldblatt, *The Transported*. Goldblatt shot these images during early morning bus rides, lasting two and a half hours each way, on which black workers made their way from their segregated "homeland" of KwaNdebele to the city of Pretoria, where they worked but were not allowed to live. Peter Magubane is notable for being a black photographer of South Africa under apartheid. Not surprisingly, this meant that for years he suffered considerable hardship and struggle in order to be able to photograph. See Magubane, *Magubane's South Africa*; and also Magubane and Mandela, *Black as I Am*.

40. This image has an interesting history that illustrates the ways in which photographs straddle the boundaries of politics and the market. It was taken while Korda worked for the magazine *Revolución* and continues today to be a symbol of revolution or revolt. Due to the absence of copyright in Cuba, how-

ever, Korda failed to obtain any royalties from it after he passed the image on to the wealthy left-wing Italian publisher Giangiacomo Feltrinelli.

41. Hopkinson, "Mediated Worlds."

42. The Hermanos Mayo were made up of five Spaniards from two families: Francisco Souza Fernández (1911–49), Cándido Souza Fernández (1922–85), and Julio Souza Fernández (b.1917), and from the del Castillo Cubillo family, Faustino del Castillo Cubillo (1913–1996) and Pablo del Castillo Cubillo (b.1922). They arrived as exiles in Mexico with a portfolio of images of the Spanish Civil War.

43. Rama's *La ciudad letrada* is a seminal text on colonial structures of cultural power in Latin America, which lays open the question of representation of, for, and by the subaltern.

44. Coronado, "Toward Agency," 130.

45. Martín Chambi website, http://martinchambi.org.

46. See http://martinchambi.org for a gallery of Chambi's images. Mario Vargas Llosa's comment can be found here.

47. A case in point is Noble, *Tina Modotti*.

48. Melo Carvalho, *Contemporary Brazilian Photography*, 10–11.

49. Ermakoff, *O negro na fotografia brasileira do século XIX*, 273.

50. Ibid., 13.

51. Costa and Rodrigues da Silva, *A fotografia moderna no Brasil*, 113–14.

52. For an interview with Miguel Rio Branco, see Joerg Colberg, "A Conversation with Miguel Rio Branco," Conscientious website, "Conscientious Extended" section, March 27, 2008, http://www.jmcolberg.com/weblog.

53. Andujar, *A vulnerabilidade do ser*.

54. Hall, "Democracy, Globalization, Difference," 35.

55. See the "Initiative: Pathshala" page on the Drik website, http://www.drik.net/ini-majorityworld.php.

56. See the Majority World webpage, http://www.majorityworld.com.

57. Questions of accessibility have been considerably eased by the infinite space of the Internet. Websites, such as Pedro Meyer's Zone Zero, selectively offer gallery space to new and established photographers. The result is a growing global community of photophiles who may only ever meet virtually but nevertheless are in dialogue with one another. It is not yet clear, however, that such spaces can compete in material terms with the elite world of the photographic art market. Perhaps part of the commodity fetishism that is attached to gallery images is the exclusive and enclosed space offered by the gallery. See http://www.zonezero.com.

58. "Life in the Ship Breaking Yard: People and Their Lives in the Ship Breaking Yard," under "Portfolios" on the Saiful Huq website, http://www.saifulhuq.com.

59. Goldberg and Solomos, *A Companion to Racial and Ethnic Studies*.

60. Hegel, *Philosophy of History*.

61. Ibid., 99.

62. Salgado's *Africa* was published in 2007. It is a compilation of images

from his current and previous photographic projects, with a foreword by Mia Couto, a writer from Mozambique.

63. Gilroy, "After the Great White Error . . . the Great Black Mirage," 73.

1. The Moving Lens

1. The *Exodus* exhibition took place in several venues around the world, such as London and Tokyo, in 2003.

2. Mraz, "Sebastiao Salgado," 21–22.

3. Salgado, *Outras Américas*, 14 (my translation).

4. Prado, *Retrato do Brasil*, 11.

5. The desolation of the figures in *Other Americas* also brings to mind the novel *La lluvia amarilla* (1985) by the Spanish writer Julio Llamazares. While this novel is set in a remote village in the Spanish Pyrenees, it shares with *Other Americas* a sense of the abandonment experienced by peasants as part of a past left behind in the rush toward modernization.

6. Paz, *The Labyrinth of Solitude*, 43. Paz explores dimensions of self and other in his works, arguing for a Hegelian dialectics of recognition. Writing principally about Mexico, Paz stresses that otherness is part of the constitution of the self. Thus the other is never in stasis, but rather, is processual and provides the mirror or wall against which the self, in this instance the Mexican, can define the contours of an evolving national selfhood.

7. Menchú, *I, Rigoberta Menchú*.

8. Such occasions of agency have included armed rebellion. Take, for instance, the example of Tupac Katari, the eighteenth-century rebel from Bolivia.

9. Price, *The Photograph*, 17–18.

10. As I wrote the first draft of this chapter, shock waves were passing around the world at the release of pictures of torture inflicted by U.S. troops on Iraqi prisoners in Abu Ghraib prison in Iraq. There is little doubt that these images have since become emblematic reminders of the injustices and brutalities of the Iraq War in a way that no written report or taped interview ever could. Yet, given the established opposition to the war and the many questionings of its validity, it is surprising that it should take these images to inform and mobilize public reaction in the West. The visual icon, it would seem, is what confirms the reality it represents, rather than vice versa.

11. See the Médecins Sans Frontières website, www.msf.org, for more details.

12. Light, *Witness in Our Time*, 7.

13. For the same reasons, it is interesting to note that *Other Americas* did not appear in Brazil until 1999 (as *Outras Américas*), by which time, of course, Salgado had already received considerable international recognition.

14. Schell, foreword to Salgado, *Sahel*, x–xii. This new edition of the photo-essay on the Sahel also includes an afterword by Eduardo Galeano, thus linking it to *An Uncertain Grace*, which relies on the collaboration of Salgado's

visual narrative with the literary prose of Galeano and a more academic, or explanatory, essay by Ritchin.

15. Price, *The Photograph*, 1–3.

16. Barthes, *Camera Lucida*.

17. Galeano, *Open Veins of Latin America*.

18. Salgado, *An Uncertain Grace*, 11.

19. Galeano, *Open Veins of Latin America*, 266.

20. Salgado, *Workers*, 7.

21. Salgado, quoted in Light, *Witness in Our Time*, 113–14.

22. Freyre, *Açucar*.

23. Ermakoff, *O negro na fotografia brasileira do século XIX*, 10–16.

24. Kossoy and Carneiro, *O olhar europeu*.

25. Paz, *The Labyrinth of Solitude*, 77–78.

26. Galeano, *Open Veins of Latin America*, 285.

27. Author's interview with Ellen Tolmie at her UNICEF office in New York, April 15, 2004.

28. See the Movimento Sem Terra website, www.mst.org.br, for more details of the MST's aims, organization, and achievements. All the figures cited in this paragraph have been taken from this website.

29. Monica Dias Martins states that the first land occupation occurred in Encruzilhada Natalino, Rio Grande do Sul, in 1979, during the Brazilian military dictatorship. Gogol, "Learning to Participate."

30. Author's interview with Geraldo Fontes, MST office in São Paolo, July 27, 2006.

31. Petras and Veltmeyer, *Cardoso's Brazil*.

32. The question of land is a poignant one in the Brazilian and, more generally, Latin American contexts. Land once inhabited by indigenous peoples was confiscated and reallocated during colonization. While the advent of slaves from Africa guaranteed that the land would be worked, nevertheless, these slaves had no rights to property of their own. Decolonization has done little to redistribute land, so that a significant portion of Brazil's racially mixed population continues to struggle for access.

33. Interview with Gerardo Fontes, São Paolo.

34. Gutiérrez, *A Theology of Liberation*, 5.

35. See Linda Pressly, "Brazil's Land Reform Dilemma," BBC Radio 4's *Crossing Continents* page on the BBC News website, http://news.bbc.co.uk/1/hi/programmes/crossing_continents/3146937.stm, August 13, 2003.

36. Interview with Gerardo Fontes, São Paolo.

37. In August 2006, I visited the Assentamento Terra Prometida. Tamara, Amaro, Rosana, Alberto, and Amadeu showed me around the settlement, land that had been occupied but was as yet unassigned legally to the MST.

38. Haroldo de Campos, "A Second Abolition," trans. Bernard McGuirk, from the project "The Sights and Voices of Dispossession: The Fight for the Land and the Emerging Culture of the MST (the Movement of the Landless Rural Workers of Brazil)," ed. Else R. P. Vieira, the Landless Voices Web Ar-

chive, http://www.landless-voices.org. Vieira's project is a good resource for information on the goals and achievements of the MST, as well for samples of support from numerous intellectuals and artists. Included in the archive are sixteen photographs by Salgado, which form part of the *Terra* exhibition, as well as a voice recording of him issuing a statement of support for the cause, which is taken from a film produced by the MST.

39. See the New York Times on the Web website "Terra: Brazil's Landless Movement," http://www.nytimes.com/specials/salgado/home, which provides the context for the MST, as well as a series of photographs from the *Terra* exhibition.

40. Clarke, *The Photograph*, 145. In his chapter on documentary photography, Clarke also explores the morality of such work. This is a point that will be explored with reference to Salgado's work in chapter 4.

41. In Delhi, for example, a law passed in 2002 makes it an offence for motorists to give money to beggars or hawkers at traffic lights, thus criminalizing both generosity and the livelihoods of youngsters, who, no longer able to sell magazines or chewing gum, frequently turn to prostitution, drug dealing, or petty crime. Seabrook, *The No-Nonsense Guide to World Poverty*, 79.

42. Salgado, *Terra*, 190.

43. Ibid., 142.

44. Ibid., 11.

45. Ibid.

46. See the Chico Buarque website, http://www.chicobuarque.com.br/.

47. Author's interview with Geraldo Fontes, MST office in São Paolo, July 27, 2006.

48. On this topic, see, for example, Meera Selva, "The Battle of the Rift Valley," *Independent*, July 26, 2004, 26. Selva explores the historical complexities surrounding contemporary conflict over land rights between colonial families in Kenya and nomadic Massai tribesmen. Another instance of the struggle for land is, of course, the Zapatista movement in Chiapas, Mexico. The dissemination of news of their struggle via the Internet has led to interesting points of concurrence between geographically and historically different groups involved in the struggle for land, thereby creating electronically maintained networks of support across distance and national boundaries. A key feature of such networks has been the sharing of analyses of neoliberalism and ways of combating this phenomenon at grassroots levels.

49. Landlessness affects the poor across the globe. In Bangladesh, for example, the case of Ghugudah Bheel marked a significant victory for the landless. Here, the British colonial landlord system of *zamindari* (landlords) was abolished at independence in 1945, and the forfeited land was handed over to the government as *khas* (or government-owned land) shortly thereafter. Despite the fact that this land was assigned by the government for redistribution to the poor, the local zamindari retained control and filed false cases against Samata, a non-governmental organization that took up the peasants' cause. Many members of this NGO were imprisoned as a result, as the land-

lords bribed the police and judges involved in the case. In 1976, following a long and arduous struggle, Samata won the case and the land was finally handed over to the peasants. Despite such victories, landlessness is a major problem in Bangladesh, where it has risen from 31 percent of the population at independence from Pakistan in 1971 to approximately 56 percent in 1996. The sole factor reducing rural landlessness is, interestingly, migration from the rural areas to urban ones. Not surprisingly, then, those Bangladeshis who are landless become forced to migrate elsewhere, to the richer parts of their country or the globe, and move beyond their regions in search of some ground beneath their feet.

50. Saramago, introduction to *Terra*, 9–13.

51. Berman, *All That Is Solid Melts into Air*.

52. Salgado, *Migrations*, 9.

53. Salgado, in *Spectre of Hope*, dir. Carlin.

54. Salgado is not alone in his efforts to offer glimpses of the underbelly of globalization. Another key example of this effort is the Malian filmmaker Abderrahmane Sissako's recent film *Bamako* (2006). The emphasis in that work is on the difficulties of development for poorer countries such as Mali in the face of national debts, transnational capitalist ventures, and persistent historical imbalances.

55. *Salgado and Galeano*, dir. Goodman.

56. Sassen, *Guests and Aliens*, 1–7.

57. Donnan and Wilson, *Frontiers of Identity, Nation and State*, 63.

58. Téllez, *Moros en la costa*, 13 (my translation).

59. Salgado et al., *Migrations*, 7.

60. Salgado, in *Spectre of Hope*, dir. Carlin.

61. It is interesting to note, for example, that in 2006 the UK introduced a written citizenship test for all those seeking naturalization. The requirement for passing such a test is not just familiarity with what the Home Office considers to be British culture, but also the ability to read and write in English. Immigrants who cannot do so are at a disadvantage. Thus, even "multicultural" societies that appear open to immigrant presence are rife with numerous invisible borders that immigrants must cross in the course of their daily lives.

62. For a fuller discussion of this topic, see Weiner, *The Global Migration Crisis*.

63. Jordan and Düvell, *Irregular Migration*, 1.

64. Salgado et al., *Migrations*, 123.

65. Salgado, in *Salgado and Galeano*, dir. Goodman.

66. See Sontag, *On Photography*.

67. Marien, *Photography*, 163.

68. Vishniac Kohn, foreword to Vishniac, *Children of a Vanished World*, xii.

69. Machel, the wife of Nelson Mandela, was appointed by the United Nations as an independent expert to carry out an assessment of the impact of armed conflict on children. Her report, presented in 1996, led to the estab-

lishment of an agenda for the protection of children facing such contexts of violence.

70. Reporters Sans Frontières used one hundred images by Salgado for their booklet *100 photos pour défendre la liberté de la presse*. The images are introduced by the well-known French press reporter and correspondent Jean Lacouture. The booklet aims to advance the struggle for the freedom of the press and contains a list of journalists killed in the course of doing their work. Lacouture emphasizes what he calls *témoignage*, or witnessing, as a central function of Salgado's photographs. Yet he also queries whether the magic of photography confiscates for its own ends the attention of those from whom it seeks engagement (7).

71. Author's interview with Ellen Tolmie at her UNICEF office in New York, April 15, 2004.

72. Salgado quoted in "Sebastião Salgado: Photographing Polio Eradication," *Polio News*, World Health Organization, July 2001, 4, www.polioeradication .org/content/polionews/polionews12.pdf.

73. Zimmerman, *The End of Polio*, 42–61.

74. Dube, *The End of Polio*, 63.

75. See Declan Walsh, "Polio Cases Jump in Pakistan as Clerics Declare Vaccination an American Plot," *Guardian*, February 15, 2007, http://www .guardian.co.uk.

76. Details of countries with incidences of polio can be found on the Global Polio Eradication Initiative website, http://www.polioeradication .org/Infectedcountries.aspx.

77. David Hevey's exhibition *Giants* was held at City Hall in London in August 2003. His other exhibitions include *Beyond the Barriers: Disability, Sexuality and Personal Relationships* (1992).

78. A case in point is the documentary film *We're Normally Different* (dir. Engels), which charts the "ordinary" desires, dreams, and hopes of four disabled people. What comes through in the film is not so much a vision of disability as difference, but one of how, despite their disabilities, what these people look for in life is much the same as what anyone else wants.

79. The website of the Media Diversity Institute offers numerous articles on various representations and perceptions of diversity in society, including disability: http://www.media-diversity.org. See Bulsara, "Depictions of People with Disabilities in the British Media," n.d., available at http://media-diversity .org.

80. See Sebastião Salgado, "Be Fruitful, and Replenish the Earth" (*Genesis*, pt. 1), *Guardian*, September 11, 2004, http://www.guardian.co.uk.

81. For more details and images of the Instituto Terra, see its website, http://www.institutoterra.org.

82. Interview with Lélia Wanick Salgado, Paris, December 2007.

83. Workers I met and spoke to at the Instituto Terra were all from the region—many had known the Salgado family for decades—and were quite clearly devoted to the project of rebuilding what they saw as their part of the world.

84. Writing on the building of dams in India, Vandana Siva states, "Water locked in canals and dams is captive water. It can be privatised, commoditised, bought, sold, and controlled by the powerful." Siva, "Water Wars in India," 9.

85. Salgado, "Be Fruitful, and Replenish the Earth."

86. The UNEP website contains a page on Salgado's *Genesis* project: see "Sebastião Salgado Joins Tara Polar Expeditions," United Nations Environment Programme website, http://www.uneptie.org.

87. At the time of writing this chapter, six instalments of *Genesis* have come out in the *Guardian Weekend*: on September 11, 2004; on May 7, 2005; on July 2, 2005; on February 11, 2006; on June 17, 2006; and on December 16, 2006.

88. Salgado, "The Rebel Farmers" (*Genesis*, pt. 6), *Guardian Weekend*, December 16, 2006, 32.

89. Salgado, *L'homme et l'eau*, 11.

90. Genesis 1:26–28.

91. Singer, *Unsanctifying Human Life*, 10.

2. Engaging Photography

1. This term is used in *Looking Back at You* (BBC Omnibus, 2000) to describe the engagement of the sugarcane worker who must "attack" the cane to fell it.

2. Museum of Modern Art, *Primitivism and Modern Art*.

3. Abbott, "Photography at the Crossroads," 42. Abbott is remarkable for having been one of the few writers and commentators on photography who was also highly skilled in practising the medium. While she was instrumental in disseminating and popularizing Eugène Atget's photographs of Paris, she also photographed American life, most notably the people and architecture of New York City. She additionally developed an academic career, having taught for over twenty years at the New School for Social Research.

4. If contemporary modernity is increasingly reliant on visual representation, a feature that has been exacerbated by the global spread of digital culture, then it is important to bear in mind that this is not necessarily an entirely new phenomenon. In curious ways, the preeminence of visuality today takes us back to earlier times, prior to the rise of print culture, when the visual played an instrumental role in the dissemination of knowledge in a world that was still largely illiterate. Medieval iconography, a key means of disseminating and maintaining religious adherence, serves as an example of such visual practices.

5. I can think of no better introduction to the contradictions and the restlessness of modernity than Berman, *All That Is Solid Melts into Air*.

6. Chapter 3 explores possible links between Hine and Salgado, as well as important divergences between the two that must be tied to the different contexts that surround their work.

7. Marien, *Photography*, 208.

8. Of particular note here is the use of photography in furthering the discipline of anthropology, itself a field of knowledge whose development was closely linked to colonial enterprise and the expansion of Western interests across the globe. Nineteenth-century photography of "natives" (indigenous Africans, Indians, Aboriginals, etc.) was invaluable in categorizing, labelling, and comparing racial and ethnic types. In this sense, photography was perceived as a safe and reliable tool for compiling Eurocentric knowledge on others. One must imagine that the photographer, presumably of European origin, wielded the camera, itself a token of Western technological advancement, and stood behind the lens, thus marking his central role in capturing the subject of study.

9. Sontag, *On Photography*, 21.

10. John Berger, "Understanding a Photograph."

11. See Rosler, "In, Around, and Afterthoughts," 267–68.

12. Ibid., 269.

13. Ibid., 271.

14. Barthes, *Camera Lucida*, 41.

15. Ibid., 47.

16. Ibid.

17. Abbott accuses practitioners of photography of having sold the medium to commercialism, exploiting its earning potential at the cost of "honest, realist representation." Thus, in her view, photography with its increasing reliance on props, studios, and brush work, devolves into a poor imitation of painting. As a result, the medium is "torn from its moorings, the whole essence of which is realism." See Abbott, "Photography at the Crossroads," 44.

18. Alfred Stieglitz edited and published *Camera Work* from 1902 to 1917.

19. Stieglitz, "Pictorial Photography," 118.

20. Ibid.

21. Anyone familiar with Abbott's striking photographs of the New York skyline, for example, will no doubt agree that her images challenge the realism she professes in her writings. While the city she chooses as her subject matter is real enough, her representations combine a unique line of vision with photographic mastery. There is skill and intelligence in her images, a neat combination of technical sharpness and acute vision. Her images are as much an invitation to imagine and envision as they are realist representations of the city.

22. Abbott, "Photography at the Crossroads," 47.

23. In the following chapter, I further explore the history of this alignment between the documentary and the lyric.

24. For more on this topic, see Furst, *Realism*. Furst's book offers essays by the major realists of the nineteenth century outlining the goals of assigning literature to the service of documenting social reality. While the essays mainly focus on literature, it is possible to draw interesting parallels between this textual realist genre of prose fiction and the visual realist genre of photography.

25. Ritchin, "The Lyric Documentarian," 147–48.

26. Nicholas Wroe, "Man with the Golden Eye," *Guardian*, June 10, 2001, http://www.guardian.co.uk.

27. Salgado, interviewed by Amanda Hopkinson, Barbican Centre, London, May 23, 2003.

28. The photos of oil wells in Kuwait, taken soon after the first Gulf War, form part of Salgado's photo-essay on workers. The International Center of Photography in New York has a particular relevance to photodocumentarians: it was founded by the creator of the concept of concerned photography, Cornell Capa, brother of Robert Capa, who is one of the founders of Magnum. Central to the efforts of such "concerned photographers" (concern being a core notion in the ethics of photojournalism espoused and promoted by Magnum) is the humanistic vein that many perceive in Salgado's work.

29. Sischy's article, titled "Good Intentions," is reprinted in the collection *Illuminations: Women Writing on Photography from the 1850s to the Present*, edited by Liz Heron and Val Williams. This volume is unusual in that it offers responses to photography selected on the basis of gender difference, the premise being that photography has conventionally been a male-dominated pursuit. The volume collects and presents women's writings on photography, thus aiming to redress this imbalance. By highlighting issues of women's vision and visibility, the volume, as a whole, challenges male-centred perceptions of history. In what the editors see as a decolonizing move, they congratulate Sischy in their introduction, stating that she "displays an integrity which one would wish for more often when critics comment on the work of the famous and the powerful" (xiii). It is clear in this statement that Salgado is implicitly classified as belonging to this latter group, and is thus placed in diametric opposition to his subjects in the scale of global power.

30. Sischy, "Good Intentions," 273.

31. Ibid., 274, 275.

32. Ibid., 277.

33. Ibid., 279, 282.

34. Easterby, quoted in Nicholas Wroe, "Man with the Golden Eye."

35. Ibid.

36. Such is the continued inequality of our world that one-fifth of humanity owns as much wealth as the remaining four-fifths—and, not surprisingly, the one-fifth that comprises this global hegemony is located in precisely those spaces of power that have been traditionally dominant. Thus, the tangible inequalities of late capitalism can be traced back to reveal complex histories of unsettled economic and political, indeed ideological, differences.

37. This question becomes all the more pertinent in current global contexts, in which, since the end of the Cold War and the fall of socialism, capitalism quickly expands its grip across a global political map that is increasingly shot through with inequalities.

38. Wenders, quoted in Strauss, *Between the Eyes*, 1.

39. Ibid., 9.

40. Author's interview with Salgado, Amazonas Images, Paris, December 11, 2007.

41. Ulrich Beck has analysed the notion of risk, which he views as central to late modernity. For Beck, late modernity advances via the proliferation of risk, so that the modern condition becomes by definition one of risk, speculation, investment, venture, and loss. For more details, see his *Risk Society: Towards a New Modernity*.

42. *Life* magazine closed in 2000, its demise marking the end of an era that spanned over a century, when global news was accessed via printed text and still image. Superceded since the 1960s by the advent of television, magazines such as *Life* struggled on for some decades but eventually found themselves rendered largely redundant by other, more immediate media. Many of the Magnum photographers made their names through *Life*.

43. Bernstein, "'The Dead Speaking of Stones and Stars,'" 139–64.

44. Adorno, *Aesthetic Theory*, 55.

45. Benjamin and Adorno were not alone in their critical dialogue: Gershom Scholem and Bertolt Brecht were equally engaged with them in a joint project of developing what we now know as critical theory. Given Benjamin's untimely death, much is owed to both Scholem and Adorno for championing his writings and, as a consequence, for influencing the ways in which his work has been interpreted.

46. For those who are not familiar with the philosophical trajectory of these two thinkers, itself axial to the ideas they debated, it is not easy to fully comprehend the details of their correspondence and debates. In seeking clarification, I am indebted to Michael Rosen for his lucid exposé of the issues at stake in his "Benjamin, Adorno, and the Decline of Aura."

47. Adorno and Benjamin, *Adorno-Benjamin Briefweschel*.

48. Benjamin, *The Arcades Project*, 392.

49. Benjamin, "A Brief History of Photography," 250.

50. Ibid.

51. Adorno and Benjamin, *Adorno-Benjamin Briefweschel*, 49.

52. Kaufman, "Aura, Still," 123.

53. Ibid.,123–24.

54. Strauss, *Between the Eyes*.

55. The Salgado exhibition was held at Arden and Anstruther, 5 Lombard Street, Petworth, West Sussex, from June 5, 2005, to June 30, 2005. Needless to say, the labelling of a photograph as a Salgado (stated in the same vein as, for example, a Picasso) unquestionably raises the image to the level of canonical art; so does the fact that the photographic image is now a collector's item. Yet the mind boggles when trying to fathom what is meant by this term. How many "Salgados" did Salgado print of the same image and in whose keeping are the other prints now? Nevertheless, the use of this phrase is a clear signal that photographs can bear the signature or hallmark of an auteur.

56. Paul Arden, "Out of the Blue," *Independent*, June 3, 2005, 36.

57. Ibid.

58. Ibid.

59. Rosler, "In, Around, and Afterthoughts," 265.

60. Soar, "The Advertising Photography of Richard Avedon and Sebastião Salgado."

61. Salgado, *Workers*, 13–14.

62. Soar, "The Advertising Photography of Richard Avedon and Sebastião Salgado," 288.

63. Ibid., 290–91.

64. Ibid., 292.

65. See the Salgado page of the Illy website for more details and images of Salgado's collaboration with Illy: http://www.illy.com/wps/wcm/connect/us/illy/art/sebastiao-salgado/.

66. *Black Gold* (dir. Francis and Francis) was shown in London to Prime Minister Tony Blair and other members of Parliament in Westminster on January 29, 2007, in a bid by the Ethiopian government to raise awareness of the imbalance between what coffee growers in Ethiopia and international coffee companies, such as Starbucks, earn per pound of coffee sold.

67. Ashley Seager, review of *Black Gold*, *Guardian*, January 29, 2007, 25.

68. Stated by Andrea Illy at the launch of the *In Principio* exhibition held at Gallery 32 in London, courtesy of the Embassy of Brazil in London, on September 10, 2007.

69. This photograph can be viewed both on the cover of and inside Kossoy, *Fotografia and Histori* (119). Gaensly, born in Switzerland in 1843, lived first in Bahia and then in São Paolo. He is best known for his postcards of Brazil and must thus be seen as a key constructor of picturesque Brazil, though many of his photographs also show aspects of modernization and development in and around São Paolo. He focused extensively on coffee production. For more on Gaensly, see Boris Kossoy, *Sao Paulo, 1900*.

70. See Salgado, *Workers*, 64–69.

71. Illy, it should be said, combines its commitment to sustainable development with distinctly postmodern methods of advertisement. The company is known to have had a pop-up shop in New York's SoHo for just three months, which sold and served its coffee. In addition, the pop-up shop acted as a three-dimensional walk-in advertisement for the brand. The images of *In Principio* were displayed as part of the advertisement. These same images were also later displayed in the offices of the FAO. Thus, the photographs serve to underline the inevitable and contradictory links that exist in late capitalism between products, markets, people, and diverse ideological interests.

72. A key image of the Serra Pelada series of images that form part of *Workers*. See Salgado, *Workers*, 310–11.

73. It goes without saying that the title given to Salgado's latest—and supposedly last—photo-essay, *Genesis*, deliberately evokes the Bible, as does the name of his travelling exhibition *Exodus*.

74. A good example of his synergistic approach is to be found in Cardenal's *Salmos*, a rewriting of the Psalms in terms of contemporary Latin American history. Another example is his *Cosmic Canticle*, in which he combines theology, science, and his vision of the greatness of Latin America.

75. Adorno's theories on music can be found on the Soundscapes website. See http://www.icce.rug.nl/~soundscapes/DATABASES/SWA/On_popular_music_1.shtml.

76. Stallabrass, "Sebastião Salgado and Fine Art Photojournalism," 134.

77. Van Riper, *Talking Photography*, 32.

78. This volume bears witness to the extreme violence wrought by socioeconomic inequalities. Several photographs focus on dead bodies, sprawled in the dirt, nameless and unrecognized. Other images show factory workers, but here, unlike in Salgado's work on industrialization, the line workers are consumed by the system, rendered anonymous by it. In the midst of the natural colours of Mexico—blue skies, bright sunshine, brown, dusty earth— there is a deep despair that cries out. Chomsky, in his *Nation* article "Notes on NAFTA: 'The Masters of Man,'" writes of an international class war, in which the "masters of mankind"—the global billion who enjoy the fruits of capital—enrich themselves on the "other people." Chomsky states, "One consequence of the globalization of the economy is the rise of new governing institutions to serve the interests of private transnational economic power. Another is the spread of the Third World social model, with islands of enormous privilege in a sea of misery and despair" (19).

79. With its focus on animals and sentient life, close to nature, Salgado's current photo-essay, *Genesis*, emphasizes the inseparability of feeling and knowing. It also highlights beauty in terms of a natural aesthetic present among nonhumans, one that is then highlighted by the aesthetic processing of these images prior to their becoming public. A keen degree of social critique is implicit here, as animals, endangered as they are by human disruptions of their habitats, nevertheless provide an example of a harmonious, and hence of aesthetic and ethical, living.

80. In 1955, Edward Steichen organized what is perhaps the landmark photographic exhibition, *The Family of Man*. The work of sixty-eight photographers from around the world was exhibited in the United States in a bid to stress the essential oneness of all humanity. A total of over five hundred images offered a globally encompassing narrative of humanity. Many of the images were by well-known photographers, including Magnum members like Henri Cartier-Bresson and Robert Capa. The global sweep of Salgado's lens has caused his work to often be referred to in terms of this ambitious exhibition.

3. Eye Witness

1. During my interview with her in Paris on December 11, 2007, Lélia Wanick Salgado spoke at length about her diverse attempts to find satisfactory

ways of linking an image to a caption. She stated that finally she had decided on creating a small booklet to accompany the main book of images, so that both could be laid open side by side. By placing the captions in a separate booklet, she stated that the viewer had the choice of consulting them as and when he or she wished.

2. As I write this, I am, of course, acutely aware of how much the visual styles of these photographers differ from one another. Nachtwey's images, for example, jolt and shock us; Jaar's approach is less to document than to evoke our collective memory—and hence conscience—through the deliberate montage of traces. Perhaps what I see in common among the names I cite in relation to Salgado is a shared ethical endeavour and a shared approach to photography as social engagement.

3. In an interview on a Brazilian television show, TV Cultura's *Programa Roda Viva*, on April 22, 1996, Salgado contrasts his work with that of a painter: while the latter takes three months to paint an image, he says, he takes 1/250 of a second to shoot one.

4. Kossoy, *Fotografia and Historia*, 97–122.

5. Solomon-Godeau, *Photography at the Dock*, xxii.

6. Ibid., xxv.

7. Sekula, "The Body and the Archive," 345.

8. Ibid., 352.

9. Ibid., 346.

10. Walker Evans, "Lyric Documentary," lecture given at Yale Art School, 1964. A transcription of the lecture is housed in the Walker Evans Archive, Museum of Modern Art, New York.

11. Evans, Hill, and Leisbrock, *Walker Evans: Lyric Documentary*. See pages 12–26 in that work for more on this lecture.

12. *Walker Evans: America*, dir. Pakay.

13. Marien, *Photography*, 208.

14. Ponge, *Le parti pris des choses*. As with Salgado's, Ponge's work has been linked to the Renaissance, in his case to the work of the French Renaissance poet Rémy Belleau.

15. Aristotle, *Poetics* 9:1451b, 1463 f.

16. Prosser, *Light in the Dark Room*, 4.

17. The *Guardian* photograph was a syndicated reprint from a Reuters article. See David Viggers, "This One Is Worth a Thousand Words," Reuters Photographers blog, *Reuters*, March 12, 2008, http://blogs.reuters.com/photo/tag/vasconcelos. Interestingly, Marc Gauthier analyses this image in the light of works by famous painters in a blog entry on March 17, 2008. "Five Keys to Understand the Aesthetics of a News Picture," *My Web Space about Art and Its History. Focal Point: Quebec City*, http://www.marcgauthier.com/blog_en.

18. During my visit to the MST offices in São Paolo and in Rio de Janeiro, as well as to Terra Prometida, an MST settlement outside Rio de Janeiro, I was struck by the prevalence of posters of images from *Terra*, which were to

be seen on walls everywhere. Salgado's images legitimized and fomented the actions of the MST with an almost mystical fervour. Likewise, during my visit in July 2006, I noted that the office of Justiça Global, an organization providing legal aid for human rights in São Paolo, also had images from *Terra* on their walls.

19. Ricoeur, *Time and Narrative*.

20. Salgado, *An Uncertain Grace*, 153 (caption to photograph on p. 89).

21. Salgado, *Sahel: The End of the Road*, 130 (caption to photograph on p. 97).

22. Strand, *Photograph—New York*, was reproduced in Alfred Stieglitz's photographic journal *Camera Work* nos. 49–59 (1917).

23. Rosler, "In, Around, and Afterthoughts," 271.

24. Ibid., 262.

25. Benjamin, "A Brief History of Photography," 250.

26. Cadava, *Words of Light*, xxix.

27. For more on various aspects of Kracauer's work, see *New Formations* 61 (summer 2007), a special issue devoted to him.

28. Kracauer, "Photography," 81.

29. Barnouw, *Critical Realism*, 17.

30. Ibid., 9.

31. Perhaps due to the relative unavailability of translations of his work in English, this valuable study of photography and film remains much underrecognized. In it, Kracauer explores the role and relevance of visual media and, more importantly, visual aesthetics for capturing the new modes of experience that characterize modernity.

32. Barnouw, *Critical Realism*, 81.

33. Siegfried Kracauer and Kristeller, *History*, 191.

34. As cited in Barnouw, *Critical Realism*, 15.

35. Gualtieri, "The Territory of Photography," 89.

36. During, *Modern Enchantments*.

37. During's work is interesting in that it reveals the extent to which secularized forms of magic, often dependent on modern technology for their effects, act as spaces of reflexivity in modern culture. He also shows how religious magic has been transformed and technologized in order to become secular, though both forms depend on performance and spectacle. In showing us the intrinsic relevance of magic to modern secular culture, During throws light on, among other things, the Harry Potter phenomenon that has become so intrinsic to contemporary experiences of childhood.

38. A good source for information and links on early forms of photography is "A Primer on Processes" on the American Museum of Photography website, http://www.photographymuseum.com/primer.html.

39. Mitchell, *What Do Pictures Want?*, 87.

40. Ibid., 48.

41. Take, for example, the case of the Bangladesh war of independence in 1971: while many contemporary viewers recall that time and have some refer-

ences to it, nevertheless, it is now seldom referred to in the press or media. The photographic exhibition *Bangladesh 1971*, organized by Autograph-ABP in April 2008, made this war vivid while also lending historical depth to general attitudes vis-á-vis the Bangla communities of East London: see "Images of the 1971 Bangladesh War at Rivington Place," *Culture24*, April 11, 2008, http://www.culture24.org.uk/home. Furthermore, for second-generation British Bangladeshis, the images helped construct historical memories of this event that preceded their time.

42. See the Art Gallery of NSW website at http://archive.artgallery.nsw.gov.au/media/archives_2006/magical_realism for details of an exhibition held in Wales in 2006 of magical realist photography. The website states that the exhibition explored the magical potential of photography.

43. Carpentier, "On the Marvelous Real in America," 85–86.

44. Jameson, "On Magical Realism in Film," 301, 303.

45. Ibid., 311.

46. This essay appears in *Magical Realism: Theory, History, Community*, a volume edited by Lois Parkinson Zamora and Wendy B. Faris. While this book establishes magical realism as an international movement, nevertheless, Carpentier's essay serves to highlight specifically Latin American features of *lo real maravilloso*.

47. Lois Parkinson Zamora, "Swords and Silver Rings: Objects and Expression in Magical Realism and the New World Baroque," *Magical Realism and the New World Baroque* (website of the University of Houston), http://www.uh.edu/~englmi.

48. García Canclini, *Culturas híbridas*.

49. Kaup, "The Future Is Entirely Fabulous," 221.

50. Much critical attention has been given to the baroque in Latin American visual culture. This is a fertile research field that marks out the ways in which the baroque offered routes to appropriation of culture by Latin Americans in the face of imperialism and colonization.

51. Campos, "The Ex-centric's Viewpoint," 4.

52. João Almino, foreword to *Haroldo de Campos in Conversation*, 7–8.

53. Campos, "The Ex-centric's Viewpoint," 5.

54. Salgado et al., *Migrations*. This work is available online at http://repositories.cdlib.org/cgi/viewcontent.cgi?article=1024&context=townsend.

55. Édouard Glissant, "Baroque as a World Philosophy," UNESCO Courier, September 1987, http://www.unesco.org/new/en/unesco-courier/. For more on questions of the baroque, hybridity, and creolization, see Édouard Glissant, "La créolisation du monde est irreversible," *Le Monde*, supplement no. 18641, December 31, 2004, 26–29.

56. Alejadinho's Sanctuary of Bom Jesus do Matozinho, with its twelve prophets guarding entry into the church, is a wonderful example of how New World baroque fused the rational discourses of institutionalized religion with the sensory.

57. Cover photo of Salgado, *An Uncertain Grace*.

58. Vieira, "Snapshots," 159.

59. Author's interview with Salgado, Amazonas Images, Paris, December 11, 2007.

60. Beverley, *Subalternity and Representation*.

61. See Guha, *Subaltern Studies*.

62. A key text on the structures of elitism in Latin America is, of course, Ángel Rama's *La ciudad letrada* (translated by John Charles Chasteen as *The Lettered City*).

63. As quoted in Beverley, *Subalternity and Representation*, xiii.

64. Salgado, *Workers*, 8.

65. Ibid., 11.

66. I thank John Kraniauskas for elaborating on this concept of transculturation and, in particular, for marking out ways of distinguishing it from that of hybridity, as laid out by García Canclini.

67. Jordanova, *History in Practice*, 166.

68. Edwards, *Raw Histories*.

69. Ibid., 235.

4. Just Regard

1. Several of the images in this collection can be seen on the website of the agency that represents Salgado in London, NB Pictures: www.nbpictures.com.

2. John Berger, in the video *Spectre of Hope* (dir. Carlin). In this video, Berger makes reference to the work of Simone Weil, who, he states, worded the ethical question as "Why? Why must I suffer this?"

3. Lingis, "The Immoralist," 197–216.

4. Hullot-Kentor, "Ethics, Aesthetics, and the Recovery of the Public World," 213.

5. Jean-François Chevrier, "Salgado, ou l'exploitation de la compassion," *Le Monde*, April 19, 2000, http://www.lemonde.fr. Chevrier is an art historian based at the École Nationale Supérieur des Beaux-Arts in Paris.

6. Ibid. My translation from the French.

7. *Spectre of Hope* (dir. Carlin).

8. Sontag, *Regarding the Pain of Others*, 70.

9. Raúl Antelo, "Apenas ideología," Clarín.com, May 25, 2002, http://www.clarin.com. The debate that took place between Antelo and Julio Ramos, two Latin American academics who have considered Salgado's work, will be explored in the last chapter.

10. Cohen, *States of Denial*, 179.

11. Ibid., 194.

12. Parker, "A Cold Light," 154.

13. Duganne, "Photography After the Fact," 67.

14. Capa, quoted in ibid., 66.

15. Think, for example, of Cartier-Bresson's photographs taken in India during the mass migrations and communal violence of Partition in 1947 and

1948. The black-and-white images of refugees share many features with Salgado's aesthetic, so that human displacement and poverty are seen in terms of a deliberate tonality, exquisite selection, and careful composition. See Cartier-Bresson, *In India*.

16. For more on this, see Parvati Nair, "Autography from the Margins." McCurry's photo appeared on the cover of the June 1985 issue of *National Geographic*.

17. Ironically, concomitant with such concern for the rights of women in Afghanistan is the fact that the U.S. invasion of Afghanistan, a response to the events of 9/11, has destroyed the lives of countless women, men, and children in this country.

18. Haleh Anvari's travelling photographic installation *Chador-Dadar* is subversive for several reasons: first, it is an outcry against the forced veiling of women in black in Iran by Islamic authorities; second, by placing women in colourful chadors against the Eiffel Tower, for example, Anvari challenges both Orientalist attitudes prevalent in the West and supposed distinctions between the veiled and the unveiled, Islam and modernity, the West and its Other. The images draw attention also to the very diverse discourses that emanate from an image when it is placed in different frames or contexts. Contrast, for example, the images of the chador-clad women against the South Bank in London or the Eiffel Tower with those of women against the Taj Mahal or Hagia Sophia. Furthermore, the bright chadors covering the women's faces and bodies loudly announce the visibility of the unseen. I find Anvari's images interesting for this reason: they act as a metaphor for photographs in general, so that we not only note what is visible, but we also feel compelled to enquire about what remains invisible. See Haleh Anvari's website, http://www.halehanvari.com.

19. Henri Cartier-Bresson, *Srinagar, Kashmir, 1948*. This image can be found in Henri Cartier-Bresson, *In India*, 16–17.

20. On August 1, 2010, *Time* put on its cover yet another photograph of an Afghan girl, modelled on McCurry's image of Sharbat Gula. This time, though, the subject had been severely disfigured, having had her nose and ears chopped off by her husband with the support of the Taliban. The image unleashed strong responses from many. Some critics accused *Time* of exploiting the subject's suffering in order to uphold U.S. presence in Afghanistan. According to Priyamvada Gopal, "The mutilated Afghan woman ultimately fills a symbolic void where there should be ideas for real change. The truth is that the US and allied regimes do not have anything substantial to offer Afghanistan beyond feeding the gargantuan war machine they have unleashed." See Priyamvada Gopal, "Burqas and Bikinis," *Guardian*, August 3, 2010, http://www.guardian.co.uk/commentisfree/2010/aug/03/burkas-bikinis-reality-afghan-lives.

21. For more on this topic, see "'Afghan Girl' Mystery Solved: *National Geographic Photographer* Finds His Most Famous Subject," NPR website, March 13, 2002, http://www.npr.org.

22. Reinhardt, Edwards, and Duganne, *Beautiful Suffering*, n.p.

23. See Solomon-Godeau, "Who Is Speaking Thus? Some Questions about Documentary Photography," *Photography at the Dock*, 301 n. 11; and Sekula, "On the Invention of Photographic Meaning," 45.

24. See, for instance, Magubane's *Untitled* (the Wenela Mine recruiting agency), taken in Johannesburg, South Africa, in 1967. This photograph is reproduced in Marien, *Photography*, 327. Magubane's images of miners are grim, reflecting the disregard shown by the mining industry to the cultures and values of local peoples. They also clearly mark the extreme poverty of the miners, their economic distress and struggle, as well as the disregard and dehumanization that is inflicted on them. Unlike Salgado's work, Magubane shows only oppression. There is no apparent outlet for hope in these images. The miners seem imprisoned by their circumstances. It is also worth noting that while this work by Magubane is overtly political to the extent that its practice often resulted in his personal suffering in the fight against apartheid, in recent years he has turned increasingly to art photography, documenting tribal peoples in post-apartheid South Africa.

25. Galeano, "Salgado, Seventeen Times," 11. This essay was written for the catalogue of *An Uncertain Grace*, Salgado's exhibition at the San Francisco Museum of Modern Art in 1990.

26. Ibid., 11.

27. See González Flores, *Fotografía y pintura*. González Flores is a practitioner, teacher, and critic of photography working in Mexico.

28. Lutz and Collins, "The Photograph as an Intersection of Gazes," 358.

29. Ibid., 359.

30. Ibid., 360.

31. Berger, *Ways of Seeing*, 1.

32. Sartre, *Modern Times*, 43.

33. Ibid., 45.

34. Ibid.

35. Given that Cartier-Bresson was one of the founding members of Magnum, it is not surprising to find that Salgado and other photojournalists who later joined that agency have in common with him, Robert Capa, and the other cofounders a deliberate espousal of the aesthetic.

36. I thank Carlos Eduardo Gaio for his help during my visit to the office of Justiça Global in São Paolo on August 2, 2006. Gaio assisted me in tracing human rights violations linked to the MST.

37. John Mraz, "Sebastião Salgado: Maneiras de ver a America Latina," trans. Geraldo A. Lobato Franco, http://www.studium.iar.unicamp.br/19/salgado/SSALGADO.pdf, n. 42. This PDF offers a Portuguese translation of Mraz's essay "Sebastião Salgado: Ways of Seeing Latin America."

38. See *Powaqqatsi: Life in Transformation*, dir. Regio. As the cover of this DVD states, this film calls into question the human cost of progress via a visual and audio experience that works on several levels: emotional, spiritual, intellectual, and aesthetic. It is interesting to note how this film, a sequel to *Koyaanisqatsi* (1983), made by the same director and aiming to contrast the beauty of nature with the frenzy of urban life, targets the viewer on these dif-

ferent levels, thus speaking not solely to reason, but also to sentience, emotion, and the imagination.

39. A large selection of Meyer's work can be found on the website of the Tyba Agency that he founded: http://www.tyba.com.br. One of the images of the Serra Pelada can also be seen on the Blogo do Universo website: "Tributo a Claus Meyer," October 10, 2009, http://juniverso.blogspot.com/2009/10/tributo-claus-meyer.html.

40. Lélia Wanick Salgado and Sebastião Salgado, untitled introduction, in Rio Branco, *Miguel Rio Branco*, n.p.

41. Strauss, *Between the Eyes*, 111.

42. W. Eugene Smith's image of Welsh miners can be viewed on the Masters of Photography website, http://www.masters-of-photography.com/S/smith/smith_miners_full.html.

43. Strauss, *Between the Eyes*, 110.

44. Kearney, "The Crisis of the Image," 12–23.

45. See Andy Grundberg's *Crisis of the Real* for more on the consequences of postmodernity on photography. Notions of pastiche, masking, and reflexivity in photography are explored here, as well as the overlap of photography with other visual media, such as television, in the postmodern age.

46. Cohen, *States of Denial*, 179.

47. Gombrich, *The Story of Art*, 302–3.

48. Kearney, "The Crisis of the Image," 12–23.

49. Levinas, *Otherwise Than Being*, 12.

50. Levinas, "Reality and Its Shadow," 129–43.

51. Wyschogrod, "The Art in Ethics," 147.

52. Levinas, "Reality and Its Shadow."

53. Flusser, *Towards a Philosophy of Photography*, 43.

54. Levinas, "The Light and the Dark," 230.

55. Nancy, *The Ground of the Image*.

56. Ibid., 71.

57. Chevrier, "Salgado, ou l'exploitation de la compassion." My translation.

58. Derrida, *Deconstruction Engaged*, 18.

59. James Johnson, "'The Arithmetic of Compassion': Rethinking the Politics of Photography," *British Journal of Political Science* 41, no. 3 (summer 2011).

60. Ibid., 27.

61. Ibid., 34.

62. Costello and Willsdon, *The Life and Death of Images*, 8–9.

63. Scarry, *On Beauty and Being Just*, 57.

64. Costello and Willsdon, *The Life and Death of Images*.

65. See Mitchell, "Cloning Terror," and Pollock, "Response to W. J. T. Mitchell."

66. Bernstein, "In Praise of Pure Violence (Matisse's War)."

67. Butler, "Response to J. M. Bernstein," 62.

5. The Practice of Photography

1. See the Instituto Terra website, http://www.institutoterra.org.

2. Rancière, *On the Shores of Politics*.

3. Ibid., 2.

4. These statements are inevitably made in the context of economic and statistical analyses that stem from Salgado's training as an economist.

5. Flavio Costa, "Retratos de la 'vida desnuda'" (interview with Julio Ramos), Clarín.com, May 25, 2002, http://www.clarin.com.

6. It is interesting to compare Salgado's photographs of gorillas from Rwanda with those of another photographer, Juan Pablo Moreiras, who states that he was with Salgado when they both took their images. Moreiras is a photographer whose work is devoted to environmental issues, such as fighting climate change. If the subjects of the two photographers are similar, their images are very different, both in their dissemination and effect. Moreiras's photographs are in colour and many of them appear digitally. As a result, they approximate the viewer to the subject, while also offering ease of access, in a way that results in a very different relation to the image from the one that we have to Salgado's black-and-white photographs.

7. Raúl Antelo, "Apenas ideología," Clarín.com, May 25, 2002, http://www.clarin.com.

8. Adorno, "Commitment," 88.

9. Ibid., 88.

10. Marder, "*Minima Patientia*," 62.

11. Ibid., 72.

12. Huxley, *The Great Naturalists*.

13. Interview with Salgado, Amazonas Images, Paris, December 11, 2007.

14. Amanda Hopkinson's interview with Salgado, Barbican Centre, London, June 2003.

15. Author's interview with Salgado, Amazonas Images, Paris, December 11, 2007.

16. Berger, "Uses of Photography," 61.

17. Ibid., 62.

18. Rancière, *The Politics of Aesthetics*.

19. Ibid., 36.

20. Ibid., 37.

21. Ibid., 38.

22. Žižek, "The Lesson of Rancière," in Rancière, *The Politics of Aesthetics*, 69–79.

23. Author's interview with Salgado, Gallery 32, London, September 10, 2007.

24. During my interview with Salgado in London on September 10, 2007, he mentioned that, rather than embark on more and more photographic projects, he intended to increasingly focus on creating theme-based collections from his archive of images. Another such volume is *Africa* (2007), an

impressive overview of the continent put together from photographs taken over the years during Salgado's many visits there.

25. Salgado, *L'homme et l'eau*, 10.

26. Interviews with Salgado, London, September 10, 2007, and Paris, December 11, 2007.

27. In this context, I was interested to note that Roser Vilallonga, a photojournalist for the newspaper *La Vanguardia* who presented her work at Expo 2008 in Zaragoza, Spain, in summer 2008 (devoted to the theme of water and sustainability), told me that she was disappointed by *Genesis*. Salgado, in her view, is a photographer of people, not places or animals. This view has been repeated to me by many. To me, it is indicative of a lack of understanding that people, place, and wildlife are inextricable from one another. People are part of nature. This is so even if the increasingly urbanized and mechanized nature of human societies turns nature into a remote form of alterity that is glimpsed through images and films. The metropolis, removed as it appears from nature, cannot exist without it.

28. Salgado, *L'homme et l'eau*, 10 (my translation).

29. Author's interview with Salgado, Amazonas Images, Paris, December 11, 2007.

30. Couto, "The Spark and the Tear," 7.

31. Appiah, *Cosmopolitanism*, 173.

32. Ibid., 104.

33. Solomon-Godeau, "'The Family of Man.'"

34. Ramos, "Los viajes de Sebastião Salgado."

35. Indeed, the invasion of Iraq is possibly one of the first wars to be transmitted via the digital medium. The proliferation of images and the increased ease of access to images lead to multiple uses to which such images may be put.

36. Salgado, in *Sebastião Salgado: The Photographer as Activist* (film).

37. Ibid.

38. Report on *Genesis*, *Guardian*, weekend supplement, September 11, 2004, 23.

39. Derrida, *The Animal That Therefore I Am*.

40. Ibid., 32.

41. Genesis 1:28, cited by David Attenborough, as quoted in Steven Connor, "Attenborough: Genesis? It Can Go Forth and Multiply," *Independent*, January 31, 2009.

42. Berger, "Why Look at Animals?," 3.

43. For more detail on this point, see Parsons, *Aesthetics and Nature*, 35–40.

44. Some information on Robert Facon Scott's diary can be gleaned from a webpage of the British Library: http://www.bl.uk/onlinegallery/onlineex/histtexts/scottdiary/.

45. Simon Hattenstone, "High Summer," *Guardian*, July 2, 2005, http://www.guardian.co.uk.

46. Sallis, *Topographies*, 8.

47. Ibid., 4.

48. Ibid., 5.

49. Ibid., 19.

50. Tuan, *Topophilia*, 4.

51. Kapuscinski, *The Other*.

52. Merleau-Ponty, *Sense and Non-sense*, x.

53. Merleau-Ponty, *The World of Perception*, 38–39.

54. Ibid., 43.

55. Ibid., 54.

56. Ibid., 57.

57. *An Inconvenient Truth*, dir. Guggenheim.

58. Karl, Marx, *The Communist Manifesto*.

59. Shiva, "War against People and Nature from the South."

60. Shiva, "Water Wars in India," 7.

61. John Vidal, "Fears for the World's Poor Countries as the Rich Grab Land to Grow Food," *Guardian*, July 3, 2009, http://www.guardian.co.uk.

62. Sharma, quoted in ibid.

63. Gutiérrez, *A Theology of Liberation*. Gutiérrez, the Peruvian Dominican priest and theologian, first wrote this seminal text on liberation theology in 1971. By politicizing the Catholic faith and refiguring religion as a route to emancipation that is at once spiritual and material, Gutiérrez revolutionized the established hierarchies to which the church had long been accustomed. This marriage of religion and politics empowered the disenfranchised; it lent voice to the hitherto voiceless and forged a sense of spiritual and political community for those relegated to exclusion and marginalization.

64. Lecture given by Salgado at the invitation of Orville Schell, University of California, Berkeley, in 2002 to mark the publication by the University of California Press of Salgado's photo-essay on famine in the Sahel region of Africa.

65. Friends of the MST, August 24, 2002, http://www.mstbrazil.org/.

66. Da Cunha, "Exodus, or an Imagined Political Community."

67. Townsend, "Responses," 25–26.

68. Davis, *Planet of Slums*.

69. Jonas Bendiksen, *The Places We Live*, http://www.theplaceswelive.com.

70. The success of the film *Slumdog Millionaire* (dir. Boyle) rests on the contrast between rapid economic expansion and slum life in Dharavi, once Asia's largest slum and now prime real estate in central Mumbai. Largely through skilful editing and expert camerawork, the film manages to turn slum life into a vibrant and colourful backdrop to modern-day India rather than offer any serious examination of the causes and structures that support disenfranchisement. The writer Arundhati Roy has strongly criticized the film on the grounds that it glamourizes and fetishizes poverty: "And here's the rub: *Slumdog Millionaire* allows real-life villains to take credit for its cinematic achievements because it lets them off the hook. It points no fingers, it

holds nobody responsible. Everyone can feel good. And that's what I feel bad about." Arundhati Roy, "Caught on Film: India 'Not Shining,'" Dawn.com, March 2, 2009, http://www.dawn.com.

71. Unger, *Democracy Realized*, 5.

72. Roberto Mangabeira Unger, "Passion: An Essay on Personality," "Philosophy and Religion" page of Unger's website, http://www.law.harvard.edu/faculty/unger/index.php.

73. Rancière, *The Future of the Image*, 15.

74. Azoulay, *The Civil Contract of Photography*, 2008, 17.

75. Ibid., 18.

Books by Sebastião Salgado

Africa. Cologne: Taschen, 2007.

The Children. New York: Aperture, 2000.

The End of Polio: A Global Effort to End a Disease. Boston: Bullfinch, 2003.

L'homme et l'eau. Paris: Éditions Terre Bleue, 2005.

Migrations: Humanity in Transition. New York: Aperture, 2000.

Outras Américas. São Paolo: Companhia das Letras, 1999.

Sahel: The End of the Road. Berkeley: University of California Press, 2004.

Terra. New York: Phaidon, 1997.

An Uncertain Grace. New York: Aperture, 1990.

Workers: *An Archaeology of the Industrial Age.* New York: Phaidon, 1993.

Books and Articles

Abbott, Berenice. "Photography at the Crossroads." *Universal Photo Almanac,* 42–47. New York: Falk, 1951.

Adams, Robert. *Beauty in Photography.* New York: Aperture, 1996.

Adorno, Theodor. *Aesthetic Theory.* Trans. Robert Hullot-Kentor. Minneapolis: University of Minnesota Press, 1998.

———. "Commitment." *Notes to Literature,* ed. Rolf Tiedemann, trans. Shierry Weber Nicholsen, 2: 76–94. New York: Columbia University Press, 1992.

Adorno, Theodor, and Walter Benjamin. *Adorno-Benjamin Briefweschel, 1928–1940.* Frankfurt am Main: Suhrkamp, 1994.

Almino, João. Foreword to *Haroldo de Campos in Conversation: In Memoriam, 1923–2003,* ed. Bernard McGuirk and Else R. P. Vieira. London: Zoilus, 2008.

Andujar, Claudia. *A vulnerabilidade do ser.* São Paolo: Cosac Naify, 2005.

Appiah, Kwame Anthony. *Cosmopolitanism: Ethics in a World of Strangers.* London: Penguin, 2007.

Aristotle. *Poetics* 9:1451b. *The Basic Works of Aristotle,* ed. Richard McKeon. New York: Random House, 1941.

Azoulay, Ariella. *The Civil Contract of Photography*. New York: Zone, 2008.

Barnouw, Dagmar. *Critical Realism: History, Photography, and the Works of Siegfried Kracauer*. Baltimore: Johns Hopkins University Press, 1994.

Barthes, Roland. *Camera Lucida*. Trans. Richard Howard. London: Fontana, 1984.

Beck, Ulrich. *Risk Society: Towards a New Modernity*. London: Sage, 1992.

Benjamin, Walter. *The Arcades Project*. Trans. H. Eiland and K. McLaughlin. Cambridge: Harvard University Press, 1999.

———. "A Small History of Photography." *One Way Street and Other Writings*, 240–57. London: Verso, 1978.

———. "On Some Motifs in Baudelaire." *Illuminations*, 155–200. New York: Shocken Books, 1969.

Berger, John. "Understanding a Photograph." *The Look of Things*, 181–85. London: Viking, 1974.

———. "Uses of Photography." *About Looking*, 30–70. London: Vintage, 1991.

———. *Ways of Seeing*. London: Penguin, 1972.

———. "Why Look at Animals?" *About Looking*, 3–30. New York: Vintage, 1991.

Berman, Marshall. *All That Is Solid Melts into Air*. London: Verso, 1982.

Bernstein, Jay M. "'The dead speaking of stones and stars': Adorno's *Aesthetic Theory*." *The Cambridge Companion to Critical Theory*, ed. Fred Rush, 139–64. Cambridge: Cambridge University Press, 2004.

———. "In Praise of Pure Violence (Matisse's War)." *The Life and Death of Images*, ed. Diarmuid Costello and Dominic Willsdon, 37–55. London: Tate, 2008.

Beverley, John. *Subalternity and Representation: Arguments in Cultural Theory*. Durham: Duke University Press, 1999.

Bowden, Charles. *Juárez: The Laboratory of Our Future*. New York: Aperture, 1998.

Butler, Judith. "Response to J. M. Bernstein." *The Life and Death of Images*, ed. Diarmuid Costello and Dominic Willsdon, 56–62. London: Tate, 2008.

Cadava, Eduardo. *Words of Light: Theses on the Photography of History*. Princeton: Princeton University Press, 1992.

Campos, Haroldo de. "The Ex-centric's Viewpoint: Tradition, Transcreation, Transculturation." *Haroldo de Campos: A Dialogue with the Brazilian Concretist Poet*, ed. K. David Jackson, 10–24. Oxford: Centre for Brazilian Studies, 2005.

Cardenal, Ernesto. *Cosmic Canticle*. New York: Curbstone, 2002.

———. *Salmos*. Madrid: Editorial Trotta, 2000.

Carpentier, Alejo. "The Baroque and the Marvelous Real." *Magical Realism: Theory, History, Community*, ed. Lois Parkinson Zamora and Wendy B. Faris, 89–108. Durham: Duke University Press, 1995.

———. "On the Marvelous Real in America." *Magical Realism: Theory, History, Community*, ed. Lois Parkinson Zamora and Wendy B. Faris, 75–84. Durham: Duke University Press, 1995.

Cartier-Bresson, Henri. *China in Transition*. London: Thames and Hudson, 1956.

———. *In India*. London: Thames and Hudson, 1987.

Chomsky, Noam. "Notes on NAFTA: 'The Masters of Man.'" *Nation*, March 29, 1993, 1–11.

Clark, T. J. "Responses." Sebastião Salgado, T. J. Clark, Orville Schell, Nancy Scheper-Hughes, Candace Slater, and Michael Watt, *Migrations: The Work of Sebastião Salgado*, n.p. Occasional Papers 26. Berkeley, Calif.: Doreen B. Townsend Center for the Humanities, 2003.

Clarke, Graham. *The Photograph*. Oxford: Oxford University Press, 1997.

Cohen, Stanley. *States of Denial: Knowing about Atrocities and Suffering*. Cambridge, Polity, 2001.

Coronado, Jorge. "Toward Agency: Photography and Everyday Subjects in Cuzco, 1900–1940." *Latin American Perspectives* 36 (2009): 119–35.

Costa, Helouise, and Renato Rodrigues da Silva. *A fotografia moderna no Brasil*. São Paolo: Cosacnaify, 1995.

Costello, Diarmuid, and Dominic Willsdon, eds. *The Life and Death of Images*. London: Tate, 2008.

Cott, Jonathan. "Sebastiao Salgado: The *Rolling Stone* Interview." *Rolling Stone*, December 1991, 12–26.

Couto, Mia. "The Spark and the Tear." Introduction to Sebastião Salgado, *Africa*, 5–8. Cologne: Taschen, 2007.

Da Cunha, Mariana A. C. "Exodus, or an Imagined Political Community: The Landless Workers Movement and Internal Migration in the Work of Sebastião Salgado." *Intexto* 2 (2004), http://seer.ufrgs.br/index.php/intexto.

Davis, Mike. *Planet of Slums*. London: Verso, 2006.

Delanty, Gerard. *Modernity and Postmodernity*. London: Thousand Oaks; New Delhi: Sage, 2000.

Derrida, Jacques. *The Animal That Therefore I Am*. New York: Fordham University Press, 2008.

———. *Deconstruction Engaged*. Ed. Paul Patton and Terry Smith. Sydney: Power, 2001.

———. *Memoirs of the Blind: The Self-portrait and Other Ruins*. Trans. Pascale-Anne Brault and Michael Naas. Chicago: University of Chicago Press, 1993.

Donnan, Hastings, and Thomas M. Wilson. *Frontiers of Identity, Nation and State*. Oxford: Berg, 1999.

Dube, Siddharth. "A Global Effort to End a Disease." In *The End of Polio: A Global Effort to End a Disease*, ed. Sebastião Salgado, 18–20, 108–33. Boston: Bullfinch, 2003.

Duganne, Erina. "Photography After the Fact." *Beautiful Suffering: Photography and the Traffic in Pain*, ed. Mark Reinhardt, Holly Edwards, and Erina Duganne. Chicago: University of Chicago Press, 2007.

During, Simon. *Modern Enchantments: The Cultural Power of Secular Magic*. Cambridge: Harvard University Press, 2002.

Dussel, Enrique. *The Underside of Modernity: Apel, Ricoeur, Rorty, Taylor and*

the *Philosophy of Liberation*. Trans. and ed. Eduardo Mendieta. New York: Humanity, 1998.

Edwards, Elizabeth. *Raw Histories: Photographs, Anthropology and Museums.* Oxford: Berg, 2001.

Ermakoff, George. *O negro na fotografia brasileira do século XIX.* Rio de Janeiro: G. Ermakoff Casa Editorial, 2004.

Evans, Walker, John T. Hill, and Heinz Leisbrock. *Walker Evans: Lyric Documentary*. Göttingen, Germany: Steidl, 2006.

Fanon, Frantz. *Black Skin, White Masks.* New York: Grove, 1967.

———. *The Wretched of the Earth*. New York: Grove, 1966.

Flusser, Vilém. *Towards a Philosophy of Photography*. London: Reaktion, 2000.

Freyre, Gilberto. *Açucar.* São Paolo: Companhia das Letras, 1997.

Furst, Lilian R., ed. *Realism*. New York: Longman, 1992.

Galeano, Eduardo. *Open Veins of Latin America.* New York: Monthly Review, 1973.

———. "Salgado, Seventeen Times." Sebastião Salgado, *An Uncertain Grace*, 15. New York: Aperture Foundation, 1990.

García Canclini, Néstor. *Culturas híbridas: Estrategias para entrar y salir de la modernidad.* Mexico City: Grijalbo, 1990.

Gautrand, Jean-Claude. "Looking at Others: Humanism and Neo-Realism." *New History of Photography*, ed. Michel Frizot, 678–720. Cologne: Könneman, 1998.

Gilroy, Paul. "After the Great White Error . . . the Great Black Mirage." *Race, Nature, and the Politics of Difference*, ed. Donald S. Moore, Jake Kosek, and Anand Pandian, 73–98. Durham: Duke University Press, 2003.

Gogol, Eugene. "Learning to Participate: The Experience of the MST in Brazil." *The Concept of Other in Latin American Liberation*, 307–27. Lanham, Md.: Lexington, 2002.

Goldberg, David Theo, and John Solomos, eds. *A Companion to Racial and Ethnic Studies*. Malden, Mass.: Blackwell, 2002.

Goldblatt, David. *The Transported: A South African Odyssey*. New York: Aperture, 1989.

Goldman, Alan. "The Aesthetic." *The Routledge Companion to Aesthetics*, ed. Berys Gaut and Dominic McIver Lopes, 181–92. London: Routledge, 2001.

Gombrich, E. H. *The Story of Art*. 16th ed. London: Phaidon, 1995.

González Flores, Laura. *Fotografía y pintura: ¿Dos medios diferentes?* Barcelona: Editorial Gustavo Gili, 2005.

Grosz, Elizabeth. *Chaos, Art, Territory*. New York: Columbia University Press, 2008.

Grundberg, Andy, ed. *Crisis of the Real: Writings on Photography since 1974.* New York: Aperture, 1999.

Gualtieri, Elena. "The Territory of Photography: Between Modernity and Utopia in Kracauer's Thought." *New Formations* 61 (summer 2007): 76–89.

Guha, Ranajit, ed. *Subaltern Studies: Volumes 1–10*. Oxford: Oxford University Press, 1982.

Gutiérrez, Gustavo. *A Theology of Liberation: History, Politics, and Salvation.* New York: Orbis, 1988.

Haas, Ernst. *The Creation.* New York: Viking, 1971.

Hall, Stuart. "Democracy, Globalization, Difference." *Democracy Unrealized: Documenta 11_Platform 1,* ed. Okwui Enwezor, Carlos Basualdo, Ute Meta Bauer, Susanne Ghez, Sarat Maharaj, Mark Nash, and Octavio Zaya, 21–37. Ostfildern-Ruit, Germany: Hatje Cantz, 2002.

Hegel, G. W. F. *Philosophy of History.* Trans. J. Sibree. New York: Wiley, 1944.

Heilbrun, Françoise. *Towards Photojournalism.* Paris: Musée d'Orsay, 2007.

Hine, Lewis W. *Men at Work.* New York: Dover, 1977.

Hopkinson, Amanda. "Mediated Worlds: Latin American Photography." *Bulletin of Latin American Research* 20, no. 4 (2001): 520–27.

Hullot-Kentor, Robert. "Ethics, Aesthetics, and the Recovery of the Public World." *Things beyond Resemblance: Collected Essays on Theodor W. Adorno,* 210–19. New York: Columbia University Press, 2006.

Huxley, Robert, ed. *The Great Naturalists.* London: Thames and Hudson, 2007.

Itúrbide, Graciela, Raghu Rai, and Sebastião Salgado. *India, México: Vientos paralelos.* Madrid: Turner, 2002.

Jameson, Fredric. "On Magical Realism in Film." *Critical Inquiry* 12, no. 12 (winter 1986): 301–25.

———. *A Singular Modernity: Essay on the Ontology of the Present.* London: Verso, 2002.

Johnson, James. "'The Arithmetic of Compassion': Rethinking the Politics of Photography." *British Journal of Political Science* 41, no. 3 (summer 2011).

Jordan, Bill, and Franck Düvell. *Irregular Migration: The Dilemmas of Transnational Mobility.* Northampton, Mass.: Edwin Elgar, 2002.

Jordanova, Ludmilla. *History in Practice.* 2nd ed. London: Hodder Arnold, 2006.

Kapuscinksi, Ryszard. *The Other.* London: Verso, 2008.

Kaufman, Robert. "Aura, Still." *Walter Benjamin and Art,* ed. Andrew Benjamin, 121–47. London: Continuum, 2005.

Kaup, Monica. "The Future Is Entirely Fabulous: The Baroque Genealogy of Latin America's Modernity." *Modern Language Quarterly* 68, no. 2 (2007): 221–41.

Kearney, Richard. "The Crisis of the Image: Levinas's Ethical Response." *The Ethics of Postmodernity: Current Trends in Continental Thought,* ed. Gary B. Madison and Marty Fairbairn, 12–23. Evanston, Ill.: Northwestern University Press, 1999.

Kossoy, Boris. *Fotografia and Historia.* São Paolo: Ateliè Editorial, 2001.

———. *Sao Paulo, 1900: Imagens de Guilherme Gaensly.* São Paulo: Companhia Brasileira de Projetos e Obras, 1988.

Kossoy, Boris, and Maria Luiza Tucci Carneiro. *O olhar europeu: O negro na iconografia brasileira do seculo XIX.* São Paolo: Editora da Universidade de São Paolo, 1994.

Kracauer, Siegfried. "Photography." *The Mass Ornament: Weimar Essays,*

trans. and ed. Thomas Levin, 75–86. Cambridge: Harvard University Press, 1995.

———. *Theory of Film: The Redemption of Physical Reality*. Princeton: Princeton University Press, 1997.

Kracauer, Siegfried, and Paul Oskar Kristeller. *History: The Last Things before the Last*. Princeton: Markus Wiener, 1995.

Leicaworld: Photography International no. 2 (2005).

Levinas, Emmanuel. "The Light and the Dark." *Difficult Freedom: Essays on Judaism*, trans. Seán Hand, 228–30. Baltimore: Johns Hopkins University Press, 1990.

———. *Otherwise Than Being, or Beyond Essence*. Trans. Alphonso Lingis. The Hague: Martines Nihoff, 1981.

———. "Reality and Its Shadow." *The Levinas Reader*, ed. Seán Hand, 129–43. Oxford: Blackwell, 1989.

Lévi-Strauss, Claude. *Saudades do Brasil*. São Paolo: Companhia Das Letras, 1994.

———. *Tristes Tropiques*. Trans. John and Doreen Weightman. New York: Atheneum, 1974

Levine, Esther. *Berlin*. Berlin: Edition Heckenhauer, 2006

Light, Ken. *Witness in Our Time: Working Lives of Documentary Photographers*. Washington: Smithsonian Institution Press, 2000.

Lingis, Alphonso. "The Immoralist." *The Ethical*, ed. Edith Wyschogrod and Gerald P. McKenny, 197–216. Oxford: Blackwell, 2003.

Llamazares, Julio. *La lluvia amarilla*. Madrid: Seix Barral, 1985.

Lutz, Catherine, and Jane Collins. "The Photograph as an Intersection of Gazes: The Example of *National Geographic*." *The Photography Reader*, ed. Liz Wells, 354–74. London: Routledge, 2003.

Machel, Graça. *The Impact of War on Children*. New York: Palgrave, 2001.

Magubane, Peter. *Magubane's South Africa*. New York: Alfred A. Knopf, 1978.

Magubane, Peter, and Zinzi Mandela. *Black as I Am*. Los Angeles: Guild of Tutors, 1978.

Marder, Michael. "*Minima Patientia*: Reflections on the Subject of Suffering." *New German Critique* 33, no. 97 (winter 2006): 53–72.

Marien, Mary Warner. *Photography: A Cultural History*. London: Laurence King, 2002.

Marx, Karl. *Communist Manifesto*. New York: Tribeca Books, 2011.

Maynard, Patrick. "Photography." *The Routledge Companion to Aesthetics*, ed. Berys Gaut and Dominic McIver Lopes, 477–90. London: Routledge, 2001.

Melo Carvalho, Maria Luiza. *Contemporary Brazilian Photography*. London: Verso, 1996.

Memorial da América Latina. *Programa Roda Viva* (booklet). Transcription of an interview with Sebastião Salgado, coordinated by Matinas Suzuki Jr., *Programa Roda Viva*, TV Cultura, Fundação Padre Anchieta, April 4, 1996. São Paolo: Pavilhão da Creatividade, 1996.

Menchú, Rigoberta. *I, Rigoberta Menchú: An Indian Woman in Guatemala*. London: Verso, 1984.

Merleau-Ponty, Maurice. *Sense and Non-sense*. Evanston, Ill.: Northwestern University Press, 1991.

———. *The World of Perception*. London: Routledge, 2004.

Miller, Russell. *Magnum: Fifty Years at the Frontline of History; The Story of the Legendary Photo Agency*. London: Pimlico, 1999.

Mitchell, W. J. T. "Cloning Terror: The War Images of 2001–04." *The Life and Death of Images*, ed. Diarmuid Costello and Dominic Willsdon, 179–207. London: Tate, 2008.

———. *What Do Pictures Want? The Lives and Loves of Images*. Chicago: University of Chicago Press, 2005.

Mraz, John. "Los Hermanos Mayo: Photographing Exile." *Film-Historia* 10, no. 1–2 (2000): 7–27. Available online at http://www.publicacions.ub.es/bibliotecaDigital/cinema/filmhistoria.

———. "Sebastião Salgado: Ways of Seeing Latin America." *Third Text* 16, no. 1 (2002): 15–30.

Museum of Modern Art. *Primitivism and Modern Art*. New York: Museum of Modern Art, 2002.

Nair, Parvati. "Autography from the Margins: Photography, Collective Self-Representation and the Disturbance of History." *Hispanic Research Journal* 9, no. 2 (2008): 1–9.

Nancy, Jean-Luc, 2005, *The Ground of the Image*. Trans. Jeff Fort. New York: Fordham University Press, 2005.

Neruda, Pablo. *Odas elementales*. Barcelona: Seix Barral, 1981.

Noble, Andrea. *Tina Modotti: Image, Texture, Photography*. Albuquerque: University of New Mexico Press, 2001.

Ortiz, Fernando. *Contrapunteo cubano del tabaco y el azúcar*. Ed. Enrico Mario Santi. Madrid: Cátedra, 2002.

Parker, Ian. "A Cold Light: How Sebastião Salgado Captures the World." *New Yorker*, April 18, 2005, 154.

Parsons, Glenn. *Aesthetics and Nature*. London: Consortium International, 2008.

Pasi, Alessandro. *Leica: Witness to a Century*. New York: W. W. Norton, 2004.

Paz, Octavio. *The Labyrinth of Solitude*. Trans. Lisander Kemp, Yara Milos, and Rachel Philips Belash. New York: Grove, 1961.

———. *The Other Mexico: Critique of the Pyramid*. Trans. Lysander Kemp. New York: Grove, 1972.

Petras, James, and Henry Veltmeyer. *Cardoso's Brazil*. Lanham, Md.: Rowman and Littlefield, 2003.

Pollock, Griselda. "Response to W. J. T. Mitchell." *The Life and Death of Images*, ed. Diarmuid Costello and Dominic Willsdon, 208–12. London: Tate, 2008.

Ponge, Francis. *Le parti pris des choses*. Paris: Bertrand Lacoste, 1994.

Prado, Paulo. *Retrato do Brasil*. 3rd ed. Rio de Janeiro: F. Briguet, 1931.

Price, Mary. *The Photograph: A Strange, Confined Space*. Stanford: Stanford University Press, 1997.

Prosser, Jay. *Light in the Dark Room: Photography and Loss*. Minneapolis: University of Minnesota Press, 2005.

Rai, Raghu. *Raghu Rai's India: Reflections in Colour*. London: Haus, 2008.

Rama, Ángel. *La ciudad letrada*. Hanover, N.H.: Ediciones del norte, 2002. Trans. John Charles Chasteen as *The Lettered City*. Durham: Duke University Press, 1996.

Ramos, Julio. "Los viajes de Sebastião Salgado." *Sujetos en tránsito: (In) migración, exilio y diáspora*, ed. Alvaro Fernández Bravo and Florencia Garramuño. Madrid: Alianza Editorial, 2003.

Rancière, Jacques. *The Future of the Image*. Trans. Gregory Elliott. London: Verso, 2007.

———. *On the Shores of Politics*. Trans. Liz Heron. London: Verso, 2007.

———. *The Politics of Aesthetics*. Trans. Gabriel Rockhill. London: Continuum, 2004.

Reinhardt, Mark, Holly Edwards, and Erina Duganne, eds. *Beautiful Suffering: Photography and the Traffic in Pain*. Chicago: University of Chicago Press, 2007.

Reporters Sans Frontières. *100 photos pour défendre la liberté de la presse*. Paris: FNAC, c. 1997.

Ricoeur, Paul. *Time and Narrative*. Trans. Kathleen McLaughlin and David Pellauer. 3 vols. Chicago: University of Chicago Press, 1990.

Rio Branco, Miguel. *Miguel Rio Branco*. São Paolo: Companhia das Letras, 1998.

Ritchin, Fred. "The Lyric Documentarian." Sebastião Salgado, *An Uncertain Grace*, 148–49. New York: Aperture, 1990.

Rosen, Michael. "Benjamin, Adorno, and the Decline of Aura." *Critical Theory*, ed. Fred Rush, 40–56. Cambridge: Cambridge University Press, 2004.

Rosler, Martha. "In, Around, and Afterthoughts." *The Photography Reader*, ed. Liz Wells, 261–74. London: Routledge, 2003.

Salgado, Sebastião, T. J. Clark, Orville Schell, Nancy Scheper-Hughes, Candace Slater, and Michael Watt. *Migrations: The Work of Sebastião Salgado*. Occasional Papers 26. Berkeley, Calif.: Doreen B. Townsend Center for the Humanities, 2003.

Sallis, John. *Topographies*. Bloomington: Indiana University Press, 2006.

Sartre, Jean-Paul. *Modern Times: Selected Non-fiction*. London: Penguin, 2000.

Sassen, Saskia. *Guests and Aliens*. New York: New Press, 1999.

Scarry, Elaine. *On Beauty and Being Just*. Princeton: Princeton University Press, 1999.

Seabrook, Jeremy. *The No-Nonsense Guide to World Poverty*. Oxford: New Internationalist, 2003.

Seager, Ashley. Review of *Black Gold*. *Guardian*, January 29, 2007, 25.

Sekula, Allan. "The Body and the Archive." *The Contest of Meaning: Critical Histories of Photography*, ed. Richard Bolton, 343–89. Cambridge: MIT Press, 1992.

———. "On the Invention of Photographic Meaning." *Artforum* 13, no. 5 (January 1975): 45.

Shiva, Vandana. "War against People and Nature from the South." *Views from the South: The Effects of Globalization and the WTO on the Third World*, ed. Sarah Anderson, 91–125. Oakland, Calif.: Food First, 2000.

———. "Water Wars in India." *Soundings*, no. 34 (autumn 2006): 7–10.

Singer, Peter. *Unsanctifying Human Life*. Ed. Helga Kuhse. Oxford: Blackwell, 2002.

Singh, Dayanita. *Privacy*. London: Steidl, 2004.

Sischy, Ingrid. "Good Intentions." *Illuminations: Women Writing on Photography from the 1850s to the Present*, ed. Liz Heron and Val Williams, 272–82. London: I. B. Tauris, 1996.

Soar, Matthew. "The Advertising Photography of Richard Avedon and Sebastião Salgado." *Image Ethics in the Digital Age*, ed. Larry Gross, John Stuart Katz, and Jay Ruby, 269–94. Minneapolis: University of Minnesota Press, 2003.

Solnit, Rebecca. *Hope in the Dark: Untold Stories, Wild Possibilities*. New York: Nation, 2005.

Solomon-Godeau, Abigail. "'The Family of Man': Refurbishing Humanism for the Postmodern Age." *The Family of Man, 1955–2001: Humanism and Postmodernism; A Reappraisal of the Photo Exhibition by Edward Steichen*, ed. Jean Back and Viktoria Schmidt-Lisenhoff, 29–57. Marburg, Germany: Jonas Verlog, 2004.

———. *Photography at the Dock: Essays on Photographic History, Institutions, and Practices*. Minneapolis: University of Minnesota Press, 2003.

Sontag, Susan. *On Photography*. London: Penguin, 1978.

———. *Regarding the Pain of Others*. London: Penguin, 2003.

Stallabrass, Julian. "Sebastião Salgado and Fine Art Photojournalism." *New Left Review* 223 (1997): 131–62.

Stieglitz, Alfred. "Pictorial Photography." *Classic Essays on Photography*, ed. Alan Trachtenberg, 115–124. New Haven, Conn.: Leete's Island, 1980.

Strauss, David Levi. *Between the Eyes: Essays on Photography and Politics*. New York: Aperture, 2003.

Tagg, John. *The Burden of Representation: Essays on Photographies and Histories*. New York: Macmillan, 1988.

Taylor, Paul, and Dorothea Lange. *An American Exodus: A Record of Human Erosion*. Paris: Editions Jean-Michel Place, 2000.

Téllez, Juan José. *Moros en la costa*. Madrid: Editorial Debate, 2001.

Tuan, Yi-Fu. *Topophilia*. New York: Columbia University Press, 1990.

Unger, Roberto Mangabeira. *Democracy Realized: The Progressive Alternative*. London: Verso, 2000.

Van Riper, Frank. *Talking Photography: Viewpoints on the Art, Craft and Business*. New York, Allworth, 2002.

Vieira, Else R. P. "Snapshots: Sebastião Salgado in England and Beyond." *Hispanic Research Journal* 5, no. 2 (June 2004): 157–75.

Vishniac, Roman. *Children of a Vanished World*. Ed. Mara Vishniac Kohn and Miriam Hartman Flacks. Berkeley: University of California Press, 1999.

Weinberg, Adam D. *On the Line: The New Color Photojournalism*. Minneapolis: Walter Arts Center, 1986.

Weiner, Myron. *The Global Migration Crisis: Challenge to States and to Human Rights*. New York: Longman, 1995.

Wyschogrod, Edith. "The Art in Ethics: Aesthetics, Objectivity, and Alterity in the Philosophy of Emmanuel Levinas." *Ethics as First Philosophy: The Significance of Emmanuel Levinas*, ed. Adriaan T. Peperzak, 137–48. New York: Routledge, 1995.

Žižek, Slavoj, "The Lesson of Rancière." Jacques Rancière, *The Politics of Aesthetics*, 69–79. London: Continuum.

Films, DVDs, and Videos

Bamako. Dir. Abderrahmane Sissako. London: Artificial Eye Film Company Ltd., 2006.

Black Gold. Dir. Nick Francis and Mark Francis. London: DogWoof Pictures, 2006.

Exodus. Dir. Sorius Samura. London: Insight News Television, 2003.

An Inconvenient Truth. Dir. Davis Guggenheim. Hollywood: Paramount Pictures, 2006.

Koyaanisqatsi. Dir. Godfrey Regio. Hollywood: MGM Home Entertainment, 1983.

Looking Back at You. Dir. Andrew Snell. London: BBC Omnibus, 2000.

Powaqqatsi: Life in Transformation. Dir. Godfrey Regio. Hollywood: MGM Home Entertainment, 1988.

Programa Roda Viva. Interview with Salgado, coordinated by Matinas Suzuki Jr. São Paolo: TV Cultura, Fundação Padre Anchieta, April 22, 1996.

Salgado and Galeano. Dir. Amy Goodman. Santa Fe, N.M.: Lannan Foundation, 2000.

Sebastião Salgado: The Photographer as Activist. Recording of discussion with Orville Schell, Ken Light, and Fred Ritchin, held at the Graduate School of Journalism, University of California, Berkeley, October 27, 2004.

Slumdog Millionaire. Dir. Danny Boyle. London: Film4, 2008.

Spectre of Hope. Dir. Paul Carlin. New York: Icarus Films, 2001.

Walker Evans: America. Dir. Sedat Pakay. New York: Hudson Film Works Inc. and WMHT Educational Telecommunications, 2000.

We're Normally Different. Dir. Susane Engels. London: ICA, 2006.

biblical imagery: in Hine's work, 180–81; in Salgado's work, 115–17, 161–62, 327n.73

Bisilliat, Maureen, 36

black-and-white photography: realism in, 185–86; Salgado's preference for, 13, 163–66

Black Gold (film), 157, 327n.66

Black Skins, White Masks (Fanon), 57

Black Star (photo agency), 245

Blake, Peter (Sir), 112

Blanchot, Maurice, 249–50

blindness, documentary photography and images of, 190–93

Boccioni, Umberto, 316n.30

bodies: in early Brazilian photography, 70–75; in rural Latin American culture, 52–59; in Salgado's photography, 41–44, 52–59

"Body and the Archive, The" (Sekula), 174–76

boias frias (nameless workers), 119–20

Bosch, Hieronymus, 151

Bourdieu, Pierre, 181

Bowden, Charles, 163–64

Brancusi, Constantin, 122

Brandt, Bill, 22

Brazil: baroque aesthetic and magical realism in, 204–7; colonization and slavery in, 65–67, 70–75; economic development in, 302–4; Gaensly's photography of, 158, 327n.69; history of photography in, 28, 31, 34–37, 70; industrialization in, 18; internal migration in, 307; mineworkers in, Salgado's photographs of, 71–75; Salgado's exile from, 3–7, 56; Salgado's photographic perspective on, 8–10

Brecht, Bertolt, 326n.45

Breton, André, 31

Buarque, Chico, 86–87

Buerk, Michael, 59–60

Burden of Representation: Essays on Photographies and Histories (Tagg), 186–87

Bushara, Ashwin, 108

Butler, Judith, 261–62

Cadava, Eduardo, 195–96

Camera Lucida (Barthes), 129–31

Camera Work (journal), 131

campesino millenarianism, 306

Campos, Haroldo de, 80, 204–7

cante minero flamenco, 231

Canto General (Neruda), 141

Capa, Cornell, 224, 325n.28

Capa, Robert, 5, 11–12, 22, 61, 224, 328n.80, 334n.35

capitalism: alienation from animals and, 292–93; challenges in Brazil to, 76–88; cultural production in context of, 141–50; documentary photography in context of, 134–38; globalization and, 38–41; intervention in, through documentary photography, 140–50; mass migration as result of, 88–104; mining's role in, 230–32; modernity and postmodernity and ideology of, 17; nature harnessed to production in, 41–44; objectification of human individuality in, 73; politics and photography and, 276–80

Cardenal, Ernesto, 162, 328n.74

Cardoso, Fernando Enrique, 76–77

Carpentier, Alejo, 202–4

Carrière, Jean-Claude, 28–29

Cartesian philosophy, 296–98

Cartier-Bresson, Henri, 5, 10–12, 22, 40, 224–25, 240–41, 328n.80, 332n.15, 334n.35

Catholicism in Latin America, Salgado's images of, 207

Césaire, Aimé, 182

Cézanne, Paul, 297–98

Chador-Dadar exhibit, 225, 333n.18

Chambi, Martín, 32–34

Charnay, Désiré, 21

Chevrier, Jean-François, 221–22, 237, 242, 254, 256

chiaroscuro technique, 248

child labor, Hine's documentation of, 180–81

children, Salgado's images of, 209–11, 213–16

Children, The (Salgado photo-essay), 15, 100–104, 108, 117; collectivity in images of, 285–86; gaze in images of, 207–11; *Genesis* images compared with, 188

Children of a Vanished World (Vishniac), 101–2

diversity, modernity and, 298–302
documentary photography: Abbott's comments on, 130–31; aesthetics vs., 44–45; as archaeology and archive, 186–90; contextualization of image in, 281–84; critical debate over, 23–25, 134–38, 140–50; ethics of, 132–38, 219–63; historiography and, 119–66; in Latin America, 30–34; motifs and symbols in, 171–76; poetic vision and, 176–83; politics and, 276–80; reality as represented in, 134–38, 141–50, 183–86; Salgado's work as, 13–14, 151–60; suffering in, 273–74; traditions of, 20–23; venues for, 156–60; as witness to events, 60–64
Donnan, Hastings, 93
"Do They Know It's Christmas?" (song), 60
Drik (photographic agency), 39
dualism, ethics of documentary photography and, 228
Dube, Siddharth, 105, 107
Duganne, Erina, 224–25
During, Simon, 199–200, 330n.37
Dussel, Enrique, 304–6
Düvell, Franck, 99

Easterby, John, 137–38
economics, Salgado's training in, photography influenced by, 14, 49–52, 74–75
Edwards, Elizabeth, 215–16
Eldorado dos Carajás massacre, Salgado's documentation of, 75, 77, 84
El guerrillero heróico (Korda), 30, 316n.40
elitism, in Salgado's work, critical concerns over, 222
El País, Salgado's work for, 14
Emerson, Peter Henry, 131–33
End of Polio: A Global Effort to End a Disease, The (Salgado), 104–9, 163
engagement, photography as tool of, 144–50, 156–60
environment: disruption of, in Salgado's Sahel famine photography, 61–64; in *Genesis* (Salgado photographic project), 311–13; modernity and postmodernity and, 18;

preoccupation in Salgado's *Genesis* with, 109–17; Salgado's photography concerning, 36–37, 298–302; Salgado's photography focusing on, 50; in Salgado's Serra Pelada photos, 230–33
epistemological disturbance, ethics of documentary photography and, 228–33
Escola Nacional Florestan Fernandes, 76
Ethical Culture School, 179
ethics: after-images and, 234–37; alterity and, 219–20; aura and, 251–52; categories and classification in context of, 226–28; epistemological disturbance and, 228–33; exchange value and, 220–21; facelessness of images and, 248–51; intersubjective relations and, 235–36; of loss, 292–93; plural perspectives and, 239–42; poetics of the unseen and, 246–48; politics and, 259–63; refracted gaze and, 237–39; refusal of compassion and, 257–59; of regard, 242–43; religiosity of images and, 252–56; in Salgado's photography, 45–46, 132–38, 162–66, 217–19; semiotics of difference and, 243–46; sentimentality and voyeurism in discussion of, 221–26; visible and invisible and, 256–57
Ethiopia, coffee industry in, 157, 327n.66
ethnographic studies, photography and, 35
Eurocentric aesthetic: ethics of documentary photography and, 226; nature in context of, 275–76; photodocumentary as art and, 122–23, 324n.8; refracted gaze and, 237–39
Evans, Walker, 28, 54, 169, 176–77, 179, 258, 299
exchange value, ethical value and, 220–21
exile, as theme in Salgado's work, 56–59, 89–104
Exodus (Salgado exhibition), 51, 92–93, 103, 178, 209; biblical references in, 327n.73

modernity: dominance of visual and, 124–26, 160, 323n.4; ethics and exchange values in, 220–21; Latin American photography and, 30–31; magical realism and, 204–7; mining's role in, 231–33; photography's role in, 119–21, 143–66; Salgado's work as critique of, 15–20, 37–41, 49–52; unevenness of, in rural Latin America, 53–59

Modotti, Tina, 31, 34

Moreiras, Juan Pablo, 336n.6

Movimento Sem Terra (Landless Workers' Movement), 7, 329n.18; industrialization of Brazil and, 230; la mística religiosity and, 305–6; Salgado's donation of photos to, 152, 244; *Terra* photo-essay images of, 75–88, 162, 185

moving image, photography vs., 144–50

Mozambique, displaced children in, 101–2

Mraz, John, 54, 57, 62, 244

Mulvey, Laura, 237

Nachtwey, James, 169, 258, 329n.2

namelessness, ethics of documentary photography and, 254–56

Namib desert, Salgado's photography of, 112, 188

Nancy, Jean-Luc, 253–56

National Child Labor Committee, 180

National Geographic (magazine), 225, 238

nature: disruption of, in Salgado's Sahel famine photography, 61–64; in *Genesis* (Salgado), 109–17, 275–76, 278; modernity and postmodernity in relation to, 18; in rural Latin America, Salgado's photography of, 52–59; Salgado's focus on man's alienation from, 41–44, 50, 68–75

Nègre, Charles, 21

neoliberalism: dispossessed subjects and rhetoric of, 127–28; documentary photography aesthetics and, 151–60; landlessness and policies of, 81–88, 320n.48; mass migration as result of, 88–104

Neruda, Pablo, 141, 182

New Yorker magazine, 134

New York Times, 81, 223

New York Times Magazine, Salgado's work for, 14

Nicaragua, political upheaval and liberation theology in, 162

Niemeyer, Oscar, 204

Nigeria, polio eradication in, 107

Noigandres group, 204–5

non-Western photography, political representation in, 39–41

North America, history of photography in, 21

objectivity, photography and margins of, 199–201

Odas elementales (Neruda), 182

On Beauty and Being Just (Scarry), 260

Open Veins of Latin America (Galeano), 65, 67

Orientalism, photographic stereotyping and, 225, 333n.18

Ortiz, Fernando, 212–13

Other Americas (Salgado), 52–59, 75, 318n.5; ambivalence of beauty in images from, 138–40; Brazilian publication of, 318n.13; criticism of, 183; decontextualized images in, 161–63, 283–84; polity as motif in, 271

Other Mexico: Critique of the Pyramid, The (Paz), 58

otherness: advertising and objectification of, 153–54; as artistic aesthetic, 122–23; ethics of documentary photography and, 254–56; perceptions of mass migration and, 99–104; in Salgado's photography, 57; viewer's response to photography and, 124–26

Out of Balance (Jaar), 245–46

Pakistan: photography in, 29–30; polio in, 105, 107

Paris Match, Salgado's work for, 14

Parker, Ian, 223–24

"Passion" (Unger), 309

patera (migrant vessel), 93

Paz, Octavio, 58, 73, 318n.6

peasant protest movements, landlessness in Brazil and, 76–88, 318n.5

Pentax 645 camera, Salgado's use of, 13

perception: aestheticization and, 140; reason and, 296–98

Peru, photodocumentary work in, 31–33

Petras, James, 76

Phaidon (press), 50

philosophy of art, photography and, 151–60

Philosophy of History (Hegel), 43

philosophy of language, 249–51

philosophy of liberation, 302–6

philosophy of photography, 225–27

photodocumentary. *See* documentary photography

photo-essay: origins of, 28; Salgado's vision of, 97–104

Photograph, The (Clarke), 81

"Photograph as an Intersection of Gazes: The Example of *National Geographic*, The" (Lutz and Collins), 238–39

photography: as aestheticization, 143–61; critical challenges to, 23–25; documentary vs. aesthetic styles of, 44–45; Eurocentric origins of, 27–28; historiography and, 119–66; history of, 18–20; as tool for activism, 59–60

Photography at the Dock: Essays on Photographic History, Institutions, and Practices (Solomon-Godeau), 173–74

photojournalism: aesthetics of, 151–60; ethics of, 132–38; objectivity and engagement in, debated concerning, 81–88; Salgado's work in, 5, 14; as witness to events, 61

Picasso, Pablo, 122

Pixel Press, 65

Places We Live, The (Bendiksen), 307–8

Plato, 145

plurality, in refracted gaze, 237–39

poetics: documentary photography and, 176–83, 246–48; politics and, 266–67

Poetics (Aristotle), 182, 280–81

polio, campaign against, Salgado's documentation of, 50–52, 104–9, 136

politics: aesthetics and, 173–76,

280–81; contextualization of image and, 281–84; ethics of photography and, 259–63; history and, 215–16; in Latin America, 77; loss and, 286–89; migration and, 307–11; photography and, 26–27, 276–80; Salgado's involvement in, 78–88; in Salgado's photography, 45–46, 75–88, 161–66, 264–71; suffering and, 273–74; topophilia and, 294–96

polity: of environment, 311–13; in Salgado's work, 267–71

Pollock, Griselda, 260

Ponge, Francis, 181–82, 329n.14

portraiture, photography as, 21

postcolonialism: magical realism and, 202–7; Salgado's work in context of, 28–30, 41–44

postmodernity: documentary photography aesthetics and, 122–23, 152–61, 335n.45; ethics and exchange values in, 220–21; philosophy of liberation and, 305–6; poetic vision in context of, 246–48; Salgado's work in context of, 15–20, 37–41, 145–50, 249–51

Pound, Ezra, 205

poverty: fetishization of, 338n.70; mass migration in wake of, 89–104; Salgado's stereotyping of, 222

Powaqqatsi (film), 244, 334n.38

power: history and, 215–16; politics and ethics, 259–63

Prado, Paulo, 56

Pressly, Linda, 78

Price, Mary, 60, 64

primitivism, photographic aesthetic and, 122–23

Principe de Asturias Award for Arts, 7

privatization, impact in Brazil of, 76–88

Prosser, Jay, 184

Proust, Marcel, 249–50

punctum, Barthes's concept of, 129–31, 187, 192, 226–27

push-and-pull factor of migration, 83–84

race: in early Brazilian photography, 69–75; in Salgado's photography, 41–44, 68–69

work of, 15–20; photodocumentary projects of, 13–14, 20–23; photographic techniques and methodology of, 10–16; travelling exhibitions of work by, 50–52; viewers' reactions to work of, 1–2
"Salgado, Seventeen Times" (Galeano), 67, 234–35
"Salgado ou l'exploitation du compassion" (Chevrier), 222
"Salgados" exhibit (Arden and Anstruther gallery), 152–54, 326n.55
Sallis, 294–95
Salmos (Cardenal), 328n.74
Samata (Bangladeshi NGO), 320n.49
Samura, Sorius, 93
Saramago, José, 7, 85, 284
Sartre, Jean-Paul, 240–41
Sassen, Saskia, 92
saudades, as motif in Salgado's photography, 56
Saudades do Brasil (Lévi-Strauss), 57
Scarry, Elaine, 260
Schein, Hegel's concept of, 148–49
Schell, Orville, 62
Scholem, Gershom, 326n.45
Scott, Robert Falcon, 293–94
Scott, Walter (Sir), 21
Seager, Ashley, 157
"Sebastião Salgado and Fine Art Photojournalism" (Stallabrass), 155–56
Sekula, Allan, 174–76, 187, 225
semiotics of image: after-images and, 234–35; difference and, 243–46
sentimentality, ethics of photography and, 221–26
Serra Pelada gold mines: after-images in photography of, 234–35; Brazilian photographers' images of, 244–46; ethical issues concerning Salgado's photography of, 229–33, 235–37, 262–63; Salgado's images of, 71–73, 117, 153–54, 172, 217, 224; semiotics of difference in photography of, 244–46
Seymour, David ("Chim"), 5, 61, 224
sfumato technique, 248
Shiva, Vandana, 37, 300, 306
Silk Cut advertising campaign, Salgado's work for, 152–54

Singer, Peter, 116–17
Singh, Dayanita, 29–30
Sischy, Ingrid, 134–38, 142, 155–56, 221, 281, 325n.29
Sissako, Abderrahmane, 321n.54
slavery: in Brazil, 65–67, 70–75, 319n.32; in Latin America, history of, 65–67, 69–70
Slumdog Millionaire (film), 338n.70
Smith, W. Eugene, 12, 231, 246
Soar, Matthew, 154–56
social justice, landlessness and notions of, 80–88
social photography, as poetic vision, 177–83
socioeconomic conditions, Salgado's photographic projects on, 14
Solnit, Rebecca, 309, 311
Solomon-Godeau, Abigail, 173–74, 186, 225–26, 287
Solomos, John, 42
Somoza Debayle, Anastasio, 162
Sontag, Susan, 101, 125–26, 151, 222, 256–59
South Africa, gold miners in, 232, 334n.24
Spanish Civil War: photographic legacy from, 32, 317n.42; photojournalism during, 12
Spectre of Hope, A (Salgado video), 97, 219, 222
Stallabrass, Julian, 155–56, 162–63
Starbucks Corporation, 157
States of Denial (Cohen), 223
Steichen, Edward, 22, 287, 328n.80
Stern, Salgado's work for, 14
Stieglitz, Alfred, 131–32
Story of Art, The (Gombrich), 248
Strait of Gibraltar, mass migration across, 92–93
Strand, Paul, 22
Strauss, David Levi, 142–43, 151–52, 245–47
Strykker, Roy, 178–79
style, suffering in, 274
subaltern studies, 210–13
Subaltern Studies Group, 210–11
Sudan, Salgado's photography of, 112–15
suffering, art and photography and, 273–74

wealth distribution, 325n.36

websites: access to photography through, 317n.57; Landless Voices Web Archive, 319n.38; Salgado's photography on, 81

Weil, Simone, 332n.2

Wenders, Wim, 142

We're Normally Different (film), 322n.78

West, Cornel, 237

W. Eugene Smith Grant in Humanistic Photography, 7

What Do Pictures Want? (Mitchell), 200–201

"Why Look at the Animals?" (Berger), 292

Williams, William Carlos, 177

Wilson, Thomas M., 93

witness: ethics of photography and, 224–26; to history, photographer as, 167–216; photographer as, in Salgado's *Sahel: L'homme en détresse*, 60–64

Witness in Our Time: Working Lives of Documentary Photographers (Light), 61

women, aesthetics of photography and, 325n.29

Words of Light: These on the Photography of History (Cadava), 195–96

Workers: An Archaeology of the Industrial Age (Salgado photo-essay): alienation as trope in, 115–16; apocalypse of industrialization in, 118; *boias frias* depicted in, 119–21;

class differences and displacement in, 302–3; colonialism as trope in, 65; ethics in context of, 136, 262–63; funding for, 224; *Genesis* images compared with, 188; global context for, 40, 88–89, 211–12; *In Principio* documentary compared with, 158; man and environment as theme in, 68–75; *Migrations* as sequel to, 308; mysticism and spirituality in images of, 161–62; other as subject in, 123–24; poetic vision in, 182–83; politics in images of, 267; publication as photo-essay, 50; Salgado's advertising work contrasted with, 152–61; subjugation and displacement in, 175–76. *See also* Serra Pelada gold mines

World Bank, 9, 79, 111

World Fair Trade Organization, 157

Wretched of the Earth (Fanon), 57

Wroe, Nicholas, 133–34, 137

Wyschogrod, Edith, 249–51

Xingu Indians, Salgado's photography of, 112

Yanomami Indians, photography of, 36

Yugoslavia, mass migration after breakup of, 98–100

Zamora, Lois Parkinson, 203–4

Zapatista movement, 58, 320n.48

Zimmerman, Chris, 105

Žižek, Slavoj, 281

PARVATI NAIR IS PROFESSOR OF HISPANIC,
CULTURAL, AND MIGRATION STUDIES AT
THE SCHOOL OF LANGUAGES, LINGUISTICS,
AND FILM AND DIRECTOR OF THE CENTRE OF
THE STUDY OF MIGRATION AT QUEEN MARY,
UNIVERSITY OF LONDON.

Library of Congress Cataloging-in-Publication Data

Nair, Parvati.
A different light : the photography of Sebastião Salgado /
Parvati Nair.
p. cm.
Includes bibliographical references and index.
ISBN 978-0-8223-5031-6 (cloth : alk. paper)
ISBN 978-0-8223-5048-4 (pbk. : alk. paper)
1. Salgado, Sebastião, 1944—Criticism and
interpretation. I. Title.
TR140.S35N35 2012
770—dc23 2011021958